Disney In-Between

The Lost Years: 1966-1986

By

Stephen ANDERSON

Text Copyright ©2024 Stephen J. Anderson

All rights reserved. Published by The Old Mill Press, Inc. No part of this book may be reproduced or transmitted, in whole or in part, in any form (beyond that permitted by Section 107 and 108 of the U.S. Copyright Law and except by reviewers for the public press) or by any means, electronic or mechanical, including photocopying, recording, or by any past, present, and future information storage, retrieval, and display systems, without written permission from the publisher. For more information contact: The Old Mill Press @ enquiry@theoldmillpress.com

Interior design and layout by Nancy Levey-Bossert

Cover design: The Book Cover Whisperer

Edited by Michele Orwin
Copy Edited by Diane Hodges
Index by Connie Binder

Set in Freight Text Pro and Century Gothic Pro used courtesy of Adobe Typekit, New Press Eroded by Galdino Otten

Printed in Korea

First Edition: September 2024

ISBN: 9798987058947
Library of Congress Control Number: 2024933248

visit theoldmillpress.com

Disney In-Between: The Lost Years 1966--1986 and The Old Mill Press, Inc. are not endorsed by or associated with The Walt Disney Company, Disney Enterprises, Inc., or any of its corporate sponsors or affiliates. For the purposes of information, commentary, and history, this book references various Disney copyrighted characters, trademarks, and registered marks owned by The Walt Disney Company and Disney Enterprises. Copyrighted names and terms, including film titles, attractions, images, and other related names, are used in this book solely for editorial, scholarship, and information purposes under the Fair Use Doctrine. Neither the author nor the publisher makes any commercial claim to their use, and neither is affiliated with The Walt Disney Company or any of its associated companies. All photographic images shown in this book are promotional for the respective IP and are viewed as individual works of art and are not sold by the author or publisher. See the associated photo credits for all applicable attributions.

Dedication

for

Mom and Dad

Burny and Dale

Table of Contents

FOREWORD .. 6

ACKNOWLEDGEMENTS ... 8

INTRODUCTION .. 10

1966 .. 12

1967 .. 34

1968 .. 46

1969 .. 56

1970 .. 70

1971 .. 80

1972 .. 92

1973 .. 98

1974 .. 108

1975 .. 120

1976 .. 150

1977 .. 170

1978	208
1979	220
1980	252
1981	284
1982	322
1983	338
1984	362
1985	394
1986	420
AFTERMATH	430
CONCLUSION	450
ENDNOTES	452
BIBLIOGRAPHY	459
PHOTO CREDITS	472
INDEX	476

Foreword

So, how did I survive?

Stephen just had to know. "Is it okay if I record you?"

"Sure," I nodded, sipping one of the multiple cups of coffee I had prepared for our session. We were going to be here for a while. Frankly, I was relieved to know that Stephen was putting in the due diligence to be a good detective. To get his quotes right. To crosscheck stories of those who made it through. And those who didn't.

He was, after all, one of us – a writer-director-artist who had survived the great changing of the guard at Disney Studios after Walt died. The wandering in the desert years. The awkward in-between years that took a toll on dreams.

You likely know Stephen Anderson for his contributions to films like *The Emperor's New Groove, Meet the Robinsons, Zootopia* and more – films that explored new ground. I also know him as a modern Sherlock Holmes. I've been under his magnifying glass.

Admittedly, my adventures at Disney started a bit earlier than his. Little Stephen was just blowing out his fifth birthday candle when I was named Teacher's Assistant for the first year of the Cal Arts Character Animation Program back in 1975. By 1977, when the first four of us – Brad Bird, John Musker, Doug Lefler and myself – were yanked out of college to begin our careers as Disney Feature Animators, we were thrilled. We had no idea that the biggest challenge to following in Walt's footsteps would come from inside the studio itself. And over time, many of us would leave the studio in order to protect Walt's creative flame elsewhere.

Several coffees into our session, Stephen and I found ourselves comparing two striking photos. One was a 2014 Vanity Fair shot of our Cal Arts A113 class, taken by the legendary Annie Leibovitz for an article entitled The Class That Roared. The other was an unpublished 1978 glossy of the Disney Feature Animation crew, taken on the lawn of the Burbank lot in the days before *The Fox and the Hound*. I was in both photos – surrounded by my peers in Annie's shot, and accompanied by four of Walt Disney's legendary Nine Old Men in the other.

Stephen and I pondered - did those two images sum up a simple split of the young generation vs the old guard? As I glanced from face to face in that black and white photo – Eric Larson, Ollie Johnston, Frank Thomas, Woolie Reitherman, Art Stevens, Glen Keene, Randy Cartwright, Don Bluth – my answer was no. It was not that simple at all.

Eric, Frank and Ollie, who had been the young punks when Walt disrupted cinema back in the 1930s, were completely supportive of us new young punks in the 1970s. They cheered us on, and encouraged us to lean into the new. Across the generational divide, we were in total sync.

Yet others in that same photo, of varying ages, were on a whole different path. They not only avoided anything new, but lobbied against equaling the emotional depth of the Disney classics for fear of receiving angry fan letters. We saw them as abandoning Walt's powerful legacy to create a new and weaker one.

We – the young punks and veteran mentors – took the premise 'What Would Walt Do' much more seriously than those who were letting his legacy fade. We made it our mission to keep it alive and vibrant.

Stephen listened. Jotted down notes.

Like a good detective, director, storyteller, artist, historian and writer, he curated all of his research into a compelling, relevant and entertaining book. You are holding it now.

Like you, I look forward to reading it, and have prepared a rich cappuccino for the occasion.

Yes, quite a few of us survived and thrived, and are now pursuing what Walt might do with all manner of future storytelling tools. But the journey to get here was as crazy as Mr. Toad's Wild Ride. So, if some of you feel like swapping out my cappuccino for a stiff whiskey before you turn the page, I won't blame you.

Thank you, Stephen Anderson, for chronicling our often treacherous course through the great Disney In-Between!

Jerry Rees

Acknowledgements

The book you hold in your hands is the synthesis of my two childhood obsessions: books *about* Disney and movies *by* Disney. It has truly been a labor of love to create.

I extend a wholehearted thank you to:

Editor Michele Orwin, copyeditor Diane Hodges, indexer Connie Binder, Nancy Levey-Bossert for layout and design and the entire team at The Old Mill Press.

My wife Heather, my son Jake, and my good friend Morgan Marquette for their patience and tireless support of my side projects.

All of the artists and filmmakers of the Walt Disney Studio from the late 60s into the late 80s for filling my childhood with joy.

Dave Block, Don Bluth, Mike Bonifer, Dave Bossert, Chris Buck, Ron Clements, Lorna Cook, Tony DeRosa, Mark Dindal, Mike Gabriel, Andy Gaskill, Mike Giaimo, Howard Green, Joe Hale, Dan Hansen, Mark Henn, Glen Keane, Sean Marshall, Annie McEveety, Dorothy McKim, John Musker, John Norton, Jerry Rees, John Scheele, Toby Shelton, Charles Martin Smith, Jonathan Taplin and Darrell Van Citters for sharing their time and their memories.

The Walt Disney Archives as well as Mary Walsh and Fox Carney of the Animation Research Library.

Carolyn Carmean, Melissa Carmean and Eric Ogg for their countless hours of editing my early manuscripts and proposals.

Tammy Tuckey, Howard Green, Ryan Tengel and Lavalle Lee for helping to secure interviews and for providing support and cheerleading.

Special thanks to Ron Clements and Tom Wilhite for allowing me access to their 2017 interview.

And my deepest gratitude to those that gave their time to this project that are no longer with us: Al Kasha, Gary Nelson, Jeb Rosebrook and Marc Stirdivant. To Dale Baer, for your kindness and gentle wisdom. And to Burny Mattinson, for the long chats, the hearty laughs, and for being the backbone of this story.

And finally to my Mom and Dad, for patiently supporting my passion for Disney by taking me to the library, the bookstore and the movies.

Introduction

Human memory tends to focus on extremes. When we reflect on our experiences, we often only see the highs and the lows. The victories and the disappointments. These are the moments that make the strongest impressions on us and become locked in our memories.

Then there are the periods in between those memorable moments. They are often moments of confusion and uncertainty. More shades of gray than black and white. These times of transition are where we learn. They are times of reflection, regrouping, and redefinition. Without these crucial periods we would not be prepared for—or able to move ahead to—the next extreme.

The craft of animation works similarly. A scene of animation is constructed using extremes and in-betweens. Rather than create every individual drawing a scene requires, an animator will draw only the necessary poses to convey a character's personality and emotions. These key drawings are called "the animator's extremes."

However, a scene is not complete without its in-betweens. Assistant animators add transitional drawings "inbetween" the extremes, to bridge the gaps. Sometimes these in-betweens are not the most appealing drawings in a scene. There may be odd stretching or morphing. Arms and legs may be mid-motion, blocking the character's face. A character may be locked in an awkward, transitional expression, eyes half-lidded in mid-blink—like a poorly timed photograph. The utilitarian quality of these drawings makes them less sought after by animation art collectors, who favor the more glamorous animator's extremes.

Without the inbetweens, the scene would consist of character

poses popping randomly from one to another. The inbetweens tie the poses together. They provide the correct number of drawings to achieve appropriate timing and give the character's movements an organic fluidity. Despite their importance, the functional nature of these drawings means they are often overlooked.

Such is the period at the Walt Disney Studio from 1966 to 1986. After the death of its founder and driving creative force, Walt Disney, the Studio was thrown into a time of awkward transition. In an instant, it ceased to be what it had always been, and without a strong leader, it was thrown into disarray. It was a time of uncertainty and fear of change. Those who picked up the torch did so with the best of intentions—to honor the legacy of Walt. But holding on to the past would go against the fundamental principles of a studio built on progress and forward-thinking.

Most accounts of the Studio's history tend to gloss over this period, at most mentioning six animated features and a handful of live-action films. But it was an important time of transformation worth our attention. The seeds of change quietly grew and flowered. The Studio gradually opened its doors to the outside world, allowing for an influx of new talent and ideas. A fresh generation of artists and filmmakers was inspired by Walt to create new things rather than carry the burden of preserving his legacy. Experimentation led to innovations that would influence the direction of the Studio as well as the entertainment industry. But it would take twenty years for these new ideas to gain footing and eventually redefine what the name Disney meant in a post-Walt world.

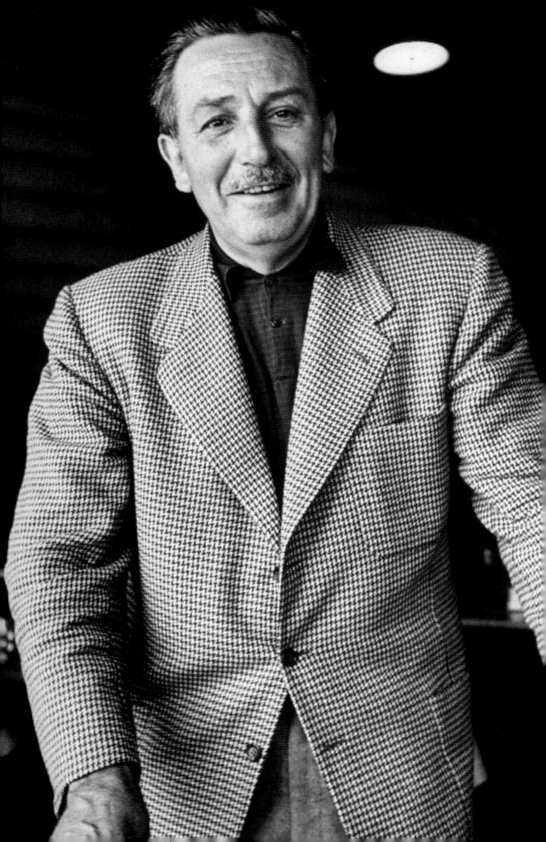

1966

"Walt's dead."

Burny Mattinson looked up from his desk where he was inbetweening a scene of animation. Ollie Johnston, one of the Studio's supervising animators, stood in the doorway, a look of pure shock on his face.

"Walt's dead!" repeated Johnston as he staggered past Mattinson into the adjoining office of Eric Larson, another supervising animator.

Gradually, word spread throughout the Studio that Walt Disney had passed away. More people gathered in Larson's office. He was considered the wise man of the group. As Larson's assistant, Mattinson had seen firsthand the profound effect that Larson's calm and steady demeanor had on his colleagues. They often came to Larson for advice, for guidance on their animation, or just to lounge in his office for a chat. Now they needed that calming presence more than ever, as the weight of the news set in. The atmosphere was somber. Even the famously cantankerous supervising animator Milt Kahl had a tear in his eye.

"We knew Walt was in the hospital," said Mattinson. "We didn't know what for." The Studio had insisted that his hospitalization was nothing more than treatment for an old polo injury. But as layout artist Joe Hale said: "Word came back within a day or so that he had had cancer and they had opened him up and realized it was too far gone."[1]

Walt's doctors had allowed him to return to the Studio for one last visit. Joe Hale recalled: "One of the saddest days was, word came down to all the different units that Walt was coming on the lot to look around. We saw Walt walking by the dialogue stage. He was just walking along. He walked all over the lot." He checked the progress of current film projects, visiting

the set of *Blackbeard's Ghost*. He discussed the new Pirates of the Caribbean ride that had recently shipped to Disneyland. Mostly, he focused on two of his most recent passions, an east coast Disneyland and his Experimental Prototype Community of Tomorrow, both located in Florida.

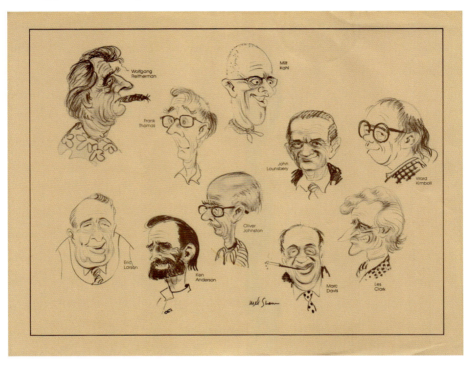

Caricatures of Walt's Nine Old Men (plus artist Ken Anderson) drawn by Mel Shaw.

Artist Ken Anderson recalled bumping into Walt outside of the Animation Building: "He had shrunk down. He was a little tiny guy compared to the guy he used to be. He seemed to be at least a head shorter than I am and much thinner. I was so glad to see him. I grabbed him by the hand and said, 'Gee, it's sure good to see you again, Walt. Happy to have you back.' And Walt looked at me. He was kind of quiet and he said, 'It's sure good to be back, Ken.'"[2] A few days later, on December 15, 1966, Walt Disney was dead.

At around 10 a.m. that day, a memo was distributed to the teams, confirming Walt's death. The entire staff went home, and the Studio shut its doors for the rest of the day. "Their father had died," said Mattinson of his animation colleagues. "They lost the one man they always wanted to please. So, it was huge."

It was a huge event for Mattinson, too. "I was devastated," he said. "The man was my idol. The man who had created all this wonderful excitement and this wonderful atmosphere. Suddenly, the world had stopped for us."

Burny Mattinson first stepped into Walt Disney's world in 1953. After graduating from high school, he marched onto the Disney lot in Burbank, portfolio in hand, ready to be part of the Studio's animation team. Mattinson had been hooked on the rich and colorful world of Disney animation ever since seeing the original theatrical release of *Pinocchio* as a child. "I thought, *I've got to be a part of this*," he recalled. "It made me want to draw. I didn't know whether to draw backgrounds or characters, but I wanted to do *that*."

Unfortunately for Mattinson, the Studio was not hiring artists on the day of his visit but they *were* looking for someone to make deliveries around the Studio lot, a position known as a "traffic boy." It wasn't exactly the job he'd hoped for but he eagerly accepted the position. "Boy, I had that foot in the door. That's what I wanted!"

As a traffic boy, Mattinson caught a glimpse of every aspect of the Studio. And there was much to see. He had joined Disney in the midst of one of the Studio's most creative, innovative and prosperous eras.

Production was underway on Walt's newest animated feature, *Lady*

and the Tramp. By this point in 1953, Walt had already produced and released three animated features throughout the '50s, kicking off the decade with *Cinderella.* That film marked the return of the full-length animated feature, after a multiyear hiatus due to the disruption of World War II. It was a critical and financial success on par with *Snow White* and was followed by *Alice in Wonderland* in 1951 and *Peter Pan* in 1953. Disney was back at the top of its game in a medium where they had no peers.

In between his deliveries, Mattinson watched the filming of the live-action epic 20,000 *Leagues Under the Sea.* Live-action filmmaking was something that Walt had always been interested in, hoping to make it as a director in the field when he first came to Hollywood in the '20s. Throughout the '40s, he used live-action in his theatrical features *The Three Caballeros, So Dear to My Heart,* and, most extensively, *Song of the South.* But in those films, either live actors were combined with animated characters or live-action segments were paired with animated ones. Walt's first, completely live-action feature was *Treasure Island,* released in 1950. After that film's success, Walt continued producing live-action films, releasing *The Story of Robin Hood* (1952) and *The Sword and the Rose* (1953).

Those three films had all been shot overseas with money that the Studio had tied up in Europe because of the war. As his interests in live-action production grew, Walt built new soundstages in Burbank and began production on 20,000 *Leagues Under the Sea,* making it the first full-length live-action feature to be filmed on the Disney lot. The epic adventure film would later be released to much critical acclaim. It would be the second-highest grossing film of 1955 and win two Academy Awards. Walt now committed to producing a regular slate of live-action films, in tandem with his animated features.

To support this commitment, the Studio would eventually purchase

Burny Mattinson's high school ID card.

315 acres of land in Placerita Canyon (about a half-hour drive north of Burbank) to be used as a location ranch. The sylvan landscape suited the Studio's repertoire of Westerns and rural-based stories. It also allowed them to keep their productions closer to home. The Studio dubbed it the Golden Oak Ranch, due to its proximity to the site where gold was first discovered in California, predating Sutter's Mill by several years.

And in addition to animation and live-action film production, Walt's biggest dream to date—Disneyland—was in the planning phase. "The Studio was alive," Mattinson recalled. "It was like Camelot."

But utopias don't come easily, and they're not built overnight. One of Walt Disney's many strengths was his ability to stay the course in the face of disruption. In his early career when his distributor pirated his star

character, Oswald the Lucky Rabbit, and poached most of his artistic staff, Disney emerged with a new star character—the now-beloved Mickey Mouse. Walt's capitalization on the innovation of sound in his 1928 short *Steamboat Willie* made cinematic history and changed the course of animation forever.

After the phenomenal success of Disney's first feature-length animated film, *Snow White and the Seven Dwarfs*, Walt's next four films released in the early '40s—*Pinocchio, Fantasia, Dumbo*, and *Bambi*—did not repeat the financial success of his debut film. *Dumbo* performed well thanks to its short production time and intentionally scaled-down costs, but the other three failed to recoup their sizable budgets due to the previous outbreak of war in Europe in 1939. This closed off one of the largest sources of box-office revenue. The production of lavish, animated features like these had to be placed on the back burner.

But this did not stop Walt from making films. He contributed to the war effort by using his resources to make training films for the military, both short and feature-length. To keep costs down and generate revenue, he made what are often referred to as "omnibus" or "package" films—films comprising a collection of shorts rather than a single narrative. Walt also discovered a new market in South America, taking his artists on a research trip to the region that yielded the vibrant and experimental features, *Saludos Amigos* in 1942 and *The Three Caballeros* in 1944.

As the country bounced back from war time, the 1950s saw major economic and population growth as well as the explosion of a new form of entertainment, the television set. In no time at all, television became so popular that it replaced the radio as the centerpiece of the American living room and caused a major disruption to the film industry. Movie theater attendance saw a significant decline, leaving studio executives wringing their hands in fear of this innovative technology.

But not Walt Disney. Like so many of his previous innovations—the first cartoon with sound, the first cartoon in Technicolor, the first feature-length animated cartoon, the multiplane camera, and the first theme park (which was still under construction at the time)—Walt saw it as merely another hill to climb. "Instead of considering TV a rival when I saw it, I said, 'I can use that,'" he once said. "I want to be a part of it."[3]

And use it he did. *One Hour in Wonderland* was broadcast at the end of 1950. It was Walt's first television program, made to promote the Studio's upcoming release of the animated feature Alice in Wonderland. Several years later, the weekly series *Walt Disney's Disneyland* premiered on the ABC network in 1954. The first episode was a work-in-progress look at the construction of Disneyland. Subsequent episodes featured miniseries like *Davy Crockett, The Hardy Boys*, and *The Adventures of Spin and Marty*, as well as selections from the Disney film library. After debuting another wildly successful program on ABC in 1955, *The Mickey Mouse Club*, television production became commonplace at the Disney Studio.

Walt's ability to weather any obstacle and improvise during times of change led the Studio through the turbulence of the 1940s and into the creative boom of the 1950s. Walt's older brother and business partner, Roy O. Disney, once described the pioneering spirit that defined their ancestors as "always curious, wondering what's over the hill or around the corner."[4] His brother Walt had that same spirit.

One disruption that Walt refused to embrace was the erosion of the Hollywood studio system. Since the late 1920s, studios filmed movies almost exclusively on their own backlots. They employed their own creative staff: actors, writers, directors, and craftspeople who were locked into long-term contracts. And most major studios had ownership and control of both their own distribution companies and their own theater chains. But by the late '40s,

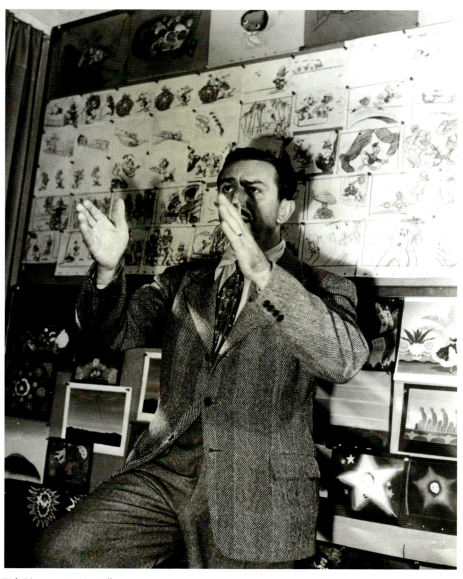
Walt Disney, master storyteller.

the Supreme Court ruled that having such vast control over theaters violated the Sherman Antitrust Act. As the Studios let go of their theater chains, they also slowly began to dissolve the exclusive contracts that held their creative teams in place. Starting in the '50s, creative talent became untethered, represented by agents and managers rather than being puzzle pieces for studios to arrange as they saw fit. Actors started to negotiate percentages of a film's profit for their compensation. Studios began to fund independent producers to generate material rather than develop it themselves, and actors began forming their own production companies to buy and develop scripts.

But Disney remained firmly rooted in the Studio system. Every aspect of the filmmaking process took place under Walt's roof. He once said, "We do everything our own way, for ourselves, with no outside interference."[5] He had his own studio staff who consistently worked on every one of his films. Comparing the screen credits for each live-action production, the same names appear again and again. It was common for a Disney director to have made multiple films at the Studio, either for the small screen, the big screen, or (in many cases) both.

Walt's loyalty to his staff was both appreciated and reciprocated. He was not always an easy man to work for, and he was notoriously stingy with praise, but most understood that this was not an expression of disregard. Instead, it was his way of motivating his teams to strive for excellence. Gordon Gordon, novelist, and screenwriter of *That Darn Cat!*, once said, "[Walt] ran a patriarchal studio. He wanted it to be a family."[6]

Walt's approach was so insular that when he and Roy experienced strain in their relationship with RKO Radio Pictures (which had distributed every Disney film since *Snow White and the Seven Dwarfs*, in 1937), the brothers abandoned the idea of struggling with another outside company and formed their own distribution division, Buena Vista. *The Living Desert*, released in late

1953, had the distinction of not only being Walt's first feature-length entry in his *True-Life Adventures* documentary series, but it was also the premier release from Disney's new distribution arm.

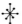

As a traffic boy, Mattinson made his pickups and deliveries and got a glimpse of every aspect of the Studio. "You really learn where everything is and that was delicious," recalled Mattinson. "I got assigned a run. My run was going to be from the Studio to the Process Lab, Camera, Ink and Paint, Editing, the soundstages, and the mill." Mattinson would also make stops at the Still Camera Department. Since copy machines didn't exist yet, any artwork or reference that needed to be mass distributed to artists was photographed and printed out later. The Still Camera Department was also where the art for the Mickey Mouse comic strip was photographed. Mattinson would run to artists Floyd Gottfredson and Al Taliaferro to pick up the strips; they'd be photographed and sent to the comic-strip syndicates.

The highlight of Mattinson's workweek came on Fridays at around 11:30 a.m., when he'd receive a call from Dolores Voght, Walt's secretary. "I had the run with the payroll department and the cashier. Dolores would call me, and she'd give me [Walt's] check, and I'd take it over and have it cashed. Three hundred dollars. [I'd] get the cash and then come back and Walt would be standing there sometimes in the doorway, and I'd give it to him there. If he talked to you, you felt like *Holy cow, Walt talked to* me! He listened to *me* talk to *him*! I felt very important."

"He was a real strong presence," recalled Mattinson, regarding his encounters with Walt. "He was bigger than life. [I'd] be behind him, and he was a chain-smoker. He'd throw the cigarette down and step on it and [I'd]

say, 'Gee, maybe I should keep this. Walt smoked it!' I didn't do it...but I thought about it."

The traffic room in the Animation Building, where Burny Mattinson would pick up his deliveries, was also the supply room for the artists. Whenever the artists called down to request something, Mattinson would deliver the supplies. While in the offices, he would peek over their shoulders to glimpse their drawings. "I wanted to be in animation! I wanted to see where the drawing was," said Mattinson.

After the animators finished their scenes, they would drop them off at the desk of Johnny Bond, who worked for the manager of the Animation Department. Bond would call Mattinson to pick up the stacks of pencil drawings and take them to the Camera Department for filming. Bond was a "real character," said Mattinson. "He had no teeth in the front, but he hated wearing dentures. He took a cigar and he stuck it [between his upper lip and gums] and he'd walk around with a cigar hanging down."

Mattinson learned Bond had been an excellent inbetweener back in the days of the old black-and-white Mickey Mouse cartoons. Mattinson approached Bond and asked him how he could learn to be an inbetweener. "Johnny says, 'Well, here. Here are two drawings. Sit down and draw the drawing that goes in between,' and he showed me how to flip. Then he'd give me more and so forth, and I kept on doing it, and then I got pretty good. Johnny eventually got me in to an opening when they [were] looking for an inbetweener. So, I got in there and started in shorts."

Mattinson's world was now the first floor of the Animation Building—the domain of the animators and their assistants. Three men ran the Animation Department. First was Harry Tytle, who managed the directors and some of the top animators. Reporting to him was Ken Peterson, who oversaw the Animation Department. Under Peterson was Andy Engman,

to whom most artists reported.

But of course, Walt himself was at the top, his office tucked in the back corner of the third floor. The Story Department was also on the third floor. Many animators were jealous that the story men were "closer to the heavens" and that "they had Walt's ear." Because of Walt's insistence on well-developed stories, and his natural gift for creating them, he kept his storyboard artists and writers within arm's reach. He would work closely with them, perfecting the stories. Once Walt felt confident in a project, he'd bring up his directors from the second floor. Walt knew the individual directors' strengths, so he would cast them on different sections of a film, the same way a director would cast actors. In his famously charismatic way, Walt would walk the directors through the story and act out the sequences. Each director had a small team that included a layout man, a background artist, and a few story sketch artists who would bring each sequence to life.

Like his process for developing animated features, Walt's live-action development was producer-driven, rather than director-driven, and the producer in the driver's seat was Walt. He relied on story editor Bill Dover to find subject matter to adapt into live-action films. According to David Swift, director of *Pollyanna* and *The Parent Trap*, Dover "had a feel, an instinctive feel, for what Disney should make. He had a nose for Disney stories."[7] Once Walt had chosen material to develop, he would launch multiple projects and then assign writers to each, working closely with them to craft a script that would meet his storytelling standards.

Walt had an intimate involvement with his writers that was unique to Disney Studios. Veteran director Robert Stevenson once commented that Walt "worked much more thoroughly and much more creatively on the script than any other producer I've worked for."[8] Disney Studios also treated their writers differently. There was no pressure to turn in script drafts quickly.

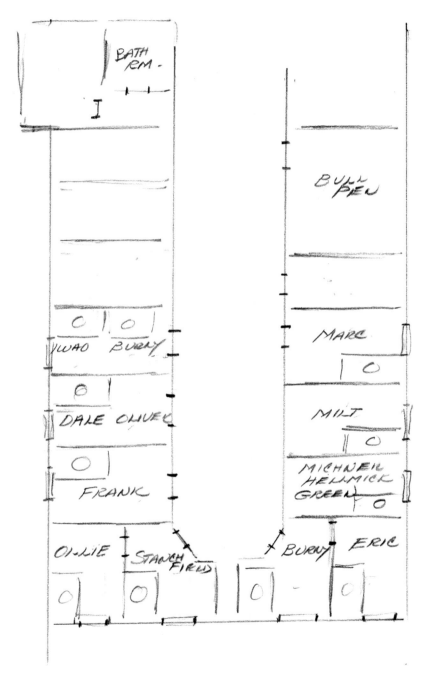

A floor plan sketch by Burny Mattinson of the offices in D Wing, in the Animation Building on the Disney lot. This approximates the office configuration throughout the 1960s and early 1970s.

DISNEY IN-BETWEEN

In fact, the Studio would cater to whatever schedule worked best for each writer, rather than the other way around. Be it working mornings and going home early, long lunches or afternoon naps, the writers could set their own pace and expectations.

After a script was approved and actors were cast, Walt would then hand the wheel to his producers and directors, trusting them to do their best work for him. He regularly visited the sets and observed them, making sure to never get in the way of the director or the team.

It was common for Disney live-action directors to have extensive television backgrounds. Many had directed feature films as well, but the bulk of their résumés involved work for the small screen. This may be a comment on how much work the infiltration of television created for the industry. It also may reflect what Walt needed from his directors—solid, experienced craftsmen. He had no use for auteurs. *He* was the visionary, and he needed filmmakers who could bring *his* vision to the screen, not their own.

Once shooting completed, Walt's involvement kicked back in during the editing phase. This was more in line with the way television shows were made and how directors in that medium were used to working. A director with an independent style and point of view on the material was not a fit for Walt's process.

Burny Mattinson's first official duty as an inbetweener was on the short *Casey Bats Again,* released in 1954. That same year saw the release of *The Vanishing Prairie*, the second feature from Walt's *True-Life Adventures* nature series. Working as an assistant on that film's editorial staff was Walt's nephew, Roy E. Disney, who joined the Studio after graduating from Pomona College.

Also, that same year, Walt gave his daughter Diane's hand in marriage to Ron Miller, a football player for the Los Angeles Rams. Concerned about his son-in-law's safety on the field (as well as how an injury to Miller could impact his future grandchildren), Walt eventually convinced Ron to work at the Studio, starting as a messenger.

Roy Jr. and Ron came into the Studio at a time of division within the Disney family. The company's growth put a strain on Walt and Roy's relationship and the brothers grew apart. This inter-relational split resulted in a division within Disney's workforce. Employees were either Walt's boys or Roy's boys, depending on where they worked in the company—on the creative side with Walt or the business side with Roy.

One of Roy's allies was Donn Tatum. Tatum had served as legal counsel for ABC and had impressed both Walt and Roy throughout their dealings with the network. Eventually, Tatum was brought into Disney to serve as the Studio's business manager.

E. Cardon Walker was one of Walt's strongest allies. He had worked his way up from traffic boy to the Animation Camera Department and then became the head of advertising and publicity. Walt once confided in Walker that he felt his nephew Roy Jr. lacked ambition. Walt doubted he'd ever achieve any measure of success, despite Roy Jr. spearheading many nature and animal-related films for the Disney television series. As a result, Walker dubbed Roy Jr. "the idiot nephew."[9]

Conversely, Walt saw great potential in his son-in-law, Ron. His daughter Diane once said, "Ron had no training for anything else. He was like a blank notebook. Dad could take him and mold him in his pattern. I think the nicest thing I ever did for Dad was that, through some quirk of fate, I was able to marry a man who fit into Dad's dream."[10] Gradually, Walt gave his son-in-law more responsibility, getting him a membership in the Directors Guild

and making him the director of his host segments for the weekly television series *The Magical World of Disney*.

Burny Mattinson became an assistant to directing animator Marc Davis on *Sleeping Beauty*. Davis was also an art instructor at the prestigious Chouinard Art Institute in Los Angeles and insisted that Mattinson attend his drawing classes, if he was to work on his team.

Another one of Davis' assistants on *Beauty* was Dave Michener, formerly a student at Chouinard. Walt had been impressed by Michener's work on one of his many visits to the school. He informed his studio personnel department to keep their eyes open for Michener's application. When it arrived, studio personnel kept their word and offered Michener a position. He started his career at Disney as an assistant animator for commercials and television shows. Following his TV stint, Michener began work on his first feature, *Sleeping Beauty*.

Sleeping Beauty was also the first feature animation experience for a young artist named Don Bluth. Hired as an inbetweener, Bluth sat in a large room with five or six other newcomers, honing their skills by inbetweening scenes from past Disney films. Eventually, Bluth did inbetweens for a production scene in *Sleeping Beauty*. When his drawings were finally approved and added into the film, he was euphoric. Since childhood, Bluth had been enamored with the rich color palettes and beautiful fluid animation of Disney features. Now his drawings would be part of that legacy.

Directing animator John Lounsbery took Bluth under his wing, based on the great potential he saw in the young man. Bluth would sit behind Lounsbery and watch him work, marveling at the way he drew and

at how humble the veteran animator was about his talent. It was through Lounsbery's guidance and encouragement that Bluth gained the confidence to persevere through the tough times in hopes that he could one day become a full-fledged animator at the Disney Studios.

Sleeping Beauty was an intensely detailed film and because of that, some inbetweeners and assistants were only able to complete one cleaned-up drawing per day. In addition, Walt's attention was hyper focused on Disneyland's opening and operation, during the film's production. His absence extended the anticipated production time and increased the cost, which exceeded the initial budget.

When the film underperformed, Walt and Roy argued over the feasibility of continuing to produce animated features. Roy's suggestion was to stop making them altogether so that Walt could focus more on the theme park and other new projects, like building another Disneyland in Florida and experiments with urban planning and art education. Roy proposed that rather than make new animated features, the company could simply rerelease their existing films every few years. Walt decided to give animation one more shot, and production began on *101 Dalmatians*, a project in development, led by story man Bill Peet.

After finishing *Sleeping Beauty*, Burny Mattinson and Dave Michener parted ways with Marc Davis. Michener became directing animator Milt Kahl's assistant and Mattinson's talents were requested by Eric Larson. It was the start of a long-lasting relationship between Mattinson and Larson. "Eric was like my dad," recalled Mattinson. "We were like father and son. We went to lunch every day at Alphonse's, which was our big watering hole. I loved Eric a lot."

Mattinson assisted Larson on *101 Dalmatians* and *The Sword in the Stone* and was inbetweening Larson's animation of the vultures in *The Jungle*

Book when Ollie Johnston broke the horrible news of Walt's passing.

On December 15, 1966, a young boy named Dale Baer came home from school to have lunch with his mother. "I've got some bad news for you," she told him. "Your hero died."

Like many children from the baby boom generation, Baer was in awe of Walt Disney because of the warm and inviting introductions he gave every Sunday on his television series. "Every kid always had heroes, you know, be it the Lone Ranger or something like that. But *he* was the epitome." 1966 had already been a difficult year for Baer. He had lost both his father and step-grandfather. Now he struggled with yet another loss. "I think I took that a lot harder than I did my relatives. How can this guy die? He's like God. He's created all this wonderful stuff. He can't die."

Baer's entire childhood centered around animation. The work of the Disney Studios was the most magical for him. Between trips to the Art of Animation exhibit at Disneyland and watching the animated segments televised on *The Mickey Mouse Club* and Disney's *Wonderful World of Color*, Dale absorbed all he could. And it wasn't easy. In those days, uncovering information about the art and craft of animation was like finding water in the desert. "My grandparents lived in North Hollywood," said Baer. " I would always have my grandfather drive me on to Buena Vista and I would sit there and stare at the Animation Building for I don't know how long. I was just trying to imagine myself walking through those doors. My whole dream was to be [there] since I was like eight years old."

Ron Clements was in high school when he heard of Walt's passing. "He was a presence. I watched the Disney show regularly." He also went to the movies regularly. Of the three theaters in his hometown of Sioux City, Iowa, the Orpheum was the home of Disney releases and Clements attended every one, beginning with *Cinderella* at the age of two. But it was a reissue of *Pinocchio* that really hooked him. He was immersed in the details, the atmosphere, and the sophisticated use of the multiplane camera for depth and scale. "Even at a pretty early age, I had this sense of quality. Walt Disney stood for quality, and he cared about the product he made." Clements became obsessed with the film, returning multiple times to see it.

Clements' passion for animation was ignited. He checked out books from the library on animation, and he repeatedly drew *Pinocchio's* cast of characters. He thought he might wish to pursue this as his career, and the Disney Studios might be the place for him to do it. "I always thought maybe I would meet him someday. I had visions of writing to Walt. I had this fantasy. I would make a film...and I would write to Walt Disney and ask him to send me money. I would make an animated feature *for* him. Disney was a big influence.

I was really sad when he died."

"That was before my grandmother died," said John Musker. "So, I don't think death had even come into my family very much." Musker had been swept up by the films of Walt Disney at a young age, with *Sleeping Beauty, 101 Dalmatians,* and the reissue of *Pinocchio* filling his imagination with color and spectacle.

At his local library, Musker stumbled across Bob Thomas' *The Art of Animation,* a book that described how those unforgettable images were created. *The Art of Animation* was published in 1958. It was meticulously researched and filled with artwork and photos, providing the most thorough and sophisticated glimpse into the process of making Disney animation. One of the photos in the book was of a group of middle-aged men whom Walt considered his top animators. "The group Walt has called the Nine Old Men," read the caption. This was a title Walt had playfully borrowed from President Franklin Delano Roosevelt, who referred to his Supreme Court members as "nine old men, all too aged to recognize a new idea."

"I checked [*The Art of Animation*] out repeatedly from the library," said Musker. "It really went behind the scenes of how animation was done, and it put faces with things. All that sort of opened the door to that world. Gee, there are people that really make this happen. There is a craft and an art to it." This book, along with a biography of Walt written by his daughter, Diane Disney Miller, and coauthored by Pete Martin, opened up new possibilities for Musker. "I did, as a seven- or eight-year-old, think I might want to become an animator someday. I pictured—because I would see Walt on his show—I will go there, and I will work for Walt Disney. So, I do remember when Walt Disney died, in 1966, sitting on my couch in Chicago, kind of teary-eyed like, 'I'm never going to meet this guy.' He did seem like a paternal figure, something kind of mystical about him."

1967
–After Walt's Death

Of his studio and his role in it, Walt Disney once said, "I think if there's any part I've played...the vital part is coordinating these talents, and encouraging these talents, and carrying them down a certain line. They're all individually very talented. I have an organization of people who are really specialists. You can't match them anywhere in the world for what they can do. But they all need to be pulled together, and that's my job."[11]

Now with Walt gone, who would be the one to bring his people together? Who would they look to for leadership? Who would guide them into the future? The only immediate answer was Walt's brother Roy. Before Walt passed, Roy had been planning to retire but now that would have to wait. He had been the quiet force behind everything that Walt had done, supporting and financing his dreams and passions. Roy's unwavering devotion to his brother left him with no choice but to step out of the shadows and into the spotlight in order to keep Walt's studio alive and bring to fruition his projects that now sat unfinished. In a statement issued both internally and to the public, he said, "We will continue to operate Walt Disney's company in the way that he has established and guided it."[12]

Roy had great faith in the teams Walt had assembled, describing them as people "who understood [Walt's] way of communicating with the public through entertainment. Walt's ways were always unique, and he built a unique organization."[13]

"Walt, wisely, took all of the Nine Old Men and he started bringing them closer together," said Burny Mattinson. "He looked to all of them collectively for input into the pictures and how we were doing them." As a result, he had given these nine individuals the tools they needed to carry

Disney animation into the future. Les Clark, Ward Kimball, and Woolie Reitherman had moved into directing. Frank Thomas, Ollie Johnston, Milt Kahl, Eric Larson and John Lounsbery continued in their roles as directing animators on the animated features. The only one of the nine to leave animation was Marc Davis, who had moved to Imagineering, joining the team responsible for the creation of Disneyland. He would continue to oversee its evolution with new attractions like Pirates of the Caribbean, which would open in spring of 1967.

Every animated feature film throughout the 1950s had been directed by animators Clyde Geronimi, Wilfred Jackson, and Hamilton Luske (except for *Sleeping Beauty*, which Geronimi directed alone). For the 1961 film *101 Dalmatians*, supervising animator Woolie Reitherman joined Geronimi and Luske as a director. Reitherman continued as the sole director on Walt's last two animated features, *The Sword in the Stone* and *The Jungle Book*. Now with Walt gone, it was decided that in addition to directing, Reitherman would produce all subsequent animated films. The responsibility for the future of Disney animation now rested on his shoulders. "I have to hand it to Woolie," said Mattinson. "[He] held the whole thing together."

Plans were put in place for *The Aristocats* to be the Studio's next animated feature. The project had begun with Walt, who asked colleague and producer Harry Tytle to search for animal stories to adapt into multipart television specials. Tytle and writers Tom McGowan and Tom Rowe pitched this idea to Walt and, several rewrites later, it had evolved into an animated film. While *The Jungle Book* was in the midst of production, artist Ken Anderson fleshed out the idea further, wallpapering his office with sketches of characters, locations and story ideas. With Anderson's work as a foundation, Woolie Reitherman and his team honed and finalized the story and *The Aristocats* was ready to go into production.

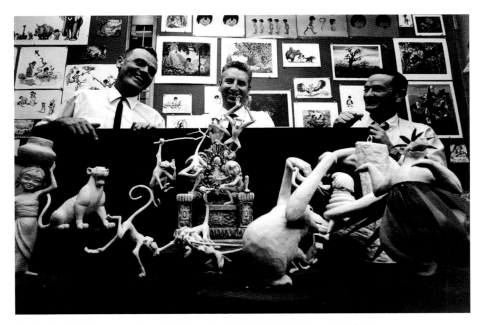

Director Woolie Reitherman, animator Eric Cleworth and directing animator John Lounsbury with maquettes from The Jungle Book.

On the live-action side, films were to be produced by James Algar, Harry Tytle, Bill Walsh, Winston Hibler, and Ron Miller. These men were natural choices to continue in Walt's absence, as they had already produced films and television under his supervision.

James Algar had proved to be extraordinarily versatile during his career at Disney, animating on films as far back as *Snow White*. Algar then began directing animation, helming the "The Sorcerer's Apprentice" segment from *Fantasia*, various sequences in *Bambi*, and the "Wind in the Willows" portion of *The Adventures of Ichabod and Mr. Toad*. Afterward, he moved into live-action, producing and directing the majority of the *True-Life Adventures* series, as well as writing and producing several of the Studio's animal-related features, such as *The Legend of Lobo* and *The Incredible Journey*. When Walt passed away, Algar was producing *The Gnome-Mobile*, which was eventually released in July 1967.

Harry Tytle was a production supervisor on many episodes of Walt's television shows throughout the '50s. He was also associate producer on the two-part *Escapade in Florence*, starring Annette Funicello and Tommy Kirk, as well as several specials like *Disneyland Goes to the World's Fair*. After Walt's passing, he became a full-fledged producer for movies made for television.

Bill Walsh had written the *Mickey Mouse* comic strip since the '40s. In the '50s, he moved into television production, shepherding shows like *Davy Crockett, Spin and Marty*, and *The Mickey Mouse Club* onto the small screen. He also wrote and produced many of Walt's most iconic theatrical features, such as *The Shaggy Dog, The Absent-Minded Professor*, and *Mary Poppins*. Walsh was working on *Blackbeard's Ghost* (starring Dean Jones and Peter Ustinov) at the time of Walt's death.

Winston Hibler started at the Studio in the '40s, working in the Story Department on the animated features *The Adventures of Ichabod and Mr. Toad, Cinderella*, and *Alice in Wonderland*. Like Walsh and Algar, Hibler also graduated to writing and producing live-action films. He wrote for the *True-Life Adventures* series, narrative nature stories like *Perri* and *Nikki, Wild Dog of the North*, and theatrical dramas like *Big Red, Those Calloways*, and *Follow Me, Boys!* In 1955, Hibler directed the Academy Award–winning short *Men Against the Arctic*. He also directed the feature *Charlie, the Lonesome Cougar*, released in October 1967, almost a year after Walt's passing.

Ron Miller began his career at Disney as an assistant director for television projects. He worked on the *Zorro* series and specials such as *I Captured the King of the Leprechauns*, which was a behind-the-scenes look at the making of the film *Darby O'Gill and the Little People*. In 1962, he directed an episode of *Disneyland* called *The Golden Horseshoe Revue*, commemorating the ten-thousandth performance of the Disneyland attraction. Miller was an associate producer on many of Walt's films of the '60s, and he went on to

produce *The Misadventures of Merlin Jones* and its sequel, *The Monkey's Uncle*. Miller's role as a producer continued after Walt's death.

There were enough film projects set in motion by Walt to keep his staff busy for years. The live-action films *Monkeys, Go Home!*; *The Adventures of Bullwhip Griffin*; *The Gnome-Mobile*; *Charlie, the Lonesome Cougar*; and *Blackbeard's Ghost*, as well as the animated feature *The Jungle Book*, would be completed and released to theaters over the course of the next year and a half.

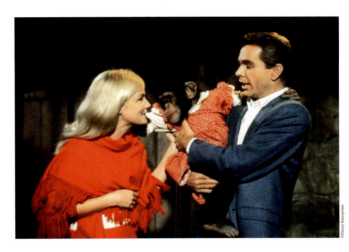

Yvette Mimieux and Dean Jones in Monkey's, Go Home!, one of the last films produced by Walt Disney.

Walt also had an entire cabinet in his office full of scripts that he'd been developing. Projects such as *Willie and the Yank*, *A Boy Called Nuthin'*, and *My Family Is a Menagerie* would eventually be filmed as episodes of the Sunday night television show.[14] Walt had hired television writer Earl Hamner to work on a script for an adaptation of Sterling North's book *Rascal*, based on the author's experience growing up with a pet raccoon.[15] A script for a third film starring science nerd Merlin Jones [from *The Misadventures of Merlin Jones* and *The Monkey's Uncle*] had also been written but would never be produced.[16]

DISNEY IN-BETWEEN

For new live-action projects, there was no single candidate deemed the obvious choice to oversee their creative development. So, instead of one person leading, like Woolie Reitherman would do for animation, the decision was made to have a committee of eight: production chief Bill Anderson, producers Walsh, Hibler, Algar, Tytle, Miller, Marketing chief Card Walker, and Walt's nephew Roy E. Disney. This group would make decisions on all things related to live-action development and production. Walt was known to have a particular distaste toward leadership by committee. However, Roy could see no other way, saying, "We will have to do it that way until the new leadership develops."[17]

Finally, there was the matter of who would run the business side of the company. In a memo to the company's board of directors (dated June 1967), Roy stated, "The people on whose advice I have relied were unanimous in their view that it is important that the Disney name be retained in top management and that I remain as its chief executive officer and president and chairman of the board."[18] He suggested that Donn Tatum, Disney's business manager, be elected executive vice president of administration and vice chairman of the board, and also that Card Walker be elected executive vice president of operations. "In making these recommendations, it is my hope and firm belief that Mr. Tatum will demonstrate to all his fitness to succeed me as chairman of the board and chief executive officer and that Mr. Walker will demonstrate his fitness to succeed me as president and chief operating officer of the company."[19] The board of directors agreed with Roy's proposal and the titles were given to Tatum and Walker.

"Disney" was no longer just a proper noun. It had become an adjective to describe wonder, imagination and fantasy. It was a brand of entertainment, wholesome and heartfelt, created for everyone to enjoy. "Part of the Disney success is our ability to create a believable world of dreams that appeals to

all age groups," said Walt. "The kind of entertainment we create is meant to appeal to every member of the family." [20]

Making family films was Walt's legacy and Roy, along with the Studio staff, was dedicated to preserving it, ensuring that the Disney name continued to stand for the values that Walt espoused. "Everybody questioned 'What would Walt do?'" said Burny Mattinson. "And the thinking was let's do what he would normally do and keep the family movies going. It became a thing of, 'okay' guys…this is our challenge. We have to keep making these pictures the way Walt would make them.' Everybody took up the challenge. They felt responsible."

The Disney Studio forged ahead, but with a cautious glance in the rear-view mirror. The future of the company would be informed by the past. Some doubted whether this was the right course of action for a studio founded on innovation and forward thinking. Actor Kurt Russell, who became a familiar face to Disney audiences at the age of fifteen with the 1966 film *Follow Me, Boys,* observed: "They used to say, 'nothing's changed since Walt died.' And I used to say to myself, 'That's just the problem.' Because things were constantly changing under Walt Disney. Constantly. Constantly. It was *never* status quo."[21]

While the Disney Studio during the 1950s could be described as Camelot, outside the castle walls, society was in conflict. The clean-cut conservatism of the Eisenhower era faced resistance from the Beat Generation. Led by authors like Allen Ginsberg and Jack Kerouac, they rejected materialism and conformity in favor of severe and brutally honest portrayals of the human experience. No sugarcoating or pretending; no happy endings. As the 1960s

took hold, this kind of moral ambiguity became inescapable as television brought up close the violence and turmoil facing the country and the world. The assassinations of John F. Kennedy and Martin Luther King Jr., the civil rights movement, the Vietnam War, and the Watergate scandal were brought directly into America's living rooms, impossible to ignore. Beatniks evolved into the hippie movement and the counterculture revolution accelerated. The youth of the day questioned the status quo, challenged authority, fought segregation, and tried to make sense of a world that was becoming increasingly more violent. It was only a matter of time until this rebellion hit Hollywood.

The first major attempt by the young generation to subvert (and eventually control) mainstream moviemaking was *Bonnie and Clyde*, released by Warner Bros. in August 1967. Even though its director, Arthur Penn, was in his forties, the film's producer and star, Warren Beatty, was just barely into his thirties. Beatty had been in the business as an actor for many years, but his career had stalled and he needed something to reenergize his status. Robert Benton and David Newman's script about 1930s bank robbers Bonnie Parker and Clyde Barrow was exactly what he needed, filled with mayhem, violence, and a nose-thumb to authority. It was the perfect reflection of the counterculture.

Even the making of *Bonnie and Clyde* went against Hollywood traditions. When writers Benton and Newman wrote their first draft, they sought to emulate the complexity and ambiguity of the films from the French New Wave, not classic gangster films from the '30s and '40s. For casting, Beatty and Penn drew from theater and live television. Other than Warren Beatty and Faye Dunaway (cast as Bonnie Parker), the actors were a far cry from the beauty and glamour of the classic Hollywood movie star. The production team escaped the Warner Bros. lot and shot on location in Texas.

And the film was violent. "We're in the Vietnamese War," said Penn. "This film cannot be immaculate and sanitized and bang-bang. It's fucking bloody. It has to be in-your-face."[22]

Beatty screened the first cut for the Warner Bros. executives in summer of '67 and it was a disaster. In a memo, studio chief Jack Warner said, "Who wants to see the rise and fall of a couple of rats?"[23] Warner hated the film and intended to bury it. During its limited run, critics tore the film to shreds.

Despite the negativity, the film did manage to gain traction. Critic Pauline Kael, writing for *The New Republic*, raved about it. More importantly, audiences loved it. *Bonnie and Clyde* received standing ovations at its first public screening at the Directors Guild Theater in Los Angeles, and at its world premiere at the Montreal International Film Festival later that summer. But it wasn't enough to convince the Studio to get behind the film. *Bonnie and Clyde* was pulled from theaters after only two weeks.

The Old Guard may have won the fight but Beatty and his team won the war when *Bonnie and Clyde* was nominated for ten Academy Awards, including Best Picture. The other nominees were socially relevant dramas like *Guess Who's Coming to Dinner*, *In the Heat of the Night*, and *The Graduate*. However, rounding out the category for that year was the socially *irrelevant* musical *Doctor Dolittle*.

Big-budget musicals like *Doctor Dolittle* epitomized excess and demonstrated how out of sync studio executives had become with an audience hungry for raw and human stories. Other musicals like *Star!*, *Hello, Dolly!*, and *Half a Sixpence* underwhelmed and underperformed. About two months after Warner Bros.

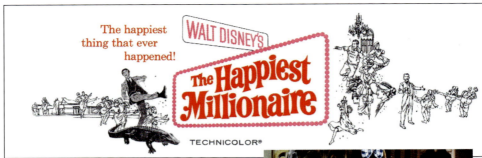

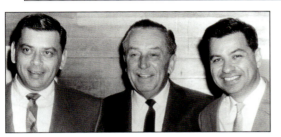

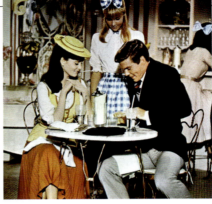

Top: Studio letterhead from 1967. Bottom left: Walt Disney flanked by songwriters Robert and Richard Sherman. Bottom right: John Davidson sings to Lesley Ann Warren about 'Detroit' in The Happiest Millionaire.

released the groundbreaking *Bonnie and Clyde*, they brought their lavish film adaptation of *Camelot* to the screen. Jack Warner saw it as the perfect vehicle for capturing the success of his previous big-screen musical, *My Fair Lady*, but for audiences in the late '60s, *Camelot* felt stale and failed to achieve the success Warner had hoped for. The Hollywood musical was dying.

Yet a month after *Camelot*'s failure, Disney premiered its lavish musical production of *The Happiest Millionaire*. It was the Studio's first step in realizing Walt's commitment to making musicals.

Extremely pleased with the success of *Mary Poppins* in 1964, Walt was determined to create more original musical productions for the screen, not just adaptations of existing stage shows like *My Fair Lady* and *The Sound of Music*. He assigned writer A.J. Carothers to fashion a musical out of a nonmusical stage play about the life of eccentric millionaire Anthony J. Drexel Biddle, which would become *The Happiest Millionaire*. Walt also took a

television project that he had in development called *The Family Band* and had writer Lowell Hawley transform it into a big-screen musical. Both projects were handed to *Mary Poppins* songwriters and Walt's musical golden boys, Richard and Robert Sherman, to write the songs.

Prior to these projects, the Sherman Brothers had composed the score for another musical that evoked the tone and fantasy of *Mary Poppins*. Called *The Magic Bedknob*, it was based on two children's books by English author Mary Norton, *The Magic Bedknob* and *Bonfires and Broomsticks*. The material had been acquired during the development of *Mary Poppins* as a backup in case negotiations with author P.L. Travers fell through. Once *Mary Poppins* moved ahead, *The Magic Bedknob* was put on hold. Walt also had the notion of producing smaller-scale musicals for Disneyland, which would then be filmed for future television or theatrical releases. The first of this series was *Hansel and Gretel*. Carothers was assigned to write the script with Norman Tokar brought on to direct.

The Happiest Millionaire premiered on November 30, 1967, in New York. The Studio was confident it would be another huge hit on the scale of *Mary Poppins*. They pulled out all the stops: mounted an enormous publicity campaign, threw a lavish premiere party, and gave *Millionaire* the road show treatment. However, it was anything but a hit. Poor reviews and a weak box-office performance led to the Studio cutting down the film's almost three-hour run time. The shorter length would allow for an increased number of showings when the film went into wide release. But the cuts did little to help, and they upset some of the crew. The Studio neglected to inform writer A.J. Carothers—or song-writing duo the Sherman Brothers—about the movie's last-minute editing. The Shermans were particularly upset that the Studio had removed their song "It Won't Be Long 'Til Christmas," which had been one of Walt's favorites from the original cut.

1968

Just a few months after *Millionaire,* the Studio debuted Walt's next musical project, *The One and Only, Genuine, Original Family Band.* The film was directed by Michael O'Herlihy, written by Lowell Hawley with songs by the Sherman Brothers. Originally called *The Family Band,* the Shermans felt that title was rather boring and gave the film a longer, more auspicious name.

While fond of every project they developed with Walt, this one held a special significance for the Shermans since it was their final collaboration with Walt. They had played their songs for him on the piano in November 1966. Anxious to get a better idea of how the songs would eventually sound, Walt gave them the go-ahead to record fully orchestrated demos and the session was booked for mid-December. By the time the session took place, Walt was gone.

Seeing the film to fruition without Walt was a bumpy ride. Bing Crosby, originally cast as the film's lead, was dropped due to his high asking price. The script was reworked, songs were dropped, and once again the film's running time was cut so theaters could fit in more showings. After the film's release, the Studio decided to halt production on any future musicals, shelving *The Magic Bedknob* and Walt's *Hansel and Gretel* project. The Sherman Brothers had been dealt too many disappointments; they decided it was time to leave Disney.

Disney's live-action film department was going through a rough period. The choice to run things by committee had become problematic, due to the sheer

number of conflicting opinions that stunted project development. The group became known as the "board of indecision."[24] Screenwriter Louis Pelletier once said, "Things began to fall apart. There was no direction. Nobody could have the final say. All the producers would get together and say something about every script...Everybody had to approve everything."[25] As a result, the Studio's writers had trouble getting ideas through the committee.

Writer Maurice Tombragel had been penning Disney films and television shows since the '50s. He wrote episodes of *Texas John Slaughter, Elfego Baca,* and *The Adventures of Gallegher*; two-part television specials like *The Waltz King* and *Escapade in Florence*; and the theatrical features *Moon Pilot* and *Monkeys, Go Home!* He had a good relationship with Walt and, just before Walt's death, had piqued his interest in a project called *Eight-Ball Express* about life in the U.S. Army. Walt thought it would make a great Sherman Brothers musical. After Walt was gone, interest in the project dissipated. The Studio assigned Tombragel to a comedy film about a college student whose brain turns into a computer, but Tombragel declined—the concept was far too ridiculous for his tastes. After that, the Studio refused to assign Tombragel any projects. He tried to sell them on an original television idea about Abraham Lincoln as a young lawyer solving a murder—an idea he thought Walt would have loved—but had no luck, and he was fired in short order.

Writer A.J. Carothers suffered a similar fate. During Walt's time, Carothers had written the theatrical features *Miracle of the White Stallions, Emil and the Detectives,* and *The Happiest Millionaire,* as well as an unproduced adaptation of Pulitzer Prize–winning author Robert Lewis Taylor's book, *A Journey to Matecumbe,* an adventure set in a post–Civil War South. Walt's story editor Bill Dover recommended another book to Carothers called *A Thrill a Minute with Jack Albany*. It was an unusual fit for the Studio, given

that the novel contained violence, profanity, and sex. However, Carothers was confident that there was a way to adapt it into a Disney film and pitched it to Walt as a comedy vehicle for Dick Van Dyke. Walt loved his take on the material. After obtaining the rights to the book, Walt said to Carothers, "Congratulations! Because of you, Disney has finally bought a dirty book!"[26] Carothers wrote a script that retained some of the riskier aspects of the book but managed to downplay them in order to suit a Disney audience. Walt enjoyed the script so much that he wanted Carothers to produce the project as well.

But with Walt gone, instead of having only to appeal to one man's taste, he now had to appeal to a group whose taste and judgment were based on interpretations of *someone else's* taste. The original cut of *A Thrill a Minute with Jack Albany* was deemed inappropriate for a Disney audience and the Studio removed every element that pushed the envelope—elements which Walt had been willing to include. After his removal as producer of the film, Carothers tried (unsuccessfully) to get other ideas off the ground. "I remember...I had submitted an idea for a picture," he said. "I don't even remember what it was now, and it went to the committee and then it came back to me, and Bill Anderson told me...it had been turned down. And I said, without even thinking first, 'I think perhaps I should leave.' And that was that. I never did anything for Disney again."[27]

A Thrill a Minute with Jack Albany was retitled *Never a Dull Moment*; this tamer version was released on June 26, 1968, starring Dick Van Dyke (as Carothers had originally intended). Actor Jerry Paris, who played Van Dyke's neighbor on *The Dick Van Dyke Show*, directed the film. *Never a Dull Moment* was Ron Miller's first film as a full-fledged producer. Miller's next two projects would be multipart television movies for *Walt Disney's Wonderful World of Color*; *The Secret of Boyne Castle*; and *Secrets of the Pirate's Inn*.

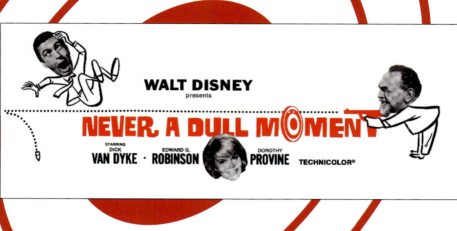

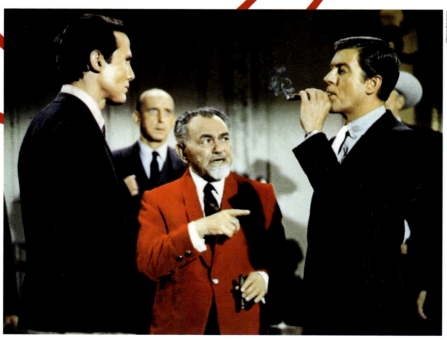

Top: Studio letterhead from 1968.
Bottom: Dick Van Dyke (right) must convince Edward G. Robinson (center) and Henry Silva (left) that he is a hitman in Never A Dull Moment.

Miller was looking for someone to helm *Secrets of the Pirate's Inn* and turned his attention to director Gary Nelson, husband of actor Judi Meredith, one of Miller's close friends. Nelson began his career as an assistant director on classic films like *Rebel Without a Cause* and *The Searchers*, alongside the legendary John Ford. He directed full-time on the television series *Have Gun—Will Travel,* in the early '60s, and went on to direct episodes of *The Patty Duke Show, Gilligan's Island,* and *Get Smart.* Miller offered him the job and Nelson immediately accepted. He looked forward to being a part of the family environment Disney was known for.

Child actor Annie McEveety was cast in one of the lead roles for *Pirate's Inn.* She was no stranger to the warm, family feeling of the Disney lot, as her family had a long history with Walt and his films. Her father, Joseph, had been an assistant director at Disney throughout the 1960s, working on films like *Moon Pilot, Son of Flubber, Mary Poppins,* and *That Darn Cat!* He became a production manager on *The Gnome-Mobile, Blackbeard's Ghost,* and *The One and Only, Genuine, Original Family Band.* Her uncle Vincent, had been an assistant director on the 1956 feature *Westward Ho the Wagons!* as well as many Disney television shows, including the *Zorro* series. Her uncle Bernard, was an assistant director on one of Walt's television specials called *Disneyland After Dark* in 1962.

McEveety grew up surrounded by the safe and welcoming atmosphere that Walt worked so hard to create for his employees and their families. She recalled the annual Christmas parties held on the Studio lot. "Every employee brought their family, and [Walt would] have a movie and all the characters in the street and then tables of gifts for everybody and it was super personal. And then he'd also have a day at Disneyland for all the families. He'd shut down the park and we'd get to go there too. It was a real respectable thing Walt did for his Disney family. From the guy that made your sandwich in the

commissary, to the tearoom, to the accountants, to the producers. Everybody was invited. It was really neat."

Eventually, McEveety followed in the footsteps of her older siblings and became a child actor. "I was the youngest of six," she said. "All my brothers were extras and had bit parts." She started her career as an extra. "I did a thing called *The Smith Family,* a lot of *Family Affair,* and *My Three Sons.* We were the people that lived a couple doors down from Johnny Whitaker and Anissa Jones in *Family Affair,* in the apartment that they were in." She made her Disney screen debut in the role of Tippy Durden, in *Secrets of the Pirate's Inn.*

Walt's philosophy of staying out of the director's way was still a common practice at Disney. As *Secrets of the Pirate's Inn* began filming, Gary Nelson enjoyed the creative freedom that philosophy afforded him. As long as he worked responsibly within the budget and within his approach to the material, no one bothered him.

Annie McEveety bonded with Nelson on the set. He treated her with respect and helped her understand the action being filmed so that her performance could be as natural as possible. She also bonded with Frank Phillips, director of photography on *Pirate's Inn.* McEveety already loved the camera, literally climbing on top of it during breaks in filming. As her relationship with Phillips grew, he gave her short, impromptu lessons about his craft. For example, during one lunch break, Phillips grabbed a spoon and turned it in different directions, showing McEveety how lighting effected objects. This captured McEveety's imagination and opened her eyes to the world of cinematography.

Frank Phillips and Gary Nelson weren't strangers. Phillips was the cameraman on Nelson's directorial debut, an episode of *Have Gun—Will Travel.* "He was a terrific guy and a really good cameraman," said Nelson.

"Knew his craft. I called him the silver fox."[28] Phillips was relatively new to Disney, his first credit being *The One and Only, Genuine, Original Family Band.*

Also new to Disney was makeup artist Robert Schiffer, who'd already had over thirty-five years' experience under his belt before joining the crew of *Pirate's Inn.* Nelson recalled Schiffer having great stories about the old days of Hollywood, including some about Nelson's father, Sam, who'd been an assistant director and director since the '20s. "[Schiffer] used to tell me stories about my dad having an affair with Rita Hayworth," said Nelson. "He said, 'Your dad was banging Rita Hayworth. Until *I* met her. Then I was banging her.' I said, 'You're lying to me.' He said, 'I don't think I am.'"[29]

The rest of the credits for *Secrets of the Pirate's Inn* are a who's who of Disney stalwarts. Co-producer Tom Leetch started as an assistant director under Walt during the '60s and was transitioning into producing. "I liked Tom," recalled Gary Nelson. "I think he was a frustrated director, but he was a good producer and he had a good sense about him."[30]

Editor Cotton Warburton began cutting films in the '40s then came to Disney in the '50s to edit *Westward Ho, the Wagons!* "He was one of Walt's favorite film editors," said Nelson. "He was old-fashioned and knew his craft very well."[31]

Art director John B. Mansbridge joined the Studio for *The Incredible Journey* in 1963, after about seven years in the business. "Always called you 'buddy,'" recalled Nelson. "He was a neat guy. A good craftsman."[32]

Set directors Hal Gausman and Emile Kuri both had long-running Disney careers. Gausman started on *Zorro* in the 1950s. Kuri's film career began in the 1930s, eventually working with directors George Stevens and Alfred Hitchcock. His first Disney project was the Academy Award–winning *20,000 Leagues Under the Sea.* Kuri worked on virtually every one of the Studio's films after that.

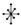

A common practice at the time was to try and breathe new life into development projects that had gone dormant during Walt's time. One such project was called *Pete's Dragon and the U.S.A.*, which television writers William Raynor and Myles Wilder took off the shelf to explore its potential.

The project dated back to 1957, when the Studio bought a story treatment from writers S.S. Field and Oscar-winning screenwriter Seton I. Miller, then hired Miller to write a first draft. It was about a boy named Pete who had escaped from an orphans' home in New England and now was on the road with his dragon, Gabriel, described as "red and green and able to breathe fire."[33] As suggested by his name, Gabriel was something of a guardian angel, a creature who "made everything right in the world," "chased away all evil," and "could do anything because it loved children."[34] In the story, the dragon can only be seen by people who "believe in dragons and fairies."[35] Miller's script kept the dragon invisible to the audience as well.

The following year, Noel Langley, screenwriter of *The Wizard of Oz*, wrote another draft of *Pete's Dragon and the U.S.A.*. That draft mostly followed the same story beats as Miller's, but it included a brief glimpse of the dragon on page 138 of a 139-page script. Described as "huge, glittering and magnificent,"[36] Gabriel is seen swimming off into the distance as a "deep, satisfied, contented snort echoes over the surface."[37] Originally intended to be a theatrical film, Walt decided it would work better as a two-part television special. Ultimately, it was shelved before the project could move beyond the writing phase.

Raynor and Wilder's new story outlines were considerable departures from the project's origins. Their first pass centered around Pete coping with

his parents' recent separation.[38] Their second version (dated October 25, 1968) had Pete in an orphanage; he and Gabriel (the dragon) sought out star-quarterback Davey Justice, whom Pete had designated as the perfect candidate to adopt him.[39] As different as the stories were, each outline held on to the idea of keeping the dragon invisible to the audience. Raynor and Wilder were unable to crack a suitable story, so the project remained on the development shelf.

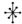

Roy O. Disney retained his positions as chairman of the board and CEO, but in November 1968, he stepped down as president of Walt Disney Productions and Donn Tatum took on the position; he would also continue as vice chairman of the board. Card Walker was elected executive vice president and COO.

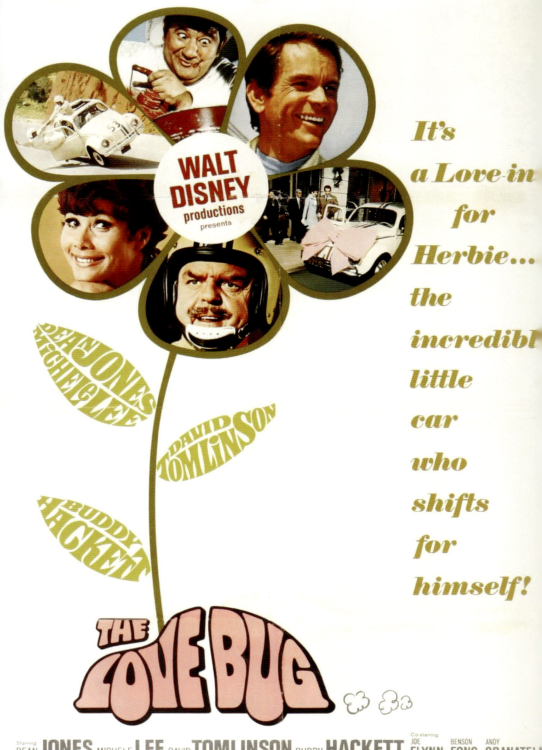

1969

Two films released a few months apart in the first half of 1969—*The Love Bug* from Disney and *Easy Rider* from Columbia Pictures—were indicative of the changes going on in Hollywood, and Disney's relationship to them.

The Love Bug reunited the *Mary Poppins* creative team of director Robert Stevenson, writer/producer Bill Walsh, and writer/artist Don DaGradi; all three had success with *Blackbeard's Ghost* the previous year. Walt himself had acquired writer Gordon Buford's story idea *Car, Boy, Girl,* about a sentient automobile, but it wasn't until after Walt's passing that Walsh set the project in motion with DaGradi as cowriter.

Easy Rider was the story of two hippies making a motorcycle trek across America. Written by Dennis Hopper, Peter Fonda, and writer Terry Southern, the script dealt with the tension and anxiety running rampant in American society and managed to confront these issues in a way that no other film had. Said Hopper: "At the moment that we made the film, the whole country was on fire. It was riots in every city."[40] Added Fonda: "All the young people were very, very upset about what was happening, as well they should've been."[41]

The Love Bug was about a little Volkswagen Beetle with a mind of its own. Anthropomorphizing inanimate objects had always been a staple of Disney animation: water-carrying brooms, dancing mushrooms, playful musical instruments, love-struck hats, and enchanted sugar bowls. But the charm of *The Love Bug* was that this little car named Herbie was a real thing—not a drawing. The filmmakers, performers, and special-effects artists could captivate audiences by imbuing a childlike heart and soul into a four-wheeled hunk of metal, even without the pliable, gestural advantages of animation.

Easy Rider was directed by Dennis Hopper. He had spent many years in Hollywood as an actor but this would make his first time in the director's chair. Of their first day of shooting, actor Peter Fonda said: "Dennis was out in the parking lot, talking to all of us, yelling at the top of his lungs 'This is my effing movie and nobody's going to take my effing movie away from me,' repeatedly for two and half hours."[42] Unfortunately, as production progressed, he would gain a reputation for being unpredictable and aggressive. Robert Stevenson, on the other hand, had a gentle and quiet approach to directing, often described as more introverted than the typical director. *The Love Bug* would be Stevenson's fourteenth film for Disney, having helmed many of

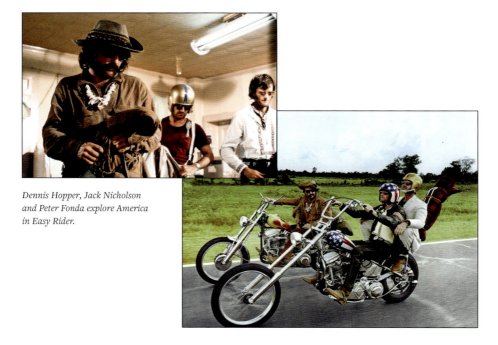

Dennis Hopper, Jack Nicholson and Peter Fonda explore America in Easy Rider.

Walt's most iconic movies such as *Old Yeller, Darby O'Gill and the Little People, The Absent-Minded Professor,* and, of course, *Mary Poppins.*

Production on *Easy Rider* was anything but typical. The film depicted

drug use, which was commonplace on the set itself. Some days, shooting consisted of only a handful of people, a couple of 16mm cameras, and no script. Hungarian cinematographer Laszlo Kovacs took many liberties with the camera. Since the film was shot entirely on location and the crew was constantly on the move, Kovacs discovered things through his lens that were unorthodox but beautiful, like shooting directly at the sun and capturing the glare of refracted light on film.[43] *Easy Rider* was a production that celebrated improvisation.

Conversely, every shot on *The Love Bug* was storyboarded and then meticulously replicated on film by director Robert Stevenson. Stevenson was used to working this way because of Walt's emphasis on using storyboards to plan out his live-action films. *Mary Poppins* had been thoroughly storyboarded by writer and artist Don DaGradi, and Stevenson had continued that practice on his subsequent films. "He got so involved with storyboarding, it became just a little too mechanical for me," said art director John Mansbridge of Stevenson. "I like to feel like I could move around a little bit."[44] But it may have been the only way Stevenson knew how to control and coordinate the enormous amount of second unit work, stunt work, and special effects required to tell the story. "You had three different crews," said *Love Bug* star Dean Jones, "and all of this material has to come together and be seamlessly edited and make sense."[45]

Easy Rider's journey from production to release was similar to *Bonnie and Clyde*'s. *Rider*'s producers Bob Rafelson and Bert Schneider screened the finished film for distributor Columbia Pictures and the Studio was baffled by it. "All the executives in blue suits and ties, and very expensive fabric," said Rafelson. "At the end of the screening, there was only one guy—he was from the mailroom. 'Man, I love that picture,' that guy said. Columbia hated the movie, and they really didn't want to distribute the movie."[46] However, after

receiving a standing ovation for *Easy Rider* at the Cannes Film Festival (along with Hopper receiving the award for Best First Work), Columbia changed its mind. When the film premiered for general audiences in July 1969 at the Beekman Theater in New York, people were lined up around the block.

One interesting comparison between the two films is how each represented the counterculture. *Easy Rider*—made by a couple of real hippies—shined the spotlight directly on them, casting them as the main characters and exploring their relationship to society. The Disney version of the hippie was a caricature used for comedic relief. The main characters in *The Love Bug* (played by Dean Jones and Michelle Lee) encounter a few hippies throughout the film, and their portrayal is on par with something one would see on *Bewitched* or *Gilligan's Island*. One scene has Jones challenged to a drag race by a young couple in a jalopy. When they're beaten by Herbie, they respond with, "Outta sight, man" and "Groovy, pop." Another scene has Michelle Lee trapped inside Herbie and, as she bangs on the window and shouts, "I'm a prisoner," the hippie in the car next to them (played by Dean Jones in makeup) replies, "We are all prisoners, chickie baby."

The Love Bug was Disney's first post-Walt hit (and its biggest success since *Mary Poppins*), becoming the second-highest-grossing film of 1969. It also became something of a template for the Disney comedies that followed: stories with a contemporary setting, centered around a fantastic or magical occurrence (usually unexplained) with car chases, heavy stunt work and special effects.

Easy Rider was only two spots behind *The Love Bug* on the box office chart for the year. The film's success showed that this young generation of filmmakers were here to stay and that creative control of Hollywood was changing hands.

The Love Bug was the final live-action project set afloat by Walt before

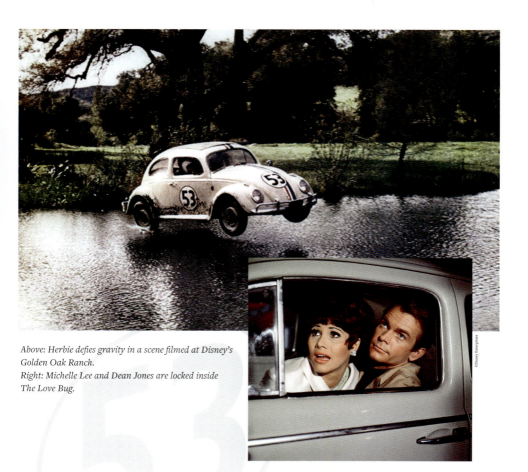

Above: Herbie defies gravity in a scene filmed at Disney's Golden Oak Ranch.
Right: Michelle Lee and Dean Jones are locked inside The Love Bug.

his death. From this point on, the producers and executives on the committee would be responsible for developing new films on their own. There would still be a few exceptions: scripts that had been shelved or properties that had been acquired, yet never fully explored during Walt's time. For example, Bill Walsh dusted off *The Magic Bedknob* and brought the Sherman Brothers back to the Studio for a brief time to polish the songs they'd written for Walt. "It was an emotional moment for us when we returned to the Disney Studio once again," said the brothers in their memoir, *Walt's Time*. "We would be completing a project we had begun under Walt's supervision, but he wouldn't

be there to guide us."[47]

Walt and his studio had a long-term relationship with the Chouinard Art Institute, based in Los Angeles. Going back to the early days of *Snow White*, Walt had enrolled his animators in night classes at Chouinard to improve their draftsmanship. The classes were taught by life drawing instructor and former Chouinard student Don Graham, who later became an in-house drawing teacher for the Studio. Because of the impact the school had on his artists and his films, Walt supported the school and helped get the organization back on its feet when it fell on difficult financial times during the 1950s.

He also had a relationship with the Los Angeles Conservatory of Music and its main supporter, Lulu May Von Hagen, the wife of a wealthy businessman. Von Hagen proposed an idea to Walt, to combine the Conservatory and Chouinard and create a community where all the arts could intersect and be studied. Walt fully embraced the idea, the merger occurred in 1961, and the California Institute of the Arts was born. Several years later, Walt would use the premiere of *Mary Poppins* as a fundraiser for the school.

With Walt gone, Roy O. Disney took it upon himself to bring CalArts to fruition. This was unknown territory for Roy. He was far more comfortable building Walt's second theme park in Orlando, Florida, than he was building a school. As the CEO and chairman of the board at Disney, he was under no obligation to consult with others when making decisions, but for CalArts, he had to consider the school's board of directors, faculty, and, eventually, the students. After much debate and research, Roy settled on the city of Valencia for the school's location. It was across town from the Studio's own Golden Oak Ranch, which had been Roy's initial suggestion for the school's location.

Construction began on the CalArts campus in May 1969. In the meantime, classes were held at the campus of a former Catholic school for girls in Burbank, called Villa Cabrini. Roy's dedication to this project endured much criticism, but he didn't waiver. He felt an intense responsibility to bring one of his brother's final passion projects to fruition: an all-encompassing art community.

The Studio released an animated short called *It's Tough to Be a Bird* on December 10, 1969. It was a comical look at the plight of birds and their sometimes-strained relationship with humans and was directed by one of Walt's trusted Nine Old Men, Ward Kimball.

Kimball had been an animator at Disney since the '30s and became a directing animator on *Pinocchio*, overseeing the character of Jiminy Cricket. In the '50s, Walt gave Kimball two educational short subjects to direct—*Adventures in Music: Melody* and *Toot, Whistle, Plunk and Boom*. Each film boasted a "first." *Melody* was the first 3D animated cartoon and *Toot, Whistle* was the first CinemaScope cartoon. Kimball produced these films while Walt was mostly absent from the Studio due to his focus on Disneyland. This allowed Kimball the freedom to explore something different and led to his reputation for being a staunch nonconformist. Walt recognized Kimball's unique vision and gave him the opportunity to produce and direct three one-hour television specials for *The Magical World of Disney*—*Man in Space*, *Man and the Moon*, and *Mars and Beyond*.

Kimball continued making shorts and television episodes. As an animator, he teamed with director Hamilton Luske on a program called *A Salute to Alaska*, which was bookended by Walt's last filmed segment as

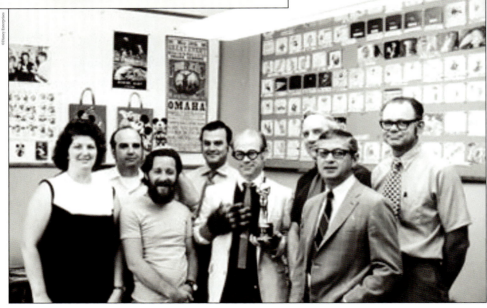

Top: The avian host of *It's Tough To Be A Bird*, voiced by frequent Disney actor Richard Bakalyan. Bottom: Ward Kimball (center) with his team, including Joe Hale, Art Stevens and Ted Berman.

host of *The Wonderful World of Color*. The episode aired four months after his death. In the post-Walt era, the two introduced audiences to some new characters from the world of Donald Duck with the theatrical short *Scrooge McDuck and Money* in 1967 (the first screen appearance of comic artist Carl Barks' creation Scrooge McDuck) and a television episode called *Pacifically Peeking* in 1968, introducing the world to Moby Duck.

As a director, Kimball had developed an unorthodox approach to his material and his newest short—*It's Tough to Be a Bird*—was no exception. The film is irreverent and fast-paced and uses two-dimensional, graphic designs brought to life through a technique known as "limited animation." Rather than the full, fluid, gestural movement of the classic Disney approach, limited animation only moves certain parts of a character while the nonmoving parts are held in place. As animation moved onto televisions screens in the late '50s and early '60s, this technique became the production standard due to its speed and cost-efficiency. Once a legitimate stylistic choice, it was now seen as "cheap" and beneath Disney's "full animation."

Kimball worked with Ted Berman to develop the story for *It's Tough to Be a Bird*. Berman had been an animator and officially moved into story on this film. Joe Hale took care of layout, and the animation was done by Eric Larson and animator Art Stevens, who'd been at the Studio since *Peter Pan* in 1953. *It's Tough to Be a Bird* won Kimball the Academy Award for Best Animated Short but now, with Walt gone, his off-brand sensibilities began to raise concern with the new leadership.

Joseph McEveety, father of child actor Annie McEveety, had moved from assistant director to production manager on several of Walt's final films,

released after his death—*The Gnome-Mobile*, *Blackbeard's Ghost*, and *The One and Only, Genuine, Original Family Band*. Unfortunately, due to health problems, McEveety was unable to continue working in production. Having always dabbled in writing, he pursued that full-time and the Studio assigned him the college student turned into a computer idea that Maurice Tombragel had previously turned down. This would be McEveety's first script for Disney, eventually titled *The Computer Wore Tennis Shoes*.

The Computer Wore Tennis Shoes was released in December 1969 and would go on to earn around six million dollars at the box office. Disney regular Kurt Russell, now eighteen, starred as Dexter Riley. Following an electrical shock while replacing a computer part, Dexter's brain becomes a computer itself, with perfect memory recall and other enhanced mental abilities. Actor Michael McGreevey, another familiar young face to Disney audiences, costarred as Russell's comic sidekick, Richard Schuyler. The two had strong onscreen chemistry and became good friends off-camera as well. True to form, Disney hired another accomplished director of the small screen, Robert Butler. Butler had helmed countless hours of television, including episodes of *The Twilight Zone*, *Hogan's Heroes*, *Batman*, and *Star Trek*. He had worked with Russell on a three-part Disney television special called *The Secret of Boyne Castle*. *The Computer Wore Tennis Shoes* was his first theatrical feature.

The film definitely owes a debt to some of Walt's earlier films, like *The Absent-Minded Professor* and *The Misadventures of Merlin Jones*. Those stories were about quirky science-minded people—a professor and a student, respectively—whose unusual and groundbreaking experiments catch the attention of a corrupt villain who wants to exploit them for personal gain. In fact, Dexter Riley is a student at Medfield College, the same college where Fred MacMurray taught in *The Absent-Minded Professor* and its follow-up, *Son*

of Flubber, making *Computer* a sequel of sorts.

Annie McEveety recalled how excited her father, Joseph, was when the film released to theaters, as it was the first that he'd written for Disney. "I remember we were in line to see *The Computer Wore Tennis Shoes,* at the Alex Theater [in Glendale, California], and it went clear around the block. Dad was just in disbelief that so many people wanted to see this movie." For Joseph McEveety, this was the beginning of a ritual he would engage in whenever a movie he wrote hit the theaters. Said Annie McEveety: "…My father would go to all the different movie theaters, and he'd sit in the back row, and he'd want to see if people would get the jokes, the laughs, at the right time. He loved to hear the people laugh. He loved to hear them get what he wrote."

Unlike Joseph, his brothers Vincent and Bernard McEveety spent most of the 1960s outside the Disney Studio, becoming prolific television directors. Vincent helmed episodes of *The Untouchables, Rawhide,* and *Perry Mason.* He directed more episodes of the original *Star Trek* than any other director, as well as the most episodes of the long-running western, *Gunsmoke.* Bernard also directed on *Gunsmoke* as well as shows like *The Virginian, Bonanza,* and *Wild Wild West.* Both Vincent and Bernard would return to Disney as feature film directors in the 1970s.

It had been a number of years since the Animation Department had hired new artists from the outside, mainly because there were so few opportunities. Even if one could break into the Studio, rising to the rank of animator would be next to impossible. The Studio employed the best animation staff in the world, and they held on tightly to their positions. But animation still proved to be a lucrative business as evidenced by the success of *The Jungle Book* in

1967, which landed a spot in the top ten box-office draws for that year. Walt and Roy had once discussed ending production on original animated films; fortunately, those plans never came to be. The future of Disney animation looked bright and the Studio remained committed to releasing a new animated film every few years. It was clear that they would need to increase their artistic ranks and build a new generation of Disney animators to continue Walt's legacy for decades to come. The Studio decided to open the doors of Disney animation and seek out new talent. They were not looking for artists with industry experience. They wanted raw and unseasoned talent. They wanted young people.

Kurt Russell as Dexter Riley, with Debbie Paine and Frank Webb from The Computer Wore Tennis Shoes.

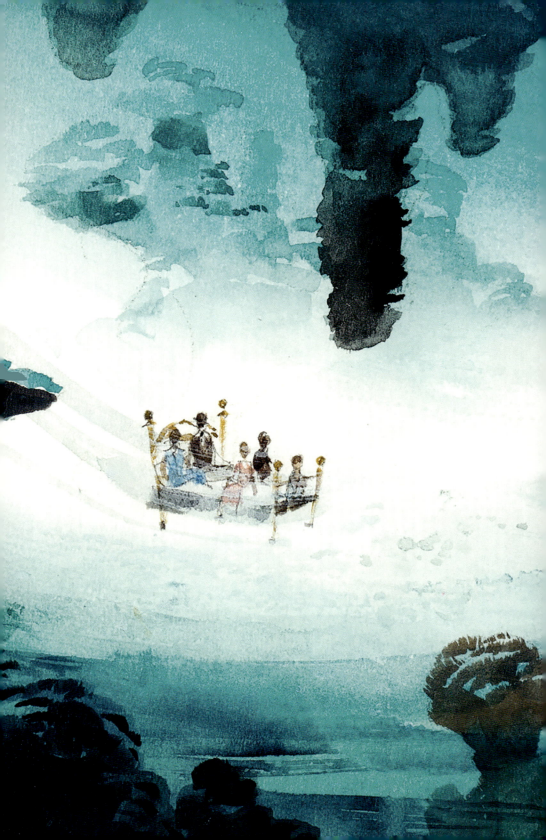

1970

In January 1970, the Studio brought in their first new animation trainee, twenty-four-year-old Ted Kierscey. He had been a student at Chouinard but was drafted into the Vietnam War, suspending his education. When he returned, he finished at Chouinard and applied to Disney. Ollie Johnston responded well to Kierscey's portfolio and he was hired. However, since it had been so long since the Studio had trained new talent, no one really knew how to do it. In fact, it became Kierscey's responsibility to learn as much as he could on his own. Ollie, John Lounsbery and Eric Larson, as well as Burny Mattinson, spent time with Kierscey and allowed him to learn by watching them work. Ted was particularly interested in special-effects animation, so he would visit the Studio's camera department and process lab, where he learned about the optical printer and how special effects were composited. He also met the Studio's small team of veteran effects artists—Jack Boyd, Jack Buckley, and Dan MacManus—all veterans of Disney animation since the '40s.

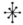

In early 1970, *The Magic Bedknob* (now titled *Bedknobs and Broomsticks*) began production. Angela Lansbury was cast in the lead role. During the early part of her career, Lansbury had been unable to convince Hollywood that she had leading lady potential, despite racking up three Oscar nominations for Supporting Actress. On Broadway, it was a different story. She won a Tony Award in 1966 for the title role in *Mame* and another in 1969 for the lead in

Bedknobs and Broomsticks concept painting by Dick Kelsey, art director of Pinocchio and Bambi.

DISNEY IN-BETWEEN

Effects animator Ted Kierscey (photograph from sometime in the 1980s).

Dear World. Now cast as apprentice witch Eglantine Price, Lansbury finally had the prime big screen role that she'd been craving for so long.

Director Robert Stevenson used his tried-and-true bag of Disney tricks to make *Bedknobs*, shooting the film almost exclusively on the Burbank lot. A portion of the Studio's backlot was transformed into the small English village of Pepperinge Eye, the hometown of Miss Price. Almost all other locations were filmed on the Disney soundstages, with a large number of matte paintings to fill in the gaps. Once again, as he'd done with *Mary Poppins* and *The Love Bug* before, Stevenson had the entire film storyboarded before shooting began. Lansbury was not used to working this way. "Every shot is pre-decided on, and drawn, and the director shoots that shot. Nothing else. So the show is actually precut,"[48] said Lansbury in a 1998 interview for the Television Academy Archives. It's clear from her tone that this hampered her creative process on *Bedknobs*, referring to filming a shot as "copying" the storyboard and the entire experience as "acting by the numbers."[49]

Television had typically been the source for much of the behind-the-scenes talent on Disney live-action films. Familiar faces from the small screen became regulars in front of the Disney cameras as well: *Maverick* star James Garner; Harry Morgan from *Dragnet*; Joe Flynn and Tim Conway from *McHale's Navy*; *Mister Peepers* star and voice of Underdog Wally Cox; *Batman's* Joker Cesar Romero; William Schallert from *The Many Loves of Dobie Gillis* and *The Patty Duke Show*; and character actors like Darren McGavin, Jack Elam, Vera Miles, and Dick Bakalyan. Since Disney continued telling the same stories that Walt told throughout the '50s and '60s, which were also the subject matter of most television programs of the day— Westerns, turn-of-the-century America, modern suburbia—these actors fit in perfectly.

However, in 1970, the television landscape began to change. Executives at the CBS network decided they needed to broaden their programming horizons, feeling that it was time to address and reflect the cultural shifts of the day. Known for shows that appealed strongly to heartland viewers, the network chose to aim for a more youthful and urban audience. They cancelled *Petticoat Junction* early in the year and replaced it that fall with *The Mary Tyler Moore Show*. Moore had become a household name as Laura Petrie, wife to Dick Van Dyke on *The Dick Van Dyke Show*. Moore's new show was created by up-and-coming television writers James Brooks and Alan Burns. The show departed from the typical sitcom in several ways. First, there were no hijinks. The stories were about appealing and relatable characters dealing with everyday problems rather than broad comedic situations that Mary would have to get herself out of. Second, it centered on a female character who wasn't married. In fact, when we meet Moore's character, Mary Richards, in the pilot, we find out that she has just broken off a long-term engagement and is trying to carve out her own place in the world. Rather than searching for another man to marry (like the typical sitcom female), she is in search of

a career and herself.

After *Mary Tyler Moore* became a hit, CBS cancelled all its salt-of-the-earth shows: *The Andy Griffith Show*, *The Beverly Hillbillies*, *Gilligan's Island*, *Green Acres, Mayberry R.F.D.*, and *Hee Haw*. CBS then broke new ground once more by premiering *All in the Family*. This show fearlessly tackled the social and political issues of the day as well as the tensions and misunderstandings between generations. The show rocketed to No. 1 in the ratings. The network's effort to redefine itself—referred to as "the rural purge"—was a success. CBS had "cancelled everything with a tree,"[50] remarked actor Pat Buttram, a regular cast member on *Green Acres*.

However, Buttram and many of these performers had a safe haven at the Disney Studio. Victims of the rural purge appeared in many of the Studio's films going forward, including Don Knotts, Ron Howard, Hal Smith, and George Lindsey from *Andy Griffith*; Ken Berry from *Mayberry R.F.D,*; and Eva Gabor, Eddie Albert, and Pat Buttram from *Green Acres*. The Studio's animated release of 1970, *The Aristocats,* included Eva Gabor, Pat Buttram, and George Lindsey in its voice cast. The story was about a Parisian cat and her three kittens who are kidnapped by their deceitful butler and must find their way back home. Gabor was Hungarian, not French. And how did Buttram and Lindsey find their way into the French countryside?

The same could be said for Americans Phil Harris and Louis Prima in the jungles of India from *The Jungle Book*. All of these performers were selected not because of how well they fit the story's tone, time period, or location but because they brought strong personalities to the characters. Their voices had unique textures and timbres, creating the perfect meal for the great Disney animators to chew on. *The Jungle Book* and *The Aristocats* began a shift in the Studio's philosophy for casting voices that would continue throughout the animated films of the '70s.

Cast members from television shows like The Andy Griffith Show and Green Acres appeared in many Disney films of the 1970s.

Walt's office had been shuttered immediately after his passing. Now studio leadership decided to open it up and archive its contents. Dave Smith, a young librarian at UCLA, got wind of the project and wrote the company, hoping to secure the job. His initiative paid off and he was hired as the Studio's first staff archivist in June 1970. Smith began the daunting task of cataloguing every book, document, memento, and piece of furniture that had been sealed in the office for the past four years. The Walt Disney Archives was born.

Ward Kimball's next film, *Dad, Can I Borrow the Car?*, debuted on September 30, 1970. It was a theatrical short with the same fast-paced and irreverent style as Kimball's *It's Tough to Be a Bird*. But *Dad, Can I Borrow the Car?* was predominantly live action. Animation was certainly present, but it was used to punctuate humor instead of as a vehicle to tell the main story. Kurt Russell

narrated the film, which chronicled the evolution of the average teenage boy in the late '60s, from playing with toy cars as a child, to taking driver's ed, to buying his first set of wheels. Kimball continued working with the same team: Ted Berman in story; Joe Hale in layout; and Art Stevens in animation. Following the completion of *Dad, Can I Borrow the Car?*, Kimball brought this team on to help with his next project—supervising the animated segments for the Studio's big-budget musical extravaganza, *Bedknobs and Broomsticks*, which had wrapped its live-action shoot a few months earlier.

The California Institute of the Arts officially opened in the fall of 1970 at a temporary location in Burbank. Its permanent location in Valencia was still under construction. Roy Disney was relieved to finally see the school active, but his relief quickly turned to shock when he heard reports of what the young folks who attended the school were up to. Students were reportedly swimming nude in the pool. Classroom equipment was disappearing, as students helped themselves to what they saw as communal property. Marijuana smoke clouded the campus, even in the faculty areas. Because Walt had never exposed his brother to the lifestyles of creatives, Roy never truly came to understand how artists conducted themselves. This kind of behavior was beyond anything Roy would tolerate and he considered it an affront to himself, Walt, and the Disney name. After making several unsuccessful attempts to sell the school, he decided to stick with it, telling one colleague, "Walt wanted this school and I'm going to get it for him."[51]

As the year drew to a close, the Studio released an ambitious Western called *The Wild Country,* shot on location in Wyoming and starring Steve Forrest and Vera Miles.

Real-life brothers Ron and Clint Howard were cast as their two children. At the ages of fifteen and ten, respectively, both were already seasoned television and film actors. Ron was best known for playing young Opie Taylor on *The Andy Griffith Show*. Both boys had worked for Disney before. Ron previously appeared in two television movies, *A Boy Called Nuthin'* and *Smoke,* and Clint provided animation voices for a young elephant in *The Jungle Book* and Roo in the Studio's first two Winnie the Pooh featurettes, *Honey Tree* and *Blustery Day*.

The Wild Country was a special film for the two Howard boys. Aside from the fun of filming a Western on the open plains of Wyoming—with veteran character actors like Morgan Woodward and Jack Elam making for a lively and entertaining shoot—it was the first time that Ron and Clint had acted together. Their parents, Rance and Jean Howard, joined the brothers on location. Rance had been an accomplished actor and writer since the '50s and was brought on to the production both as a dialogue coach for his sons as well as an unofficial script consultant. The elder Howard was given a small part onscreen as well.

In addition to the joy of having his family with him during filming, Ron loved working with the director, Robert Totten. "Totten was bearded, short and stout, built like a fireplug. And a little intimidating," recalled Howard in his memoir *The Boys,* written with his brother Clint. "But that was part of why I liked him—he was the first director not to treat me with kid gloves."[52]

Ron and his brother Clint loved making *The Wild Country* and were proud of their performances. But by the time the film hit theaters in December

1970, Ron's enthusiasm had cooled. "Frankly, I was embarrassed to be in a corny Disney movie," said Howard. At almost seventeen, he was desperate to shake off the wholesome image of his *Andy Griffith Show* character. "The film stiffed at the box office. I was relieved. That meant that it was only around in theaters and drive-ins for about two weeks before it disappeared. That's a harsh thing to acknowledge, that I was rooting against my own movie. But such was the push-pull of adolescence, in which my gratitude for all that Opie had given me existed in tension with my desire to be a man.[53]"

Ron Howard also wanted to be a director. He'd made a few short films on his own and his relationship with director Robert Totten fueled him to continue pursuing this passion. "Bob Totten's mentoring was a formative experience in terms of my filmmaking aspirations," said Howard.[54] "When Totten learned of my aspirations, he softened—a little—and took me under his wing, explaining the ways he positioned his cameras and composed his shots, and telling me how he varied his directorial approach from actor to actor, depending upon their psychological makeup and the needs of the scene."[55] Several years later, Ron Howard would make his feature film directing debut with *Grand Theft Auto*, written by himself and his father, and produced by Roger Corman.

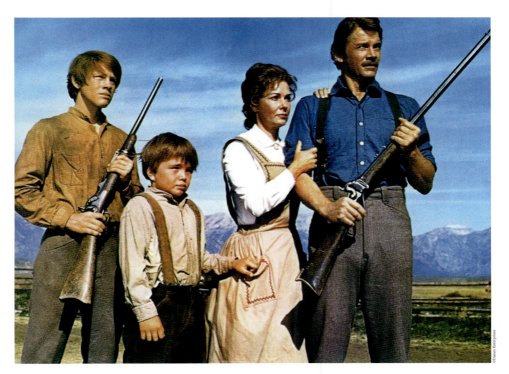

Ron Howard and his bother Clint, with Vera Miles and Steve Forrest from The Wild Country.

1971

It's impossible to overstate the contribution that artist Ken Anderson had on the animated features of the post-Walt era. As Burny Mattinson said: "Ken was really our development guy around there, and Woolie had huge respect for Ken. A lot of the credit goes to Ken." Anderson's office was an explosion of story ideas. He would fill his walls with energetic pen and marker sketches suggesting every story possibility and character personality he could imagine. "He would do lots of little sketches and pin them up all around his room there," said Mattinson. "He loved to get up and sell it to you. It was great. He was wonderful that way."

The Studio's current animated feature in production was a new take on the story of *Robin Hood*. Not only was Ken Anderson indispensable to its development but the concept itself was his. Several years earlier, Anderson and Card Walker were on a fishing trip and their conversation turned to what new animated feature would follow *The Aristocats*. Anderson mentioned that the story group had been developing a take on *The Three Musicians from Bremen,* but Walker failed to see the potential. He then told Anderson to come up with his own idea for a film, suggesting he take a classic story or fairy tale and replace the human characters with animals. Anderson thought of the Robin Hood legend and matched each character from the story with their animal counterpart—Robin Hood as a fox, Little John as a bear, and Prince John as a lion. Walker, and eventually director Woolie Reitherman, thought this would make a great film.

Anderson's impact on the art of Disney animation is monumental. Through his talents for production design, background layout, and story

Unused poster concept for Bedknobs and Broomsticks by prolific Disney artist Paul Wenzel.

development, he shaped and defined all of Walt's animated films, starting with *Snow White and Seven Dwarfs,* on which he served as art director.

Anderson even helped save the Disney animated feature from extinction. After the lackluster box-office performance of *Sleeping Beauty* in 1959, Walt and Roy considered halting production on new films. The project to follow *Sleeping Beauty* was 101 *Dalmatians* and as that film's art director, it fell on Anderson to find a way to produce the film within a smaller budget in order to prove that animated features were still financially viable.

Anderson proposed a new production process developed by Ub Iwerks, Walt's colleague from the early days of his black-and-white Mickey Mouse cartoons and now the man in charge of developing new technologies and special-effects techniques for the Studio. Iwerks came up with a way to use the Xerox copying technology to transfer animators' drawings directly onto the clear sheets of celluloid that were used to create the final frames of animation. Traditionally, this was the job of the women of the Ink and Paint Department. They would transfer the animators' drawings onto the cels by hand, inking every line and then filling in those lines with paint from an enormous library of colors that they mixed themselves. These cels were then laid on top of painted backgrounds and filmed one at a time, creating a frame of film per cel. It was the precise and painstaking work of these women that gave Disney animation the richness and beauty audiences associated with the Studio's classic films. The accepted philosophy of the day was that only a woman's touch could produce this type of delicate work.

But Anderson proposed that a machine could do the work instead, which could benefit the film a great deal. Eliminating the hand-inking step would bring costs down and increase efficiency. The animators were thrilled because the technology transferred their drawings verbatim, versus having them traced by someone else. And from an art direction standpoint, the

heavy black lines that resulted from the Xerox process would give the film a bold and contemporary look, allowing Anderson to create a design approach for 101 *Dalmatians* that was totally different from the films that came before.

Despite the benefits, there was resistance. Of course, the Ink and Paint Department was not happy about being replaced by this new technology. And Walt himself was leery about such a drastic change in the Disney animation style. Regarding Walt's reaction to his proof-of-concept test, Anderson said: "He liked it, but he didn't think I should use it. 'You're not going to do that in the final [movie].' I said, 'Oh, sure. That was the idea.' He said, 'You can't do that. You can't make it look like [this].'"[56]

Anderson persevered, and 101 *Dalmatians* was released to critical and box-office success. However, Walt was not happy that Anderson and his team had ignored him. "I don't know what [Walt] wanted, but he did not like it," recalled the art director. "He thought he had been sabotaged."[57] As a result, Walt forbade Anderson from asserting his own style on future animated films. "He said, 'No more Ken Anderson. Ken has made the pictures the way he wants them…no more of that.' And he said, 'You're not gonna have anything to do with it, Ken.' And he had fired everybody who had worked for me."[58] For someone like Walt, who had built his reputation on embracing new ideas, his reaction was uncharacteristically resistant.

Ironically, despite Walt putting his foot down, the technique that Anderson developed for 101 *Dalmatians* would become the Studio's house style for all its animation throughout the next fifteen years.

Though not officially assigned as a mentor, Ken Anderson still had a profound influence on the current generation of younger artists. "I considered [Ken Anderson] to be number one in the history of the world when it came to story development and story sketch," said Dave Michener, who'd been assisting Milt Kahl throughout the '60s and by the early '70s, had

risen to the rank of animator. Now Michener had an itch to explore the world of story development. "I always wanted to be more involved in the story and control how it was going to look when it was finished on film."[59]

Michener made the jump into the story department on *Robin Hood* and seized every opportunity he could to learn from Ken Anderson. "I tried as hard as I could to absorb what he did and talk to him about it and ask him why he did it," recalled Michener. "We had adjoining rooms. He had me parked right next to him. He was so strong at visual design and just incredibly great at drafting."[60] Whenever Dave was assigned a sequence from the film to storyboard, he would consult with Anderson since so much of the story and characters had come from his pen. So passionate was Michener about emulating Anderson's approach, he even sought out the same artistic tools. Said Michener: "Ken Anderson used to have an India ink pen called a Mont Blanc and I looked for that pen everywhere, and I finally found a store that sold Mont Blanc pens. And I bought three of them—fine point, medium point, and a heavy point. Ken was a hero of mine."[61]

Another acolyte of Anderson's was Dale Baer, a graduate of Chouinard Art Institute who had joined the Studio in 1971 as the second member of the animation training program, alongside Ted Kierscey. The two young men were expected to do personal animation tests as part of their training. Baer would go up to Anderson's office and, when no one was around, photocopy one of his story vignettes to use as a background to animate to. These personal tests were only to be done on their own time so, during regular work hours, Baer was a rough inbetweener working under Ollie Johnston and Frank Thomas on *Robin Hood*.

Story and character development sketches for Robin Hood by Ken Anderson.

DISNEY IN-BETWEEN 85

Eventually, the two trainees were to have their animation reviewed by the remaining six of the Nine Old Men. Word had gotten to Kierscey and Baer that the character of Goofy would be good to use in their final tests, since he was broad, cartoony, and easier to animate than a more complex or realistic character. Plus, back in the '40s and '50s, Woolie Reitherman—who would be judging their progress—was one of the top Goofy animators, so it would be a great way for the two to impress him. Baer started working but was getting caught up in the detail of the character—the stitching on his patches, the whiskers on his chin, and so forth. He was told to "loosen up" and to help him do so, Baer took a trip to the Morgue.

The Morgue was located in the basement of the Animation Building and was where the Studio stored artwork from past films: animation drawings, layout drawings, background paintings, etc. As far back as the late '20s, the Disney Studio saved and stored artwork, which has since become a common practice. By 1971, the Morgue had amassed an extensive collection. It's unknown exactly when this library received its macabre moniker but the Studio's current archives include a layout drawing from 1938 with the word "morgue" scribbled on it.[62]

All artists were free to visit the Morgue and check out artwork for study and inspiration. On his visit, Baer found an old scene by another top Goofy animator, John Sibley. As he flipped through the animator's finished drawings, a rough scribble fell out of the stack. It was crude. Nothing at all like the refined drawings he'd studied. Yet with just a few strokes of his pencil, Sibley had captured so much attitude and movement. Baer, upon viewing this simplistic piece, suddenly understood what it meant to "loosen up."

For Baer's fellow trainee Ted Kierscey, the Morgue opened his eyes to the world of special-effects animation. He studied scenes of water animation from the climax of *Pinocchio*, when Geppetto washes ashore after battling

Monstro the whale. Kierscey was in awe of the beauty and sophistication of the crashing waves and the ebb and flow of the tide, animated by a little-known artist named Ted Palmer.

Experiences like these were why the Morgue existed, but over time the underground storage area was neglected. Termites and insects got into the drawings and damaged them. Jack Brady, the man in charge of the Morgue, had a habit of trimming artwork so it would fit neatly on the shelves. As the years went on, the artwork was compromised.

In addition to accepting outside trainees, studio leadership began training from within. The first group was four assistant animators who had been working for the Nine Old Men. They worked for eight weeks on their tests, but when they were reviewed, none passed. No one understood how this was possible since many of them were already animating production scenes, even though they didn't officially have the title of animator yet. It was discovered that the reason this first group didn't pass was because the veteran animators didn't want to lose their trusted assistants. Another group of assistants was assembled and this time, all four passed.

Burny Mattinson was in that second group of assistants who advanced to the rank of animator. He had done an ambitious test of Prince John, animating to one of actor Peter Ustinov's recorded outtakes. Instead of one test scene, he decided to do three, storyboarding the piece to create a through line between the scenes. Because of this, he was assigned to animate under Ollie Johnston, who was the primary animator for Prince John.

Another member of Mattinson's group to be promoted was Don Bluth. After inbetweening on *Sleeping Beauty*, Bluth left Disney. He returned

to animation in the late '60s as a layout artist on several television series for Filmation animation studio. Now he was back at Disney and was promoted to animator, working under Frank Thomas.

Production was in full-swing on several new live-action theatrical features, each one spearheaded by a member of the McEveety clan. Vincent was in the director's chair for *The Biscuit Eater*. His brother, Bernard, was directing his first film for the Studio called *Napoleon and Samantha*. And writer Joseph had scripted the sequel to *The Computer Wore Tennis Shoes,* called *Now You See Him, Now You Don't*. Returning for this second installment were actors Kurt Russell, Michael McGreevey, Joe Flynn, Cesar Romero, and director Robert Butler.

 The McEveety brothers would be an integral part of the post-Walt era. Over a span of eleven years, Bernard would direct five films for the Studio, Joseph would write a total of seven, and Vincent would direct sixteen films for Disney.

As 1971 drew to a close, *Bedknobs and Broomsticks* was released to theaters, starring Angela Lansbury and David Tomlinson in the lead roles. Once again, as had happened with *The Happiest Millionaire* and *Family Band*, the film's running time was shaved down before its premiere. In order to accommodate the stage show at Radio City Music Hall, the film was cut from 140 minutes to about 120, costing the Sherman Brothers several of their songs in the trim. "And as the songs were removed," said the Shermans, "so too was much of

the dialogue—scenes that provided the heart, the color, the personality.[63] Most of the warmth was taken right out of the picture. Where *Mary Poppins* has love and tears, *Bedknobs* has schtick and funny dialogue."[64] This would be the Shermans' last involvement with Disney for a long time.

Taken on its own, *Bedknobs and Broomsticks* is a charming musical fantasy. Viewed in context of the Studio's history, it's hard not to see the attempts at replicating not just the financial success of *Mary Poppins,* but also that film's tone, structure, and identity. Between Tomlinson on the screen, the Sherman Brothers' songs, and the production team of Robert Stevenson, Bill Walsh, and Don DaGradi, the two films feel alike. Conceptually, *Bedknobs* is the story of a magical maternal woman shepherding children through a trip to fantastic worlds. The songs by the Sherman Brothers have their charms; however, they feel similar to many of their songs for *Poppins.* "Portobello Road" has the same haunting calliope as "Chim Chim Cher-ee." "The Beautiful Briny Sea" underwater sequence is this film's "Jolly Holiday" (although in all fairness, "The Beautiful Briny Sea" was originally written for *Poppins*). And the song that speaks to *Bedknobs and Broomsticks'* emotional core, which in *Poppins* was "Feed the Birds," is the lovely, Oscar-nominated song "The Age of Not Believing." But in *Poppins,* "Feed the Birds" tees up the emotional choice that Michael must make on his outing to the bank, as well as the lesson that Mr. Banks must learn. In *Bedknobs*, the emotion of the song goes nowhere. It has no relevance to the film's story, themes, or characters.

However, *Bedknobs and Broomsticks* has many merits. Lansbury relishes her starring role as Eglantine Price and carries the film with wit and warmth. She has wonderful chemistry with the children as well as with Tomlinson. After playing two stuffed shirts in a row for Disney—Mr. Banks in *Mary Poppins* and Peter Thorndyke in *The Love Bug*—it's nice to see Tomlinson play against type as the comical huckster Professor Emelius

Angela Lansbury at the premiere of Bedknobs and Broomsticks.

Brown. It's a shame that Tomlinson's introductory number, "With a Flair," was removed from the original release version because it's one of his finest moments in the film (the song can be seen in the reconstructed version of the film, released on DVD in 2001 for the film's thirtieth anniversary). The live-action/animation soccer game sequence, directed by Ward Kimball, drew much attention at the film's release. It was frequently excised and included in clip shows of great moments in Disney animation.

Bedknobs and Broomsticks failed to crack the top ten highest-grossing films for the year, putting it behind future classics such as *A Clockwork Orange, The Last Picture Show, The French Connection*, and the top grosser *Fiddler on the Roof,* which also won Best Picture at the 1972 Academy Awards. *Bedknobs* was nominated for five Oscars, winning for Best Visual Effects. Lansbury received a Golden Globe nomination for Best Actress in a Musical or Comedy.

On December 20, one week after the premiere of *Bedknobs*, Roy O. Disney passed away. He had given the opening day speech at Walt Disney World in October and the brand-new CalArts campus opened in Valencia, California, in November, with schools for film, music, art, dance, and theater all under one roof. With these two projects complete, he had finally finished his brother's work. The only thing left on his agenda had been the matter of succession. He had decided that Card Walker should run Walt Disney Productions, a role Walker accepted. Ron Miller would continue as feature film producer and executive producer of *The Wonderful World of Disney*, and Roy E. Disney would continue producing films for television.

1972

In an article from *Disney News*, Ron Miller reflected on the state of the Studio. He said: "With seven feature films, seventeen hour-long episodes of *The Wonderful World of Disney*, and twenty-six half-hour *Mouse Factory* shows in various stages of production or completion, Walt Disney Productions' 1972 production schedule represents an all-time high for the Studio."[65]

Frank Thomas, Ollie Johnston, and Milt Kahl were asked to help mentor the new trainees and animators. Initially, it wasn't the right fit for them. They had been out of the training arena for so long, they struggled to articulate a process that, to them, was instinctual. As brilliant an animator as Kahl was, trying to explain his approach to animating flustered him and usually led to him stammering and stuttering through his lectures. He could be bombastic and cantankerous, which came off as a bit terrifying to the newer artists.

For Burny Mattinson, working under Ollie Johnston on *Robin Hood* proved to be frustrating. Each time Mattinson brought his animation to him for feedback, Ollie's notes would take the scene in a different direction. "After the third or fourth time, I realized that he was just giving me make-work projects and it was not actually pushing me toward finishing scenes that were going to get in the picture," recalled Mattinson. "And I think I was with him for about two months and finally one day I said, 'Ollie, let's remain friends. I'd rather not work with you. I'd rather just be your friend.'"

Now on his own, Mattinson approached Frank Thomas for help with

Self-caricatures by Frank Thomas and Ollie Johnston.

a problem he was having animating a scene of Sir Hiss. Thomas' response was, "That's your problem. You're an animator, *you* figure it out!"

John Lounsbery proved to be a natural mentor, as Dale Baer discovered. "He loved advancing young people," said Baer. "He would do everything he could, if he saw talent in you, to get you where you needed to be. He was one of these guys you could just walk into his room, and he'd just invite you right on in. You weren't afraid to go see him." Thanks to his training by Lounsbury, Baer was promoted to animator at the end of production on *Robin Hood*.

Mattinson eventually reunited with Eric Larson, whose close friendship and excellent mentorship Mattinson valued. Out of all the directing animators, Larson was the one who rose to the top for training and mentoring. "Eric was the epitome," said Mattinson. "He was great. And everybody wound up coming to him. The funny thing is even experienced animators would come to Eric. Lounsbery would still come down and flip things and Eric would give him opinions. Because I had passed so well, thanks to Eric and some good teaching on his part, they started thinking, 'Eric, you've got to start being the teacher here.'" Larson moved into his own wing and began recruiting, traveling to art schools, and evaluating portfolios.

Ward Kimball brought his unique brand of anarchy back to the small screen with a new series called *The Mouse Factory*. Each episode began with live-action footage of Disney characters (in their costumed form from the parks) punching in on a time clock, followed by a celebrity who would introduce themselves as well as the theme of each episode. Then, using clips from animated features, shorts, live-action films, plus host segments costarring

those costumed characters, the theme was explored through slapstick gags, frenetic editing, and an irreverence toward the Disney name. But those in charge, sensitive to Kimball's irreverent approach, canceled the show after two seasons.

Gary Goldman and Lorna Cook joined Eric Larson's program as new trainees. Cook desperately wanted to be a Disney animator. Goldman, on the other hand, hadn't seen a Disney movie since he was a child. Each artist was assigned production work under an animator and, in their off-hours, had four weeks to complete their personal animation test. If they passed, they had four more weeks to prepare for another test. At that point, they'd learn whether there was a future for them at the Studio. Goldman moved into D-wing, where animator Don Bluth welcomed him warmly. "He shook my hand and he says, 'Good luck,'" recalled Goldman. "It seemed like after he introduced himself, I ended up in his office every coffee break that we had. I learned a lot from Don. Eventually he became a steady mentor to me, in helping me get to the different plateaus."[66] Goldman and Cook worked with Larson on their tests and made it through to the second round. After that, Goldman passed but Cook did not and was let go from Disney. She was devastated that her dream would not become a reality. Bluth—who had befriended her—supported and encouraged Cook. He advised her not to give up and told her that she should continue working in the business and seek out a job at Filmation, his previous employer. Cook was hired by Filmation the next day.

Another trainee who started around the same time was Heidi Guedel. She'd studied animation at Chouinard and came to Disney right as that school was transforming into CalArts. Her former classmate, Dale Baer, introduced

her to John Lounsbery, suggesting that he would be a good person to have in her corner come review time. Lounsbery gave her some inbetweens to do, and he was impressed by her efforts. Sure enough, when her work was reviewed, he spoke up on her behalf, and she was officially assigned to *Robin Hood* as an inbetweener. She also met Don Bluth who, having recently been promoted to animator, didn't have a dedicated assistant working with him. He chose Guedel for the job and mentored her in the art of assistant animation.

A young artist named Glen Keane took a spring-break road trip from Arizona to visit CalArts with his dad, Bil Keane, creator of the popular newspaper comic strip *The Family Circus*. When father and son arrived at CalArts, the school was closed for spring break. Glen describes what happened next: "This stoner guy's walking across the street and Dad says, 'Uh, excuse me, young man.' I was like, 'Oh, Dad, what are you doing? Oh, so embarrassing!' He said, 'Look, this is my son Glen. He wants to go to this school but the school's closed. Would you take his portfolio and drop it off at the art school 'cuz Glen wants to be a painter?' I was like, 'Dad, this guy doesn't care.' 'Sure man, okay,' and he takes the portfolio and we drive away." Weeks later, Glen received a letter from CalArts congratulating him on being accepted into the School of Film Graphics. His first thought was that the stoner guy had dropped his portfolio off at the wrong department. Glen called the school to explain that he'd been accepted to the wrong program and that he wanted to be a painter. The school told him that since he'd been accepted into Film Graphics, it was the only way he'd be able to attend. So that fall, Glen Keane started his education at CalArts and though it wasn't his chosen path, it led to his discovery of this strange thing called animation. The School of Film Graphics at CalArts was not geared toward narrative, character animation. It focused on experimental, nonlinear, abstract animation. Veteran animation artist Jules Engel headed the department. Engel

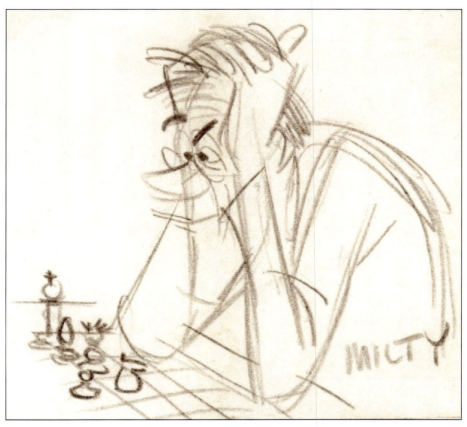

Self-caricature by Milt Kahl.

was a designer and color stylist who had worked on *Fantasia* and *Bambi* in the '40s, then went on to establish the UPA animation studio in the '60s. UPA's approach was to intentionally go against the traditional, dimensional style of Disney, which was also the approach that Engel took for his curriculum at CalArts. After learning about Engel's program, it became clear to animators Frank Thomas, Ollie Johnston, Milt Kahl, and their colleagues that CalArts would not be teaching the Disney way, despite its Disney association. They disengaged from the school.

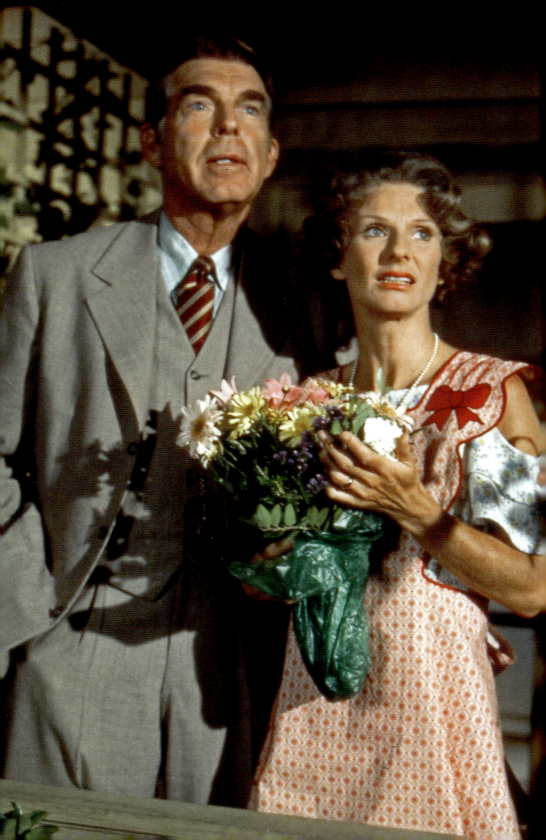

1973

Roy E. Disney directed two one-hour programs for the '73–'74 season of *The Wonderful World of Disney*. *Call It Courage* was based on the Newbery Award–winning book by Armstrong Sperry. Roy E. Disney also directed the first half of a two-part story called *Mustang*, a boy-and-his-horse story set in Mexico. The second half was directed by Frank Zuniga, who'd been a producer and cameraman for Disney on several television films in the late '60s. Part two of *Mustang* was his first assignment as a director, and he would continue making television films for the Studio through the early '80s.

In early '73, production on several new live-action projects was underway. *The Island at the Top of the World*, referred to in *Disney News* magazine as "…an exciting multimillion-dollar adventure epic, similar in scope to *20,000 Leagues*,"[67] was shooting in Oregon, Norway, and Burbank. It was based on the novel *The Lost Ones* by Ian Cameron, which proposed that Vikings, lost in the North Atlantic, had survived and built a colony on a volcanically heated island.[68] The script was by John Whedon—grandfather of future filmmaker Joss Whedon—and was his second screenplay for Disney, after *The Bears and I*. In addition, producer Bill Walsh had two comedies in the works—*The World's Greatest Athlete* and *Herbie Rides Again*, a sequel to his previous hit, *The Love Bug*.

Fred MacMurray starred in the theatrical feature *Charley and the Angel*, directed by Vincent McEveety and released in March. MacMurray had

Fred MacMurray and Cloris Leachman as Charley and Nettie Appleby in Charley and the Angel.

DISNEY IN-BETWEEN

99

Pre-production artwork from
The Island at the Top of the World.
Above: Concept painting by Peter Ellenshaw.
Left and below: Storyboards (artist unknown).

built his reputation in classic films like *Double Indemnity, The Caine Mutiny*, and *The Apartment* as well as on the television series *My Three Sons*. He'd also become a regular in Walt's films, appearing in some of his most iconic, like *The Shaggy Dog, The Absent-Minded Professor*, and Walt's second attempt at a big screen musical, *The Happiest Millionaire.*

In *Charley and the Angel*, MacMurray played Charley, who is informed by an angel (Harry Morgan) of his imminent death, leading to a change of heart and a change of behavior toward his family. Cloris Leachman played MacMurray's wife. She added to her long list of award nominations when she received a nod as Best Actress—Musical or Comedy from the Golden Globes for her performance in *Charley and the Angel*. For MacMurray, this would be his only post-Walt appearance and his last film for the Studio.

Marc Stirdivant, a recent USC graduate, was writing, producing, and editing short documentary featurettes for a local PBS station in Southern California when his agent contacted him about an opening for an associate story editor at the Disney Studios. This was a dream opportunity for Stirdivant. He'd grown up watching *The Mickey Mouse Club, Davy Crockett,* and the construction of Disneyland from the windows of his parents' car. After graduating from high school, he had shot a 16mm documentary called *Walt Disney: The Man and His Miracles,* about Walt Disney's life and career. Stirdivant's agent sent that film to Disney, and it landed him an interview and ultimately the associate story editor position.

Stirdivant joined the Disney live-action Story Department in June 1973, working for Frank Paris, the Studio's current executive story editor. Paris was a former television writer and producer who spent many years

on *Gunsmoke,* producing over fifty episodes of the long-running Western. Stirdivant was now one of two associate story editors who worked under Paris. The associate editor's job was to search for scripts, novels, articles, and other potential raw material for future films and television shows. The duo would then present the material to the Studio's team of readers for evaluation. If the readers responded well, the material went to the in-house producing staff, to see if there was any interest in developing a script based on the subject matter.

A studio that employed staff producers and an internal development department was in stark contrast to the way projects were developed throughout the rest of Hollywood and something Stirdivant took particular note of. At this point, most producers had gone independent and would develop their material outside studio walls. They would either option an existing script from a writer or hire a writer to develop a script based on material they were interested in. Only then, with a completed script in hand, would they take the project to a studio and try to sell it. By holding on to Walt's insular approach, Disney honored his demand for independence. However, as the years went on, this way of working threw them further out of step with the rest of the film industry.

Actor James Garner appeared in two back-to-back Disney films. The first was *One Little Indian*, released in the summer of 1973. It was a period Western about a cavalry deserter on the run who gets saddled with a Native American boy and two camels. In his 2011 memoir, Garner said of the film: "I've done things I'm not proud of. This is one of them. The only bright spot was a ten-year-old Jodie Foster."[69] This was Foster's third appearance in a Disney film.

Morgan Woodward, Jodie Foster, Clay O'Brien and Vera Miles in One Little Indian.

Annie McEveety's uncle Bernard directed *One Little Indian* (his second theatrical feature for Disney). Said McEveety of him: "My uncle Bernard was a little dry. My uncle Vince and my dad (Joseph) were, like, super funny, and my uncle Bernard was pretty funny too, but my uncle Bernard was kind of struck with a tragedy. [His] fourteen-year-old son died suddenly, and it kind of changed his life. He lost that light, that spark. So, I only got to see the… stricter, sterner, more pissed off uncle Bernard. I've heard he was not like that all of his life."

Several months after the release of *One Little Indian*, shooting for Garner's next film for the Studio began on location in Kauai. The working title was *Paniolo*. Vincent McEveety—Bernard's brother—directed the film. Garner played a shanghaied Texas rancher taken in by a young boy and his mother after the rancher finds himself washed up on a Hawaiian shore. Vera Miles played the mother in the film, after just starring alongside Garner in *One Little Indian*. This film was also something of a Western, the word

"paniolo" meaning "cowboy" in Hawaiian. The film's final title was eventually changed to *The Castaway Cowboy* and was released in August 1974. Garner's assessment of his second Disney outing was not much of an improvement over his first. As he stated in his memoir: "The best thing in it is the Hawaiian scenery."[70]

In August, Ward Kimball retired from Walt Disney Productions, just shy of forty years with the Studio. He had grown frustrated with how his recent work had been categorized as "un-Disney" by the current leadership, simply because of its irreverence and experimentation.

In an interview with animation historian, John Canemaker, Kimball commented about the climate at the Studio: "You just can't be free and open about things. That's the way I've always operated there, and I've gotten in trouble. But Walt always appreciated the fact that I was trying something. I just can't honestly continue to work within that framework or that climate, with these people who have set themselves up as judges as to what is…'Disney' and what isn't."[71]

Kimball would frequently return to the Studio to give lectures to new trainees and younger artists. Ted Kierscey attended one of those lectures, during which Kimball was asked why he'd retired. Kierscey recalled: "All he said was 'Boredom.' He wasn't malicious about it, but he said it in a way that was just honest."[72]

Robin Hood was released on November 8, 1973, and did well at the box office. The top three grossers for the year were *The Sting*, *The Exorcist*, and *American Graffiti*, the latter written and directed by a young filmmaker named George Lucas and produced by Francis Ford Coppola. Coppola himself had

experienced a massive critical and commercial success the year prior for his direction of *The Godfather*. Lucas had made his directorial debut with a bleak, futuristic thriller called *THX 1138*, distributed by American Zoetrope, the independent studio that Lucas and Coppola had founded.

American Zoetrope was based in San Francisco, intentionally removed from Hollywood executives. "The Bay Area guys, like George, were way more out of the control of the Studios because they were up there and not down [in Hollywood]," said actor Charles Martin Smith, one of the stars of *American Graffiti*. "There was a feeling, I think, in the '70s, that things were very wide open. When I worked with George Lucas and Coppola and those guys, there was a whole movement of new, interesting young filmmakers."

In the late '60s, young talent like Warren Beatty, Dennis Hopper, and Peter Fonda had been outnumbered by the old guard when they broke new ground with *Bonnie and Clyde* and *Easy Rider*. Now Lucas and Coppola, as well as other young filmmakers like Brian De Palma, Martin Scorsese, and Steven Spielberg, had grown into the dominant force of the new Hollywood.

Throughout the early '70s, artist Ken Anderson turned his pen toward developing new animated feature ideas that could follow *Robin Hood* onto theater screens. Two of his passion projects were *Catfish Bend* and *Scruffy*. *Catfish Bend* was based on a series of books by Paul Lucien Burman. The cast consisted of clothed, talking animals, sort of a *Wind in the Willows* set on the banks of the Mississippi River. *Scruffy* was an adaptation of a 1962 book by Paul Gallico, author of the source material for Walt's 1964 live-action film *The Three Lives of Thomasina*. With a backdrop of World War II, *Scruffy* dealt with a legend surrounding the apes of Gibraltar.

But another animated project overtook Anderson's development ideas. It was called *The Rescuers* and it drew from the 1959 book of the same name and its sequel, *Miss Bianca* (1962), both by Margery Sharp. There had been numerous attempts at adapting these books when Walt was alive, but nothing had come of them. But now, Woolie Reitherman and his team created a new story involving a psychotic villain and the kidnapping of a little girl. These ideas reinvigorated the project, allowing *The Rescuers* to become the Studio's next animated film in production.

However, it would be some time before that production was ready to begin, leaving a significant gap between the completion of *Robin Hood* and the start of *The Rescuers*. Since the theatrical short *Winnie the Pooh and the Blustery Day* had been quite successful a few years earlier, the Studio decided that making another Pooh featurette would be just the thing to bridge the gap.

Woolie decided to only produce *Winnie the Pooh and Tigger Too* and chose John Lounsbery to direct the film. Lounsbery was reluctant to move away from animating. Dale Baer recalled: "He was packing up his room to move upstairs to direct on *Pooh* and I said, 'Well, what's it like to be a director?' He said, 'I don't know, I just want to be a good animator someday.'"

Catfish Bend (top) and Scruffy (bottom) development sketches by Ken Anderson.

DISNEY IN-BETWEEN

Illustration by Ernest H. Shephard from
A.A. Milne's story In Which Pooh and Piglet
Go Hunting and Nearly Catch a Woozle, one
of the tales adapted for Winnie the Pooh and
Tigger Too.

1974

The animators on *Winnie the Pooh and Tigger Too* were a mix of veterans and newcomers. This blend of varying experience levels on projects was becoming the norm. Frank Thomas, Ollie Johnston, Milt Kahl, and Eric Larson continued as directing animators. Dale Baer, Don Bluth, and the recently promoted Gary Goldman were full-fledged animators. Trainees John Pomeroy, Dick Sebast, Jim George, and Andy Gaskill also animated production scenes even though they had not received a promotion to the rank of animator.

Heidi Guedel continued inbetweening and doing personal tests on the side. She was looking through the film's storyboards and one particular scene connected with her. It was a scene of Tigger kissing the ground after being stuck at the top of a tree. John Lounsbery knew no one was working on that scene, and he suggested that Guedel use it as the subject for her next test. She worked hard on the scene and brought it to Don Bluth for a critique. Bluth's room was full of colleagues taking a break, and as Guedel ran her scene, the room burst into laughter. However, someone pointed out that, despite what Lounsbery had told her, the scene had already been assigned to another trainee.

Unsure of how to proceed, Guedel discussed the issue with Milt Kahl, who was supervising this particular sequence. She played her scene for Kahl, and he loved it. In fact, he thought it was better than what the other trainee had done and even considered having Guedel's version cut into the final film instead. Ultimately, he decided not to. "I was at once disappointed and thrilled at the response my work had evoked from an important animator whom I respected for his unflinching, if sometime tactless, honesty,"[73] said

Guedel in her memoir, *ANM8RX*.

Kahl then offered her some unexpected advice. Guedel wrote that Kahl said: "'I hear you're a darned good assistant to Don Bluth. Y'know, women have not been encouraged as animators here because we expect someone to make a career of animation, not get married, get pregnant, and quit after we've put all this time and effort into them.' He continued: 'We consider Don Bluth a very gifted animator and he needs a top-notch assistant. You should be glad to have that position here. You can learn a lot from him.'"[74] Guedel, while appreciative of Kahl's feedback, refused to throw away her ambition to become an animator simply because of the gender standards of the time.

Ron Clements finally made it from Iowa to Disney. He started in the training program in January 1974 and was welcomed by his fellow trainees in a unique way. "*The Exorcist* had come out and had a big impact," he said. "So, there was a thing called the Gross Gallery where [the current trainees] did all these drawings of the Pooh characters all doing stuff from *The Exorcist*, vomiting and head-spinning. And I think they thought it would be funny to put all those drawings around my desk where I was going to be…. They had really decorated the whole thing."

Clements began his training. He spent four weeks on his personal test, had his review, spent another four weeks on another personal test, then had his final review. This had become the typical pattern for all trainees in Larson's program. Clements made it through all eight weeks and became an inbetweener on *Tigger Too*. He worked on another personal test on his own time, choosing Cruella De Vil as his subject. His ambition paid off. The test was such a success that Frank Thomas and Ollie Johnston came to his

room and playfully yet respectfully bowed to him. Thomas requested that Clements come work with him and train to be an animator.

Clements' test also attracted the attention of Don Bluth. "My Cruella test went over really big, so then Don sort of noticed me," said Clements. "I don't think he paid much attention before then. One day, when I was having lunch, Don sits down and he lets me know about the project in his garage, which I had no idea about." Bluth was developing his own animated feature outside of Disney called *The Piper*, an adaptation of 'The Pied Piper of Hamelin.' Said Clements: "In his garage, he had an animation stand, and he had a Moviola, and he showed me a reel, like seven to nine minutes. And it...had cleanup animation, it had rough animation, some story sketches. I would swear it had color in it too. Very *Pinocchio*-esque." Bluth had a natural charisma and became something of a leader to the new group of young artists. When he found someone he thought had particularly strong talent, he would work to recruit them for his side project. "It was a little cult-like," said Clements. "You would be sort of secretly brought and shown the project and enticed to work on the project. For free."

At CalArts, student Glen Keane attended a talk given by a group of the younger artists currently at Disney. The talk inspired Keane to put together a portfolio and apply to the Studio. He did, and he procured a meeting with Larson. Being a painter, most of Keane's work was geared toward fine art. As Larson flipped through, he stopped on a simple pen sketch of a figure that Keane had dashed off in a couple of seconds. Larson asked Keane to do more sketches like that one. The following week, Keane returned with seven sketchbooks full of quick, observation drawings. Larson flipped through them, tore a few pages from each sketchbook, and sent the handful of drawings to the review board. Keane was accepted and walked into the Disney Studio for the first time in September 1974.

Keane describes his first impressions: "It was probably at about three in the afternoon and the light [was] coming in at a certain angle. The floors were all linoleum, polished floors, with that kind of reflective surface. But it was the smell of the place that just really hit me. I'd always liked my dad's studio, the smell of it. And this was this wonderful combination of cigarettes, scotch, and pencil shavings. It was like artistic incense. It was sacred. It was wonderful. Very magical place and time."

Keane moved into a room with Ron Clements and Andy Gaskill. His colleagues were so knowledgeable about the Studio and its artists. This was a knowledge that Keane did not have and he was overwhelmed by how little he knew about his surroundings. Another distraction at the time was the Studio's destruction of the old sheets of celluloid that animated characters were inked and painted onto. This caused quite a frenzy amongst Keane's fellow trainees. "They were going out to the dumpsters where Disney was in the process of shredding cels because they were so flammable. And who cared about these, anyway," recalled Keane. "And people were coming back, 'Hey, didja see? I got these out of the dumpster!' *Pinocchio* cels!" Recalled Dale Baer: "I remember when they had a bin out behind Stage 4, which is now Stage 5. All the cels were thrown out there. You'd just dive into this dumpster and rifle through it and hopefully you'd find something that hadn't gotten rained on or baked in the sun."

James Algar wrote and produced a two-part docudrama called *Two Against the Arctic,* that aired in the fall of 1974, and was based on the book *Icebound Summer* by Sally Carrighar. The story was about two Eskimo siblings who go with their father on a walrus-hunting trip. On the journey, their father goes missing and the children must make the trek back home on their own. The film was shot on location in Alaska with two children from Nome playing the leads. The children were not actors, so the script emphasized narration

Joseph and Lolly, the young protagonists of Two Against the Arctic.

over dialogue so that the children wouldn't feel pressure to perform. But the crew quickly discovered that the children showed a natural talent for acting, so the script was rewritten to give their characters more on-camera dialogue.

Algar was familiar with the fluid process of documentary filmmaking, having spent years overseeing so many of Walt's *True-Life Adventures*. "Improvisation and flexibility are two key ingredients in a nature film," said Algar in an interview in *Disney News* magazine. "Rigidity is disastrous. The best moments are spontaneous. There is control, of course. The basic story line is adhered to. But photographers must have the freedom to shoot as much footage as any occasion demands. Nature is unpredictable and exciting—that's what our films try to show. It may take twenty feet of film to get one foot of usable material, but that one foot of film might be the most exciting moment in a two-hour picture."[75]

DISNEY IN-BETWEEN

Herbie Rides Again was the Studio's first theatrical release of 1974. Aside from Herbie himself, none of the characters from *The Love Bug* returned. The closest was screen legend Helen Hayes' character, Mrs. Steinmetz, who was the aunt of Buddy Hackett's character from the previous film. Keenan Wynn played villain Alonzo Hawk, a character he was reprising not from a Herbie film but from *The Absent-Minded Professor* and its sequel, *Son of Flubber*. With the crossover of Hawk into the world of Herbie, as well as the previously stated Medfield College connection between the Fred MacMurray films and the Kurt Russell/Dexter Riley comedies, one could say Disney had created something of a connected universe, intentional or otherwise.

Released a month after *Herbie* was Bernard McEveety's third film for Disney, *The Bears and I*. Filmed on location in Oregon and Washington, it was a man-versus-nature story that was so common in the Disney canon. The film was based on Robert Franklin Leslie's memoir, which documented his experience raising three orphaned bear cubs.

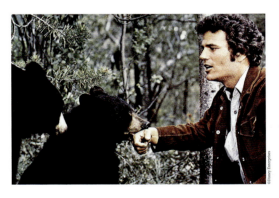

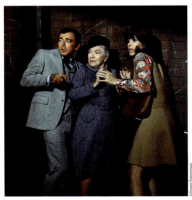

Above: Patrick Wayne and his ursine costars from The Bears and I.
Right: Ken Berry, Helen Hayes and Stefanie Powers in Herbie Rides Again.

As had happened with the big-budget Hollywood musical, the disaster movie was another dying enterprise. This genre had been made popular by producer Irwin Allen with films like *The Towering Inferno* and *The Poseidon Adventure*. In 1974, TV writers Bob Barbash and Richard Landau felt they had a new spin on that dying genre. Their pitch was essentially *The Poseidon Adventure* in Space; a space station full of people experience a cosmic event and become stranded in the far reaches of the galaxy.[76] Frank Paris liked the idea and hired the team to develop a script with Winston Hibler attached as producer. During development, the writers decided that a black hole could pose a potential threat to the inhabitants of the space station. While their idea was solid, Hibler retired, and the project was shelved.

The Sporting Proposition was another film in production. It was based on a James Aldridge novel about a young Australian farm boy and the wild pony he is gifted by a local ranch owner. Later retitled *Ride a Wild Pony*, the film was written by Rosemary Anne Sisson and shot entirely in Australia. Aside from producer Jerome Courtland, executive producer Ron Miller, and director Don Chaffey (who had previously directed *Greyfriars Bobby* and *The Three Lives of Thomasina* for Walt), none of the usual Disney suspects appear in its screen credits, making this film an anomaly for the time.

It was Marc Stirdivant in the live-action Story Department who had found and developed *Ride a Wild Pony*. The film was his attempt to break out of the patterns and habits that the Studio had gotten into during the '70s. Said Stirdivant: "There was this tradition of Disney live-action entertainment which was very wholesome and family-oriented and all of that. But there was also this desire—and it was part of the reason I was brought in—to elevate that to something that was perhaps more sophisticated. And so we made an

effort to do that and that was actually kind of a mandate for me to be on the lookout for those kinds of projects."

Pit Ponies was another Stirdivant project, also written by Rosemary Anne Sisson. *Pit Ponies* was about three children who save coal mining ponies from destruction. It too was shot on location with a non-Disney crew and was an early attempt at bringing in an outside director. Said Stirdivant: "One of the things I was asked to do was watch a lot of TV movies. If there was someone I thought was particularly interesting, [I was] to bring that name forward. As there was with…finding more serious stories [to] tell, there was also this effort…[to] find some other directors. Let's bring in some new blood. Let's see what else somebody can do under our framework." English director Charles Jarrott, winner of a Best Director Golden Globe for *Anne of a Thousand Days,* was brought in to direct the film, which became known as *The Littlest Horse Thieves.*

The Studio welcomed another outsider on to the lot, director John Hough. Hough had directed on the classic British series *The Avengers*, made a Hammer horror film called *Twins of Evil*, and received acclaim for the paranormal thriller *The Legend of Hell House*. Not quite the résumé one would expect for a Disney director, but the project he was brought in for was different for the Studio. *Escape to Witch Mountain*—based on a novel by Alexander Key—is the story of two orphans with psychic powers who discover that they are aliens from another planet. It was the Disney Studio's first significant entry into the science-fiction genre. Hough's work on *Hell House* attracted the attention of Disney. "They screened it at the Disney Studios and apparently the executives were all really shaken up by seeing this film," said Hough. "It's one of the best films I ever made. As a result of that, Disney contacted me to do this film as it dealt with the paranormal and telepathy." Hough jumped at the chance to diversify his résumé. "It was

always a dream of mine that I would come over and work for them," he said. "I really like working with children, and I wanted to do something that would have...longevity...for decades."[77]

While some may have scoffed at how insulated the Studio was in the '70s, Hough found it to be a welcome change. He said: "Disney was a totally different situation than...in England, where I had to do a lot more in terms of writing and creating and improvising. But with Disney, their setup was such that they did so many things for you, that you were able to be totally creative.[78] Hairdressing, wardrobe, makeup, the art department, everything was really departmentalized and they were all experts."[79]

On *Escape to Witch Mountain,* Hough worked with kids, animals, and lots of special effects. To prepare those effects scenes, he would talk through his vision with a storyboard artist and those sketches would be passed on to the visual effects team. "This was Art Cruickshank and Danny Lee," said Hough. "And their job was to figure out how to do it. And they were really brilliant. They would go backstage on the Disney Studios, where they had their own department, and they would rig up stuff and then they would try and work out how to do it. And they would go through a period of elimination of tricks and ideas until they finally solved how to do it. And I was given total freedom to just dream up what I wanted to do."[80]

For the animal actors, replicas of the final sets were built on the lot. Their trainers would then rehearse for weeks, getting the animals accustomed to the fake sets so they'd be ready for filming on the real ones. The Casting Department came through with two strong choices to play the pair of young siblings: Ike Eisenmann and Kim Richards. Said Hough: "When we cast them and they met up, they got on straight away. Ike was more of a quiet person and a little bit shy at the beginning. Kim was bouncier and more ebullient. It was obvious to me, when I saw them both together, that they were just

perfect for the film."[81]

Hough had developed his own visual style over the years, and it was imperative that he bring his sense of staging and composition to the material. "I insisted on shooting everything at natural speed and for real. I tried to avoid under-cranking the camera. The other thing I tried to bring to the picture was a sense of realism in the locations and I asked that I could shoot most of the picture on location, which was a departure for Disney at the time. Indeed, seventy-five percent of this film was shot on location. Nearly all the locations were inland of Carmel or [in] Carmel."[82] Hough's style consisted of low camera angles with strong, compositional elements. He also looked for unique camera angles, straying from the typical way of staging a family film. "I was shooting through mirrors, underneath cars, hanging off the side of cars," he said. "And that's the sort of thing that Frank Phillips, the cameraman, enjoyed so much."[83] There is no doubt that *Witch Mountain* is a product of seventies-era Disney storytelling, but because Hough was allowed to infuse his personal style into the production, the suspense and the supernatural aspects of the story were heightened, giving *Witch Mountain* a different feel from other Disney films of the era.

The Studio had very high hopes for the theatrical holiday release of *The Island at the Top of the World*. To build anticipation and awareness, they created detailed dioramas of scenes from the film and installed them in the shop windows on Main Street at both Disneyland and Walt Disney World. So confident were they that the movie would be a hit, they planned an elaborate E-ticket attraction, based on the film, as part of a proposal for a new land at the parks, called Discovery Bay. Unfortunately, the film seriously

David Hartman, Mako, Donald Sinden, Agneta Eckemyr and David Gwillim encounter killer whales in The Island at the Top of the World.

underperformed at the box office and all subsequent plans for the new land and attraction were jettisoned.

Winnie the Pooh and Tigger Too accompanied the release of *The Island at the Top of the World*. Both films received Academy Award nominations, *Tigger Too* for Best Animated Short and *Island* for Best Art Direction/Set Decoration.

The Studio had now produced three Winnie the Pooh short subjects. *Winnie the Pooh and the Honey Tree*, released in 1966, was the only Pooh film to be overseen personally by Walt. It was followed by the Academy Award–winning *Winnie the Pooh and the Blustery Day* in 1968 and now *Tigger Too*. The decision was made to edit the three shorts together and release them as a feature. Walt's original intention had been to make a full-length film about Pooh and his friends, once he'd secured the rights to the A.A. Milne books in the early '60s. However, feeling that the slow pace of life in the Hundred Acre Wood might be difficult for audiences to sit through for more than thirty minutes, he decided that shorts would better suit the material. Perhaps feeling that audiences were now familiar enough with Winnie the Pooh to tolerate a feature-length film, the Studio leadership edited the shorts together, with new animation created to transition between them, and released *The Many Adventures of Winnie the Pooh* three years later.

FIRE & BURGLAR PROOF
BURGLAR & STILLMAN MAKER

1975

After releasing *Escape to Witch Mountain* to theaters in March, the Studio had a massive hit four months later with *The Apple Dumpling Gang*. It went on to become the third-highest-grossing Disney live-action film, after *Mary Poppins* and *The Love Bug*. *The Apple Dumpling Gang* story was based on a book by Jack Bickham. The backdrop of the film was the California Gold Rush and it starred Bill Bixby as a gambler who gets stuck with three orphaned children. This was Don Knotts' first appearance in a Disney film and Tim Conway's second, after *The World's Greatest Athlete* two years earlier. Bixby and the children formed the titular Apple Dumpling Gang, with Knotts and Conway playing supporting roles. However, the two made such a strong comic duo that they stole the show.

Disney stalwart Norman Tokar was behind the camera for *The Apple Dumpling Gang*. Before coming to Disney, Tokar directed many television shows, including ninety-three episodes of *Leave It to Beaver*. During his time with Walt, Tokar helmed dramatic films like *Big Red* and *Those Calloways* and was then given the reins of Walt's ambitious musical *The Happiest Millionaire*. During the post-Walt period, Tokar was able to expand his repertoire into broad comedy with films like *The Boatniks* and *Snowball Express*. Set decorator John Kuri once said of Tokar: "He was very serious. He always wore this sun cap he would pull down around his ears and he'd be pacing back and forth. You'd look at him and you'd wonder, *How can this guy direct comedy?*"[84]

*Don Knotts and Tim Conway
steal the show in* The Apple Dumpling Gang.

CalArts announced the start of a new program for the fall semester of 1975. With support from the Disney Studio, the program's intended focus was on the disciplines of character animation with former Disney artists serving as faculty. They were to impress upon their students the fundamentals of hand-drawn, personality animation—an extension of what Disney already had implemented with Eric Larson's training regimen. It was an added bonus that the program, and the training it offered, could increase the talent pool for future studio recruiting efforts.

Jerry Rees was the first student accepted. He became the teaching assistant for the department head, former Disney shorts director, Jack Hannah. The summer before the program started, Rees spent time at the Disney Studio, collecting artwork to hang on the walls for the incoming students to reference and gain inspiration from. The Studio made pristine copies for him to take back to CalArts, and preparations continued for the program's fall debut. Said Rees: "And then I was getting phone calls from fellow students-to-be, so I was answering the phone for Jack Hannah. So, it was like, 'How many S's in Lasseter?' and 'Brad Bird, like the flying bird?' And John Musker. So, I spoke to them before I met any of them. And then we all went out to [classroom] A113."

The first class of the CalArts Character Animation program included Rees, John Musker, Darrell Van Citters, John Lasseter, Brad Bird, Bruce Morris, and Leslie Margolin. The group shared a passion for the art and craft of personality animation. "We got very definite instruction on figure drawing from Elmer Plummer [and] design from Bill Moore," said John Musker. "Jack Hannah was our animation teacher, and he was almost more of a story guy/director. He hadn't been an animator that long, so in terms of the techniques of animation, that became mostly self-taught. It was a very collegial atmosphere. We learned as much from each other as

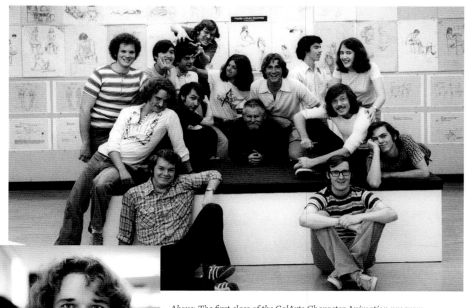

Above: The first class of the CalArts Character Animation program.
Back row: Joe Lanzisero, Darrell Van Citters, Brett Thompson,
John Lasseter, Leslie Margolin, Mike Cedeno, Paul Nowak, Nancy Beiman.
Middle Row: Jerry Rees, Bruce Morris, instructor Elmer Plummer,
Brad Bird, Doug Lefler.
Front Row: Harry Sabin, John Musker.
Left: Jerry Rees.

we did from that."

Musker continued: "I think I'd read the [Christopher] Finch book, *The Art of Walt Disney* [published in 1973], so I got…a sense of who some of these animators are, but I got a much stronger sense of that in my first year at CalArts then, because we literally had scenes of animation they had xeroxed for us that we could flip and study and look at. I was surrounded by people like Brad Bird who knew every Milt Kahl scene that had been done and in fact could pick out which scenes were by Milt Kahl, which I totally scoffed at, at the time. 'You can't tell which ones he animated!' He's like, 'Yes, I can!' And he could."

These young people came together at CalArts during a time when

DISNEY IN-BETWEEN

the animation industry was not as healthy as it once had been. Said Darrell Van Citters: "If you go back to 1975, the future of animation was pretty bleak. It was a dumb career move. I didn't even have any vision beyond just going to school and learning animation. It shortly turned out that the only place you could apply what we were learning was Disney because everybody else was Hanna-Barbera or Filmation or TV commercials. There really wasn't a lot of places to do classic animation. We just were like, 'We hope we get on the Disney ship when we graduate just because that's the only place we can practice this.'"

After his success in *American Graffiti*, actor Charles Martin Smith had trouble finding more big screen roles. "It was a strange time for a teenage actor...," said Smith. "There were very few movies being made with teenage casts. I didn't really want to be on a TV series. They...did talk to me about it at one point. I decided not to do it." Around this time, Disney offered Smith a role in a comedy film called *Double Trouble*, which he accepted. "I wasn't getting a lot of other offers, so I thought, *yeah, this will be fun*, and David Niven was

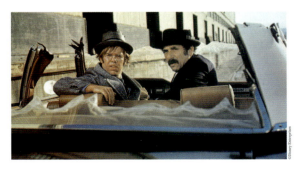

Charles Martin Smith as Terry 'Toad' Fields in American Graffiti (left) and playing opposite Herschel Bernardi in No Deposit, No Return (above).

going to be the star of it. Legendary actor. So, I took the part."

At the helm of *Double Trouble* (eventually retitled *No Deposit, No Return*) was director Norman Tokar, fresh off his success with *The Apple Dumpling Gang*. Contrary to set decorator John Kuri's previous assessment of the director being a serious sort of fellow, Smith found Tokar to be "a real character. He had been an actor, I guess, and I think he'd done comedy and I always got the impression that he still wanted to be an actor." Indeed, Tokar had performed on Broadway during his twenties. "He loved to get up and play all the parts for everybody. I liked him. He was good to me.'"

Smith enjoyed shooting the film. He had the opportunity to work with such greats as Don Knotts, David Niven, and Herschel Bernardi (whom Smith had already worked with on a previous project). Said Smith of working for Disney: "You didn't have to worry about whether the movie was going to make money or not. Everybody knew...it wasn't going to be a huge success. It wasn't going to be really reviewed by the critics. You wouldn't be panned for a bad performance. It was kind of like doing children's theater. It was...a safe place for an actor."

"They weren't looking for big box-office hits," recalled Dale Baer. "At that time, they were still going to rerelease stuff every seven years to a new audience, and it was a done deal. When I started, they rereleased *Snow White*. Made eleven million dollars! They didn't have to do anything. They just stuck it out there. I didn't even notice any advertising. They didn't sweat it."

"It was a little sleepy," added future animation producer Don Hahn. "It was a very small, family-run business and Walt's son-in-law was upstairs and he was producing all the movies."[85] As a result, the Studio had a much different feel than the rest of Hollywood. For Charles Martin Smith, who'd worked at other studio lots in town, the difference was palpable. "It was a little bit off to the side," said Smith. "You felt as though it was marginalized

because they were…doing kids' films. It felt a little more old-fashioned and a little cornier."

That corniness may have been looked down upon by many on the outside, but for those on the inside it was home. "The lot felt very appealing," remembered Ron Clements. "A lot of grass, squirrels, birds. Not a typical Hollywood studio."

"I loved walking around [the lot]," said Dale Baer. "You could wander around, nobody cared. They didn't shut you out of the stages." When Baer faced a creative block on a scene of animation, he would escape to the calm of the lot to recharge. "I would get a sandwich and go sit on the front porch of one of the houses or I'd go sit in a buggy on the western lot. [There] used to be a lagoon and there was a berm around it, and it had fake swamp-type trees and they had a boat there. So, I'd go…and I'd sit in the boat on the water. It was the greatest place to me."

When people speak of their memories of working at the Disney Studio during this time, two words are mentioned time and time again: "loyalty" and "family." *Witch Mountain* star Kim Richards said: "Once I started working for Disney, there was no place like home. Disney is probably the most loyal studio. It's like a family."[86] Actor and director Jodie Foster said: "There's a real loyalty to Disney. A real family feeling to Disney. It isn't made up. It's actually a real family feeling."[87] And director Gary Nelson added: "The thing about the different people that worked on most of the pictures that were made there is loyalty. Most of the people were loyal to the Disney brand. To Walt himself and beyond Walt."[88]

The Animation Department was now run by production manager Don

Duckwall. He had started at Disney in the '40s as an assistant director then moved into management on *The Jungle Book*. Woolie Reitherman continued shepherding new animated features through development and production. "He was the one and only guy who could run this place at that time," said Dale Baer. "Nobody had the kind of guts that he had and a good approach to putting a simple film together."

Reitherman had been with Walt since the '30s but left to fly fighter planes during World War II. When Reitherman returned to Disney, he advanced to the position of directing animator. Once there, he became known for animating dynamic action sequences like the dinosaur fight in *Fantasia* and Tramp fighting the alley dogs in *Lady and the Tramp*. He was a tall and imposing figure and, at times, hard to read. Said Glen Keane: "When you're looking at Woolie, you are trying to understand his feelings because he's not saying anything. So, you're studying him and that's when you notice his face is an explosion of wrinkles. Just a thousand wrinkles. And he always had this...cigar that he'd chew on. He wouldn't smoke it."

As a director, Reitherman kept control of the films from the seat of his Moviola. The Moviola was one of the primary tools of an animation director of this era. It was a film editing machine where one could view reels of film projected onto a small screen. It had foot pedals that would start and stop the film as well as run it forward and backward. Reitherman viewed and critiqued animators' rough pencil tests through the Moviola. He would also edit their scenes into the film to assess the continuity. "He'd play with the [levers], moving the film with the pedals and running it back and forth. I always felt when he was at the Moviola, he was driving his airplane," said Burny Mattinson. According to Don Bluth: "He would put a piece of [paper] over the Moviola [screen]. Then he would take a pencil and...sort of draw what you should have done. And sometimes through the critique that you

A Moviola, similar to the one used by Woolie Reitherman.

got, I found...that's where you learned the fastest."[89]

"Woolie's door was wide open," said Dale Baer. "You could peek into his room, and he'd be there behind his desk. He'd get up and say, 'Come on in! Put it up on the Moviola.' If it wasn't just the worst piece of garbage you ever did, and if it looked like it was going to work in continuity, he'd say, 'Well, let's cut it in and see what this thing looks like.'"

Under Reitherman's guidance, the way a story was told in a Disney animated feature began to change. Walt often threw out sequences he felt hurt the pacing of a film or stopped a story's progression. The most famous example of this practice was the Seven Dwarfs' soup-eating sequence from *Snow White*, which had made it all the way through pencil animation before Walt decided it was superfluous to the story. But with Reitherman, the individual sequences and set pieces became priority. Gone was an emphasis on a strong, over-arching narrative and, in its place, a simple thread to tie individual moments together.

According to animation director John Musker: "Animation was king. King to the extent that everything was below animation. Layout, story, everything. Story people had turned into kind of yes-men for the director, and they were not given as free a reign. And under Woolie, I think the animators were elevated to that God-like status, so they would re-thumbnail their own scenes in some cases to make it easier to animate or just to put over the performances the best. It was all driven by those performances." Where

animators once felt the sting of being subservient to the story department under Walt, now *they* were the ones at the top of the food chain.

Musker continued: "And then production value—in terms of the richness of backgrounds, and effects as an embellishment, and the kind of pixie dust layer—that had gone away for budgetary reasons. And I think Woolie didn't care about that stuff as much so that had really gone by the wayside, driven a lot by budget."

Added Dale Baer: "We didn't have that much money to spend on a movie. We had four million dollars. We had X amount of time, we had X amount of people. The people you see on the screen credits, outside of Ink and Paint, that was it. There were no extra people."

"I appreciated Woolie," said Burny Mattinson. "He was looking for entertainment and he didn't care where it came from, and it was just 'get something up. Get it moving!'"

To save time and money on *Robin Hood*, Reitherman even went so far as to have old animation scenes from *The Jungle Book*, *Aristocats*, and *Snow White* pulled from the Morgue and then have animators trace the new film's characters over them. It pained the artists to do this, though most could understand why Reitherman was doing it. There was no such empathy from Milt Kahl. He was furious that Reitherman would engage in such a cheap production tactic. Woolie stood his ground, and the scenes that were traced off the old animation stayed in *Robin Hood*. There was little reason to think that anyone would notice. This was before home video, and most people didn't have the means to watch and rewatch a film to catch such things.

The Studio continued using the Xerox-based art direction style that Ken Anderson had developed for *101 Dalmatians*. This technique may not have taken hold if Walt had been alive, due to his displeasure with its aesthetic. But with the emphasis shifting to character animation and, given how well

the Xerox process replicated the animator's drawings, it was perfectly suited to the films being made during this time.

But to some, the repetition of style and tone signaled a creative rut. "Every movie from *Snow White* to *Pinocchio* to *Fantasia*, all different," remarked Dale Baer. "All of a sudden you get *Aristocats*, then *Robin Hood*, then *Rescuers*...they were all pretty much the same. I always thought they got themselves in kind of a safe spot, after Walt died. They didn't have the guts really to experiment and go in a different direction."

Ron Miller revived the disaster-movie-in-space project under the working title of *Space Probe One*. After his success behind the camera on *Escape to Witch Mountain*, John Hough was brought in to direct, and illustrator Robert T. McCall was hired to create preproduction paintings. He had previously worked for NASA, painting scenes of the universe and space travel. McCall also had experience with film, having worked on conceptual paintings for the World War II epic *Tora, Tora, Tora*, and illustrations for *2001: A Space Odyssey*.[90] His painting of the latter film's circular space station was used for its iconic poster. McCall's *Space Probe One* paintings popped up in articles about upcoming projects, building anticipation for Disney's entry into the science-fiction genre. As *Space Probe One* strove to break new ground, other projects stayed well within Disney's comfort zone.

The Studio considered making another big-screen musical and was interested in songwriter Joe Raposo as a potential collaborator.[91] He'd written songs for

Sesame Street and the Muppets, as well as *The Electric Company*, and Richard Williams' *Raggedy Ann and Andy* animated feature. Word about the project spread to songwriting team Al Kasha and Joel Hirschhorn. The duo had recently won their second Academy Award for their song "We May Never Love Like This Again" from *The Towering Inferno*. Their first Oscar was for "The Morning After" from *The Poseidon Adventure*.

Kasha and Hirschhorn had long dreamt of writing songs for Disney and, through their friendship with composer Irwin Kostal, had met with producer Bill Walsh several years earlier to express their interest. At that time, there were no projects available but now there was an opportunity. Kasha and Hirschhorn returned to the Disney lot, this time meeting with producer Jerome Courtland, who handed them the current story treatment for *Pete's Dragon and the U.S.A.* Courtland felt the material was perfect for a musical and had been trying to convince Ron Miller that he was right. Kasha went home with the treatment, worked out ideas for songs, and the team returned to the Studio. They shared their thoughts with Courtland, Miller, and a new screenwriter, Malcolm Marmorstein. Kasha also expressed concern over the lack of screen time for the titular dragon but was leery about bringing up the subject with Miller. Said Kasha: "Ron was a very judgmental kind of guy. Very tough guy. And honestly, my leg was shaking [from nerves]. So, I said, 'You have him in one scene.' [Ron] said, 'What's wrong with it?' I said, 'Well, you're calling it *Pete's Dragon and the U.S.A.* and you have the dragon in one scene and that's it.'" Thanks to Kasha's outspokenness, Miller hired the team to write songs for the project.

Malcolm Marmorstein also began writing and turned in a first draft of the script, now called *Pete's Dragon*, in September 1975. This new version was about a young orphan named Pete, running from an abusive family called the Gogans, taken in by a lighthouse keeper named Nora and pursued by a

snake oil salesman named Doc Terminus, who wants to trap his dragon and sell potions made from his body parts. In the third act, a character named Ferdinand, impresario of Ferdinand's Famous Four Ring Frolic, also wants to get his hands on the dragon to build a circus act around him. Marmorstein changed the dragon's name from Gabriel to Elliot who, despite Kasha's suggestion, still did not appear onscreen.[92]

 A few traditional movie musicals achieved success throughout the '70s, but the genre was turning away from Broadway-style theatrical music. Now contemporary rock musicals were on the rise: *Jesus Christ Superstar*, *Tommy*, and *The Rocky Horror Picture Show*, to name a few. Kasha and Hirschhorn's experience was the traditional "book" musical, so they stuck with that approach for their songs. One was a ballad for the character of Nora to sing to her lover who had been lost at sea. In a wink to their previous Oscar-winning songs, they called it "Candle on the Water," "candle" representing fire [*The Towering Inferno*] and "water" for *The Poseidon Adventure*. In their research, Kasha and Hirschhorn discovered a location in Maine, where the film was to take place, called Passamaquoddy Bay. They decided to use that as the name of the fishing village in the story and, taking a cue from famous Disney songs with nonsense words in the title—"Zip-A-Dee-Doo-Dah" and "Chim Chim Cher-ee," for example—they incorporated the tongue-twister quality of the name Passamaquoddy into a song. They even wrote a song for the evil Ferdinand, called "The Greatest Star of All," about his plans for making Elliot into a sideshow phenomenon. However, the Ferdinand subplot was eventually cut in favor of having only one villain in the film, so Kasha and Hirschhorn's song went unused.

Gary Nelson's most recent film, *The Boy Who Talked to Badgers*, had kicked off the twenty-second season of *The Wonderful World of Disney*. While producer James Algar was prepping a new project for Nelson to direct, Ron Miller tossed a different script to Nelson, saying, "You're gonna do this." The title was *Freaky Friday*. Mary Rodgers had written the script, based on her book of the same name. It was another high-concept comedy with a supernatural slant—a mother and a daughter switch bodies and must survive a day in each other's skin. Nelson had extensive experience directing television comedy and was able to fill the cast with seasoned pros like John Astin, Dick Van Patten, Sorrell Booke, and Ruth Buzzi. Said Nelson, "Having done so much comedy up to that time, with *Get Smart* and *Gilligan's Island* and on and on, I knew an awful lot of actors that could play those parts and hopefully not be over the top in terms of the characters they were playing because the characters were pretty broad in the script."

For the role of the mother, Mrs. Andrews, Nelson cast Barbara Harris, a respected stage and screen actor. She had received nominations for an Oscar and several Golden Globes and had won a Tony and a Grammy. Harris began her career as a member of the Compass Players, the first American improvisational theater troupe, whose alumni include Alan Alda, Ed Asner, Valerie Harper, Elaine May, and Mike Nichols. Harris put this experience to good use on the set of *Freaky Friday*. Said Nelson: "She would come up with the greatest improvisational pieces of business, or even dialogue. I just loved it because I never knew exactly what was going to come out of her, so it was kind of a joy. One particular day she had left her script on the chair next to my chair, and the script was open, and she had these notes that she'd penciled in on the page, on the scene that we were doing. It wasn't just improv on the spot. This was well-rehearsed improvisation. She could come up with these things at night, write them down, and then make you feel that they're

happening right there. I thought, *Now that's a real talent.*"

Jodie Foster had already been cast as daughter Annabelle prior to Nelson being brought onto the project. Foster had been acting since she was only two years old, eventually appearing in many commercials and television series. She also spent time at the Disney Studio, performing in the television movie *Menace on the Mountain* and the feature films *Napoleon and Samantha* and *One Little Indian.* At the age of fourteen, she played a prostitute in Martin Scorsese's *Taxi Driver,* a role which earned her an Oscar nomination and began her transition toward more mature roles. Looking for ways to expand her body of work, she auditioned for the female lead in George Lucas' follow-up to *American Graffiti.* Foster won the part in Lucas' pulp science-fiction epic, but her mother realized she was still under contract to Disney for two films, the first being *Freaky Friday*. Foster had to turn Lucas down. The part of Princess Leia would have to go to someone else. Said Foster: "*Freaky Friday*, for me, is a transition between being a child actor and being more of an adult-leaning actor. Where I still have some of the childishness of being a kid but still some of the self-consciousness, in some ways, of the adolescent trying to become an adult. But it was also the beginning of a real self-consciousness for me. I didn't like the way my teeth were, I didn't like my body, I didn't like my face. I didn't want to wear anything...sleeveless. And going through that kind of period is very hard to do onscreen. So, I guess I was probably going through the same thing that Annabelle is going through in *Freaky Friday*."[93]

Burny Mattinson was animating on *Winnie the Pooh and Tigger Too* when Frank Thomas noticed the thumbnail sketches Mattinson had done to plan out his animation poses. Thomas noted a strong storytelling quality in the

drawings and thought Mattinson could be useful in story. When Thomas asked him to help out, Mattinson was reluctant.

"I thought, *Oh, I don't want to do that*," said Mattinson. "*I love animating! I don't want to do story sketches.* Besides that, Woolie didn't have a very good reputation with story people. He was kind of tough." Eventually Mattinson took the assignment, given that it would only be a week's worth of work. He moved up to the third floor and started working in the Story Department on *The Rescuers*, sharing an office with story artist Vance Gerry. Gerry had joined the Studio in the '50s as an inbetweener. Afterward, he moved into background layout where he would pitch in with story panels whenever needed. Said Mattinson: "Woolie started depending on Vance more and more and pretty soon he was doing it full time. On *Jungle Book,* Woolie would always get an idea in the middle of a picture and, even though it was fully boarded out by Bill Peet, there'd be a piece of business he'd want to see boarded out and filled in in the story reel. That's where Vance would do quickies and put them in. And that's kind of how he grew into it." Mattinson finished his story assignment, and Woolie Reitherman and Ken Anderson were so impressed that they asked Mattinson to stay in Story. "And I stayed," said Mattinson. "I found out I enjoyed that better. Gee, you didn't have to do so many drawings, but you were more concerned with ideas and that was really fun!"

The Rescuers marked the first feature experience for young layout artist Dan Hansen. Hansen was a UCLA graduate who started as a trainee in 1975, studying under master layout artist Don Griffith, who'd been at the Studio since the '30s. Said Hansen: "There were a couple of young people, Tom Lay and Chris Lane and myself. Without question, Don was heads and shoulders above everyone else and yet he was the most humble guy in the world." During this period, finding information about the craft of animating

was difficult. It was even harder to learn about being a layout artist. Said Hansen: "I knew a little bit about layout, but it was impossible to find out information. Even with Don Griffith, he was amazingly good and yet because he was self-taught, he just didn't know how to talk about it. Oftentimes, I'd take him something I had done, and he would throw a piece of paper on top of it, and he would change something. And I'd say, 'Why'd you do that?' as a way of understanding. And he'd say, 'Because it looks better.' He didn't understand what design was. He knew how to *do* it, but he didn't know what it was called."

As Glen Keane was nearing the end of his eight weeks of training with Eric Larson, he was given his first production scene to animate on *The Rescuers*. It was a scene of Bernard, the mouse janitor, sweeping the floor of the Rescue Aid Society. Keane's success led to his promotion to inbetweener, working under animator John Pomeroy. "John was just phenomenal," said Keane. "His ability to draw was beautiful. John was just an incredibly magnetic personality too. Intense. Maybe it was also his eyebrows that were so focused. And he could imitate anybody in the hallway just by walking. He would just do a walk, and everybody knew exactly who that was. Just born to animate." Keane continued: "So, I started doing rough inbetweens with him and I had such a heavy hand. When I would draw, literally the points were... snapping off the pencil all the time. Eric was always talking about drawing with sincerity and I *sincerely* wanted to be a better animator. I'd just push harder on my pencil all the time and it just wasn't working until I learned that sincerity meant believing a character was real. That was such an important discovery for me."

Pomeroy was animating the character of Penny under Ollie Johnston, who was one of four directing animators on the film. The others were Frank Thomas, Milt Kahl, and Don Bluth. Bluth became the first of

the new generation to ascend to this rank, a rank previously reserved only for members of the Nine Old Men. It was indicative of how the Studio leadership felt about Bluth and his potential as a leader at the Studio. Said Keane: "There was quite a void left about who was going to run things, and Don Bluth was the leader of this new group coming in and I was enamored with Don. Don talked about bringing back the vitality of those old films and everybody was like, 'Yeah, that's going to be wonderful.'" Bluth's passion also spoke to Pomeroy and animator Gary Goldman, and the three men formed a tight bond. "All three of us grew up watching Disney animation from the golden age and dreaming of being a part of it," said Bluth. "When we met at the Studio sometime in the mid-seventies and realized that Walt was now missing, and the animation beauty of his era was fading, it became a cause for alarm. We didn't want it to die."[94] For this reason, Bluth continued making independent projects in his garage on weekends. His feature, *The Piper*, was on the shelf for the time being, and Bluth was now working on an animated short called *Banjo the Woodpile Cat*. Bluth continued: "We also felt that Eric Larson's animation training program was passive. Creating a movie was more than just being able to animate. It needed a more comprehensive curriculum. We chose to teach ourselves after hours in my garage with the *Banjo the Woodpile Cat* project."[95] Keane was invited to be part of the project and accepted with enthusiasm. "I took a hundred dollars and bought mirrors for his little studio," he said. These mirrors were used by the animators to act out their scenes and observe their poses and expressions for reference. "But I was only making ninety dollars a week. I didn't have a hundred dollars to put into that, but I did."

DISNEY IN-BETWEEN

As a full-time story artist, Burny Mattinson was now in proximity to Woolie Reitherman and could observe Reitherman's approach to developing a story. Reitherman would meet with writer Larry Clemmons in the mornings and the two would brainstorm ideas for a particular sequence. Of Clemmons, Mattinson said: "Larry was a gag man and he worked with Bob Hope and that's where he got his chops. He worked in radio and early television as a gag man and came in to work with Woolie. He was a really nice guy." Clemmons would write up pages then the two would head to Mattinson's office where Reitherman would give direction on what he wanted. As Mattinson storyboarded, Reitherman would often come by to check on his progress. Said Mattinson: "He had a habit of coming in and looking over your work before you had it worked out in your own head and I would take it and hide it in the drawers. I wouldn't pin them up. I finally got to the point of having confidence where I'd put it up and not worry so much with Woolie."

When the time came to show his sequence to Reitherman, Mattinson made sure to rehearse his pitch so he'd be confident with what he had before inviting Reitherman to his office. "I'd bring in Don Griffith. I'd bring in anybody who had two legs," said Mattinson. "In fact, honest to God, I did bring in the cleaning ladies when they'd come in, and I would pitch it to them. Anybody. I liked pitching to people because the more I pitched it, the more I would get empowered by it and then I felt like I was shining when I was doing it." Mattinson continued: "Woolie would come in and look it over and he wouldn't even talk to you about it. He'd just kind of look it over and then Frank, Ollie, and Milt—his peers—would be the ones called in and then you'd pitch it to them. And then they would discuss it and you just *butted out*. You don't say anything, just take notes. As they were going through, you could see the thing would be disintegrating slowly before your eyes! And then you'd tear it all down and you start again. But I never felt bad about it

because it always was better."

This iterative process of building an idea, tearing it down, and rebuilding it was a staple of the Disney story development process, a process Mattinson had learned from working with Vance Gerry. Said Mattinson: "[Vance] always worked at a small table, but he had this big stack of drawings that were piled up. Woolie would give him a scene to do, and he'd [pin up the sketches] and again he'd have to tear it all down and then he'd pile the sketches up. Then he'd start again, tear it down, pile the sketches up, tear it down..." Mattinson discovered that the reason Gerry saved all of his discards was because, after several fruitless iterations of a sequence, Reitherman would often want to return to the initial pass, feeling it was better the first time. Rather than redraw ideas that had been trashed, Gerry could simply fish out the drawings from the stack and pin up the old version.

To use as a jumping-off-point for his storyboards, Reitherman would often give Mattinson one of development artist Mel Shaw's pastel concept drawings "mainly for the layout, the staging of where it happens, and then you would go from there and develop the sequence," said Mattinson. For every new project, Mel Shaw would create a "beat board." This was an outline of the major story events, told through a series of pastel illustrations. These outlines were suggestions of the overall direction and shape that each narrative could take.

Shaw had first worked at Disney throughout the '30s and '40s, developing story ideas for *Fantasia, Bambi, The Wind in the Willows*, and *Song of the South*. He left the Studio and started his own independent design firm but was invited back to Disney in the early '70s after Ron Miller learned about Shaw's skills at story development from the artist's former colleagues. Shaw's first assignment was for Reitherman on *The Rescuers*, creating dramatic pastel drawings of orphaned Penny's message in a bottle as it travels from

the swamp to the shores of Manhattan. After that, Shaw's beautiful pastels, combined with Ken Anderson's endless story ideas, lifted each film off the blank page and onto the storyboard.

The generation gap in the Animation Studio became evident as more young artists joined Eric Larson's training program and were eventually promoted to assistant and/or animator positions. Said Ron Clements: "The interesting thing about that period is that you had these older animators who were in their sixties, and then most all the trainees were in their twenties. And there were not a lot of people in between." From this vantage point, these young artists had a unique view of the remaining six of Walt's Nine Old Men.

Regarding Reitherman, Glen Keane said: "Imagine Jack Palance coming in and being an animator at Disney, working with these young whippersnappers. That was the way Woolie was with young animators. You were pretty much nothing. You had to really prove yourself. There was just no respect toward you because why should he? He had the best working with him."

John Lounsbery continued directing, moving from *Winnie the Pooh and Tigger Too* to *The Rescuers*, alongside Reitherman. "I think that was kind of a detriment to [Lounsbery's] health, too," said Dale Baer. "I don't think he liked the pressure. I think he would rather have just been sitting at his drawing board doing his thing." Baer continued going to Lounsbery for guidance even though he was not Baer's official mentor. Said Baer: "Lounsbery comes into my life, and he was the one guy you could go to, and he always called you into his room when he'd see you. He was just the nicest person to just sit and talk

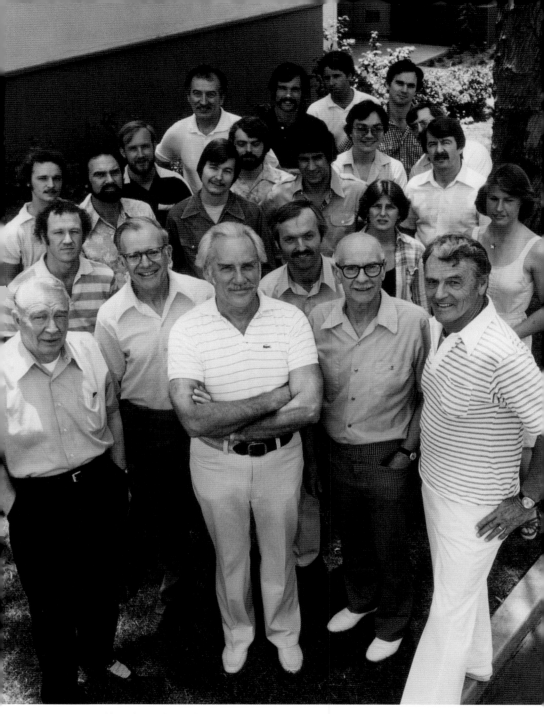

Disney Animation's old guard meets the new blood. Front row: Eric Larson, Art Stevens, Ollie Johnston, Woolie Reitherman. Row 2: Glen Keane, Frank Thomas, Don Bluth, Emily Jiuliano, Heidi Guedel. Row 3: Jerry Rees, Dorse Lanpher, Randy Cartwright, Bill Hajee, Gary Goldman. Row 4: Ed Gombert, Ron Clements, Andy Gaskill, Chuck Harvey. Row 5: Dale Oliver, Jim George, Ted Kierscey, John Pomeroy.

DISNEY IN-BETWEEN

to. You felt so comfortable with this man. He was always smiling."

Clements, who had a similar bond with Thomas, said: "I can't imagine a more enviable situation in terms of learning animation. And we would talk a lot about all kinds of stuff. I didn't grow up with a father, and I didn't have a lot of mentor figures, so...a certain aspect of that was very meaningful to me."

According to Keane, Frank Thomas and Ollie Johnston "operated like clockwork. I mean, they were a machine, literally animating most of the films that were being done. Between the two of them, they'd probably do sixty, seventy percent of the animation in the whole movie. They had their lunches. They'd come in with their brown bags. They had a very structured little schedule that they stuck with." Said Baer: "Every week, you'd see Ollie and Frank with a scene under their arm, taking it home, working on it on weekends, working on it on vacation. And Lounsbery was the only guy that, once five o'clock hit, he'd put on his jacket, get to his car, and go home. He did his job, but he didn't want to live [at work]. He had a family."

Lounsbery's colleagues did not appreciate his desire for a healthy work-life balance. "Frank Thomas one time made a comment that Lounsbery was lazy because he didn't take work home," said Baer. "He just says, 'Lounsbery could be as good as Milt if he wasn't so lazy.' I'm thinking, '*Lazy?*' You go by Lounsbery's office every day, and he's hunched over that desk, working like crazy."

Milt Kahl had thrown himself a fortieth anniversary party at The Penthouse, the exclusive, men's-only club on the top floor of the Animation Building. The gender restriction had been lifted for the event and at about three o'clock in the afternoon, Kahl's animation colleagues gathered for the festivities. Said Baer: "Lounsbery sort of parked himself near the elevators and Woolie was getting pretty toasted that night. Come five o'clock, Lounsbery starts heading for the elevators and Woolie says, 'What's the matter, Louns,

you can't party on your own time?' And that bothered [Lounsbery] that whole weekend. This was on a Friday. And I came in on Monday and...had to go up to layout for something and he was up there talking to these guys about it. This thing bothered him *all weekend*."

Rivalries between artists of this caliber were inevitable. They were professionals but they were also human, with vulnerabilities and idiosyncrasies. Clements recalled hearing Milt Kahl venting to Frank Thomas about always being assigned to the straight, human characters, like Peter Pan and Wendy. "He was given those kinds of characters because they were so difficult to draw and he was the best draughtsman," said Clements. "I think he took a lot of pride in it but complained anyway because that was his personality. But then he looked at Frank and kind of stared at him and said, 'YOU got to do Hook! I would've given ANYTHING to do Hook and YOU got to do Hook!'"

In addition to witnessing these personality clashes, the young folks also had the privilege of hearing accounts from the older folks about Walt. These firsthand experiences were of great interest to the newer guard. "In every conversation, Walt Disney was there," recalled Keane. "It was almost like they couldn't really talk about animation without reflecting back on the struggle with Walt and their frustrations with him and how hard they had to work and how insulted they felt by him at times. They were still dealing with all these unsettled issues. Like, 'Oh, I did all that for Walt. If only he could've just said how happy he was. He never did. Never said that.'" Baer recalled Eric Larson's frustrations with his former boss: "He would get totally chewed out by Disney himself because he was approaching things from more of a cartoony kind of aspect. I think this was on *Bambi* when he did the owl. It wasn't what Walt had in mind and Walt just laid into him but he kind of took it in stride and made it better."

The Dynamic Duo of Frank Thomas and Ollie Johnston (with photobomb by Herbie the Love Bug).

Frank Thomas and Ollie Johnston had evolved into successful mentors. Not so much for Milt Kahl, whose explosive nature kept him from developing those skills. "Frank and Ollie and Eric were really enthusiastic about working with the young people and very patient and nurturing," recalled Clements. "Milt was a different sort of personality. He was cantankerous, curmudgeonly."

"I was still fearful of Milt," said Baer. "Milt was the only guy who had his door closed all the time. You'd knock on it and you'd hear this nasty 'What!?' After one or two times, you stopped going to see him because you kind of were afraid of him."

But not everyone's experience with Kahl was the same. After seven years as his assistant, Dave Michener saw Kahl differently. "Milt treated me like a son. I felt sad that he had such a short fuse, but he was usually right.

When he really took out after somebody, they pretty much earned it."[96] Said Heidi Guedel: "[Milt] did not reward suck-ups. I learned...that it was best to joke with Milt and even be a little irreverent or bawdy. He'd jump up and down, guffaw like a big kid."[97]

But according to Michener: "If you did something wrong or something he didn't agree with, you knew about it...and so did everybody in the whole studio."[98] Milt's outbursts were something of legend within the walls of the Animation Building. "Milt would blow," recalled Michener. "I mean big-time. I mean just slamming doors and storming around and kicking things. You never wanted to be on the wrong side of him. It was life threatening."[99]

Animator Ted Kierscey recalled: "One time I was in Ed [Hansen's] office talking with him about something. The office wall was a common wall with Milt Kahl's office, so anything Milt was doing, you could hear it through the wall and the walls were thin. I heard a crash. And then I heard another crash and the second one was against the wall. What he was doing was he was throwing furniture in his office because he would just lose it. He would be so frustrated with something he had not done well that that was his way of losing his frustration. And Ed would always say, 'Don't pay any attention to that. He's just going off again.'"[100]

Kahl was also losing patience with Reitherman's executive decisions. He'd unloaded on Reitherman before, for recycling animation from past movies for *Robin Hood*. Now on *The Rescuers*, Kahl took issue with a song sequence Reitherman added into the film. He and writer Larry Clemmons had built a sequence around a group of swamp critters (who had been repurposed from Ken Anderson's *Catfish Bend*). The two lead mice, Bernard and Bianca, meet these critters on their search for the missing orphan, Penny. They brought in Phil Harris to voice a character named Colonel Bullfrog, who led the group of Swamp Folks in a marching song. Clemmons had written the

lyrics to the tune of the "Colonel Bogey March" from *The Bridge on the River Kwai*. According to Ron Clements, some of the cringeworthy lyrics included: "We're Dixie's finest and that ain't all. I'm the guy who invented 'Hi, y'all!'" Burny Mattinson recalled: "Milt stood up in front of a lot of people and just said, 'That's terrible! We don't need that in our pictures,' and so forth. And Woolie was really embarrassed by that."

Eventually, Kahl's frustrations grew to include Frank Thomas and Ollie Johnston. Burny explained: "I remember so clearly. We were all in the story room. Vance was there. Woolie invited Frank and Ollie and Milt and basically, they were looking at some scene in black and white on the screen and Milt said, 'Oh, I want to re-do that scene (that was done by Glen or Pomeroy of Penny walking up the stairs).' He says, 'Yeah, I want to do that over again but it's all looking pretty good.' And Woolie said, 'What do you want to do that for? It's working!' He says, 'Well, I just want to do it over. I think it needs to be done over.'" After that, Reitherman solicited Thomas' opinion, then Ollie's. Both agreed with Reitherman that the scene looked good as it was. Kahl was fuming about being ganged up on and having his instincts questioned. This led to a permanent fracture in his relationship with them. Mattinson continued: "Milt, who was down in D-wing about two doors from the end, he picked up all his belongings and had them all moved to the bullpen at the beginning of the corridor. Frank and Ollie stayed down at the very end of the wing. They never talked. That was it.'"

"Milt left before *Rescuers* was finished," recalled Clements. "His original plan was he wanted to animate all of Madame Medusa. He just wanted to have every frame, and it didn't end up that way. He animated most of her but then Cliff Nordberg animated some stuff, and you can tell it's a little different than the stuff Milt did."

The "Colonel Bullfrog" sequence ended up being cut from the film.

Consequently, Ron Clements lost his first completed scenes of animation in a Disney film. It wouldn't be the last time this happened to him. Veteran animator Cliff Nordberg had animated a sequence with Madame Medusa's alligators chasing Bernard and Bianca around the steamboat and getting tangled up in the drapes. Frank Thomas had a different idea. He thought it would be better to have the alligators playing a pipe organ instead. In a move indicative of the amount of power these directing animators had at the time, Nordberg's animation was cut from the film and Thomas reconceived and reanimated the sequence with help from Clements. When the rough animation was cut into the film, Reitherman felt it was too long and trimmed it down. Clements' animation was once again on the cutting room floor.

Said Clements: "Drunk jokes were really big at that time, so I did a drunk bit with Bernard where he's drinking swamp juice. *That* stayed in the movie, so that was my first animation." Clements received a promotion to animator during the making of *The Rescuers*. Keane stepped into the role of assistant to Ollie after John Pomeroy began animating on his own.

Lorna Cook returned to the Studio, securing a job in the Comic Strip Department, working for artist Carson Van Osten. Over time, she worked her way back into the Animation Department. Said Cook: "Originally, I was with Ollie Johnston, and he was a little like, 'Eh, I don't know about this. I haven't really worked with a woman before.'" She ended up sharing an office with Sylvia Mattinson, cleanup artist and wife of Burny Mattinson. "Sylvia, God bless her," said Cook. "She told it like it was. And said, 'Yeah, well the last woman who was here, she didn't make it either.' And I thought, *oh, Okay!* But I wasn't daunted. I thought, *Let's see where it goes*, and I was just young and hopeful and foolish. But I loved it. I felt 'this is it!'"

Cook developed a close relationship with John Pomeroy, which meant she also became friends with Gary Goldman and Don Bluth, so tightly bonded

were the three men. It was a commonly held belief that Ron Miller viewed Bluth as the person who would one day take over the Animation Department and lead it into the future. Many of the younger generation were loyal to Bluth and his vision for Disney animation. Others found themselves on the outside. As a directing animator, Bluth assigned scenes to his animators and, according to Dale Baer: "I was getting the dregs of some of this stuff, while his guys were getting more of the choice stuff. And so tensions were starting to build there a little bit."

Burny Mattinson finished doing story on *Rescuers* and found himself without a project to move onto. Woolie Reitherman snapped him up, turning Mattinson into his "go-fer." He started giving Mattinson jobs to do, like taking some of Mel Shaw's pastel sketches and turning them into a title sequence for the film or figuring out special effects like water ripples and twinkling stars. He even brought Mattinson out onto the recording stage and encouraged him to give direction to the voice actors. "I started realizing much later that what he was doing was keeping me busy doing things and at the same time, I was learning," recalled Mattinson. "We had a lot of fun! Woolie and I were starting to get along really, really great. It became a wonderful relationship."

Card Walker invited veteran director David Swift to return to Disney. Swift had written and directed *Pollyanna* and *The Parent Trap* for Walt back in the early '60s. As Swift dug through the pile of properties that the Studio owned the rights to, he came across a book by Michael Innes called *Christmas at Candleshoe* and chose to adapt it into a screenplay. Once finished, his script was approved and Swift shepherded the film into production as its director, scouting locations, building sets, and choosing his cast. For the two adult

leads, Swift secured David Niven, who had recently appeared in *No Deposit, No Return*, and Katharine Hepburn. Hepburn agreed to step out of retirement for the new film but, oddly enough, the Studio was not interested in working with her. Instead, they wanted Helen Hayes for the part. For the teenage lead, the Studio insisted on Jodie Foster. It was the perfect project to fulfill her commitment to the Studio after *Freaky Friday*. Swift disagreed with this choice, feeling that Foster was wrong for the role, but the Studio stood firm and he lost the battle.[101]

At the close of the year, the Studio rereleased Walt's first full-length live-action film, *Treasure Island*, back into theaters. Made prior to the advent of the ratings system, the film was now given a PG by the Motion Picture Association of America. The Disney Studio had never released a PG-rated film and seemed to have no intention of doing so. They cut approximately nine minutes from the film, bringing the rating down and preserving their G-rated image.

David Niven and Jodie Foster in Candleshoe.

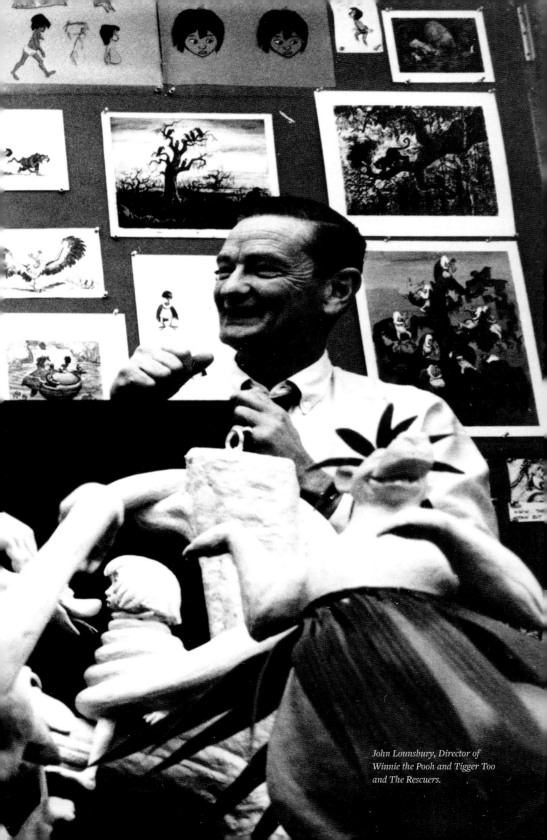

John Lounsbury, Director of Winnie the Pooh and Tigger Too *and* The Rescuers.

1976

John Lounsbery passed away in early 1976. "He had gone on a skiing trip," said Dale Baer. "Woolie was a pilot and so he would fly all his buddies wherever they wanted to go. And so, he flew them up to Mammoth that weekend. That's when Louns was having chest pains. He couldn't ski with everybody else." When he returned from the trip, Lounsbery went into the hospital for open heart surgery. Unfortunately, he died during the procedure.

Some months later, music major Don Hahn left Cal State Northridge and came to Disney to work in the Morgue with Leroy Anderson. Hahn and Anderson attended the same church and this connection helped Hahn land a job as senior clerk. Hahn helped with archiving as well as delivering art pieces that were requested by the staff. Said Hahn: "The Franks and Ollies of the world would call for some old animation. Woolie Reitherman was the king of reuse, so he would call for animation to be reused in films, so I would deliver it. They would come down and say, 'Woolie needs Scene 25 from *Bambi*,' so I'd go to the shelf, find it, put it under my arm, walk upstairs, give it to Lorraine, his secretary, or give it to whoever ordered the scene." Hahn was also an artist, and he often lingered after making a delivery to see what folks were working on. He recalled: "I could take a scene to Ken Anderson, and I'd go, 'Whatcha doin' and he'd be designing some characters or Bob McRae would be working on *The New Mickey Mouse Club* titles or whatever it was."[102]

Hahn also discovered—as others before him had—that the artwork in the Morgue was not being stored in the most ideal way. Said Hahn: "There was a hot water heater and a couple of boilers down at the end of the long hallway and that's where they kept all the old shorts—like *Steamboat Willie* and *Plane Crazy*—in a cage covered with chicken wire in this steam room,

basically. It was perhaps less than archivally ideal. The music morgue was down there at the same time so all the sheet music for the old films [was there]. There was a background morgue that had all the backgrounds. A lot of the backgrounds had cels glued on them. For a long time, the head of the Ink and Paint Department would cut them out and take the characters and put some library paste on the back and stick them on the background so you kind of see the whole setup. That was common."[103] For Hahn, being elbow to elbow with this amazing artwork acted as a launchpad for his education in the art of animation.

Don Hahn.

The Studio released the live-action film *No Deposit, No Return* on February 5, 1976, to generally negative reviews. Charles Champlin of *The Los Angeles Times* decried the Studio's lack of malleability. He described *No Deposit* as "the kind of well-engineered and undemanding comedy the Studio by now can turn out in its sleep."[104]

Gary Arnold of *The Washington Post* was even less amused. He colorfully described the film as "an undistinguished, expendable piece of entertainment, written and directed in a consistently laborious manner that betrays no sense of pleasure in filmmaking, storytelling or even juvenile

behavior and family life."[105]

Treasure of Matecumbe was released a few months later. It was one of the passion projects writer A.J. Carothers developed under Walt's supervision but had lost control of when he left the Studio. His replacements were Don Tait as writer and Bill Anderson as producer. It's unclear how much, if any, of his script appeared in the final film. His name did not appear in the film's credits.

As *Pete's Dragon* moved closer to production, the casting process began. British entertainer Jim Dale won the role of snake-oil salesman Doc Terminus, after names like Ray Bolger and Russ Tamblyn had been considered.[106] Dale had a wide range of theatrical talents and experiences. He'd performed stand-up comedy, been a U.K. pop star, and acted in Shakespeare as well as in Sir Laurence Olivier's National Theatre Company. Dale had roles in the British film series *Carry On*, and in the '70s, landed roles in Broadway productions. For his performance in *Scapino* (1974), Dale received a Tony nomination. Studio documents show Jack Elam was considered for the patriarch of Pete's adopted family, Merle Gogan.[107] This role ended up in the hands of veteran actor Charles Tyner. For his sinister spouse Lena, Kasha and Hirschhorn reunited

Musical comedy star Jim Dale.

Grammy-winning singer Helen Reddy.

with Shelly Winters, who they'd worked with before on *The Poseidon Adventure*. Entertainment legends Red Buttons and Mickey Rooney rounded out the supporting cast.

Grammy-winning recording star Helen Reddy, singer of the popular feminist anthem "I Am Woman," was cast in the lead role of Nora, the lighthouse keeper. Songwriters Kasha and Hirschhorn had initially favored superstar Olivia Newton-John for the part, but Reddy was deemed the better choice.

For the role of Pete, the Studio auditioned hundreds of child actors. One of those actors was eleven-year-old Sean Marshall. He recalled: "We must've gone through a series of probably thirty different interviews over the course of several months. We did a lot of part-reading and then toward the end, we did singing. We didn't really do that much dancing. Toward the very end, they kind of introduced us to the guys that were writing all the songs and then they would sit at a piano and run us through a series of things, different songs and what have you. They'd play some famous old Disney song while you were singing the actual song from *Pete's Dragon* just to see if you could hold your key and timing and all that. And then they finally narrowed it down to myself and one other kid."[108] After that, Marshall got the part, and the real work began. Marshall remembers: "During the first month or so, we were doing all the choreography and learning all the songs. They were still doing it on piano at the time, so it took some time to get the orchestration and everything done. Right at the very end, we met the choreographer, Onna

[White]. We had probably several months of choreography. We did that before we even started filming."[109]

As the first year of the CalArts Character Animation program came to a close, the students' reputation had spread. Don Bluth attended the end-of-the-year screening of student films and was impressed with what he saw. Ron Clements recalled: "He saw films of John Lasseter and John Musker and Brad Bird, that whole group. And Don came back, and he gathered all of us around and said, 'I just went to CalArts. I saw these films and you guys got *a lot* to be worried about because there's some great talent there.'" John Musker came to the Studio that summer as an intern and worked with Eric Larson on animation tests for several months.

That same summer, students Brad Bird and Jerry Rees visited the Studio. They dropped in on Frank Thomas and Ollie Johnston, who were busy working on a sequence in *The Rescuers* with Bernard, Bianca, and Penny trapped in an underground cave. Thomas and Johnston had blocked out the entire sequence themselves while Woolie Reitherman was on a monthlong vacation. When he returned, he okayed their work, and it went into the movie. Bird and Rees were blown away by how Thomas and Johnston had ended the sequence—a cliff-hanger that kept the viewer in suspense as to whether Penny survived the rushing tide waters. To the students, it was bold and daring. It harkened back to the hard drama of classic Disney moments like Pinocchio's death. But Bird and Rees' enthusiasm tanked when Thomas and Johnston told them that Woolie ordered cuts to the sequence for length. All the suspense that would lend the viewer tension would have to go. There was nothing Thomas or Johnston could do to change Reitherman's decision.

In a bold move, Bird and Rees marched straight to Reitherman's office to confront him. They pleaded their case, but the director would not budge. This was a rare instance of Thomas and Johnston not getting their way. This served, too, as a lesson to the young artists that the best creative decision does not always win.

Even though he'd finally made it to the rank of animator, Ron Clements' real passion was for story. "When I was a kid, I wrote stories a lot," said Clements. "I liked to write. I wrote a novel when I was eleven, and I wrote my own comic books." Before coming to the Studio, he had seen *Robin Hood*. He loved the character animation, but the film's loose, episodic story disappointed him. Determined to not allow *The Rescuers* to succumb to the same problems, he sent story notes and suggestions to Reitherman. Clements recalled: "Frank liked the notes, but Woolie did not like the tone of my notes. I think the tone of my notes was strong and he preferred a tone that was more 'here's a suggestion,' or 'you could do this' or 'it might be interesting to do this,' with qualifiers. I didn't have the qualifiers in those first notes. After that, the notes I sent were more diplomatic."

The Morgue had loose parameters, which became problematic. People would check out animation drawings, but they would not return them. Said Don Hahn: "It was frowned upon, but there was no door on the Morgue. It was completely open. You could go down there and wander around and look at things, so it wasn't like it was a terribly valuable asset and it wasn't valuable in a dollar sense. It was just for animators to use. It was a reference library."[110] Hahn and a few others launched an initiative to archive the artwork. The group started stamping dates, as well as scene and sequence numbers, on every animation drawing. "I was tired of explaining to people why it was called the Morgue," recalled Hahn. "Finally, I wrote a sign and it said, 'Animation Research Library' and I pinned it up on the door

above 'The Morgue' and finally we got rid of that title."[111]

Woolie Reitherman summoned Don Bluth to his office and informed him that he needed Bluth to become a director. For Bluth, this was a surprise. "I said, 'Well, what I want to do is animate' and he said, 'No, we need someone to direct too.' So, from that moment on, he started being very familiar and very sweet, actually. Fatherly. It was most different."[112] Reitherman added a piece of advice for Bluth: "He said, 'When you go into directing, you have to be very careful because if you get too familiar with the people you're directing, you won't be able to direct them. And they won't like you.'"[113]

Ron Miller dedicated himself to preserving the family environment that Walt had created at the Studio. He often gave jobs to the family members of those who were loyal to Disney. "He took care of all the guys that Disney took care of," said Annie McEveety. "He took care of all Disney's friends' 'kids.'" McEveety's father, Joseph, had been dedicated to Walt. As a result of that devotion, he became good friends with Ron Miller. McEveety had stepped away from acting by the time she was seventeen but continued working for Disney, thanks to a job in the mailroom given to her by Miller.

"Ron Miller was extremely cool to me," recalled Annie McEveety. "I would deliver Ron's mail and his secretary was Lucille. Ron would say, 'Lucille, is that Annie?' and she'd go 'yes,' and he'd have me come in and I'd go in his office, and we'd talk about this, and we'd talk about that. That's who Ron Miller was. Ron Miller was the coolest guy. And another incredibly strong, solid man that you could look up to."

Annie's brother Stephen also joined the family. He'd come on board as a production assistant in the Special Effects Department. But it wasn't just

the McEveetys. Several generations of Winston Hibler's family were present on the lot. Harrison Ellenshaw—son of matte painter and production designer Peter Ellenshaw—had recently joined the Special Effects Department, following in his father's footsteps as a matte painter. Jim Luske—son of animation director Hamilton Luske—had been an assistant camera operator since 1970 on films such as *The Boatniks*, *Bedknobs and Broomsticks*, and *The Island at the Top of the World*.

And of course, Miller's own kids had jobs, working alongside Annie McEveety in the mailroom. She recalled: "We were all really terrible at what we did because we were spoiled McEveetys and Millers and we just did a bad job." According to McEveety, they were passable at their job in the mornings, but it was a different story after lunch. She continued: "You could easily get a couple beers when you were seventeen and eighteen in Burbank, California, in any given restaurant because nobody cared back then. So, we'd come back lit. The mail wouldn't get delivered. The phones would be ringing. And our boss was not a happy guy, having McEveetys and Millers. He was an old ex-army guy. I remember I got pulled into his office and he said, 'What am I supposed to do, fire a McEveety or fire a Miller? How can you help me get this job done?'"

Annie's true passion remained within the Camera Department, having been inspired by cameraman Frank Phillips when she was a child. Said McEveety: "When my [mailroom] job was over at five, I would go on set [with] Frankie Phillips. He had his set of guys. They would let me train. He just helped bring me into this career that he promised—when I was nine—that he would help me when I got older. And, when I got older, I said, 'Frankie, here I am.'"

Pete's Dragon began filming in the summer of 1976. "It was kind of funny because I think the original director was supposed to be Gene Kelly," recalled actor Sean Marshall. "A lot of us were very nervous. We had a little bit of dancing experience but we figured if Gene Kelly was going to be directing it, you're going to have to be a fantastic dancer. But he ended up pulling out because he had conflicts."[114]

Directing duties were then given to Don Chaffey. *Pete's Dragon* would be his fifth film for Disney. Said Marshall: "He was a very friendly guy. I don't think he was necessarily a fan of kids...but we got along fine. He got along really well with Helen Reddy because they were both from Australia. Really good director. Really, really organized. I mean for such a large movie with so many moving parts, I think he really had that stuff down."[115]

Filming for the cave exteriors and the built-to-scale lighthouse began in Moro Bay, California, with the remaining exteriors shot at Disney's Golden Oak Ranch in Santa Clarita. Everything else was shot on the Disney lot. Sections of the lighthouse were replicated on soundstages. According to Sean Marshall: "The whole town of Passamaquoddy was actually built on the Disney backlot in Burbank. It was a huge set, and it took six months to make. They added a matte element in the background there to make it look like we were really on the east coast. They even built a harbor and filled it with water, loaded it with boats that you could sail around on. It was as real as any small town in America."[116]

Marshall had fond memories of his fellow cast members. "Jim [Dale] was huge into taking pictures. He had a couple of really nice cameras, and he took nonstop pictures when he wasn't filming. Helen bought me a Polaroid camera and then he was like, 'Oh, Polaroid? What you need is something much better.' So, he went out and bought me a Nikon FM, I think it was. So, we were like pals, walking around snapping shots of everything. Loved

Helen. We got along really, really well. My mom was a big fan, so I heard all her music before so it was really cool.[117] She was the mother figure who was kind of the protector of me. I loved her to death."[118]

Helen Reddy had recently made the move into acting. Before this film, her only other part was playing a nun in *Airport 1975*. Recalled Al Kasha: "Mickey Rooney was very helpful in helping her be an actress. He really gave her good advice. She gave him a hard time, but he didn't care."

"Mickey Rooney, that was an honor working with him," continues Kasha. "It was really fabulous. To be honest, he was a pain in the ass but what a great pain in the ass he was."

Marshall remembered: "Mickey was just hilarious all the time, but when you had Mickey and Red [Buttons] together, it was unbelievable. They were so funny.[119] I remember there was a scene in the movie where Mickey and Red were walking to the cave, when they were both supposed to be drunk, and I think Red was going to show Mickey where the dragon was living in the cave. When they filmed the scene, it must have been five minutes long, the two of them playing off each other, being drunk, stumbling down the beach, which was hilarious."[120]

Animation layout artist Joe Hale recalled another memory of Rooney and Buttons: "Mickey Rooney was sitting in a chair, and he told a joke. And it was a clean joke. Red Buttons said, 'Get out of that chair' and Red sat down and then *he* told a joke. And then Mickey says, 'Let me sit there' and he sat down and then *he* told another joke. And then Red. And each one of them went through about ten jokes. They were all clean, and they were all funny as hell and I'd never heard *any* of them before."

Joe Hale was now the go-to guy for working out the complex choreography of combining live-action with animation, having previously done the job on *Mary Poppins* and *Bedknobs and Broomsticks*. Now for *Pete's*

Dragon, Hale was on the set during scenes involving Elliot the dragon, working with director Don Chaffey and Frank Phillips to ensure there was an appropriate amount of space in the frame for the animators to add the dragon in later. Said Hale: "You'd have a scene where you'd have the little boy, Sean, standing there and watching the dragon jump back and forth over his head. Well, you had to figure out where to put the camera. A lot of times, you'd have to put a character in a place where the cameraman and the live-action director felt that the composition was wrong. I made a thing called the 'dragon-finder ...I figured out the 50mm standard lens shot, and then I made

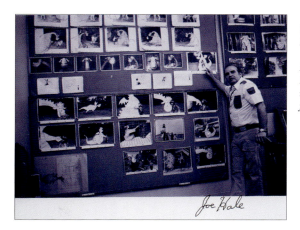

Top: Joe Hale with pre-production images from *Pete's Dragon*.

Bottom: Ken Anderson's story sketch (left) and Hale's layout for the same scene (right), showing Elliot's scale, proportions and how he should fit into the live-action footage.

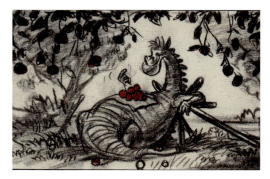
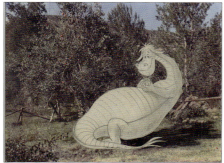

DISNEY IN-BETWEEN

little transparent slides of the different scenes that you could put in there of the dragon and then you could look at the scene and see where the kid is and see where the dragon's head was."

Hale also made sure that Elliot's scale was just right when it came to dragon/actor interactions. Said Hale: "I made a great big dragon. A full size. It was a big plywood cut out. Where he climbs up on his stomach, I designed a set piece that was the same size as the dragon's stomach and Pete runs up the belly and sits down."[121]

Added Marshall: "They also had moldings of the dragon's head and moldings of his feet and arms that they would use when they were setting up the scenes. They had the neck and the head on a pole, and they would hold it up so that everyone could kind of get the feeling of how big the dragon was and where he was supposed to be. But I did have a really good idea because they were excellent, fantastic moldings."[122]

Poppins and *Bedknobs* were predominantly live-action films with animated characters used only in isolated fantasy sequences. *Pete's Dragon* was a different challenge, since the animated character was an actual cast member, seen throughout the film. This made the relationship between the live-action crew and the animation team more crucial.

Don Bluth's first directing assignment was to bring Elliot the dragon to the screen. "I was on the set to make sure that we had room to put the dragon in there," he said. "Ken Anderson, that was his baby, the dragon. He was on the set a lot and enjoyed just being there as the creator of the dragon."[123] Indeed, Elliot the dragon was truly a product of Anderson's imagination. He'd designed the character and storyboarded many moments from the film, fleshing out his personality and his relationship to best friend Pete.

Marshall said: "The animators were always on set, and they were always showing us the newest storyboards, plus doing a lot of free-form

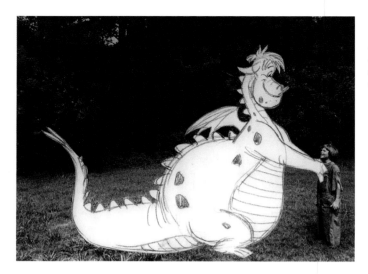

Photograph of actor Sean Marshall with a sketch of Elliot the dragon for scale reference.

drawing so everyone kind of knew what was going on and what it was going to more or less look like. They wanted everyone to keep a clear idea in their head of what was going on. So, it was fascinating for a kid of my age to see all those really excellent artists doing all that great work."[124]

Pete's Dragon was an ambitious project for Disney. It combined visual effects, animation, music, and choreography. Even with the care and planning that went into balancing these elements, every now and then, a happy accident could still occur. Hale remembered one in particular: "We were on our last night of shooting, and it was a scene where the dragon comes in and pushes the wind wagon. Shoves it out of the scene. It was starting to get daylight. We had the chance for one more shot. We had a big bungee cord that would trigger a thing and the bungee cord would pull the wagon out of the scene. So, they had this cable buried that stopped the wagon from going too far and killing somebody. So, we shoot the scene, and the wagon comes shooting through and the cable pops out of the ground and hits this lantern, and it goes flying through the air. And Don Chaffey goes, 'Oh my God!' And I said, 'Don, did you see that dragon's tail hit that lantern?' And he says, 'Can

you make that work?' And I said, 'Yeah!' And we did."

While Sean Marshall was filming his part in *Pete's Dragon*, a brand-new cast of Mouseketeers were shooting episodes for *The New Mickey Mouse Club* that would premiere in January 1977. Since they were all on the lot together, Marshall would hang out with some of the group. He learned that not all child actors were created equal. "They told me they were always told 'Sean is the king. Sean is the star.' Even though we're not doing the same thing 'when he's on, you have to treat him a different way.' So, that...set me back because, you know, I had never been treated like that before. As far as I was concerned, we were all on the same footing. We were all just kid actors. But yeah, they had been talking to the Mouseketeers about acting a certain way around me."[125] It was a clear sign of how much importance the Studio placed on the production of *Pete's Dragon*.

Filming Pete's Dragon on the backlot of the Walt Disney Studios (holding a megaphone on the left is director Don Chaffey).

Story sketch of Pete and Elliot by Ken Anderson.

The second class of the CalArts Character Animation program began in the fall of 1976. "You get to CalArts, and suddenly you're with like-minded people," said Chris Buck, one of the new students. "Here suddenly are all these people that are so passionate about it and knew so much about it. I felt like I was home, in a way. Mike Giaimo was in my class, and Tim Burton, and Larry White." Mike Giaimo adds: "Chris and I became friends almost immediately at school. We met in line at registration. He was just right in front of me, so we started up a conversation and we really connected at school for those two years. John Lasseter and I were great buddies at CalArts, and I would assist him on his film, like maybe doing inbetweens, helping him shoot film late at night."

As these young men began their education, another was just leaving school with hopes of working in the film business. Howard Green graduated from the University of Southern California with an MBA in marketing. Recalled Green: "I wrote fifty letters to heads of Marketing, Distribution, and Publicity at all the Studios and Irving Ludwig, who was the head of

distribution for many years at Disney, ultimately took a gamble on me and hired me as a sales trainee in distribution."

Green started at the Studio in November 1976. Even though he hadn't intended to work for Disney, he was excited about the possibilities. "I think Disney is different than all the other studios," said Green. "It's the only studio that the name means anything. You couldn't really name Warner Bros. movies, but you could always name Disney movies."

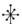

Writer Joseph McEveety passed away in October 1976. McEveety had open heart surgery in the late '60s, which was why he'd chosen to leave production and switch to a writing career. "He ended up having a heart transplant in like, 1973," said daughter Annie. "He was the first man ever to have a pacemaker and heart transplant." Problems continued to plague him, and he died eight months after *No Deposit, No Return* was released—his sixth film for Disney. His final screenplay, *Hot Lead and Cold Feet*, arrived in theaters two years after his passing.

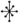

The Studio's holiday release for that year was *The Shaggy D.A.*, a sequel to one of Walt's more popular films, *The Shaggy Dog*. If there was a film that epitomized the Disney live-action-comedy genre of the '70s, it was this one. The high-concept idea had a supernatural element and plenty of slapstick chases. For a film that stuck so closely to the Disney formula, the reviews were mostly positive. Charles Champlin of *The Los Angeles Times* said the film "is right off the assembly line, but it is still the most competent line of

its kind."[126] Roger Ebert called it "one of Disney's better recent efforts,"[127] and Gene Siskel said it was "far better than most of the live-action comedies to come out of the Studio in recent years. Don Tait actually has written a cute script that gives adults in the audience a few laughs while watching the inevitable and unending pratfalls designed for the kids."[128]

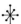

Ten years had passed since Walt Disney's death and, as 1976 drew to a close, the Studio lost more members of its old guard. *The Shaggy D.A.* would be the final film for director Robert Stevenson, ending his almost twenty-year run with the Studio. It was also producer Bill Anderson's final film before he retired. Producer Bill Walsh had died the year before, and in August 1976, producer Winston Hibler passed away. These were four of Walt's most trusted colleagues, and they stayed loyal to him long after he was gone.

Without Anderson, Walsh, and Hibler, Roy Sr.'s "committee" was down to five members. The group of staff producers was down to two members, with Harry Tytle and James Algar leaving the Studio within the next few years. This left only Card Walker, Roy E. Disney, and Ron Miller as the remaining members from either group. Miller alternated between producer and executive producer on every film the Studio made. Roy E. directed and/or produced animal-oriented films for television. This year saw the premiere of his production of *The Flight of the Grey Wolf* on the small screen.

Miller groomed new producers who had been active in many productions for the Studio. After coproducing *The Secrets of the Pirate's Inn* with Miller, Tom Leetch continued as a coproducer and an associate producer on films like *Snowball Express* and *One Little Indian*. He was associate producer for *Freaky Friday*, with Miller producing.

DISNEY IN-BETWEEN

Jan Williams began as a producer's assistant on three of the Studio's films of 1976: *No Deposit, No Return*, *The Shaggy D.A.*, and the television film *The Whiz Kid and the Carnival Caper*. After cutting his teeth on those films, he would move right to associate producer for the third *Herbie* sequel, *Herbie Goes to Monte Carlo*. After a few years, he became a producer full-time.

Kevin Corcoran followed the same path as Williams. As a child actor, Corcoran achieved stardom at Disney throughout the '50s, playing Moochie, from the *Spin and Marty* television series. He also appeared in some of Walt's biggest films: *Old Yeller*, *The Shaggy Dog*, *Pollyanna*, and *Swiss Family Robinson*. Corcoran left acting and became a producer's assistant on *Treasure of Matecumbe*. After that, he became an associate producer.

Jerome Courtland was already a full-fledged producer, having shepherded *Escape to Witch Mountain* and *Ride a Wild Pony* through production. His diverse history with the Studio went back to his days as an actor. Courtland played the lead in Walt's television series, *The Saga of Andy Burnett*, and acted in the 1958 feature *Tonka*. He also sang the theme song for *Old Yeller*. During the '60s, Courtland became a producer's assistant at Disney, while also producing and directing non-Disney shows like *The Flying Nun* and *Nancy*. Beginning with the television movie *Hog Wild* in 1974, he produced and directed feature films for the Disney Studio. His project in 1976 was *Pete's Dragon*.

Story sketch by Ken Anderson.

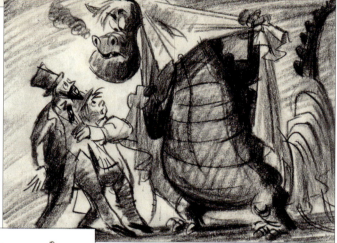

Story and character development sketches for Pete's Dragon by Ken Anderson.

DISNEY IN-BETWEEN

1977

Freaky Friday had its world premiere in Los Angeles at the close of 1976 and was then released to theaters in January 1977. The film's concept of a mother and daughter who switch bodies in order to walk a day in the other's shoes had all the qualities of the typical Disney premise—a high-concept idea with an unexplained supernatural occurrence. It was also filled with the same sitcom tropes so common in the Studio's comedies of this era: teenagers never clean their room and only eat junk food; mom is domestic; dad is always late for work and prepping for a big presentation; and corporate secretaries are always seductive. But between these cliches were glimpses of something a little smarter and a little more subversive.

When daughter Annabelle's messy bedroom is mistaken for her younger brother's, and a character snickers about a boy having a dollhouse, Barbara Harris' first response is "He's a very peculiar boy," but then adds, "He's liberated!" The body-switching concept leads to some questionable situations for a Disney film. Annabelle, played by Jodie Foster, in her middle-aged mother's body, flirts with a teenage boy. Annabelle's father gets his engine revved when his wife (who is actually his daughter) innocently calls him Daddy."

But it's the growth of Annabelle's character that is the most compelling aspect of the film. She attends a parent-teacher conference in her mother's body. There, she learns that she has a high IQ. She also possesses an exceptional verbal aptitude. These were things that Annabelle didn't know about herself. Her teachers had been unable to get through to her to cultivate her abilities and her potential. At the end of the film, when

Jodie Foster as Annabelle Andrews in Freaky Friday.

mother and daughter return to their respective bodies, Annabelle expresses uncertainty about moving forward. She doesn't know how she feels about herself now. Her mother, having previously criticized Anabelle's appearance, tells her daughter that she can look and dress however she wants. "I wasn't talking about how I look," interrupts Annabelle. "I was talking about the way I am. I'm so much smarter than I thought. And so much dumber." As her mother embraces her, she says, "My darling, aren't we all?" This emphasis on emotional and intellectual growth, rather than an emphasis on the physical, is notable. One would assume that a story like this, told during this time, by this studio, would focus more on the superficial. And that the emphasis would be on the "ugly duckling" aspects of the maturation of a teenage girl. If the book had been adapted by one of the Studio's stable of writers, rather than by the author of the source material, would this subtle but important distinction have been made?

Unfortunately, before we get to Annabelle's revelation, the film switches to the worst aspect of '70s Disney. The climax includes an absolutely ridiculous car-and-boat chase that feels detached from the tone of the movie. Suddenly, the characters become props for cartoon gags rather than motivating the action through their choices. It's as if the Studio was incapable of releasing a film without a slapstick chase at the end. It seemed as obligatory as having opening credits or a card saying, "The End" when the film was over. *Freaky Friday* did well at the box office and was generally well-reviewed by critics. Foster and Harris both received Golden Globe nominations for female actor in a leading role. "That might have been the best project I ever worked on," said Gary Nelson. "It just worked for me, and it became kind of a little classic movie that will live on forever."

Don Bluth and his animation team were hard at work on *Pete's Dragon*. This was the first Disney-animated production that did not include any of the Nine Old Men. It was a positive experience for many of the young artists, Ron Clements and Lorna Cook, in particular. Bluth had offered Cook encouragement years before, now he was officially her mentor. "He was very good," said Cook. "Very patient. As a young animator, you spend a lot of hours looking over somebody's shoulder, and that's what I did. Learning the language. All the principles of animation and gathering the information and taking it in." Even though she was an inbetweener, Don gave her scenes to animate, and she learned fast. Ron Clements loved Bluth's practice of drawing key poses for his animators to use as a guide. These drawings freed up Clements to focus on the action and the subtleties of his acting. Said Clements: "That really helped me a lot because that was the hardest part for me, the drawing part. And Don left me alone. He would give me sections of continuity and there wasn't a lot of changes. So that was a good experience for me."

Others, like Dale Baer and Glen Keane, struggled on the project. Neither of them could master drawing Elliot the dragon, which they felt was far too complex a design. Ron Miller had tasked Ken Anderson with the job of creating the character but, once Bluth became the animation director, he took Anderson's design and reworked it. "I couldn't draw this dragon for the life of me," recalled Baer. "I saw Ken Anderson's sketches of the dragon, and they were charming as can be. But then when Don got a hold of it, it became the most difficult thing to draw. So, I was failing miserably on that picture, trying to figure this character out. I forget how many weeks or months I was on that picture, but I wasn't getting anywhere on it." Keane added: "I felt like I was doing okay with Ollie on *The Rescuers* but then *Pete's Dragon* came along, and Don was very focused on the design...and John Pomeroy was a

natural at interpreting Don. I tried as hard as I could to animate in that sense of design and I wasn't good enough, at that point. I didn't understand design like that. I felt like I was doomed. I was never going to be an animator."

Bluth's key poses were helpful for Clements, but others felt that this practice took freedom away from the animators. The feeling among many in the animation ranks was that Bluth was a control freak. Dale Baer went into Bluth's office to show him his progress on a scene. Recalled Baer: "He was looking at the Moviola and he was just shaking his head. He was looking at an Andy Gaskill scene and all Don could say was, 'Why can't people do what you tell them to do?'" And according to Ron Clements: "[Bluth] did not like working for Ron Miller. He did not like *at all* being told what to do."

But other artists saw this aspect of Bluth as admirable—a sign of passion and leadership. "He was very good, and you kind of want to hang around that," said Lorna Cook. "He wasn't soft. He wasn't always easy to work with. His standards were high. But he did have the patience and I needed that."

Bluth developed quite a following among certain like-minded individuals. "He was like the Pied Piper," said Baer. "He wound up getting this little clique going, and that's around the time I kind of was getting disenchanted with the place." *Banjo the Woodpile Cat* continued production in Bluth's garage, keeping it as under the radar as possible. But even that would bleed into regular work hours, with the group sometimes holding *Banjo* meetings in the Studio. Recalled Baer: "They had this big sign…on the door that said MEETING IN PROGRESS—DO NOT DISTURB. And you could hear all of them in there laughing away. And if you had stuff to show him, you had to wait."

Bluth invited Clements to be a part of *Banjo,* but Ron turned down the offer. "I was very loyal," he said. "I just didn't want to be a part of that,

and I wasn't." Keane had been enthusiastic about being part of the project, but eventually felt the cold shoulder from Bluth. Regarding the money Keane had donated to help with *Banjo,* he recalled: "When I got married [in 1975], he gave me that hundred dollars back, which was kind of a way of him saying, 'I know you're no longer one of us.' At least, that's how I took it. And the fact that his door was shut to me suddenly."

Baer had also joined Bluth's independent project early on, but eventually stepped away. He said: "It was taking its toll [on me], going to Culver City [where Bluth lived] every weekend, so I quit and parted ways, which I think is part of why there were not very good feelings because I walked away from the whole thing."

During this era, it was rare to see theatrical animated features besides the ones from Disney. Every now and then, studios would release an animated feature, like Filmation's *Journey Back to Oz* (1972) or Hanna-Barbera's *Charlotte's Web* (1973). But they couldn't compete with the Disney name or the caliber of talent behind it. 1977 saw an assortment of new features released with a range of styles and subject matter. On one end of the spectrum were family musicals like *The Mouse and His Child,* directed by Charles Swenson and Fred Wolf, and *Raggedy Ann and Andy,* directed by animator Richard Williams. On the other end, was the fiercely independent Ralph Bakshi. Bakshi distanced himself from the mainstream by making films with a gritty art style and adult subject matter, like the X-rated *Fritz the Cat* (1972).

Dale Baer caught Bakshi's latest film, *Wizards,* which was a postapocalyptic fantasy with an anti-war message. "I thought, *This guy's got a lot of guts to put something up on the screen like thi*s," he said. "There's nothing in there that's Disney at all, outside of some decent drawing." Baer was so discouraged by his experiences at Disney that he decided to meet with Bakshi

to see if there was a place for him on the maverick director's next project. "He *hired* me and *doubled* my salary from what I was making," recalled Baer. "So, I thought, *Well, okay, that answers that question.* So, I went back and I turned in my notice." As Baer prepared to leave Disney, a colleague told Dale about a comment that Bluth had made about him in another meeting. Baer recalled: "He said, 'As you all know, Dale's leaving. And when he comes back, we'll just have to start all over again.' Meaning he was going to have to retrain me to his way of things. Well, I swore up and down, once I heard that, I was *never* going to come back as long as he was [at the Studio]. I'll get a job as a garbage man before I come back [to Disney]."

Walt's Boys now outnumbered Roy E. Disney, since the only remaining members of the original post-Walt leadership team, besides himself, were Card Walker and Ron Miller. Frustrated by his status and the lack of direction for his family's company, Roy met with his business associate—and lawyer—Stanley Gold. Roy's previous attorney had been Frank Wells, a former colleague of Gold's at the law firm Gang, Tyre & Brown. Gold became Roy Jr.'s lawyer when Wells left the firm to help run Warner Bros. Gold and Roy discussed options and decided it might be time for him to leave the company. They tried to negotiate a deal where Roy could continue to develop material for Disney as an independent producer, but nothing came of it.

Roy resigned from the company on March 4, 1977. In his statement, he said: "The creative atmosphere for which the Company has so long been famous, and on which it prides itself has, in my opinion, become stagnant. I do not believe it is a place where I, and perhaps others, can realize our creative capacities. Motion pictures, and the fund of new ideas they are capable of

generating, have always been the fountainhead of the Company, but present management continues to make and remake the same kind of motion pictures, with less and less critical and box office success. The Company is no longer sensitive to its creative heritage. Rather it has substituted short-range benefits…for long-range creative planning."

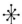

Director Gary Nelson's brother Jim was associate producer on a large-scale science-fiction film, for which he helped create and build an entire special-effects company to handle the project's ambitious workload. From the company's warehouse in Van Nuys, California, Jim would call up Gary and gush about the film. Recalled Nelson: "He would say, 'I'm working on the best *goddamn* movie I've ever been on in my life.' I said, 'What is it?' He said, 'Oh, it's everything. It's space, it's the future, it's the past, it's Westerns.' I said, 'Oh yeah, bullshit, Jim.'" But on May 25, 1977, when 20th Century Fox released *Star Wars* in theaters, Nelson saw that his brother's words were *far* from bullshit. "I was blown away. I couldn't believe it. I stood in line outside Grauman's Chinese Theater on a Saturday to watch it. It was beyond anything that I had ever seen. The whole industry changed. And it changed overnight."

About two years earlier, *Jaws* had set this change in motion. Released by Universal Pictures and directed by a young Steven Spielberg, *Jaws* was a smash hit. It was the top box-office grosser of all time until being dethroned by *Star Wars*. The tide was turning from the cinema verité approach of the New Hollywood to the age of the blockbuster. The cynicism, moral ambiguity, and artistic expression of auteur directors was giving way to films centered around spectacle, clearly defined heroes and villains, and most importantly, box-office dollars. They were high-concept stories told with sophistication

and style. They were innovative in their use of special effects and pioneered new techniques that would be unlike anything audiences had seen. And even though they were rated PG, they would truly appeal to all ages. In essence, they would be everything a Disney movie could, and should, be.

In fact, Spielberg and Lucas both grew up watching Walt Disney's films. They drew inspiration from them. Spielberg and composer John Williams quoted "When You Wish Upon a Star" in the score for the climax of *Close Encounters*. In J.W. Rinzler's book *The Making of Star Wars*, Spielberg is quoted as saying: "George always described [*Star Wars*] to me as a kids' picture, a little Disney film, that he didn't think anyone would want to see, but he wanted to see it."[129]

When initially shopping the project around Hollywood, Lucas had made a stop at Disney but the Studio passed on it. Said Lucas: "I think Disney would have accepted this movie if Walt Disney were still alive. Walt Disney not only had vision, but he was also an extremely adventurous person. He wasn't afraid."[130] Burny Mattinson agreed, saying: "[*Star Wars*] would've appealed to Walt no end because he was always striving to get something new, something fresh, and he was very aware that we would fall into the trap of doing things the way we did before."

Ultimately, associate producer Jim Nelson's name did not appear in the credits of *Star Wars*. Said Gary Nelson of his brother: "He got into a fight with Lucas, and Lucas blamed him for going over budget on the miniature units and the special-effects units, so he took his points away from him. Pissed my brother off. So, he completed the film, but he took his name off it. That was his protest."

The Rescuers was released in June 1977 as a double bill with the live-action nature short *A Tale of Two Critters*. *The Rescuers* was well-received by critics and was a moderate success at the box office. Ron Clements was happy with how the film turned out. He'd enjoyed his time working on it but, according to Clements: "There was just this sense, and it continued among the young generation, that we could do better. There was just this feeling like we wanted to do something that had impact." Ron and his peers, as well as their friends outside of the Studio, were in their twenties. But when he returned home to Iowa to visit, none of his friends had seen *The Rescuers*. They'd heard of it, and heard it was good, but it wasn't attractive enough to get them into the theater. The new generation of animation artists hoped that they could create something that would appeal to families and to people their own age. *Star Wars* proved it was possible for an all-ages film to hit big. Could they get that to happen at Disney?

The Black Cauldron seemed like the project to do it. The proposed film would be based on an award-winning series of books written by Lloyd Alexander that were published throughout the '6os. The story was a fantasy adventure rooted in Welsh mythology with a classic hero's-journey structure. Disney had bought the rights in the early '70s and began developing the animated epic. Mel Shaw outlined the film's story through his beautiful pastel vignettes and his work lined the main hallway of the Animation Building. These vignettes enticed every young artist who stepped through the doors and anticipation for the project grew over time. Said Glen Keane: "From the moment I got in, the first day, it was about *The Black Cauldron*. In all the hallways was *Black Cauldron*." Clements recalled: "The first day I was at Disney, I heard about *The Black Cauldron*. I think there was still thinking that *Black Cauldron* would be the next movie after *The Rescuers*."

Frank Thomas and Ollie Johnston were the strongest advocates for

the project. They loved the story and had met with author Lloyd Alexander many times at the Studio to discuss the film. They saw it as their chance to work alongside this new generation of artists that they had helped cultivate and together, bring back classic Disney for a contemporary audience. It would have the scope and scale of a *Sleeping Beauty*. The tone would feel more like *Pinocchio*, depicting a darker, more dangerous world. Even though the books were for children, Alexander never approached them that way. He wrote them more for himself and embraced deeper, more complex ideas. If they followed his lead, the Studio could potentially make their own *Star Wars*. But they'd have to wait a bit longer. Woolie Reitherman brought a new project to the Studio, called *The Fox and the Hound*, based on a book by Daniel P. Mannix. It was decided that it would follow *The Rescuers* as the Studio's next animated film.

Howard Green moved into Publicity after spending a year in Disney's Distribution Department. This department was a mix of old school and new school. Green worked with Leonard Shannon, who was a publicist from Walt's day. "He did *Pollyanna* and *Parent Trap*," recalled Green. "Leonard Shannon kind of took me under his wing and critiqued me often. He was tough. A wonderful guy." Alongside Shannon were many younger publicists such as Arlene Ludwig and Missy Sutton. Like the McEveetys and the Millers, these two were children of longtime Disney employees. Ludwig was the daughter of Irving Ludwig, who had helped Walt and his brother Roy build their own distribution company, Buena Vista. Sutton was the daughter of the late Winston Hibler, prolific producer for the Studio. Mike Bonifer joined Green as a new face in the department. Bonifer was new to Publicity and

new to Disney. These publicists reported to Tom Jones, the head of Publicity, who in turn reported to Bob King, the head of Marketing. Green recalled: "Bob was a good boss because he wasn't afraid to let people do their thing." Bonifer remembered: "He was saddled with a lot of transition pictures when the market was changing, and the pictures were changing, and it was very hard to calibrate how to go out." King also found himself in an interesting position reporting to Card Walker, who had served as the company's head of Marketing years ago. "He was sort of Card Walker's whipping boy," said Green. "Because Card had done [King's job] before," added Bonifer. "He's got the CEO of the company looking over him and criticizing and micromanaging."

The Consumer Products and Publishing Department worked in tandem with publicity. Vince Jefferds, who was a former boxer, ran the department. According to Green: "[Jefferds was] the meanest man in the Studio." Bonifer added: "He was big. He was an important guy. And just crusty as hell. He would chew people out." Under Jefferds was Lee Reem, who was in charge of product tie-ins. Said Green: "He was the guy who'd get Goodyear tires on *Herbie Goes Bananas* and Baskin-Robbins to name a new flavor after each movie. It was pre-McDonald's, so the tie-ins were more like Smucker's jelly."

Green's first day in Publicity was also the day that *Herbie Goes to Monte Carlo* hit theaters. "Herbie put his tire prints in cement at the Chinese Theater," recalled Green. "It was a temporary thing. They pried them up the next day. That was my introduction to the world of ballyhoo and Disney publicity."

That same month, Marketing head Bob King hired a young man named Tom Wilhite to replace Tom Jones as head of publicity. "[Wilhite] came from the world of PR agencies," said Green. "He worked for Rogers and Cowan, and he had made quite a name for himself there. It was a really

exciting time in publicity."

Tom Wilhite brought a fresh perspective to the Studio. He wasn't paralyzed by the Studio's past or bogged down by the weight of "What would Walt do?" Recalled Green: "Publicity was sort of the revolutionary nucleus, I think. We were all interested in movies and Disney and excited about what the future could hold for Disney. We would stay late at night and talk about films and critique Disney films and bring in films to screen from the UCLA archives."

Head of Publicity and future VP of Production Tom Wilhite.

Wilhite instructed Bonifer to immerse himself in the Disney film library. Bonifer was so new to the company, Wilhite thought this immersion would benefit him. And it did. Bonifer found kindred spirits in the only other concentrated group of young people on the lot, the Animation Department. Bonifer recalled: "It was so intimate, and if you networked with the younger animators, everything was about some kind of insubordination. Like, 'Yeah we'll watch want we want to watch, we'll work on what we want to work on' and we had that same attitude. 'We're going to set up a screening. Everybody, I'm watching *Dumbo* today at three o'clock, if anybody wants to come over.'"

Story editor Frank Paris hired writer Jeb Rosebrook to work on the *Space Probe One* script. Known for writing on the television series *The Waltons,* as well

as the Steve McQueen rodeo drama *Junior Bonner*, Rosebrook was mystified by why he was considered for the job. Despite his lack of experience in the science-fiction genre, Paris wanted him, and Rosebrook accepted. Chris Hibler inherited production duties from his father, Winston, who'd been the original producer but had passed away the year before. "I had a brief meeting with Miller and also John Hough, who was the director," recalled Rosebrook. "I read all the scripts, and then I went to work to try and bring whatever direction I could to it without changing the concept of what *Space Probe* was."

Rosebrook shared a wing in the Animation Building with writer Don Tait. Tait began as a story analyst for Warner Bros., 20th Century Fox, and MGM. He then moved into writing and producing television for Columbia and Universal. His first Disney feature film script was for *Snowball Express* in 1972. After that—according to an article in *Disney News* magazine—Tait had signed a six-year contract "to write exclusively for the Walt Disney Productions' family-oriented enterprise." During those six years, he wrote the scripts for *The Castaway Cowboy* and *Treasure of Matecumbe* as well as the hit films *The Apple Dumpling Gang* and *The Shaggy D.A.*

Tait had multiple projects in the works. One was an adaptation of a book by Rev. Albert Fay Hill called *The North Avenue Irregulars.* He was also writing a sequel to *The Apple Dumpling Gang* and an update of Mark Twain's *A Connecticut Yankee in King Arthur's Court*, later titled *The Unidentified Flying Oddball.* Regarding his feelings about working at Disney, Tait is quoted as saying, "I feel closer to the people I work with here than in any other studio. I'm not just a cog in a wheel, I'm a *person* here."[131]

For the *Space Probe One* project, Rosebrook created the principle human characters. He added two robots to the cast, the innocent B.O.B. and the villainous Maximilian. He enjoyed working with Hough, whom he found to be collaborative. "John Hough was a very, very nice guy. He was the kind of

director you like to work with who was somebody you could bounce ideas off. I was used to working with directors and somewhat taking their lead." Since the initial concept for the project was a disaster movie in space, the previous writers had the spaceship *almost* going into the black hole. Rosebrook and Hough imagined a different ending. "John Hough and I came up with the idea of why not go *through* the black hole?" said Rosebrook. "Once we gave [Ron] Miller the idea, that's when I went off to do serious writing on my own."

Old-timer Johnny Bond remained in charge of delivering animator's scenes to the Camera Department so they could be filmed for review. Still "a character," as Burny Mattinson had described him, the walls behind Bond's desk were peppered with explicit photos of nude women taken from men's magazines. This was the kind of thing that men could get away with in the workplace, once upon a time. Perhaps it was also the Studio's practice of keeping its male and female employees separate that allowed this behavior to remain unchecked. Historically, animation artists at Disney had been predominantly male and their world was the Animation Building. The women of Ink and Paint occupied their own building next door, apart from the men. It's safe to assume that it had been mostly male eyes that glimpsed Bond's colorful office decor when they dropped their scenes off at his desk.

But during the '70s, more women joined the ranks of the animation industry, as well as the Disney Studio, eventually breaking into the typically male role of animator. As a result, this kind of behavior was now called into question by the female animators who would have to interact with Bond. In her memoir, animator Heidi Guedel said: "No one was at all concerned that this might be embarrassing for the few women who had to stand there

several times a week." Guedel turned the tables on Bond and tore an explicit picture out of a *Playgirl* magazine. While working late, she hid the picture of a naked man among Bond's collection of women. "The first time I did this, Johnny didn't catch on for several days," said Guedel. "Then someone happened to notice this one contrasting picture and pointed it out. He had an absolute cursing fit! I was amazed at how angry this made him and it simply spurred me on. I'd drag a chair into Johnny Bond's enclave, put it on top of the counter, climb up as high as possible and tape another large photo of a naked and aroused male where it was especially difficult for old...Johnny to tear it down."[132]

Another aspect of the gender separation that broke down during this period involved recreation at the Studio. Since the early days of Walt's Burbank lot, the Animation Building and the Ink and Paint Building each had a gender-specific facility. The Penthouse—an exclusive, men's-only club—occupied the top floor of the Animation Building. It included a restaurant, a barbershop, and a deck where the clientele were often found sunbathing in the nude. In the Ink and Paint Building, the women had the Tea Room, operated by the proper-yet-irreverent Vera Lelean. It had a dining area, a sundeck, showers, and several large couches where women could rest.

The Penthouse and the Tea Room were each off-limits to the opposite sex. In the past, when some men ignored the unspoken restrictions on the Tea Room, the Studio's director of labor relations had to make an official decree that those services were only for inkers and painters. But as the years progressed, the restrictions that prohibited men from visiting the women's cafe were relaxed. By the '70s, men routinely came for tea, coffee, and pastries yet women were still forbidden to visit the Penthouse. This did not jibe with the new attitudes of women in the workplace. It was a particular source of frustration for fellow animation trainees Heidi Guedel and Leslie Margolin.

"We decided to inform the National Organization for Women about this apparent inequity," said Guedel. "Our identities were kept confidential, and our complaint was definitely heard. NOW apparently jumped at the chance to challenge Disney Studios on a gender bias issue. The Studio was given a choice between closing the Penthouse Club, allowing women of requisite professional caliber to join, or providing separate but equal facilities for us."[133]

Said director Gary Nelson, who often frequented the Penthouse: "They protested. They wanted equal rights. They wanted to be able to come into the Penthouse too, and Ron strongly opposed it because Walt didn't want women up there. It was just for the guys. They kept on and they kept on and so finally Ron gave in, and they allowed women in, and they were all very excited. Two days later he closed it down." Added Guedel: "This punitive response only deepened the cross-gender resentment at the Studio. We knew that all those men who were deprived of their special retreat must have been speculating about which of the women had actually complained."[134]

Animator Dave Block was committed to realizing his dream of working at Disney. After he finished animating on Richard Williams' *Raggedy Ann and Andy*, Block left New York for Los Angeles. He recalled: "I knew I needed to get in by May because June was going to be the first graduating class from CalArts, and I knew the whole game was going to change when those guys came out. Those guys had a leg up on everybody." Block drew whenever and wherever he could. "I finally got in on my third try. It was like the first week of April in '77. So, I beat the line." Block was euphoric about working at the Studio, feeling like he "...had gotten to heaven. It was unbelievable. The linoleum on the floors in the Animation Building were still the same. They

were gunmetal gray. Really ugly. But who cared? *Walt* had walked on them!" Block worked well with Eric Larson in his training program. Thanks to his previous animating experience, Block was able to move right into production at Disney. Said Block: "*Pete's Dragon* was in a crunch, trying to get that thing done and they knew I had been an assistant animator, so they didn't have to train me."

As Block had predicted, the first wave of CalArts students hit Disney in the summer of 1977. The new recruits were Jerry Rees, Bruce Morris, Brad Bird, Henry Selick, and John Musker, returning after his internship the previous year. Joining these four in Larson's training program were Dan Haskett and Bill Kroyer, both from other art schools. Musker had already experienced Larson's mentoring skills when he interned in the summer of 1976. Now as a full-fledged trainee, Musker saw the true depth of Larson's talent and inspiration. Recalled Musker: "Eric's thing that he said back then—and I can't remember if he was quoting somebody else—he said,

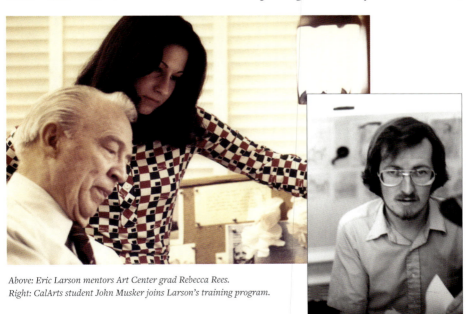

Above: Eric Larson mentors Art Center grad Rebecca Rees.
Right: CalArts student John Musker joins Larson's training program.

'We're only limited by our imaginations and then our ability to draw what we can imagine.' So, it was really like the sky's the limit, but you've got to be able to communicate what you're imagining and that's your only limitation. And certainly, his big thing was relatability and be an observer of human behavior and animal behavior." Block added that Larson "had the most wonderful bedside manner. He was so gentle with you. And his solutions to things were so simple. He had this belly, so he'd always sit pretty far back, and the way he'd hold the pencil was the lightest thing. You'd swear that if you leaned over his shoulder and blew, you could blow the pencil out of his hand. And it was all arm, never wrist. God, he was the greatest."

For Larson, the repetitive nature of his training program was growing stale. His artists would do test after test. The tests were wonderful learning tools, but they were otherwise disposable. At lunch one day, Mattinson suggested that Larson direct a short and use these new trainees as his crew. Larson loved the idea, and he chose a pitch by up-and-coming story artist Pete Young, called *The Small One*, to be the subject. Young partnered with Vance Gerry, and they began storyboarding. Larson had only ever directed one time before, on *Sleeping Beauty*. He had been removed from that position midway through the film due to friction with Walt. So, when *The Small One* was announced, the young animators were ecstatic over the opportunity to collaborate with their beloved mentor on an actual film.

Larson also chose seasoned animator Cliff Nordberg to be on the crew. "He was a very experienced animator and Eric was very fond of him," recalled Mattinson. "He always said, 'If I was opening up an animation studio, I'd get two people—John Lounsbery and Cliff Nordberg.' Nordberg was on the second string of animators. He was not one of the Nine Old Men, but he was still very good. And he would do very innovative things, and Eric would be just like, 'I never would've done it this way, but God

bless him, it's great what he did!'"

Mattinson helped by going through the storyboards, adding more panels to flesh out the characters' actions for the young animators to follow. Top animators Glen Keane and John Pomeroy began suggesting character design ideas and doing animation tests. To Keane's delight, Eric wanted to go in the direction of his designs. "[Glen] was really looked to by Eric as his main young guy that was...going to be helping set the style of it," said Musker. "And so, the early style, partly because of Eric and because of Glen's sensibilities, was a cartoony style. It also fit with the idea that it would be easier to draw than some of the way the features had gone, with this more naturalistic, more angular drawing style."

One Monday morning, the *Small One* team walked into the building and discovered that all their work on the film was gone. "Everything we'd been working on, every scene, everything on the second floor that we had handed out and done was all taken away," remembered Mattison. Larson phoned Don Duckwall, who informed Larson that management decided to give the film to Don Bluth to direct.

Rumors spread that it was Bluth who had gone to Ron Miller and advocated the film be taken from Eric. Some accounts claimed that John Pomeroy had motivated Bluth, jealous that Larson had chosen Keane's designs over his own. Others said it was entirely Bluth's idea. In some accounts, Bluth's argument to Miller was that Larson was too old and unfit to be directing. Others claimed that Bluth was motivated by his own personal investment in the future of Disney animation. He believed in the classic Disney tradition with all his heart and felt that its tradition must be preserved and passed down to younger generations. This could only happen through a naturalistic and sophisticated character design style—more solid construction, more details on the characters and more complex shapes. The

soft, simple, pliable forms of Keane's work would not appropriately develop the draftsmanship skills and proficiency in the craft needed to continue the Disney tradition. Other accounts put the decision solely in Miller's hands. In a 2019 post on his Instagram account, Don Bluth said of *The Small One*: "This is the film that should [have] been directed by Eric Larson and the new trainees. The powers on the third floor decided to have me direct as a good training project. As they thought I was going to be the next director of the animators. I am sure Eric was disappointed and I apologize for that."[135] Whatever, or whoever, motivated the decision, Miller handed the project to Bluth.

"Eric was crushed," recalled Block. Said John Musker: "He just kind of shook his head and put up his hands. He was not a confrontational guy or a political guy." Musker continued: "To depose Eric, the most gentle benevolent soul, it all seemed like someone had shot Santa Claus dead in front of our eyes. This didn't make any sense to us at all. The world was upside down in that Eric was no longer directing it, and Don Bluth—who we knew peripherally because we hadn't had too much direct experience—was going to be directing it. Glen's stuff was out, and John Pomeroy was going to be redesigning it and re-styling it. A lot of us were upset."

This event damaged the relationship between Bluth and this new group of young artists—mostly from CalArts—as well as many of their more experienced colleagues. Said Mattinson: "I thought, *Geez, what a hell of a thing to do!* And everybody knew that was just a rotten thing, but Bluth got away with it. Mel Shaw was just fit to be tied." Glen Keane recalled: "[Pomeroy] and I were super close, played racquetball together all the time, as well as Don Bluth and I. And then after that Eric Larson thing, we did not talk for a year."

Keane left *The Small One* and joined Frank Thomas and Ollie Johnston

for early development on *The Fox and the Hound*. Dan Haskett and Bill Kroyer also came on to that project, having been rejected by Bluth for *The Small One*. Haskett began working with Frank Thomas, and Bill Kroyer was assigned to Andy Gaskill. The rest of the new group of trainees—Jerry Rees, Brad Bird, and John Musker—stayed to animate on *The Small One*. Rees was promoted to animator. After a few tests to prove himself to Bluth, Musker became an animating assistant and worked with Cliff Nordberg. Dave Block refused to stay and work on *The Small One* with Bluth. He said: "It *pissed me off* that they had done this to Eric, and I said, 'I'm *not* going to animate on this thing.' I said, 'I am not going to make this my first Disney credit.'"

John Pomeroy and Gary Goldman became directing animators on *The Small One*. Many young artists who felt great loyalty and respect for Bluth came into their own on the project. Most notably, four of the female assistants. Linda Miller, Heidi Guedel, Emily Juiliano. and Lorna Cook were promoted to animators. Guedel had experienced the old-fashioned attitudes about women ascending the ranks at Disney. She'd heard Milt Kahl's speech about women not being willing to commit to a career in animation. She had observed Woolie Reitherman's outspoken views about not wanting to work with female animators. But under Bluth, things were different. "He held no prejudices whatsoever," said Guedel. "Nothing mattered—age, race, gender—nothing. Don was truly fair. It was incredibly liberating to work under that kind of director for a change."[136] Said Cook: "Don really championed the women, and I will be forever grateful for that. It was a positive, wonderful step into a career that I did love, so I really appreciated it. And we earned it. We all worked very hard. Nothing was given freely."

Bluth's side project, *Banjo the Woodpile Cat*, continued full speed ahead. "*Banjo* was perhaps twenty-five percent complete in terms of pencil test animation," recalled Guedel. "There was still cleanup to do followed by

inking and painting of all the cels and reshooting the entire film in color. An incredible undertaking, never before attempted by artists working full-time for a major studio."[137]

"Don's garage in Culver City was a hotbed of animation," remembered Don Hahn. "I was twenty years old. I learned how to inbetween there. I learned how to paint cels there. And then, you could stay until three in the morning and shoot it in his living room, where he had a full animation camera. He had no furniture in his house. He had a lot of cats around, so you had to chase the fleas off of your cels before you shot. But you could learn how to do everything in Don's house. I literally learned the whole craft over a couple of summers."[138]

Cook added: "Being with Don and Gary and John was like an old-school Disney way of doing things. Passion is the key word here. Very passionate about what ideals they held."

For Bluth, the work they were doing on *Banjo* could also benefit films in the works at Disney. "We were learning things that would really help move the pictures and make them better," said Bluth. "I knew because we'd experimented. Woolie was minimalized. He was taking things *off* the screen to make it cheaper. I was saying, 'You don't have to do that. You *can* put them on the screen.' For example, a reflection. You can draw the reflection, *or* you can take the cel, turn it upside down, position it, take it out of focus, and you got a reflection without more labor."[139] Bluth eventually told Ron Miller about *Banjo*. He was desperate to show Miller what they'd been learning. To Bluth's frustration, Miller refused to look at the film. "I said, 'Why don't you want to see it?'" recalled Bluth. "He said, 'We're making things *here*. You don't need to go out there and make stuff.'"[140]

The CalArts folks grew frustrated with Bluth's practices, becoming more philosophically opposed to his ideas and sensibilities. One example

was Bluth's practice of filming live-action reference for his animators on *The Small One*. This was something that Walt had done in his heyday. In some cases, he and his teams filmed entire live-action versions of animated films like *Cinderella, Alice in Wonderland,* and *Peter Pan* before the animators began work. The difference was that Walt used professional actors—in some cases, the actors who provided the actual voices of their characters. Bluth didn't do that. He and his team filmed each other, and many felt that the acting was inauthentic and amateurish. To make matters worse, Bluth mandated that the reference be followed for a higher-quality look. The feeling was that many of the artists wouldn't be able to animate the scenes without the reference. But the idea of following reference instead of inventing a performance from the animator's head, heart, and hand, was blasphemous to the CalArts purists, particularly Brad Bird.

The group vented their frustrations to each other, and to Kroyer, who wasn't working on *Small One* but had great empathy for the struggles of his colleagues. Kroyer decided to inform Don Bluth that the team was unhappy. Surely, Bluth would want to diffuse any ill feelings. Instead, Bluth unleashed his own frustrations on Kroyer. According to Musker: "He basically told Kroyer—among the quotes I still remember—that 'we're trying to make a feature-style film here.' Some of us were saying we liked the Glen/Eric version better, and he was like, 'That would be setting us back. That's all backward thinking. That isn't up to the standards of Disney. Cliff Nordberg is *the bottom of the barrel*. So, if you want to emulate him in any way, you're going the wrong direction.' The upshot was he was mad. He wanted us to kind of shut up and draw and 'quit giving me grief and just do the work and you'll be better for it. What right have you got to complain?'"

Bluth went down to the group's bullpen with the intent to clear the air. "He said, 'You guys are green,'" recalled Musker. "[He said], 'You have

to be here for years before you have any right to have an opinion,' basically. And that 'this studio—I don't care what you've heard—this studio has always been built on a system of kings and serfs and John Pomeroy is a king, and you guys are serfs.' And this is supposed to get us behind the program? If you say Don was a manipulator or a cult leader, he was not doing things that were helping us join the cult. And he was just like, 'This room is a *rat's nest* of innuendo and rumor and it's got to stop. This is just not healthy.'" After that, the group adopted the name The Rat's Nest, a moniker they wore proudly.

The Animation Department was now in the midst of a civil war. On one end of the battlefield were the members of The Rat's Nest and their sympathetic colleagues—such as Ron Clements. On the other end was the group dubbed the Bluthies," people who were behind Don one hundred percent. Said Lorna Cook: "I was aware of it, and I didn't buy into any of that crap, really. I'm not cliquey. I don't appreciate it. Just get the work done."

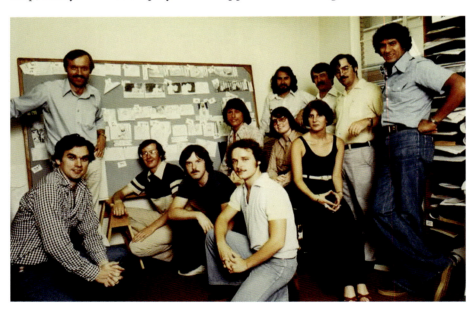

A pause in the civil war for publicity. Standing on the left: Don Bluth. Kneeling: John Pomeroy, John Musker, Brad Bird, Jerry Rees. Sitting: Heidi Guedel, Linda Miller, Emily Jiuliano. Standing on the right: Jeffrey Varab, Gary Goldman, Chuck Harvey, Bill Hajee.

"I can't say that they hated each other, but it was close to that," recalled Don Hahn. "[Bluth] was very autocratic. He wanted to do it his way. CalArts guys were much more improvisational. Much more pirate-flag mentality. They were somewhat professional but didn't really like Don and didn't really get along with his clique at all."[141]

Just as Hollywood had faced rebellious youth in the'60s, the same need to question authority and challenge the status quo now infiltrated the halls of Disney. "CalArts was just a big noise," said Bluth. "A group of nice kids with youthful ambitions, each trying to advance their career."[142] It was clear the CalArts faction would make it difficult for Bluth to lead the Animation Department. Said Musker: "I think through the course of *The Small One*, Don realized these CalArts people—and other people—they're difficult to control [and] they're not buying my religion."

All of this made Bluth weigh the benefits of staying at Disney. To him, he was simply trying to impart his passion for how things should be done, yet he was getting such resistance from these new recruits. Said Bluth of his thoughts at the time: "Maybe I'm not supposed to be here. Walt's not here, why am I here?"[143]

Looking back today, Musker does allow some room for Bluth's assessment of their motives at the time. "The system at CalArts did produce a bunch of directors, in many cases," said Musker. "Everybody was directing their own little film. You were your own animator, your own director, your own layout artist. You did it all. So, the idea of coming into a studio system where you were told to just do this [one] thing...."

But that one thing—the craft of hand-drawn animation—was in danger of being lost. The only way to preserve it was through time, mentorship, and, most of all, patience—something that is often in short supply with young people. Especially ones who have tasted autonomy and

then had it taken away by the established leadership. Unfortunately, the Studio was not in the business of nurturing individuals. As had been the case with Walt, Disney was not a place for auteurs.

As if Eric Larson's dismissal from *Small One* wasn't bad enough, Ron Miller excused Frank Thomas and Ollie Johnston from working on their passion project, *The Black Cauldron*. Miller felt pressured to facilitate the transition from the old guard to the new generation, so he decided that *Cauldron* would be "the young people's picture." Glen Keane recalled: "Ollie came in, and I could just tell he was really down. I'd never seen him be like that. And he said, "Well, I've never had anybody say this to me before, but they told me that I'm not allowed to work on something. Frank and I were told that we were to stay away from *The Black Cauldron*.'"

Keane was furious at Miller's decision. *He* was one of the young people and *he wanted* Thomas and Johnston on the movie. But there was nothing anyone could do. Thomas and Johnston went back to their desks and

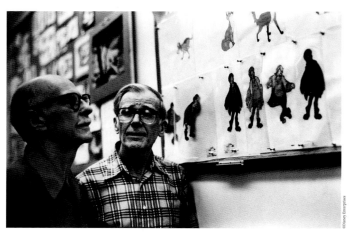

Frank Thomas and Ollie Johnston look over character models from The Fox and the Hound.

continued work on *Fox and the Hound*.

Ron Clements' interest in story continued. He was particularly taken by Alexander's *Chronicles of Prydain*. Clements wrote a treatment for *Cauldron* that many people read, including Don Bluth. Bluth was under consideration to direct the film. Clements' treatment was well-received and he was invited to work with Bluth and a writer named Earl Kress, who was also working on *The Fox and the Hound*. But Ron realized that he and Bluth had very different approaches to story development. They also had different approaches to the source material. Clements felt Bluth was not interested in drawing elements from the books. Clements' involvement tapered off, but his interest in story didn't. The construction of the whole movie (rather than the individual pieces) fascinated him, and he desperately wanted to stay in story. But Ron's animation on *The Rescuers* and *Pete's Dragon* had been so well received. As far as the Studio was concerned at the time, an animator was much more valuable than a story person. Ron moved on to *The Fox and the Hound* and was promoted to supervising animator.

Pete's Dragon was released in November 1977, with a gala premiere at Radio City Music Hall in New York. To kick it off, actor Sean Marshall rode a seventeen-foot-tall, forty-foot-long Elliot float down Fifth Avenue. Marshall and the Elliot float also appeared in the half time show at the Orange Bowl in Orlando, on January 2, 1978. Disney put on the show and themed it around their newest attraction debuting at both Disneyland and Walt Disney World that summer—The Main Street Electrical Parade. When the first park guests saw the illuminated Elliot rolling down Main Street, U.S.A., they also saw the original Pete riding on top, which Marshall continued to do for some time.

"I didn't do it every day, but I did it on weekends. It was usually two or three times a day. We were at Disneyland just constantly. They'd be like, 'Hey, you want to go and do this?' and we were like, 'Heck, yeah! We'll hang out at Disneyland all day.' I think the big thing was that they wanted the draw of having the original Pete on the dragon for the first several weeks or couple of months."[144]

The film did moderate business but received mixed reviews. One element that was universally praised was the character of Elliot. There was a definite dip in interest whenever he was off-screen. This is quite interesting, given that the original concept was to never show the dragon. No one can know how that idea would have panned out, but it's not difficult to imagine that the reviews would have been much harsher.

Kasha and Hirschhorn, along with Irwin Kostal, received Golden Globe and Academy Award nominations for the film's score. "Candle on the Water" was nominated for an Oscar for Best Original Song. Kasha and Hirschhorn continued working for Disney, writing songs for live-action films as well as for EPCOT Center in Orlando. Their song, "I'd Like to Be You for a Day" from the opening titles of *Freaky Friday*, had been nominated for a Golden Globe the previous year.

It was clear that the Studio hoped for a success on par with *Mary Poppins,* even echoing elements of that film's publicity campaign. For example, the title on the poster was written in almost the same font as Walt's 1964 film. The only difference was that *Pete's Dragon* was written with what look like curved neon tubes rather than the round, marquee bulbs of *Poppins*. In their magazine, *Disney News*, the Studio described it as "The most ambitious film since *Mary Poppins*," which is true on the surface. As Walt did with *Poppins, Pete's Dragon* uses every special effect and storytelling trick in the Disney playbook. But from a story standpoint, the film never reaches for a

universal truth the way the 1964 film does with its exploration of fatherhood. The closest *Pete's Dragon* ever gets to a core human value is the song "There's Room for Everyone in This World," about tolerance and acceptance. Like "Feed the Birds" from *Poppins*, the song carries the film's thematic statement, but it's isolated to a musical moment and never returns as part of the story. Taken on its own, the film is charming and has entertaining moments, but unfortunately, that seems to be the extent of its ambitions.

Disney artist Peter Ellenshaw was brought on to *The Black Hole* as production designer. Ellenshaw had been working for the Studio as a matte painter, special-effects artist, art director, and production designer since the '50s. He'd won an Oscar in 1965 for his special-effects work on *Mary Poppins* and had more recently been nominated for art direction/production design for *Bedknobs and Broomsticks* and *The Island at the Top of the World*.

The Studio had neglected to mention to Ellenshaw that artist Robert McCall had already been working on design concepts for the film. In his memoir, Ellenshaw said: "Coming in to take over the art direction was very embarrassing to me. I had no idea that Bob had been working as the art director, and here was I being asked to do the same thing. I asked Ron Miller what he was going to do about it. He said, 'Bob will understand that you are taking over.' I don't know how they did this, but next time I came, he wasn't at the Studio. If I had known this was to happen, I would not have taken the job."[145]

Ellenshaw had years of service to Disney Studios under his belt. Writer Jeb Rosebrook was concerned that, because of Ron Miller's fierce loyalty to those in the Disney family, Ellenshaw may have been given power

over the film's story development as well as the visuals. It made Rosebrook feel he was at a disadvantage. "It was just like being in school," recalled Rosebrook. "Peter was your professor and you reported in. We would have meetings every week and go through what I'd written and Peter would make comments. I can't say we were real chummy."

But Ellenshaw had a different perspective on the story's development. "Special-effects people aren't story people particularly," he wrote in his memoir. "We'd discuss what we thought about space but the story itself was left up to the writers. Ron Miller was constantly unhappy with the story, but at each of our weekly meetings, it seemed to be no different than the week before."[146]

Matte painter and production designer Peter Ellenshaw.

To make matters worse, director John Hough left the project, ending the creative collaboration Rosebrook had enjoyed so much. "I don't know whether he just got tired of waiting or whether Miller got tired of *him* waiting or Ellenshaw got tired of Hough," said Rosebrook. "I wish he'd stayed [and] that we could've both gone through the whole thing." Rosebrook continued writing on his own with Peter Ellenshaw and Chris Hibler to guide him. He wasn't sure if Ron Miller ever saw his script pages.

Harrison Ellenshaw, Peter's son, returned to Disney to run the matte

painting department for *The Black Hole*. He had come to Disney in the early '70s but had left to be a matte painter on Nicholas Roeg's *The Man Who Fell to Earth* and then on *Star Wars*. In leaving George Lucas' film and returning to Disney for *The Black Hole*, Ellenshaw was moving away from the forefront of effects technology back to the old studio system and more traditional effects techniques. It would also be his first time working alongside his father.

Harrison would go on to supervise over 150 matte paintings for *The Black Hole*. He also was involved in brainstorming an ending for the film. Recalled Rosebrook: "[Harrison] and I got together several times because he felt, and I felt, that we should have a very challenging ending to what happens after you go through a black hole. I think that Harrison's idea was like they had ended up in the beginning of time. That was the whole idea. Which somewhat makes sense, I guess, that you had gone through a black hole to find the beginning of time."

The Fox and the Hound was given to artist Mel Shaw to do his usual story outline in pastel vignettes. He simplified the narrative and removed much of the violence from the source material. Recalled Dave Block: "We'd read the book and it was like, 'How did anyone think this would make an animated movie?' It's a real adult story. So, we were kind of scratching our heads about how that evolved into an animated Disney movie."

Reitherman and writer Larry Clemmons fleshed out Shaw's outline then assembled a story team that included Dave Michener and Burny Mattinson. The balance of tone would continue to be an issue throughout the evolution of the project. One of the sequences Mattinson storyboarded was the opening of the film, where a mother fox, chased by hunters, drops her

baby safely by a fence post and continues running. To make it more dramatic, Mattinson added an offscreen gunshot, when the mother fox clears the frame. Almost the exact same moment happened in *Bambi*— sanctioned by Walt himself— yet both Reitherman and Ron Miller worried it was too violent for a Disney film. On the other hand, the first work that Frank Thomas and Ollie Johnston did on the film was the initial meeting of the young fox and hound, which could not have been more precious. Thomas and Johnston conceived and animated the entire sequence by themselves.

Reitherman continued advocating for Don Bluth and told Ron Miller that he wanted Bluth to be directing on *The Fox and the Hound*. However, Miller was also getting his ear bent by many of the CalArts/Rat's Nest folks. These groups did not want Bluth to have further leadership opportunities at the Studio. "CalArts did not want me in that position," said Bluth. "They were very vocal about it, and Ron started listening. I don't know what they were saying. And Ron met with me and said, 'They don't want you to direct.' And I said, 'Well, if they don't want me to direct, I don't want to direct *them*.' It would be painful and nothing good could come out of that. So, what I said is maybe I should go down and animate and see what happens. And so, I went back to my desk and animated, but I knew that wouldn't satisfy me."[147]

As Frank Thomas and Ollie Johnston finished their sequence of Tod the fox meeting Copper the hound, they decided to retire from animating. Recalled Glen Keane: "I noticed that Ollie's hand was beginning to shake a little bit. But he loved animating. I think that they would easily have made it all the way through *The Black Cauldron* and would've been part of our team on *The Great Mouse Detective* and all the way through up to who knows. Maybe they

wouldn't have gotten old quite as fast as they did." The two maintained a presence in the building. They moved into an office on the second floor to begin writing and assembling materials for a book about the history and principles of Disney animation. With Larson still focused on training, Reitherman was now the last of the original Nine Old Men working on the productions.

The generation behind Reitherman's— even though they hadn't been elevated to Nine Old Men status— was full of talent and had been contributing to the animated features he'd been directing throughout the '60s and '70s. Reitherman had worked closely with animators Eric Cleworth and Julius Svendsen. Recalled Mattinson: "Julius was a great big, tall Swede. Nice guy! Sweetheart of a man. Wonderful animator. Cleworth [was] too. Cleworth did beautiful animation." Both men had started animating at the Studio in the '50s and worked in story on *The Aristocats* and *Robin Hood*. Another tried-and-true animator was Hal King, who came to the Studio in the '40s. King cut his teeth on shorts and afterward, animated on features. He rose to the position of directing animator on *Lady and the Tramp*. Baer recalled: "Even though Hal King wasn't one of the Nine Old Men, he was one of these guys that you felt comfortable going to because you knew you weren't going to get put down about what you did. One of Hal King's famous quotes to me was, 'You know, there's a thousand ways to do this. Let's take *yours* and let's make it work.'"

And of course, there was Cliff Nordberg, who was directing animator on *The Small One*, despite Bluth's ongoing negativity toward his work. Recalled Ron Clements: "I was going into Don to show him some scenes and Cliff Nordberg was in there before me, and Cliff was showing his scene, and Don was very complimentary. Cliff left and Don says to me, 'Ugh! It's terrible.'"

After *Robin Hood* was completed, this middle generation of talent began to thin out. Hal King retired. Reitherman had considered making Eric Cleworth the director for *Winnie the Pooh and Tigger Too* but changed his mind and gave it to John Lounsbery. Cleworth then decided it was time to leave. Recalled Mattinson: "Just prior to that, there was a big buzz of everybody buying mutual funds. Well, Cleworth believed in mutual funds so much, so he put up his house, his cars, everything. He put everything he had into mutual funds...and they went through the roof! That same time is when Woolie said, 'No, I'm gonna have Louns direct.' [Cleworth] said, 'Well, I'm retiring,' and he cashed in all his mutual funds and became like a millionaire. He went down to Mexico with his wife, and he lived there for a number of years and built a hacienda and just had a great life down here."

Sadly, Julius Svendsen died in a boating accident. "He took a vacation with his boys up in Sacramento," recalled Mattinson. "They got a houseboat on the Sacramento River, and they were up there for a couple of weeks and suddenly we got news that he was dead. We were all absolutely shocked because he was such a big, lovable guy." Cliff Nordberg passed away at the end of 1979, after having been promoted to supervising animator on *The Fox and the Hound*.

This left Reitherman with—in the words of Glen Keane—a "team of young whippersnappers" to draw talent from. Keane continued: "It was the week after Frank and Ollie had retired and it was Monday. On the Moviola, [Woolie] had *The Fox and the Hound* and I had a sequence with Tod and Vixey where they were supposed to meet. And Woolie's going through shot by shot and stopping at various scenes and he's like, 'Well, we got to cut *that* out of the film.' I said, 'Why?' [Woolie said], 'Nobody here can animate it. Ollie was the only one who could do *that*.' 'I'd like to try.' 'No.' And he just kept going. Absolutely no confidence at all in my abilities and I guess

rightfully so, maybe."

"He was losing his confidence," confirmed Mattinson. "You could tell Woolie's assurance wasn't there. He was really depending more and more on myself and Vance [Gerry] and the story guys that were working on the film. And a lot on Mel Shaw and of course Larry [Clemmons]." But even Clemmons retired around this time, leaving Reitherman without his writer and story partner who'd been at his side for years.

There were two men left from this middle generation that Reitherman could still rely on— animator Art Stevens and story man Ted Berman. They had worked with Ward Kimball on his last few projects and were now working under Reitherman on *The Fox and the Hound*. Berman had started as an animator but transitioned into Story in the late '60s. According to John Musker: "He was a nice guy. He was…kind of vague. Ken O'Connor, the great layout man, said, 'I never was overly impressed at an abundance of gray matter from Ted.'" Stevens had been an animator since the '50s and also designed and animated many of the title sequences that the Studio used on their live-action comedies throughout the '70s.

In contrast to Berman, Stevens had more of an edge to his personality. Dale Baer found this out firsthand on *Robin Hood*. Reitherman decided some of Stevens' animation of Little John fighting rhinos needed to be redone and he wanted Baer to do it. Baer recalled: "Woolie had called me up and asked me if I wanted to do it and I said, 'Sure,' and I said, 'Do you want me to do the rhinos too?' and Woolie said, 'Good question!' So, he calls up Art Stevens and says, 'Dale's going to be redrawing your Little Johns. What do you think about him redrawing your rhinos?' I thought, *Oh, that's not a good idea!* And I went down there and [Art] laid into me so violently, it scared the crap out of me. So, he didn't speak to me for the longest time." Mattinson adds: "Art was one of those people that could really fool you. You had to be careful with

Art. He could smile in your face and act like your old buddy, but he could be vengeful and remember things."

Art Stevens never quite got used to the amount of scrutiny Reitherman gave his animation. "Woolie of course would sit there on the Moviola— which he loved doing—and run [Stevens' animation] back and forth," recalled Mattinson. "I could feel there was an animosity between Art, who didn't want to tackle Woolie or make a confrontation. He bristled when [Woolie] would go over a scene. But there was no doubt, Woolie could take any scene that Art gave him and make it live and work because he would say, 'Take two frames out of there, do this,' and the whole thing would look so much better." Ted Berman felt a similar pressure under Reitherman's leadership as the role of the story artist became more utilitarian and less creative. "He was always under Woolie's thumb," recalled Mattinson. "You'd go into [Ted's] room, and he'd have all these Pepto-Bismol bottles, and they were all piled up. Empties. Poor guy was run through the mill."

As members of the generation who *weren't* the Nine Old Men, it could be frustrating to watch opportunities and accolades pass them by. Stevens, in particular, seemed frustrated about having to live in their shadow. "Art would come down to my office all the time and I'd talk about how wonderful Frank and Ollie were," recalled Glen Keane. "Art would always remind me about how they never had the time of day for him."

Marc Stirdivant enjoyed being part of the live-action Story Department. Still, he hoped it could serve as a stepping-stone to other things. He wanted to become a producer, but in the short term, he found an opportunity to try his hand at writing. He had a strong reaction to an outline that came across

his desk, written by novelist and screenwriter Ernest K. Gann. Stirdivant took the outline and expanded it into a fifty-page treatment in about a week, then gave it to Frank Paris. Paris gave it to Ron Miller, who was impressed with Stirdivant's writing as well as his initiative. Producer Jan Williams was assigned to the project, which became known as *The Last Flight of Noah's Ark*. Stirdivant didn't receive credit or payment for his writing, but his efforts earned him a spot on the Studio's radar. He also gained the opportunity to cultivate a relationship with Williams, whom Stirdivant described as: "Great guy. Very funny. Very down-to-earth. Good story mind. Thoroughly enjoyed working with him."

Another project on Williams' desk was a science-fiction novel the Studio had bought, called *The Game of X* by Robert Sheckley. Stirdivant and Williams took Sheckley's story of an American everyman who gets pulled into the world of spies and espionage and added their own elements. Recalled Stirdivant: "Jan and I came up with all of these ideas that he would be a cartoonist and the things that he would do would be based on these kind of spy comics that he wrote. I did a treatment on it, and we called it *The Istanbul Express* and I did that for free. It was like another fifty-, sixty-page treatment where we put in all these crazy ideas, and they bought that from me and then hired me to do the screenplay." Miller wanted to move Stirdivant into an associate producer role, so Stirdivant left Frank Paris and the Story Department. He moved into an office on the third floor of the Animation Building, where he began looking for material to adapt. Stirdivant said, "I remember actually apologizing to Frank. I said, 'I'm so sorry. I'm going to leave you a vacuum here,' and he goes, 'Are you kidding me? This makes *me* look good!'"

Return From Witch Mountain poster concept.

1978

The Studio released *Return From Witch Mountain* in March 1978. This was a sequel to the successful 1975 film *Escape to Witch Mountain*. Once again, Jerome Courtland was the producer and John Hough was back in the director's chair, having stepped away from *The Black Hole*. Ike Eisenmann and Kim Richards reprised their roles as Tony and Tia. This time, they returned to Earth to visit Southern—rather than Northern— California. Hough had created such a safe environment for the two child actors on the first film, they were thrilled to hear they would be working with him again. Said Eisenmann: "When I found out John was directing again, of course I was excited because it would be like, 'Okay good, this is gonna be the same kind of family environment.'"[148] Richards added: "I look at John as almost like a father figure [or] uncle. Seeing him again was really exciting."[149] "We just went, met up, laughed and joked as if we'd just finished filming the other film,"[150] remembered Hough.

Writer Malcolm Marmorstein came on board to write the script and Kevin Corcoran became the film's associate producer. There were also new faces in front of the camera, with screen legends Bette Davis and Christopher Lee adding their star power to the roles of the film's villains.

Return From Witch Mountain does not live up to its predecessor. The catalyst for the story is that Tony and Tia arrive in Los Angeles for vacation. That's all. There's no other narrative drive. The siblings are quickly split up when Tony is abducted by Lee and Davis' cardboard baddies, who see his powers as a means to take over the world and get rich. Tia searches for her missing brother, finding help in an L.A. street gang. Given that this is a Disney movie, the gang is made up of kids, rendered with all the complexity of sitcom characters, with names like Muscles, Crusher, and Dazzler.

The star power and charisma of Christopher Lee and Bette Davis is undeniable, yet their inclusion throws the movie out of balance, sidelining Tony and Tia in favor of the two screen legends. Whereas the first film was all about the siblings decoding their faded memories to find out who they are and where they come from, this film reduces them to one-note B-level characters. For the entire film, Tia simply shouts "Tony!" as she sees visions of his whereabouts. Tony does nothing but stare into space, his mind under the control of Lee and Davis. The strongest idea in the film is pitting Tony and Tia against each other, in an inversion of the tight bond the siblings had in the first film. Even though their actual confrontation doesn't happen until the climax of the sequel, the marketing campaign made it seem like it was the central conceit to the whole film.

Christopher Lee and Bette Davis make their ransom demands in Return From Witch Mountain.

That same month, writer Jeb Rosebrook was taken off *The Black Hole* and let go from the Studio. Rosebrook was blindsided. He had never gotten a sense from Frank Paris or producer Chris Hibler that there were issues with his pages. The only thing that had changed was that director Gary Nelson had come on board to helm the project. At first, Nelson had turned the project down, having been unimpressed with the script. But Ron Miller persisted and invited Nelson to come to the Studio to look at Peter Ellenshaw's concept paintings. Recalled Nelson: "We met, and he showed me these paintings of different hardware and some renderings of different scenes, and I thought,

This is magnificent. I had never seen anything quite like it. Peter Ellenshaw, in my mind, was a genius. Just the idea that we could put something like that on film was enough to make me want to do the picture. Which I signed on to do."

Like Rosebrook, Nelson was an unusual choice. He had no experience in the science-fiction genre. Even so, Miller seemed to have confidence that he was the right man for the job. The film was deep in preproduction and began shooting in the fall of 1978. Rosebrook was ready to roll up his sleeves and collaborate with Nelson like he'd always done, but it wasn't to be. "I was working towards the ending. I just kind of indicated what I thought it would be like going through [the black hole]. I never got to write the ending. I guess I had no inkling what was going to happen to me."

Eli Bloodshy, one of three roles played by Jim Dale in Hot Lead and Cold Feet.

Hot Lead and Cold Feet was a big release for the Studio that summer. This was a comedic Western starring Jim Dale, Don Knotts, Karen Valentine, Jack Elam, and Darren McGavin. After his turn as the comic villain in *Pete's Dragon*, Dale played three roles in the film— two twin brothers and their elderly grandfather. Robert Butler came on board as director, his previous films for Disney being the first two Medfield/Dexter Riley films, *The Computer Wore Tennis Shoes* and *Now You See Him, Now You Don't*. Hot Lead and

Cold Feet was Butler's last major project for Disney. He moved into television, creating the hit show *Remington Steele* that launched the career of actor Pierce Brosnan.

The second wave of CalArts students hit the Studio in the fall of 1978. Chris Buck, Mike Giaimo, and Tim Burton, who left the school after their second year, and Darrell Van Citters, who had just finished his third year, were in this new group. When they walked through the doors of the Animation Building, these four realized that the place appeared to be frozen in time. Mike Giaimo recalled: "…As a twenty-two-year-old, I thought *everything's so old!* The phones were still those old heavy Bakelite phones with not even the coiled cord. The old linoleum on the floor. Even though Kem Webber designed the building and the furniture, I just looked at the streamline furniture and thought, *wow, it's not even modern!* So, nothing changed in that building since what, '39 or '40, whenever the building was completed."

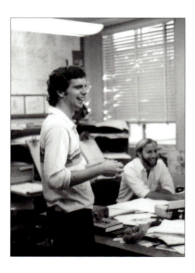
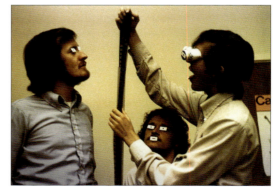

Left: *Chris Buck and Mike Giaimo.*
Right: *John Musker, Jerry Rees and Darrell Van Citters.*

They would soon learn that the aesthetic of the Studio was not the only feature of Disney that was stuck in the past. According to Van Citters: "Ron [Miller] was scared of his own shadow...because 'What would Walt do?' Walt had been dead for over ten years. People were still running that place as 'What would Walt do?' And it was always like third-generation photocopies of what Walt was doing. It was awkward."

The July issue of the Studio's internal newsletter, *The Newsreel*, provided a glaring example of how sidelined innovation and artistry were. The issue's cover paid tribute to the recent passing of an executive accountant, complete with a picture and a full article about the man. By contrast, a tiny blurb on a later page quietly announced the passing of Mary Blair, animation concept artist and designer of It's a Small World. "This bean-counter got so much attention and Mary Blair was so minimal," said Giaimo. "It was just so indicative of the time. It was about trying to keep status quo, and it wasn't about invention, and it wasn't about artistry. The Studio was in a period of stasis. I think [none] of us from CalArts [knew] how much stasis...really was there."

The inertia seemed insurmountable, but there were voices trying to disrupt it. One of those voices was Eric Larson. "Eric didn't want to repeat the past," recalled Chris Buck. "He saw what was in all of us and I think he understood, 'Hey, *we* didn't repeat the past. We were the guys on the cutting edge back then. And now *you* guys need to be that.'"

Frank Thomas and Ollie Johnston continued to advise the new artists, even though they weren't official mentors. Buck continued: "When we would talk to them, it was always 'Make it your own. We did our thing. That's us. You don't have to keep doing us. And redoing us.' They didn't want us to tell the same stories."

Partway through *Fox and the Hound*'s production, director Woolie

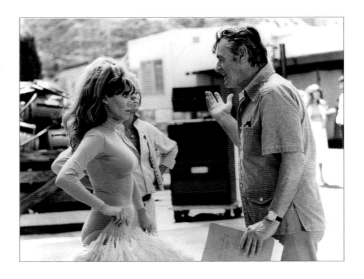

Singer/actor Charo on the Disney lot, filming live-action reference for The Fox and the Hound with director Woolie Reitherman.

Reitherman decided to add a song in the second half to remedy what he saw as a pacing issue. He created a musical number sung by two cranes, voiced by Phil Harris and popular Latin entertainer of the day Charo. They recorded a demo and the sequence was storyboarded and screened for the crew. Darrell Van Citters remembered: "We came back in our bullpen, and we just went, *Aaaaaaagh!* I mean it was so bad."

Reitherman brought Charo to the Studio to film live-action reference for the animators to use. Recalled David Block: "We all filed out one day onto a soundstage to watch Woolie choreograph this thing with Charo. It was one of these wickedly hot days. They had fans on in the soundstage, but Charo was just sweating like mad, and she wasn't wearing anything under the shirt and Woolie was having the best time with it. But it was a terrible sequence." Added Van Citters: "Out of the big seven studios, we knew we were number seven. When we looked at stuff like that, we knew *why* we were number seven."

As had happened before, people called Reitherman's preferences into question. Said Van Citters: "His taste in filmmaking was [that] he

generally would go for the burlesque in things like that, rather than class, or even cinema, sometimes." Previously, when Milt Kahl had raised hell about the Colonel Bullfrog sequence in *The Rescuers*, Reitherman had Frank Thomas, Ollie Johnston, and Larry Clemmons in his court to back him up. Now Reitherman had no one.

Mattinson recalled: "Apparently, Art [Stevens] and Ted [Berman] went to Ron and bad-mouthed Woolie. They wanted to direct, and they seized on the opportunity to bitch to Ron Miller, who felt like Woolie was getting old and they needed to get some new blood in there. So, Ron apparently called Woolie up and said he wanted to give these guys a chance. They'd been around a long time, and they deserved a chance." Dale Baer said: "I think there was some bitterness because they didn't get to where they wanted to be, *when* they wanted to be there. And so now when they had this opportunity late in their careers, they didn't want anyone standing in their way. Why they had a vendetta against Woolie, I have no idea. Woolie was the fairest person, director-wise, I've ever worked with [at Disney]."

"It broke Woolie's heart," said Mattinson. Regarding Stevens and Berman, he added: "I had liked them before...but after that, there was another side of them."

Dave Michener was also going to direct on *The Fox and the Hound*, alongside Stevens and Berman, but was pushed out of the position when a man named Rick Rich filled the third director spot, instead. Rich had started at Disney in the mailroom and became Art Stevens' assistant director. Don Hahn, who had been an assistant director for both Don Bluth and Woolie Mattinson, described the assistant director role as: "...like a personal assistant almost. I got coffee, I would pay their gas bill, I would do anything they needed. I would clean his Moviola screen and make sure Woolie had cigars and I would sit in story meetings and take notes. I would work on recording

sessions and take notes there."[151] It was an important job but not one that was considered creative. When people saw Rich become a full-fledged director— a job that *was* creative— it made an impression. Said John Musker of Rick Rich: "I think he kind of got Art's ear, and Art relied on him as a sounding board and he would offer suggestions, so Art kind of groomed him to be a director."

This created friction between the artists and Art Stevens and Ted Berman. Said John Musker: "We didn't get along with them, generally. Brad [Bird] clashed with them repeatedly. They just didn't kind of get what a lot of us were doing." Not everyone had ill feelings toward the two directors. Heidi Guedel was assigned to Art Stevens' unit when she was animating on *The Fox and the Hound*. She found Stevens to be supportive and willing to give her opportunities to shine. "He encouraged me and approved of everything I did," said Guedel in her memoir. "Art...planned to assign me an especially touching sequence in which [Widow Tweed] leaves Tod alone in the woods. My work on *The Fox and the Hound* was the best I'd ever done for Disney and I was being treated with increasing respect."[152]

Woolie Reitherman remained on the film as the producer, but it became clear that he would have trouble staying in his lane. For example, Art Stevens assigned a sequence to Glen Keane and encouraged him to thumbnail the entire thing himself. When Stevens showed Keane's work to Reitherman, he vetoed the idea. This left Stevens feeling powerless as a director. Ultimately, Reitherman was taken off the film. However, he stayed at the Studio and worked with Mel Shaw to develop *Musicana*, a follow-up to *Fantasia*.

Musicana was to consist of short segments set to music, just like Walt's 1940 film, but Mel Shaw and Woolie Reitherman wanted to do something different. The two men decided to base each segment on a myth or folktale

from around the world and accompany that with corresponding music from that country and culture. Breaking with the original film's concept of using only instrumental music, Reitherman and Shaw suggested using songs with lyrics. For example, they proposed a South American piece with a song by Yma Sumac and a Dixieland jazz piece by Louis Armstrong and Ella Fitzgerald.

Despite their ambitions, the two were unable to get *Musicana* off the ground. Reitherman eventually retired and left Disney for good, bringing the era of the Nine Old Men to a close. "It was sad to see that generation move on," recalled Glen Keane. "Not valued. Just not managed. Not cherished." Now Art Stevens and Ted Berman became the senior leaders of the Animation Department, and the younger generation of artists gradually gained more responsibilities.

Director Gary Nelson began assembling his cast for *The Black Hole*. As he worked with the casting director, Nelson was surprised at the pushback his suggestions received. Often his ideas would be rejected simply because casting had never heard of the actor he recommended. Nelson recalled: "One idea I had was Sigourney Weaver and [the head of casting] said, 'What kind of a name is that? That's not a Disney name.' I thought that's kind of fucking weird." Ultimately, actors Joseph Bottoms, Robert Forster, Anthony Perkins, Ernest Borgnine, and Maximilian Schell were all signed.

The biggest snag in casting came with the role of Kate, the female lead. An actor named Jennifer O'Neill was cast in the role. Her long hair made the opening scene depicting the crew floating in zero-gravity difficult to make convincing. Nelson asked her to cut it so that it would make the illusion easier to achieve but O'Neill refused, her long hair being part of her

fame as a former Cover Girl model. Nelson continued to pressure her and finally, after she'd had a few drinks with her hairdresser, O'Neill agreed to cut it. Unfortunately, her struggle and ultimate compromise regarding her personal appearance turned out to be for naught. On her way home from the Studio that night, O'Neill was in a car accident and unable to continue with the film. Yvette Mimieux, who had short, curly hair, was hired to replace O'Neill. The film would shoot from October 1978 through April 1979.

The Small One was released in theaters for the 1978 Christmas season, attached to a rerelease of *Pinocchio*. The short film had a particularly strong effect on a young artist named Mike Gabriel, who had been repeatedly rejected by Disney after multiple application attempts. "I went to *The Small One*," he recalled. "I just sat there and hated every second of that. And I knew [Disney was] off the rails. I knew this wasn't good. I thought, *I am better than this. I guarantee I'm better than this. They can't turn me down if they're putting this kind of stuff out*.'" Gabriel stayed the course and applied again. Finally, Disney accepted him.

With *The Small One* in theaters, rumors circulated that Don Bluth wanted to leave the Studio. But, according to Ron Clements: "Ron Miller said...Don promised him that that was not true at all...he had no plans to do that and that, if he ever did leave the Studio, Ron would be the first to know. That was just not true...."

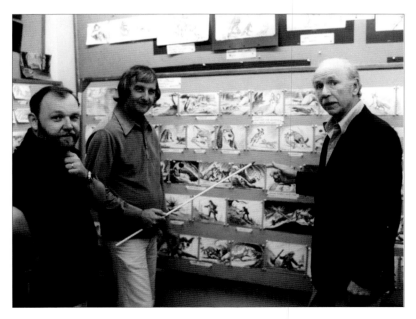

Top: Mel Shaw, singer/actor Pearl Bailey and Woolie Reitherman share a belly laugh.
Bottom: Burny Mattinson and Dave Michener pitch a sequence to actor Jack Albertson, voice of hunter Amos Slade in The Fox and the Hound.

1979

The Wonderful World of Disney aired new films throughout the year. *Donovan's Kid* premiered in January, teaming up Disney regulars Darren McGavin and Mickey Rooney. They played two con men in 1900s San Francisco. It would be the last Disney film directed by Bernard McEveety before his full-time return to television on shows like *The A-Team, Knight Rider,* and *Simon and Simon.*

Shadow of Fear was another film for the Sunday night show. It starred Ike Eisenmann, who'd played Tony in the *Witch Mountain* films and had appeared in many other Disney productions. The film also starred Lisa Whelchel, who had been one of the new Mouseketeers in the short-lived *The New Mickey Mouse Club* that aired in 1977. In just a few months, Whelchel would become a star on the hit sitcom *The Facts of Life.*

It was clear that *The Black Hole* would be a complex special-effects picture. Disney still operated under the old system, with their established craft departments nestled inside the Burbank lot. There was no need to search for outside facilities to provide special effects. So, the team of Peter Ellenshaw, Art Cruickshank (miniature photography), Danny Lee (mechanical effects), and Eustace Lycett (compositing)— each Academy Award winners—did all the effects work on the film. Rounding out the team was Harrison Ellenshaw, who was in charge of matte paintings.

After Jeb Rosebrook left *The Black Hole*, another writer, Gerry

Poster art for Herbie Goes Bananas by artist Paul Wenzel.

Day, came on to do rewrites. She was a veteran of television dramas and Westerns. She had also rewritten Rosebrook on his first writing assignment, on the television series *The Virginian*. Despite her contributions to the script, *The Black Hole* went into production without an ending. The title and the premise promised a trip into a black hole, but the team had no sense of what exactly that would that look like. Rosebrook and Harrison Ellenshaw had brainstormed many versions. All the ideas pointed toward a cerebral and existential conclusion, more *2001* than *Star Wars*. The idea that initially went forward had the journey into the black hole immediately followed by a close-up of two fingers touching. Then, the camera would pull back to reveal that it was the ceiling of the Sistine Chapel, with Yvette Mimieux's character, Kate, staring up at the image. Peter Ellenshaw went to Rome and shot the footage but eventually the idea was scrapped in favor of what became the final version—the heroes go to heaven and the villains go to hell.

Chicago-based film critics Roger Ebert and Gene Siskel were consistently underwhelmed by the Disney films of this period and spoke frankly about their disappointments on their movie review program, *Sneak Previews*. On a segment dedicated to the newest Disney live-action comedy, *The North Avenue Irregulars* (released in February 1979, Gene Siskel introduced the film by saying: "There's a report out of Hollywood that Disney Studios is going to try to make a wider variety of movies in the future, not just its usual juvenile slapstick stuff for kids who like to see people fall on their faces, see cars split in two, and dogs fly through the air. Well, after seeing *The North Avenue Irregulars*, it's easy to see what the Disney folks are finally realizing—they've got to modernize their material. It's wearing awfully thin now. *North Avenue Irregulars* is thoroughly mediocre."[153]

In the Animation Building, at the top of its center staircase, was an employee library. It had been a fixture of the Studio for many years, as evidenced by the number of books that bore Walt Disney's signature on the checkout slips. Gale Warren, one of the librarians at the time, said: "There was a room with three desks for the researchers, and the counter to the side where you would check out books. We did research for the Art Department, the scenic designers, and people in Live Action and then for Animation, all the picture research. We were mostly picture research. We subscribed to over one hundred magazines."[154] Every two weeks, Warren curated a small art show inside the library, pinning work to the walls, which were lined with corkboard.

Warren was planning a summer trip to Great Britain with her sister. Before leaving, she needed to fill the empty time slot left on her art show schedule. Her fiancé John Musker and his animation colleagues, were chronic caricaturists. John constantly made her laugh with his drawings of her, which he'd used over the years as a flirting tactic. She told him to gather up all the caricatures he could find and build a show that could be slotted in for August.

While Warren was gone, Musker set up the show. "I was left to my own devices. There were a few rules that we created early on. One was that no caricature could go unsigned. You had to say who you were so you couldn't do a cheap shot. It had to be an expensive shot that would cost you later. I didn't want to put the names of the people right under the drawings when I hung it. I wrote the captions of who everyone was, but I put those off to the side so that you could kind of look and say, 'I think that's so and so' and you look over there and see if you were right. It's like a game. You guess who it is. Those were the only ground rules. There was relatively no censorship.'"[155]

When Warren returned and ascended the stairs to the library, she saw people spilling out of the doors. The library was packed with people laughing and pointing at about 150 cartooned likenesses of themselves and

their colleagues. Musker included many of his own drawings as well as work from Mike Giaimo, Tim Burton, and a young story artist named Joe Ranft. For the next two weeks, Warren could barely reach her desk due to the number of people crammed into the space. The show was a hit and became an annual event.

Once they'd finished their training program, Chris Buck, Mike Giaimo, and Darrell Van Citters were thrown into the cleanup inbetween pool. Eventually, each artist was picked by an animator to be their assistant (Van Citters with John Musker, Giaimo with Andy Gaskill, and Buck with Brad Bird). Now, in the thick of production on *The Fox and the Hound*, they could watch the power dynamics between the three factions that had formed: the CalArts gang (and those allied with them), the Bluthies, and the directors— Berman, Stevens, and Rich. The most prominent question on everyone's mind was which faction would be the ones to lead Disney animation into the future, and in what direction would they take it?

Jerry Rees also became an animator and was assigned to the character of Dinky, a small bird who served as a comic relief in *The Fox and the Hound*. Rees took his inspiration from real life. He studied the birds he saw every day on the Studio lot, amazed at the speed of their movements in contrast with their states of stillness in between. He worked at translating that movement into his animation, using blur frames and other techniques typically reserved for broad cartoons, rather than the sophisticated feel of Disney animation. When Rees played his scenes, everyone was amazed at the results, including the directors. That is until Rees flipped the individual drawings and the directors saw those blurred and stretched inbetween

drawings. Their response was that those animation techniques were too cartoony and therefore inappropriate for a Disney feature. Rees argued that in motion, no one sees those frames. They *feel* the motion, which was all that mattered. His argument fell on deaf ears. Going forward, he had to sneak these tricks into his animation and make sure his scenes were inked and painted onto cels before they could be caught by Berman and Stevens. Rees couldn't believe that after having been trained to draw from real life, he was being punished for doing exactly that.

Bluth and his group continued moving in the opposite direction, staging live-action reference for their sequences, using each other as the performers. They acted out the business then rotoscoped the footage (traced it onto animation paper). This got under the skin of the altruistic CalArts students. Said Chris Buck: "We felt like that just wasn't true to the art form. And we were seeing rotoscoped scenes that they animated that just had lost a lot of life and we felt that it was being used as a crutch." Added Van Citters: "Don's focus seemed to be more on motion than *emotion*." Yes, in the past, the Studio was known to film live-action reference for their animators to use. But reference is one thing. Tracing animation from live-action footage was blasphemous.

Animator Brad Bird was frustrated with Bluth and his way of doing things. Ron Clements recalled that Bird would often come into his office, plop down in a chair, and vent his frustrations. Eventually, Bird hit his boiling point and was heard marching up and down the halls yelling, "No more roto! No more roto!"[156] One account of the incident says that Bird took an empty Sparkletts water bottle and banged it against the floor repeatedly. Another account claims that he took said Sparkletts bottle and hurled it down the hall. Either way, his tantrums raised the ire of some older folks. They complained to Ed Hansen, who in turn fired Bird.

Brad Bird's self-caricature.

However, Bird was quickly snapped up by Lisberger Studios, based in Venice, California. This small animation studio was in the midst of a hiring frenzy as they were knee-deep in production on an original animated feature called *Animalympics*. Steven Lisberger, director and creative leader of the studio, had recently relocated himself and his small staff from Boston to Los Angeles. Being new in town and not knowing a single soul in the animation community, they scored an enormous win by getting an ex-Disney artist like Bird to animate on their film.

Bird's former colleague Bill Kroyer, who had left Disney due to his lackluster experience on *The Fox and the Hound* and a disinterest in working on *The Black Cauldron*, was already at Lisberger Studios. Kroyer and Bird, as well as many other local artists recruited by Kroyer, fit in well with Lisberger's existing team, made up of Boston artists like Peter Mueller, Roger Allers, and John Norton. Norton was a jack-of-all-trades for Lisberger, doing story development and art direction, as well as both effects and character animation for *Animalympics*.

Several years earlier, while they were still in Boston, Norton designed and animated a television advertisement for a local rock radio station. The commercial starred a neon warrior, brought to life through animation that was lit from underneath, creating a glowing effect. Norton recalled: "Steve [Lisberger] started calling the warrior Tron, from the word 'electronic.'" The

commercial was so successful that it won a 1978 Clio Award for Best Station I.D. in the U.S.

Lisberger began dreaming up story concepts for a feature film that could star the Tron character and be produced through a mixture of hand-drawn backlit animation and the newly emerging technology of computer animation. Lisberger and his team researched the computer technology of the day, bringing in consultants like Alan Kay, inventor of the first laptop computer. Lisberger also hired writer Bonnie MacBird to help write the script (Kay and MacBird would later marry). As the *Tron* project took shape, Lisberger's hope was that *Animalympics* would be a huge success, giving them the funding they'd need to make their *Tron* film independently.

Like Jerry Rees, Glen Keane's animation inspiration derived from some non-Disney ideas. Keane was a rabid fan of Tex Avery, director of many beloved cartoons from Warner Bros. and MGM. He loved to study how Avery's animators used blur, stretch, and multiple-image frames to accent their work. Keane had a sequence

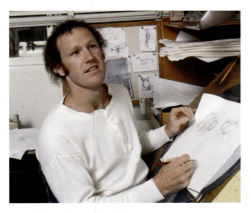

Supervising Animator Glen Keane.

where Tod the fox is trying to catch a fish and slips and falls into the water. Since the action he was animating was broad, he put these techniques into practice in his scene. Keane recalled: "Tod is in this log and the fish goes down between his legs and I had him split into two for a second, which was

causing terrible, terrible chaos in the cleanup department because I was doing things like that."

The idea of combining different schools of animation to create something new was exciting to Keane. Not everyone agreed. At one point, animator John Pomeroy paid him a visit. Keane remembered: "He was really angry with the animation that I was doing. He came in shaking, so angry with me. He said, 'Glen, I've got to talk to you.' He said, 'You have personally just set animation back forty years. You are just showboating. Grandstanding. I just don't know what to say but I just had to come down and say this,' and he got up and left."

Shortly after that, on September 13, 1979, Don Bluth, John Pomeroy, Gary Goldman, and fourteen other artists marched into Ed Hansen's office. One by one, they resigned from Disney.

One of those fourteen artists was Lorna Cook. She'd been in a difficult position. The three men had hashed out their plans to leave Disney unbeknownst to her, so the news came as a huge shock. She had worked so hard to get back into Disney, after initially being let go, and had now made it to the rank of animator. How could she walk out on that? However, she'd grown to love and respect Bluth's art and leadership. Complicating things even more was that she and John Pomeroy had recently gotten married. Staying at Disney while the others left was out of the question and would have spelled certain doom for her marriage. She had no choice but to get in line and tender her resignation. Cook was in the latter half of the group of defecting artists so, by the time it was her turn to talk to Hansen, he was fuming. "The daggers," she remembered. "I just could feel it. I genuinely liked Ed Hansen a great deal. I like people and I don't like disappointing them, and I did not want to feel like I was an ingrate, which I was *not*."

Heidi Guedel also left with Bluth. Like Cook, Heidi felt the same kind

of anxiety as she arrived at the Studio that morning. "My intestines were cramped into throbbing knots," she recalled. "I had spent the night before crying and trying to make up my mind. It was terrible to contemplate walking into Ed Hansen's office and quitting...just after he had done me the honor of giving me my own office, my own assistant, and my own personal Moviola. I hated to disappoint Art Stevens, who had promised me such outstanding material to animate in *The Fox and the Hound*. We would all be walking out in mid-production, something...unheard of. I'd spent six years getting to this point at Disney Studios. How could I do this?"[157]

In her memoir, Guedel gives the painful details of her resignation. She and her assistant animator, Sally Voorheis, "walked into Ed Hansen's office together. We must have looked ashen. The exodus had already begun. Several of the other animators had resigned earlier that morning. When Ed saw Sally and I, he blanched...and...called Art Stevens and told him to come down to his office." They sat in uncomfortable silence until Stevens arrived. Guedel told him: "Art, I am so grateful to you for everything you've done for me. You have been wonderful to work for. If everyone else here had treated me the way you have, I would never even consider leaving.' Art Stevens' eyes filled with tears. Yet he never took his eyes...from mine. 'This is a painful decision. I hate to disappoint you, Art. I will always remember you and be grateful.' He nodded, extended his hand, and thanked me for what I said. Then he slumped back in his chair and looked down at his lap. Ed Hansen curtly instructed Sally and I to have our belongings out of our room before noon."[158]

Lorna Cook added: "They were roilingly, boilingly mad. I've never been hustled so fast out of a place in my life. They were like, *bam*, outta here. They were witnessing something that had never happened, and it was very bold and brave. There was something calling that required us to take action. We did it for the love of the craft, and we really wanted to see how far we

could push ourselves. [Don] did not live extravagantly. He was never money hungry. It was never that. It was all about the work. And getting better."

"I wanted to concentrate on the art," said Bluth. "I didn't want to fight wars. It turned into politics that turned into a battle for power and not really the art. I saw the writing on the wall, and I saw that whole group of kids from CalArts who were really, really excited about their own careers. What *they* wanted to do. So, you had too many cooks in the kitchen."[159] Added Darrell Van Citters: "Without CalArts it would have been a whole different story. Don would have taken the place in his direction. CalArts kind of ruined his plans."

Leaving Disney allowed Bluth the freedom to pursue animation the way he wanted to do it. He could preserve the classic Disney animation traditions he felt had been lost. The work he and his team had done in his garage on *Banjo* proved he knew how to produce animation and that he didn't need Disney's roof over his head while he did so. Because of the *Banjo* project, Bluth found investors in Aurora Productions, who were willing to put up several million dollars for a feature film from the recently formed Don Bluth Productions. "I have no regret," said Bluth. "I think it was something that had to be, and I think in the bigger picture, it helped everyone. I was able to be creative and feel free. All that's good."[160]

"[Bluth] was deep in his career," recalled Don Hahn. "He wanted to just cut to the chase. He felt like, 'We've had success in my garage. Let's just go do it,' and so he piled everybody in a pickup truck, literally, and took off. And it was seductive. If you were a young artist, he was an incredibly charismatic leader. So, he was worth following." Those who didn't follow were dumbfounded by the exodus. It was clear to everyone that Ron Miller was intending to give Bluth the keys to the kingdom. "He was going to be the new Woolie," continues Don Hahn. "[Bluth] assured them he wasn't leaving

and that he was there for the long haul. He really was the centerpiece for the new generation and then, very shortly after he promised that he would stay, he left. Ron felt very betrayed by it all because he had invested and trusted the whole studio to this guy."[161]

Many felt that Bluth had deliberately chosen to leave at a time when it would hurt the Studio the most—in the middle of a production. The staff on a film in those days was small and losing so many key artists was detrimental to *The Fox and the Hound*. The film's release date had to be pushed back a year. Ron Miller put on a brave face, but he was clearly rattled by Bluth's exodus, especially since it was widely covered in the media. Tom Wilhite, head of publicity, recalled: "It was a big embarrassment for the company because they went noisily. That, I think, was the intention. Disney is always a great big target, so you get more attention if you talk about not being appreciated by Disney."[162]

"Ron Miller gathered the troops up," recalled John Musker. "[He] said…'Well, the cancer has been removed,'" referring to Bluth. Musker continued: "Don Duckwall, who was [Miller's] head of production…got relieved of his duties. He sort of took the in-house fall. Like, 'You should've seen that coming. You should've headed this off. We just had twelve people walk out on your watch.'"

As everyone buckled down and worked harder to finish the film, all the negativity that had been felt from, and aimed at, Bluth and his group began to dissipate. Said Darrell Van Citters: "The irony is that for us, it felt like a breath of fresh air and management was in panic mode. 'Oh shit. What are we gonna do? We lost half the staff!' To us, we were looking at it, going 'So

what? You lost a few, but what they were doing wasn't in your best interest.' At least that's how we felt. So, to us there was no panic at all and it gave us a chance to do other things, open up opportunities."

Animator Jerry Rees would direct the opening sequence of *The Fox and the Hound*, where the mother fox leaves young Tod at the Widow's farm. Recalled Rees: "I was directing this sequence and had done something that I felt was very emotional and that would have been really powerful and impactful. It was conveying that the mother had protected the baby and then had been shot and [now] this [fox] was an orphan. It didn't show anything. It was as delicate as *Bambi* is. We were really being spurred on by new cinema. We were looking at Lucas and Spielberg and Coppola and those guys and we went, '*That* is legitimate storytelling.'" But directors Art Stevens and Ted Berman resisted the ideas Rees and his team put forth. They neither had the cinematic ambition of these young men, nor did they appreciate what the sequence implied. Said Rees: "Art and Ted...watched it and, at the end, they went, 'Well, she's dead.' And we went, 'Isn't that the story point?' And they went, 'Oh no, we have to make people think maybe she got away,' and I went, 'Really? Do you want to tell the story of a delinquent mom who abandons her cub? But they're like, 'No, no. We can't do that.' So right away, we put aside the cinematic thing."

Glen Keane was also in charge of his own sequence involving adult Tod and his love interest, Vixey. Keane had a lot on his plate due to the depleted animation ranks from the Bluth walkout and was feeling the pressure to complete the footage. He grabbed anyone whose work he liked and assembled a unit without the consent of management. One of his artists was Chris Buck, who had found himself without an animator to cling to since Brad Bird was no longer at the Studio. Another was an odd and quirky artist named Tim Burton. Keane's group was young, and were still inbetweeners,

but he gave them scenes to animate anyway.

Keane loved spending time with Buck and Burton, who were close friends from their CalArts days. Everyone loved Burton's work, particularly his personal sketchbooks. Recalled Van Citters: "He would go out to the [mall] on weekends, he would go anywhere, and he would just draw people. His sketchbooks were just full of these crazy caricatured people and were really cool. Really new and fresh, and we were just like, 'Wow, this guy's incredible!'" Burton's style was so unique he had trouble fitting his drawings into the traditional Disney style. Recalled Keane: "He was trying to do Vixey, and he was drawing these unbelievably sharp, long, pointed claws. And I was trying to draw these soft little teeth instead of razor sharp and he's got a thousand. We don't want to scare the kids with this."

Burton struggled to produce inbetweens and animation that matched what was required of him to be successful at the Studio. "He was so frustrated," recalled Buck. "I was Glen's assistant at that point, so I could kind of draw in the Glen style. Tim would come to my room all the time. He would give me a scene. He's like, 'Could you just draw over that and make it look like Glen's stuff before I go in there? 'Cuz I can't really do it.' So, I would help him out there. One time, Tim came into Chris' room and drew a fried egg with an

Tim Burton, Randy Cartwright and Jerry Rees work on their live-action short Luau.

anguished expression on its face. Buck asked him what it was. 'It's Fried Egg Man,' replied Burton. 'That's me.'"

Burton would vent his frustrations in other ways. One day, Buck came back to his office after lunch to get some work done. Burton had perched himself atop Buck's' desk in a vulture-like pose, sitting and staring down at his friend without a word. Another time, Buck went to Burton's office to see if he wanted to take a break and go for a walk. His chair was empty. When Buck asked Burton's office mate if Burton was around, she pointed to the coat closet. Buck opened it, and found Burton standing in the dark, staring straight ahead. Burton also began making short films during nights and weekends. A passionate fan of schlocky science-fiction and horror films, Burton created a Mexican wrestling horror film called *Doctor of Doom*. He enlisted his Disney colleagues to be the cast and crew, Van Citters starring as a monster and Buck as a female maid named Pepe Quesadilla. Later, he teamed up with Jerry Rees to direct *Luau,* a half hour send-up of the beach party movies from the '50s. This one starred new hire Mike Gabriel. Being from Huntington Beach, California, and the owner of his own surfboard, Gabriel was the perfect choice for the lead role.

Gabriel had applied to the Studio, motivated by this negative reaction to *The Small One*. He was hired at Disney just as the memories of Bluth and his team were fading. Even though Gabriel was not a CalArts grad, he became fast friends with members of that group, in particular, Chris Buck, Tim Burton, and Darrell Van Citters.

John Lasseter also arrived at Disney. Like Van Citters, Lasseter was a member of the inaugural Character Animation class at CalArts but, unlike Van Citters, he chose to stay an extra year in order to make one final student film. Now, after four years of schooling, Lasseter joined the ranks of Disney animation. Recalled Mike Gabriel: "Lasseter was...in the group with us...

He was always hanging in our offices. The baseball team we were on—The Disney Slugs— John was on that. Tim was third base."

Gabriel would attend employee screenings of the Studio's latest live-action releases with fellow animation artist Mike Giaimo, who would make fun of the films by laughing inappropriately loud at all the parts that weren't supposed to be funny. "We would kind of mock and ridicule how bad the live action was," recalled Gabriel. "And let's face it, even the animation we knew wasn't great. We knew it had great potential, great parts. So, we always felt like we weren't doing films anywhere near what we should be doing from the very beginning. I was right in line with the CalArts guys who definitely felt that way."

Marc Stirdivant's first big project, *The Last Flight of Noah's Ark*, began shooting in the fall of 1979 in California and Hawaii. As cameras rolled on that film, a news story broke that caught his attention. He recalled: "I'd seen an article in the *L.A. Times* about two East German families who had escaped to the west via a hot-air balloon that they'd built themselves in secret. And I thought that was consistent with this notion of 'Okay, it's a family story, it's a clean story, but it's a more exciting, more dramatic, more realistic story,' so I ran with that to Tom Leetch."

Stirdivant and Leetch took it to Ron Miller, and within a few days, a Studio representative was on a plane to Munich, where the two families were currently living, to negotiate the rights to their story. Writer John McGreevey was hired to begin work on the film. McGreevey was the father of Michael McGreevey, the young actor who'd appeared in countless Disney live-action films. The two German families— the Strelzyks and the Wetzels—

were brought to the Studio and each family member told their account of the events that led to their escape. With the help of a translator, Leetch, Stirdivant, and McGreevey devoured the details and frantically scribbled notes about what they felt needed to be in the film. In an attempt to keep Stirdivant on the path to producing, Miller made him associate producer on the film, now titled *Night Crossing*. Said Stirdivant: "That was going to be my apprenticeship so I could learn how to be a producer, what was involved. It was the responsibility of the Disney producer to both develop the project, be the creative overseer of the project *and* be responsible for the money as well. So, because I had brought *Night Crossing* to the Studio, Ron was good enough to assign me to work with Tom [Leetch]. Tom sort of became my mentor. Everything I learned about making movies, or having professional relationships with people who make movies, I learned from Tom Leetch."

Stirdivant helped with the script's development as well as preproduction and a portion of the filming in Munich. He and Leetch went to battle with the Studio about how the film would look.

"We shot in real places for a lot of it," recalled Stirdivant. "We had a British cinematographer, Tony Imi, whose work we had admired, and we told him we want a really realistic look. That story felt it didn't deserve the same look as *The Strongest Man in the World* and it was kind of a battle because the [feeling] was, 'Well, a movie like the one you guys want to make isn't going to look good in drive-in theaters. It needs to be hot. It needs to be bright because we play in drive-in theaters.' That was the argument at the time."

Director John Hough began work on his third Disney film; an adaptation of a 1976 supernatural thriller called *The Watcher in the Woods*. Producer Tom

Leetch had found the book of the same name, written by Florence Engel Randall. Leetch was impressed by the unique story as well as Randall's ability to defy the reader's expectations about which direction the story was headed. He told Ron Miller about the property, pitching it as "our *Exorcist*."[163] Hough's background in the horror and supernatural genres made him the perfect choice for director. Harry Spalding— writer of many supernatural and science-fiction films as well as several films for Disney— kicked off the script. Later, Hough brought in his colleague Brian Clemens, creator and writer of *The Avengers* television series, and the two continued developing the story.

 The supernatural thriller was not a genre that Walt had worked in, so it was unfamiliar territory for Disney. The *Witch Mountain* films were certainly a step in that direction, but those targeted a younger audience. The ambition for *Watcher* was to make something scarier. Something more adult. How far could Disney push the envelope without alienating its audience? Tone was a constant source of discussion. Clemens' draft was deemed too dark and sinister. Another writer, Rosemary Anne Sisson, came in to take the edge off and bring a more American sensibility to the dialogue. Eventually the script was approved and Hough and his team were given total freedom to put it on film. They shot almost everything on location in England, beginning in August 1979. Robert Wise's 1963 ghost story *The Haunting* had been influential to Hough when he had made *The Legend of Hell House*. He chose to pay tribute to that film by shooting *Watcher* at the same location—a mansion in Oxford. The ending of the film needed a fair number of special effects, so a set was built on a soundstage at Pinewood Studios to accommodate them.

Walt was quoted as saying, "You hate to repeat yourself. I don't like to make sequels to my pictures. I like to take a new thing and develop something, a new concept."[164]

For the most part, this was true, though Walt did make an occasional sequel. *Savage Sam* continued the story of *Old Yeller*, and *The Monkey's Uncle* was a follow-up to *The Misadventures of Merlin Jones*. During the period after Walt's death, the Studio leaned more on sequels. There was *The Shaggy D.A.*, a sequel to *The Shaggy Dog*. There was the Medfield trilogy, starring Kurt Russell as science nerd Dexter Riley. Cruella De Vil was under consideration to be the villain in *The Rescuers,* almost making that film a semi-sequel to *101 Dalmatians*. Successful films like *Escape to Witch Mountain* and *The Apple Dumpling Gang* each got a sequel. And one of the Studio's most profitable films in the post-Walt era, *The Love Bug*, turned into something of a franchise.

The fourth installment of the adventures of Herbie the enchanted Volkswagen Beetle began shooting in the fall of 1979. Charles Martin Smith was offered a part in the film and was happy to return to Disney. Said Smith: "You knew when you did a movie like that that you'd get paid really well and that there wasn't any pressure to deliver anything particularly. It was kind of a freebie for an actor. You didn't have to worry that if the movie flopped, you'd get blamed. So, they were just fun movies to do." Much of the filming took place in Puerto Vallarta, where the cast and crew stayed in a beachside resort. When Smith wasn't filming, he was lying at the pool having margaritas. The cast was full of wonderful comedians and character actors that Smith loved being around. He recalled: "Cloris Leachman [was] hilarious. Harvey Korman was very funny. He was a very unhappy guy, I always thought. He was funny to be around, but the grouchier he got, then he'd *really* be funny. Alex Rocco, who later became a friend, and Richard Jaeckel. We had Vito Scotti. He was so good. I remember as a young actor watching him do his thing

thinking, *Good God, this guy is good. Holy smoke!*"

Howard Green also stayed in Puerto Vallarta with the team, now in a new role as unit publicist. *Herbie Goes Bananas* was his first film in that role. Said Green: "I would be on set. We'd have press people come down and visit. We'd have the unit photographer that you'd be in charge of. You'd be interviewing all the different people—the filmmakers and the stars—to gather material for the production notes, press kits. [You'd] be the person that people could go to get the photos or know about the film. Be kind of a specialist within the Publicity Department about that film."

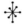

Animation continued on *The Fox and the Hound*. Once Bluth and his team were gone, John Musker began animating on the film's human characters, Amos Slade and Widow Tweed. Prior to that, he'd been working on the comic characters, Dinky and Boomer, due to his knack for broad, comedic acting. Ron Clements' talent lay in animating dramatic acting scenes but his interest in being an animator waned while working on *The Fox and the Hound*. He was becoming increasingly interested in story development and writing. As he'd done on *The Rescuers,* Clements sent in notes critiquing the film's story. One aspect that he took aim at was the fate of Chief, the canine mentor of Copper the hound. Late in the film's second act, a chase between the adult fox and hound leads to a large trestle bridge where Chief is hit by an oncoming train. Copper blames Tod for the incident and it sets in motion the final conflict between the fox and the hound. In the original book, Chief is hit by an oncoming train and killed. In Disney's adaptation, Chief is hit by the train but only suffers a broken leg. Clements—and many of the other young artists—felt that the choice to keep this character alive lessened Copper's

thirst for revenge toward Tod. Chief needed to die. They brought their case before Stevens and Berman, but their pleas went unheard. The directors were too afraid of shocking their family audience. Ron Clements recalled that the directors were "afraid it was just too dark, and darkness is always a question. Young people are never afraid to go too dark."

And in the case of these particular young people, why would they be afraid? They grew up on Walt's films, full of dark moments, frightening images and scenes of death. The wicked Queen's transformation in *Snow White*. Pinocchio caged by Stromboli and the horrific scene of Lampwick turning into a donkey. The cold permanence of the death of Bambi's mother by a hunter's gun. And this wasn't limited to his animated films. "A very primal movie for me when I was a kid was *Darby O'Gill and the Little People*," recalled John Musker of Walt's 1959 live-action film. "That had the banshee in it which terrified me. It was one of a number of things that terrified me, including Maleficent [from *Sleeping Beauty*]." And certainly one of the most unforgettable moments from Walt's body of work is the shocking ending to his 1957 film *Old Yeller*, where the young boy at the center of the story must shoot and kill his beloved dog, now infected with rabies.

Walt never worried about these moments being too frightening. He never sugarcoated his stories in order to protect children. "Life is composed of lights and shadows," he once said, "and we would be untruthful, insincere, and saccharine if we tried to pretend there were no shadows. Most things are good, and they are the strongest things, but there are evil things too and you could do a child no favor by trying to shield it from reality."[165]

But these artists felt stinging disappointment as they pushed to uphold and maintain this balance of light and shadow, only to be told that their ideas were too risky and would sacrifice the safe haven of the brand. "It was frustrating to feel like the films were limited and you just wanted to break

out of that stigma," said Ron Clements. "We loved animated movies," added Chris Buck. "[We were] a bunch of young adult guys that liked animated movies. Why do we have to make it immature, or immature subject matter?" Said Mike Gabriel: "We didn't want to redefine Disney, we just wanted to *reclaim* Disney. Why aren't we making great films like they did in the past?"

"Is it possible that the moviegoing audience could get as excited for animation as they did for (current) live-action films," questioned John Musker. "It seemed almost hard to imagine."

Another effort to deepen the stakes of *The Fox and the Hound* came from Glen Keane and John Lasseter, who set out to reimagine the film's climactic sequence. The existing climax involved a fight between Copper, Tod, and a giant grizzly bear. Keane and Lasseter had viewed a recent screening and found the initial approach to the sequence to be underwhelming. They were fiercely determined to find a better way to stage the action. Inspired by one of Mel Shaw's dynamic pastel drawings, the two sat in Keane's office and brainstormed a new version of the fight that took place in front of a roaring waterfall. Said Keane of Lasseter: "He was always going around talking to people. His strength is connecting. Helping you get excited about an idea. So, John stood behind me and I sat there, and we sketched it out. It was really pretty cool. We both knew that this was going to be so much better."

Keane jumped into storyboarding and animating the sequence with a raw energy and passion. Everyone who saw it was in awe of the work the two had done to improve the sequence. Said Mike Gabriel: "It was so powerful when it was rough and full in the storyboards and the first animated pass. It was incredible what those guys had done with that sequence. And when you saw Glen's original rough drawings, all that stuff in pencil animation, that was exciting to watch. So, we had the thrill of that, watching Glen in his full fury doing something exciting and working with John." When Jerry

Rees wrapped up his animation work, he stepped in to help clean up Glen's bear fight, wanting to personally ensure that the quality of Keane's drawings were protected. The younger generation felt that they were finally getting a chance to break through and make important contributions to a Disney film. But only Rees was going above and beyond in the scenes that he was cleaning up. The rest of the cleanup animation lacked dimension and energy in the lines. To make matters worse, Rick Rich took over the sequence, and none of the young people had much respect for him. "Rick Rich had never really directed," recalled Van Citters. "He was doing this bear fight which really was directed by Glen. Glen...built the whole thing. Rick had been an assistant director, which was basically somebody who helps out the directors. He didn't actually direct anything." Rich's influence on the sequence led to the popular opinion that Glen and John's original intent had been compromised. "They butchered John and Glen's bear fight sequence," said Gabriel. "It's a glimmer of what it was."

Darrell Van Citters often animated under the direction of Ted Berman, but also did work under Art Stevens. "Both Ted and Art did not like energetic animation," remembers Van Citters. "We used to joke that...when you walked in the room...Ted watched you in slow motion because that's the only way he could process it. Because the animation was constantly slowing it down which, to them, was Disney animation but again, Disney animation covers a wide swath and there's a whole variety of stuff going on in there and to them, anything we were doing wasn't it."

This also applied to the pace at which Van Citters worked. At one point on *The Fox and the Hound*, he had roughed out an animated scene in about a day, filmed a test on the video pencil test machine, then went to Ted Berman to show him. Berman refused to look at it. Chris Buck recalled the incident: "[Ted] said. 'I just gave you this scene just the other day.' And Darrell's like,

'Yeah, I just wanted to show you.' 'No, no, no! You gotta go think about it more! You can't do it that fast. You gotta go think.' Darrell's like, 'Well, what about some critique on it? You gonna tell me how to make it better?' 'No, no. Just go back and think about it more.' He's like, 'Alright, I'll go *think* about it.' So, Darrell sat on the scene for a week. Didn't do a thing. A week later he shows the director the scene, and the director says, 'That's better! There you go! Now you're *thinking*!'

"There was a lack of respect for the directors, that's for sure," said Chris Buck of Stevens, Berman, and Rich. "And that came from our youth. We felt that the guys who were still around directing were the guys that had outlasted the other guys. To us, they were kind of the B team. Why isn't Eric directing? Why aren't Frank and Ollie having more to do with this? It was a new regime, and we were struggling with respect for them."

The Luau crew: back row: Brett Newton, Jay Jackson, Gale (Warren) Musker, Louis Tate, George Sukara, Joe Ranft. Middle row: Harry Sabin, Terry Hamada, Jerry Rees, John Musker. Front row: Sue Kroyer, Tim Burton, Sue Frankenberger, Randy Cartwright. Seated in foreground: Amy Sabin.

Added Van Citters: "They got the chance to produce and direct, but they hadn't ever been mentored into that spot. They're coming into it not knowing anything about 1: how to do the basics of the job and 2: learning how to deal with young Turks. There was nobody who kind of went between us and management and said, 'This is how we're going to make this thing work.' There was a psychological way to handle that, and nobody did, so it was [conflict] from the beginning."

 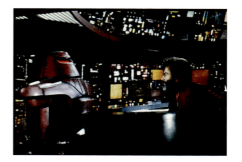

Scenes from The Black Hole: Top left: Robert Forester flanked by B.O.B. and V.I.N.CENT. Top right: Maximilian the robot faces off with Maximillian Schell, the actor. Bottom: The USS Palomino at the edge of the black hole.

Market research was a new practice for companies during the late '70s. Disney's Marketing Department started off their efforts by collecting information on the Disney brand and discovered that the popularity of *The Wonderful World of Disney* was fading. The beloved TV series had been on the air since the '50s, but contemporary viewers were not as enamored with it as audiences of the past had been. This discovery spawned a theory that the dip in interest would cause a ripple effect throughout other divisions in the company. With an expensive prestige picture like *The Black Hole* on the horizon, there was much at stake.

As the head of publicity, Tom Wilhite began considering ways to promote the Studio's outer space epic. However, it became clear to him that the film's script was not as strong as it could be. Production designer Peter Ellenshaw agreed: "We started out with a poor story and that, I think, is what damned the picture from the start. It doesn't work to write scripts by committee."[166] As he did with previous Disney films, Wilhite sent a memo to Ron Miller, offering his critique and expressing his concerns. But without any time to make changes to *The Black Hole*, Wilhite had to create ways of promoting the *film* without promoting the *story*. The initial teaser was produced by Robert Abel and Associates, a company known for creating computer animation for television commercials and films. The teaser begins with a star field over which a green, wire-frame grid appears. As a voice-over describes the destructive force of a black hole, the grid becomes a vortex, which the camera is slowly pulled into it. The short piece was engaging and piqued audience curiosity, even without any clips from the film to give a sense of what the movie was about.

Wilhite's other idea was to focus on the design of the picture and use Peter Ellenshaw as the spokesman. Said Wilhite: "The sort of impressionistic paintings by Peter Ellenshaw were great images of the movie, in some ways more interesting than the actual movie."[167]

The Museum of Modern Art held an exhibition of Ellenshaw's art and career. This received press coverage, which resulted in a growing interest in the film. "So, in doing that, we got a lot of...attention," recalled Wilhite. "*People* magazine did a piece on Peter. A lot of mainstream articles and coverage came out about that. And one day, Ron ran into me somewhere, and he said, 'How do you know how to do all this stuff?' And you know, it's just what I'd learned at Rogers and Cowan, how you figure out how to put an angle on it. So...I'd come to the attention of Ron."[168]

As audiences' tastes changed, and as the sophistication of movies aimed at a general audience grew, a G rating was the kiss of death. For *The Black Hole* to appeal to a wider audience, Ron Miller and director Gary Nelson wanted a PG rating for the film. Nelson also requested that the Disney name not appear on advertisements for the film's test audience screening in Portland, Oregon.

"I said, 'We're looking for more audience than just young people, you know, children going to see a Disney film,'" recalled Nelson. "I said, 'So when you advertise this preview, don't put Disney on the advertisement because I would like to see people coming in to see it that didn't know they were seeing a Disney film.' They didn't pay attention to me, of course, and the big banner [said]: 'Tonight: Walt Disney's new film *The Black Hole*.' When I saw that, I went ballistic, and I confronted Ron. I said, 'I'm going up in the projection room and take as much of the film that I can carry with me, 'cause we're not going to run it.' He said, 'The hell you are,' and it became kind of a shoving match down in the lobby of the theater. I called my lawyer and I said, 'This is what I'm going to do,' and he said, 'I don't think you should do that.' I said, 'Well, I'm gonna do it anyway,' and he said, 'I advise you not to do it.' I took his advice."

"After five years' preparation and fourteen months of filming and processing,"[169] *The Black Hole* premiered in London on December 18, 1979, and had its U.S. premiere on December 20. It was the first Disney film in history to carry a PG rating. Everyone at the Studio was certain the film would be a hit since big-budget science-fiction films were very popular at the time. But *The Black Hole* received lackluster reviews. Siskel and Ebert were brutal, with Gene Siskel commenting: "Can Disney make a good film anymore? It's been a long, long time. What's going on? Are they afraid of Walt Disney's memory or something?"[170]

Inevitably, *The Black Hole* was compared to George Lucas' 1977 film. It was often referred to as "Disney's answer to *Star Wars*," even though the film began development several years before the release of *Star Wars*. Had they acted quicker, Disney could've beaten Lucas into theaters.

Screenwriter Jeb Rosebrook wasn't invited to any of the screenings before the film's release. When he did see it, there was a notable absence of the first ten pages of his script. This surprised Rosebrook. These cuts took out the critical character development of the crew of the Palomino as they prepared to launch for their mission. He couldn't understand why that material had been eliminated since without it, the characters lacked dimension. How could something that would have emotionally endeared viewers to the story be left behind?

After being a part of the extensive press tour for *The Black Hole*, Peter Ellenshaw returned to Disney only to discover that the campaign Wilhite had built around Ellenshaw (and the work he'd done) had damaged his standing with the rest of his team. He recalled: "I came back to the Studio only to find that people I had worked with thought I had been taking all the credit for the film, boasting that I did it all by myself! This was not true, but it hurt just the same."[171]

Ellenshaw and his team received a nomination for Best Visual Effects at the Academy Awards. Even this could not cut the tension between them. "As we were...shown to our seats at the theater on the night of the Oscars, at first, I was ignored when I said hello to my fellow nominees. So, when we were all seated, I got up from my seat and went to each person and looked them in the eye and shook their hand, wives as well. We had all worked hard on that picture as friends and it was a sad way for this to end."[172]

Because of Tom Wilhite's publicity efforts, Miller grew to respect his talents. Miller promoted Wilhite to vice president of production for motion

Peter Ellenshaw's visions of hell from the climax of The Black Hole.

pictures at the end of 1979. "I think Card Walker had been pushing Ron to get some help," said Wilhite. "It could also have been that they were getting Ron ready to become president of the company. Card, not long after that, became CEO."[173]

The hierarchy of the Studio at the time consisted of senior management, who were heavily indoctrinated in the ways of Walt, and a middle management who were comfortable and complacent. "The middle

management tended to be a little weak in terms of sticking their neck out," recalled Wilhite. "I'm sure that that is one of the reasons I got promoted. I had come from the outside. When I came there, I was twenty-four. There was not an up-and-coming younger generation of people, and I did know what I was doing. It wasn't that I was an idiot, but I think it's also that there weren't that many people who were showing up on the radar. That, I think, was a whole change that was beginning to happen that was...threatening. I can certainly say that people had their axe out for me, and I think it's just because something had to give."[174]

One item on Wilhite's agenda was to refresh the live-action Story Department. There was a feeling that story editor Frank Paris was not looking for ideas that would broaden the Disney name. Recalled Wilhite: "I used to say, 'We're the last exit on the Ventura Freeway before Forest Lawn [Cemetery].' Whenever we got sent something, you knew it had been sent to everybody else."[175]

Paris left and Wilhite brought in David Ermine from Fox to run the Story Department. Said Wilhite: "The philosophy was really to say, 'What can we do that is sort of, in its essence, Disney but plays off Disney's reputation, and strengths, and history, and take it a little farther?'"

Wilhite's next task was to begin changing the Studio's reputation throughout the industry. "We started just trying to get people to take Disney seriously as a place to come and do business," said Wilhite. "And that was a slow process."[176]

Wilhite was the perfect choice to make the needed changes to the Studio's processes and culture. "It was such a chaotic environment, and he was so specific," said Mike Bonifer about Wilhite. "Specific how he dressed, specific how he edited press releases and, in chaos, something that specific will hold the center, and he became that person."

Actor Charles Martin Smith recalled a story he'd heard about Ron Miller going to see *The Black Hole* at a theater with a paying audience, to observe their reactions. Smith said: "There wasn't much of a line for that movie, but there was a *big* line for the movie at the theater next door and that was *The Black Stallion*. He saw it was about a horse and he thought, *Well, that's interesting*, so he went in and watched *The Black Stallion* and came out of it saying, 'This is the kind of movie Disney should be making.'"

The Black Stallion was about children and animals. It had the classic Disney elements, but the storytelling was contemporary and sophisticated. Miller sought out the film's director, Carroll Ballard, and invited him to make a movie for Disney. As it turned out, Ballard was already attached to a property Disney was interested in buying. This was a film adaptation of Farley Mowat's book, *Never Cry Wolf*, published in 1963. A team of producers that included Lewis Allen and Jack Couffer— the latter being a Disney alum from the *True-Life Adventures* series as well as many of the Studio's animal narrative films— had already begun developing the material. Wilhite approached Ballard and the producers and made a deal.

Around this time, Charles Martin Smith was on the Universal lot, interviewing for an acting job. Walking through the commissary, he spotted his friend, cinematographer Caleb Deschanel, eating lunch with someone. Deschanel had shot *More American Graffiti*, in which Smith had reprised his role of Terry the Toad, so the two had become friends. Deschanel had also shot *The Black Stallion* and the man at the table with him was Carroll Ballard. Smith went over to say hello and meet Ballard for the first time, praising his direction of *Stallion*. Later that evening, Deschanel called Smith and asked permission to pass his phone number on to Ballard. The director was interested in hiring Smith to play the lead in a film he was making for Disney.

250 1979

*Behind the scenes of Luau.
Top left: Randy Cartwright,
Joe Ranft and Tim Burton.
Bottom right: Mike Gabriel
and his surfboard.*

DISNEY IN-BETWEEN 251

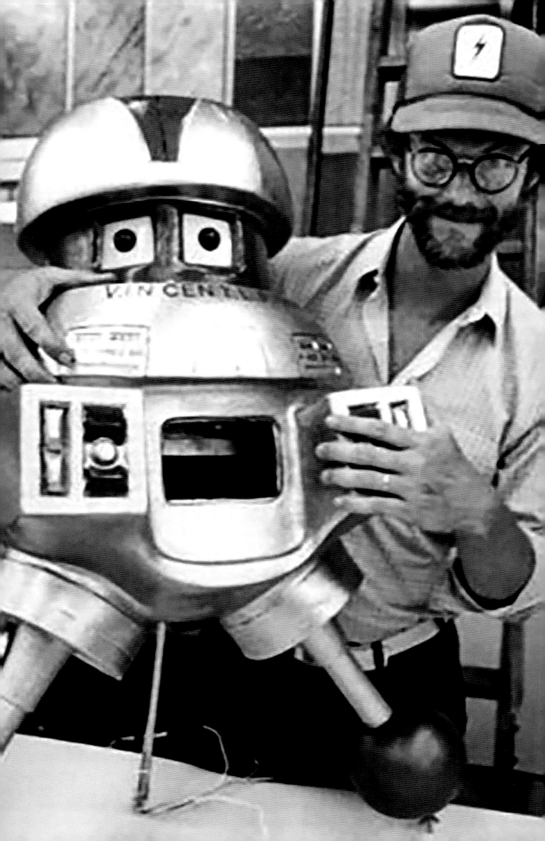

1980

Disney released the film *Midnight Madness* in February 1980. The film was aimed directly at a younger crowd, made by filmmakers who were part of that same generation. In another attempt to broaden the Studio's audience, Ron Miller signed filmmakers Michael Nankin and David Wechter, fresh out of UCLA, to write and direct the film for Disney. It would be the Studio's second PG-rated film and this time, the marketing materials made no mention of Disney at all. Even though the film represented an attempt at something different, many of the usual Disney suspects were present behind the camera. Makeup artist Robert Schiffer, art director John Mansbridge, and cinematographer Frank Phillips gave the film the same overall look as any other Disney film of that era. Even the Disney lot itself can be seen standing in for many of the film's exteriors.

The movie ended up being critic Roger Ebert's "Dog of the Week" on *Sneak Previews*. Ebert called it "a real disappointment from the Disney organization which isn't even putting the Walt Disney name on this picture because of some fairly mild PG-rated jokes. I guess *Midnight Madness* is supposed to be a PG-rated version of *Animal House*, but the plot is a mess, the characters race aimlessly around Los Angeles, and the slapstick gags aren't funny either."[177]

The Watcher in the Woods was suffering from the same issue *The Black Hole* had—trouble with the ending. By nature of the concept, the Watcher's presence is felt but never seen. Its identity remains a mystery until a revelation comes at the end. In the book, the Watcher is revealed to be an

Visual Effects Supervisor Richard Taylor hanging out with V.I.N.CENT from The Black Hole.

alien child who came into our world through an interplanetary portal. The Disney filmmakers went in a different direction. Their Watcher was also an alien but one that had inadvertently switched places thirty years ago with a young girl named Karen during an eclipse, leaving Karen stranded in its world and it stranded in ours. Said director John Hough: "In the film that I shot, [Jan, the main character] actually gets taken by the alien and goes back into the other world from where the alien comes and rescues Karen who's trapped...and brings her back."[178] This "other world" location was created by production illustrator Leon Harris, who'd previously worked on *West Side Story*, *The Sound of Music*, and *The Black Hole* as well as art directing *Star Trek: The Motion Picture*.

The alien itself was a puppet whose design was overseen by animator Henry Selick. Selick invited his animation colleague Andy Gaskill to help with the design of the alien, specifically the creature's head. Once his design was approved, said Gaskill: "I did a polyform head that was about the size of a grapefruit and then we turned it over to the staff shop. It was a fully operating sculpture shop [on the lot] where they did the casting and they did the epoxy molds and all that."[179] There, Gaskill's prototype was turned into a full-size prop, measuring about three feet in diameter. Once the head was attached to the other elements of the puppet, the alien was ready for its close-up. On set at Pinewood Studios in England, the alien puppet was operated by Joe Hale, John Emerson, Rick Heinrichs and Henry Selick. The live-action elements of the "other world" "sequence were also shot there, with special effects and blue screen work taking place back in Los Angeles. Unfortunately, Hough had left the project and was unable to oversee its completion.

The film's New York premiere was fast approaching, and there was no time left to finish the "other world" sequence. *The Watcher in the Woods* premiered in April 1980 without it. In the film's final moments, the

alien materializes, grabs actor Lynn-Holly Johnson [who played Jan], and disappears, only to have Johnson return a beat later with the missing Karen. Without that important sequence to fill in the gap, the alien came out of left field and the audience was completely confused.

"I didn't see the finished version until the film [premiered] in New York," said John Hough. "And the film had worked great for eighty-three minutes. The last four minutes undid all the good work of the previous eighty-three minutes, when the monster came onto the screen, the alien. It moved in a very stiff way. The alien should've only been seen in *minute* flashes. The public and the critic's reaction to the look of the alien was so horrendous, everybody started laughing, practically."[180]

To make matters worse, the end credits referred to the "other world" sequence and listed the names of those who created it. But that sequence was not in the film. Critic reviews the following day were scathing and Disney immediately pulled the movie from release. They moved up a rerelease of *Mary Poppins* by an entire year to fill the slot vacated by *Watcher*. Then they set about trying to figure out how to salvage the film. The entire "other world" sequence was completed and cut into the film, but the Studio decided to ultimately ditch the whole thing for an entirely new ending. They brought on Vincent McEveety to direct, gathered the cast and crew, and returned to Pinewood Studios to put it on film. Said Hough: "Disney reshot the ending without any special effects. The alien *never* appeared in the final film at all. I wasn't to reshoot the ending because I'd gone on to another film at this point and wasn't available. And I would've reshot the ending too, had I been available to shoot it. It was always a real sad moment for me that I wasn't able to reshoot this ending."[181]

Steven Lisberger's *Tron* project hit a roadblock when he was forced to close his Venice, California, studio in 1980, due to *Animalympics* facing some unexpected challenges. The film was about anthropomorphic animals staging their own Olympic games and it was made in two parts, Winter and Summer. The Winter portion aired on television in early 1980 but soon after, President Jimmy Carter boycotted the real Olympics in retaliation for the Soviet Union's invasion of Afghanistan. As a result, *Animalympics* was not the success that Lisberger hoped for. The second part was never aired and he had no choice but to shut down and disband his team.

Undeterred, Lisberger connected with a producer named Donald Kushner and they shopped *Tron* around town, ultimately getting rejected by all of the major studios. They even pitched the idea to the Animation Department at Disney, who gave them a resounding NO. But word of Lisberger's idea made it to Tom Wilhite, who expressed interest in hearing the pitch. To Wilhite, Lisberger's idea felt very "Disney" yet was totally original. To make it would require experimentation and innovation, something that had been in short supply at the Studio as of late. He saw enormous potential in the project but as a live-action special-effects epic, rather than the all-animated take that Lisberger had been pitching.

It was an enormous leap of faith from all involved parties. This newly proposed live-action approach to *Tron* raised a few areas of concern. Lisberger was unproven as a live-action director but would be helming a large-scale event picture. And all of his talk of unfamiliar techniques like backlighting and computer animation led to confusion as to exactly how this film would come together. Ron Miller had no idea what the team was up to, and Lisberger's independent spirit made him uninterested in bending toward the Studio's wishes. Harrison Ellenshaw was brought on as associate producer of the film and was able to keep the peace between the two sides.

He was, on one hand, a connection to the old school and on the other, a young person himself. Said Mike Bonifer: "They would've thrown that film off the lot if it wasn't for Harrison holding Ron Miller's hand through the

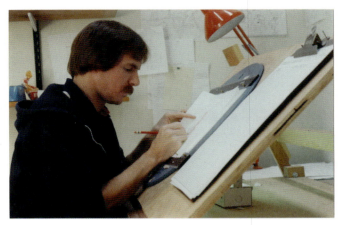

Artist John Norton from his days at Lisberger Studios.

whole thing because nobody knew what was going on."

To show everyone what Lisberger had in mind, he created a fifteen minute, full color test reel. Instead of using optical techniques like blue screen compositing to place the live actors into the computer world, Lisberger, Harrison Ellenshaw and director of photography Bruce Logan chose to use photographic techniques. The actors would be shot in black and white on a soundstage and each frame of that footage would be printed out on giant photographic sheets. The circuitry on the costumes would be added through backlit animation and then all the elements would be *re-photographed* on Disney's vertically-mounted animation cameras. Even though *Tron* was now a live-action film, it would be made like an animated one.

The test was deemed a success and Lisberger could now build his team, which set up shop on the third floor of the Animation Building. "The *Tron* crew was not welcomed with open arms by the Animation Department,"

remembered former Lisberger Studios alum John Norton, who was invited by Steven Lisberger to rejoin the project at Disney as part of the art department. "Especially the executives. They weren't happy about having us there. We were very much outsiders and kept separate." The philosophical issue that *Tron* raised within the Disney walls would linger through most of the production. Just saying the word "computer" sent most people into a tailspin. This was a place of hammer and nails, pencils and paper. Making a film with and about computers was seen as blasphemous, especially within the hallowed halls of Walt's Animation Building. Making matters worse, several of the Animation Department's own joined the project, like animators Jerry Rees, Andy Gaskill and returning artist Bill Kroyer.

"I don't think Jerry's and Andy Gaskill's decision to work on *Tron* was looked at favorably by the Feature Animation people," recalled John Norton. "Jerry was one of the few people who saw the potential of the movie and asked if he could work on it." Said Rees: "To me, it felt like the Disney that we were all inspired by. Everything was about innovation and diving headfirst into whatever's new and make it the best version of that. Jumping onto *Tron* kept me in that mode." This was Gaskill's second opportunity to explore assignments outside of the animation realm, after his short time on *The Watcher in the Woods.* "It was a very lateral kind of organization," he said. "If you're in animation, you might be recruited to work on something at WDI [Walt Disney Imagineering] or on a live-action movie. You could try different things if they saw you could handle it. If you could do the work, they had no problem reassigning you as a lateral move."[182]

For a film that was as groundbreaking as *Tron* turned out to be, it began in the most traditional of ways—with drawings. This small team of artists was tasked with storyboarding all of the sequences that took place inside the computer world, just as if it were a typical all-animated film. "We

were just sort of all on our own," said John Norton. "I think I pitched a [story] board once or twice but I don't remember having a lot of discussion about the storyboards with Steve. We just sort of sketched them out and sent them over to Steve. For a while, Bill Kroyer and I shared a workspace. Later, he and Jerry Rees boarded and choreographed the animation for the light cycle chase. I boarded a sequence where Clu is driving a tank vehicle and he's shooting at some Recognizers. Andy Gaskill did a lot of the storyboards. Beautiful boards. Man, that guy can draw." Rounding out the storyboard team was Jean "Moebius" Giraud, renowned comic artist and one of Hollywood's leading visualists.

Futurist Syd Mead and illustrator Peter Lloyd were also invited by Lisberger to help flesh out the cyber world of *Tron*. Mead's focus was on vehicles like the light cycles as well as the detailed circuitry that adorned the costume of actor Bruce Boxleitner, who'd been cast as the character of Tron. Of Peter Lloyd's work, Norton said: "He was a hot illustrator at the time. He had done a couple of Grateful Dead album covers and he was using a sort of neon line work in his illustrations. Steve asked him to come in and do some inspirational illustrations in color, showing what could be done with the bottom-lit glowing line look. He did some beautiful sketches of what became the ring game [the jai alai-inspired gladiator game inside the computer world].

John Norton himself designed several key elements from the *Tron* universe. "I designed the Recognizers and the Bit character," he recalled. "The design of the Recognizers was exactly the design I did for an early concept back in Venice. It never changed. Steve asked me to design the Recognizers and he said, 'See if you can design something using just straight lines because it could save us a lot of money in the computer animation.' It's a lot more expensive to design, generate, and move things that are curved than things

that are just straight lines."

As the design process wound down and the live-action shoot loomed on the horizon, effects supervisors Harrison Ellenshaw and Richard Taylor had to figure out how to actually produce the film's special effects on a grand scale. To oversee the complex and time-consuming photographic effects, Taylor enlisted the wide-ranging talents of John Scheele. "I went to Harvard, went to CalArts, have a good background in film," said Scheele. "I'm good with mechanics. And I had a bit of a career in rock and roll photography. I had some background in CGI but also in backlit compositing and motion control technology was a specialty of mine. I came on board and fit right in to the problem of doing the first backlit composites of what the characters might look like." Because Scheele's team would need to use the cameras typically reserved for animation production, they had to find ways of working that wouldn't interfere with the current films. "So there, right on the third floor, we built a test camera. I set up a 4 x 5 camera at home. And we used

An Ektachrome of actors Dan Shor, Jeff Bridges and Bruce Boxleitner from Tron.

G2 Graphics. They were *the* great innovative, dominating company in doing graphic work for all the record industry and advertising industry. So we had

our own independent camera and our off-lot graphics team developing and working out techniques."

Crucial to the backlit animation process was making photographic prints of every frame of the live actors in full costume so that the computer circuitry on the characters could be added by effects animators. These prints were called Kodaliths. "It's main uses were for typography, to shoot type in a graphics lab," explained Scheele. "To shoot anything where you had to reduce it down to pure black and white and use of half tones. You end up with an absolutely black and white image that nonetheless appears to have some gradation." Each film frame had to be blown up to 20 x 12 1/2 to give room for the animators to work. Luckily, Disney had a long history of producing large size print outs of live-action film. The reference footage they traditionally shot for their animators would be printed out at the same dimensions as their animation paper, so the animators could put them on their drawing tables and work over them. "No other place on the planet had the history of doing that" added Scheele. "They had the actual production line and really skilled operators underneath."

Never Cry Wolf began production in May 1980. As Charles Martin Smith prepared for the adventure ahead, cinematographer Caleb Deschanel, familiar with how director Carroll Ballard operated, advised him as a friend to be put on a weekly contract. Recalled Smith: "He said, 'How long did Carroll say the movie was going to take to shoot?' and it seems to me like Carroll said something like…at least fifteen, eighteen weeks. Pretty long shoot. Anyway, Caleb said, 'It's going to be double, whatever Carroll says,' and it turned out we shot a total of nine months spread over two years. Unheard of." This

was indicative of Ballard's unique way of making movies. There was never a final script for the film, even though there were drafts assembled by writers Sam Hamm, Richard Kletter, and even novelist Ken Kesey. "There was kind of a loose script, but Carroll largely threw it out and would just make up scenes," recalled Smith. "The scenes were improvised mostly and sketched out and I kind of became the sorcerer's apprentice and *I* would write scenes. Or Carroll would come to me in the morning and say, 'Think of three funny things you could do while you're watching the wolves.' So I'd say, 'Well, okay, how about folding paper airplanes?' And I'm standing there, throwing those. We would work out these things and then we'd film them."

From their base in Skagway, Alaska, the crew would send their dailies back to the Burbank lot. Most of the footage was shot without sound. Since there was no final script to give the shots any story context, Wilhite and Miller had to go on faith that what Ballard was shooting would add up to something. "I don't think they knew what we were doing," said Smith. "It didn't adhere to any script. There would just be these random shots of a wolf running left to right and me running left to right and right to left. I think Disney simply did not know how to control Carroll and I think they didn't really have much else going on…that they believed in, so they kind of let Carroll Ballard, this mad genius, do what he wanted to do."

The summer of 1980 saw the fourth CalArts wave hit the shores of the Disney Studio. Mark Henn, Brian McEntee, and Louis Tate all joined Larson's training program. One of their classmates, Mark Dindal, had started at Disney a month earlier as an effects animator. While still a student, Dindal noticed that the majority of his classmates were interested in becoming character animators.

With *The Fox and the Hound* in full swing, and the Studio's ranks depleted by the Bluth exodus, special-effects animators were in high demand at Disney, so he wisely shifted his focus away from character animation toward effects. As a result, Dindal arrived at the Studio and began animating on production scenes right away. By this time, Ted Kierscey had advanced through the ranks and was now heading up the small effects department that included Disney veteran Jack Boyd.

As John Norton worked away on his storyboards for *Tron*, he was intrigued by the "two old guys working on a book" in the office next door to his. He recalled: "Our shared hallway was often stacked with boards filled with art from past Disney animated classics. I gradually came to realize that the two old guys were Frank Thomas and Ollie Johnston and they were putting together their book *The Illusion of Life*. They were clearly very busy, so our interaction never really went beyond greetings in the hallway, much to my later regret."

Animation trainee Mark Henn mustered up the courage to introduce himself to the busy Frank Thomas and Ollie Johnston. In their subsequent chats, Thomas gave him valuable advice. "I struggled with my drawing," Henn recalled: "I was very loose. I could scribble things out quickly. Then I saw other people's drawings that were really tight, and on-model, and I just had this pile of spaghetti that I had to make sense out of." Frank told Mark that in the past, his colleagues had laughed at his drawings. "You can't be looking over your shoulder worrying about who's drawing better than you, but it's what you're doing with those drawings," Thomas told him. This took a weight off Henn's shoulders and boosted his confidence. Eventually, Mark made it through Larson's program, and Glen Keane chose Mark to be his rough assistant on *Fox and the Hound*.

This new batch of talent discovered what previous groups had come

to accept—Disney Studios was a sleepy place. The films had no set release dates for the crews to work toward. Instead, the films lumbered through production until someone decided it was a good time to finish and release them. In the world of feature-length animation, Disney was the only game in town, so there was little incentive to rush their films into theaters. Animators were given one scene at a time to animate. If the directors weren't ready to see their animation, the artists would have to sit and wait until they were. This younger generation was full of creativity and hungry to express it. If it wasn't getting on the screen, it had to go somewhere.

Mike Giaimo dealt with his boredom by putting on a show. He had life-sized cutouts of famous entertainers and a collection of kitschy vinyl 45s in his office. On a whim, he rigged the mouth on a cutout of Eddie Fisher, opened his office window, and did a puppet show, lip-syncing to one of the records. Several people stopped and watched. Giaimo continued doing this whenever he had time during a break. The popularity of the shows grew, as did the production value and the cast of cardboard celebrities. These became

The two-dimensional stars of The Eddie Show: Eddie Fisher, Marlon Brando and Doris Day.

known as "The Eddie Shows."

The mandatory union breaks were another recreation ritual for the animation artists—one in the morning and one in the afternoon. When the clock struck 10 a.m., everyone put their pencils down and wandered next door to the Ink and Paint Building, where they would buy snacks and drinks from Francis, the current proprietor of the Tea Room.

With snacks in hand, they'd walk the Studio's backlot. First stop was a town square set, complete with storefronts and a roundabout. The next section was the residential neighborhood where *The Shaggy Dog*, *The Absent-Minded Professor*, and *That Darn Cat!* had been filmed. After that was an old Western town, and last was the set for the *Zorro* television series from the '50s. At that time, the town of Passamaquoddy, from *Pete's Dragon*, was still standing. For these young people, most of whom had been hard-core Disney fans since childhood, it was the ultimate playground.

Mike Giaimo and Joe Ranft take a stroll through the backlot (note: the sidewalk left of center is where Elliot walks through wet cement in Pete's Dragon).

DISNEY IN-BETWEEN

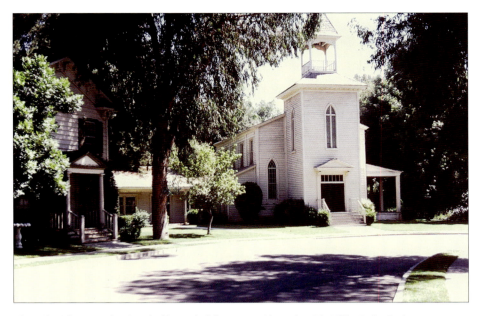

The residential street on the Disney backlot. To the left, Dean Jones' house from The Million Dollar Duck *and to the right, the church from* The North Avenue Irregulars.

Mark Dindal recalled initially resisting the temptation to climb around the backlot structures. "At first, you thought, we shouldn't go in there. We're gonna get in trouble. But little by little, we started to venture in and climb up the tower of the *North Avenue Irregulars* church. And then there would be all kinds of discarded props back there that some people would bring back and put in their rooms and we thought, *Wow, what a rebel. You took that thing from the backlot!* Nobody cared." Darrell Van Citters recalled: "There was one time Louis Tate came walking around the backlot and we'd found a whole bunch of these plastic rubber tomatoes and he walked by the *Zorro* set, and he got pelted from both sides. Stupid stuff." Mark Dindal describes another instance: "Somebody found like a seven-foot hot dog. Maybe it was used in *The World's Greatest Athlete.* They brought it back and stuck it in Dave [Block]'s chair. I remember him walking in and just getting such a kick out of it."

When the morning break was over, they would return to their desks and work until about 11:30 a.m. "You'd put the pencil down around 11:30 and start talking to people and then you go off to lunch," remembered Dave Block. "The afternoon would go the same way. You'd come back at one o'clock, and you'd sit down and fool around for a little and then you'd finally get to work

Western Street built in 1958 and featured in The Apple Dumpling Gang and Hot Lead and Cold Feet.

because, at a quarter to three, was another break! And you'd go back to the Tea Room and do the whole routine all over again. Pretty cool life!"

Volleyball games at lunch and during the afternoon break were also a common way to blow off steam yet uncommon to anyone not used to the relaxed atmosphere of the Disney lot. Dorothy (Aronica) McKim had recently been hired at the Studio, working in the employment office. Seeing grown men playing sports in the workplace seemed incongruous. "This is work?"

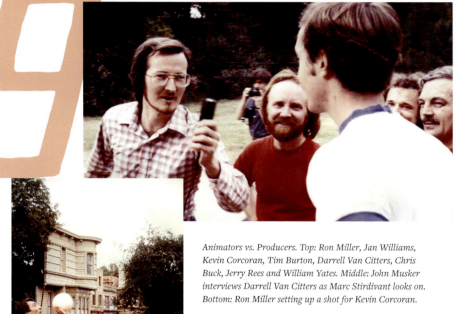

Animators vs. Producers. Top: Ron Miller, Jan Williams, Kevin Corcoran, Tim Burton, Darrell Van Citters, Chris Buck, Jerry Rees and William Yates. Middle: John Musker interviews Darrell Van Citters as Marc Stirdivant looks on. Bottom: Ron Miller setting up a shot for Kevin Corcoran.

1980

she thought. "I came from data processing [which] was very corporate. Who plays volleyball at work? This is so weird."

It got weirder when Darrell Van Citters decided to have some fun with Ron Miller and sent a memo challenging him to a volleyball game for control of the Studio. Of course, Van Citters' challenge was tongue-in-cheek but Miller, a former athlete, still had a competitive streak and accepted the challenge. So, a team of young twentysomething animators played Miller and his group of middle-aged staff producers, none of whom were good at the sport. The young Turks beat them soundly. A contract was drawn up and signed, giving control of the Studio to the young guys. Miller, not wanting anyone to misconstrue it as a real document, signed it with an X.

Miller would take his staff producers on an annual deep-sea fishing trip out of San Diego. Since the animator ranks were relatively small, those who had earned the title of animator were invited along for fishing, drinking, and seasickness.

Nowhere else in Hollywood could employees rub shoulders like this with the CEO of their company. This was indicative of how different Disney was in those days. Miller occupied Walt's office in the original Animation Building on the lot, so it was common to pass him in the halls and receive a warm greeting. Despite many questioning his qualifications to run a movie studio, he was well-liked.

Card Walker, who presided over Miller, possessed a very different temperament. While Miller was laid-back and friendly, Walker was harsh and, at times, considered mean. He also fiercely guarded the Disney name and image, regardless of what effect that might have on the company's success. In a speech to stockholders, Walker was quoted as saying of the Disney company, "We may bore you, but we will never shock you."[183] According to Wilhite: "The thing that was going on at the time is, 'We don't want to mess

with anything because we don't know what's going to happen if we do.' And so, there wasn't a lot of experimentation. Part of what I was dealing with was how do you expand within the parameters of the Walt Disney image…without messing it up too fast?"[184]

Disney remained the last vestige of the old studio system in Hollywood. Everything was done in-house by established artistic and technical departments. Composers, cinematographers, special effects—all under one roof. From an experiential point of view, it could be thrilling. "I was so impressed with the existence of this apprenticeship system, this filmmaking tradition," recalled John Scheele. "Disney history was intact. Here's Ub Iwerks' son Don Iwerks, the head of all the shops and engineering. Their shops were spic-and-span and brilliant. I would comfort myself sometimes [by going] into the power plant with the polished floors and the furnaces and the big giant Frankenstein dials from the 40s. And it's still workin' great! They would really solve problems for us and they met us like equals. It felt like I was working with my family."

However from an aesthetic standpoint, this way of working created a homogeneous feeling to the films. Each one had their sound recorded and mixed on the lot. Said Marc Stirdivant: "I'd say up until Tom [Wilhite] came on board, the Disney movies all looked the same. They all sounded the same. They had that big, bright, hot, garish color." Between the backlot, soundstages and the Golden Oak Ranch, some films were shot exclusively on Disney property. And, aside from the rare exception now and then, all films were produced and directed by the small stable of in-house talent.

Wilhite wanted to open the Studio gates to outside filmmakers, inviting top filmmaking talent like Steven Spielberg to make movies with Disney. However, the only profit-sharing program the Studio had was reserved for Miller, Walker, and upper management. This de-incentivized

many high-profile directors from coming on board. "We did start changing the deals, which was to give [creative] people a percentage like everybody else," said Wilhite.

Gradually, filmmakers did come to the Studio. Writers Tim Hunter and Charlie Haas pitched an adaptation of S.E. Hinton's young adult coming-of-age novel, *Tex*, which Hunter also wanted to direct. Wilhite loved their first draft and put the movie into production, giving Hunter his directorial debut. Tom encouraged filmmakers to not be bound by the Studio's in-house departments. They could find outside talent and shoot off the lot. *Tex* was shot on location in Oklahoma. With the exception of Robert Schiffer in makeup and art director John Mansbridge, the cast and crew were non-Disney players.

Wilhite also invited acclaimed sound designer Walter Murch to the Studio to develop projects. Murch was fresh off a double Oscar nomination for both picture editing and sound design on Francis Ford Coppola's *Apocalypse Now*, winning the award for the latter. He'd previously designed sound for Coppola on *The Godfather Part II* and *The Conversation*, and for George Lucas on *THX 1138* and *American Graffiti*. In Michael Ondaatje's book *The Conversations: Walter Murch and the Art of Editing Film*, Murch said: "I was on a list that a film critic for the *L.A. Times* had compiled at Wilhite's behest—a list of people who were not directors now but who might soon be. I guess the Disney people worked their way down to the M's and I got a call."[185]

Wilhite asked him what kind of film he'd want to make at Disney and Murch's answer came easily. "I said right away, a sequel to *The Wizard of Oz*," he recalled. "For three reasons. I had loved L. Frank Baum's *Oz* series when I was a child. I also loved the daring of trying to make a sequel. A little like saying, 'Let's make a sequel to *Gone with the Wind*.' It's a classic film. So, I was taking on something pretty heavy duty. And the third reason was

that after my son, Walter, was born, I began watching *Sesame Street* and the Muppets. I recognized in the Muppets a sensibility and a technical simplicity and sophistication that reminded me of Oz."[186]

To Murch's delight, Wilhite said yes. Disney already owned the rights to a large number of Baum's books, thanks to Walt's previous interest in adapting the Oz stories. However, the rights were about to lapse. "So speaking pragmatically," said Wilhite, "it seemed like a good idea to use them. I told Walter to go ahead because, even though he's not the most demonstrative person in the world, when he talked about the Oz books, he came to life."[187]

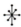

David Ermine, head of the Story Department, had always loved Ray Bradbury's book *Something Wicked This Way Comes*. The origins of the novel date back to 1956, after Bradbury and his wife had seen a screening of Gene Kelly's *Invitation to the Dance*. Bradbury was so impressed with the breadth of Kelly's talents that he was determined to work with the man. He dug out a short story from his files called "The Black Ferris," expanded it into a screenplay called *Dark Carnival*, and sent it to Kelly. Unable to raise the funds to produce the film, Kelly returned the material to Bradbury who, over the course of three years, turned the story into a novel and published it in 1962.

On the set of Something Wicked This Way Comes with director Jack Clayton (standing on the ladder) and author Ray Bradbury.

Ermine looked into the availability of *Something Wicked This Way Comes* and found out it was owned by actor Kirk Douglas. He'd bought the property for his son Peter to produce, hired Bradbury to write the script, and set the project up at Paramount. That version never went into production, so Ermine and Wilhite were able to approach Douglas about making the film at Disney. To direct the film, Wilhite reached out to Walter Hill, Jean-Jacques Beineix, and Carroll Ballard but none were interested. Wilhite moved to the next name on his list, Jack Clayton. Clayton had directed *The Great Gatsby* (1974) but was best known for helming the classic supernatural thriller *The Innocents* (1961). Clayton accepted the job, and he brought in writers Richard McDonald and John Mortimer to do a rewrite on the script. The film was targeted for a holiday 1982 release.

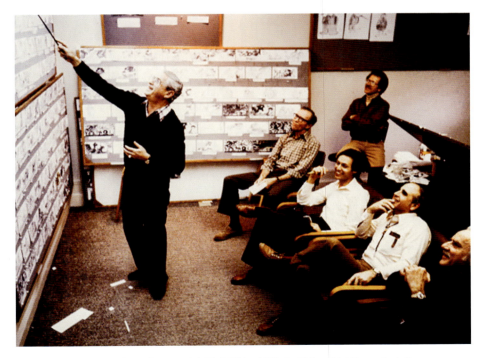

The Black Cauldron leadership: Ted Berman (pitching), Richard Rich, Joe Hale and Art Stevens (seated).

DISNEY IN-BETWEEN

The Disney Studio built a partnership with Paramount Pictures, whose president and CEO was Michael Eisner. He had two live-action projects that he was interested in partnering with Disney for. The first was *Popeye*, a musical adaptation of the classic comic strip. That project began shooting on location in Malta in January 1980. Robert Altman directed the film, Robert Evans produced it, and it starred Robin Williams in his first film role. The second was a lavish sword-and-sorcery epic called *Dragonslayer,* shot in the U.K. in June 1980. Disney agreed to cofinance the films. Paramount would distribute them domestically, and Disney would distribute them internationally.

 The Studio had done this once before. In 1979, Buena Vista distributed *Take Down,* a film about a high-school wrestling team. It starred Bernard Herrmann, Lorenzo Lamas, and *The Brady Bunch's* Maureen McCormick, and had been produced outside the Studio's walls. Three years after the release of *Popeye* and *Dragonslayer,* Disney would pick up the domestic distribution for a film called *Running Brave.* This was based on the true story of Billy Mills (played by Robby Benson), a Lakota athlete who won a gold medal for track and field in the 1964 Tokyo Olympics. Eventually, both films would find a home on The Disney Channel.

 It's not unusual in Hollywood for studios to distribute films they have not produced. But it *was* unusual for the Disney Studio of this era, given how closed-off they'd been from the rest of the film community. For the Studio to peek over the fence and get involved with outside productions showed that change was finally happening.

As *The Fox and the Hound* neared the finish line, attention turned full-time to *The Black Cauldron*. Artists began rolling on to the project, inspired by Mel Shaw's pastel vignettes as well as Lloyd Alexander's books. "People were just

Young Taran menaced by The Horned King in one of Mel Shaw's pastel drawings for The Black Cauldron.

reading those books voraciously," recalled Dave Block. "Whereas *The Fox and the Hound*, there was so much that had to be rewritten to make it into a child's story, *The Chronicles of Prydain* just jump off the page. You don't even have to change anything. We were so excited about it!" Many saw it as the film that could be the new generation's *Snow White* or *Pinocchio*. It had the potential to revive Disney animation in a big way.

Even though Tom Wilhite's domain was live-action, he found himself connecting more with many of the animation artists. "The only

body of interesting young people in the company were in the Animation Department," he recalled. "I found it the place where the more unusual ideas were coming out, even if they weren't all formed."[188] He had sat in on some story meetings for *The Fox and the Hound* and observed the tension between the older directors and the younger artists. Now with Stevens, Berman, and Rich holding the reins on *Cauldron*, Wilhite felt that there should be a younger director in the mix to balance out the sensibilities. He approached John Musker with the notion. "At first, I wasn't sure if I wanted to do it, and then I said, 'Well, maybe I can give a voice to the young people.'" Musker accepted the position.

To produce *The Black Cauldron*, Wilhite tapped Joe Hale. Besides having a long history with Disney in both animation and live action, Hale had recently supervised the team that created the alien for *The Watcher in*

The Cauldron Born by Mel Shaw.

the Woods. Since that team was made up of young artists like Henry Selick and Rick Heinrichs, Hale was viewed as someone who could connect with the younger generation. Musker said of Hale: "[Joe Hale] used to be in the [Ward] Kimball unit, so he was a little bit of a lefty, in terms of just filmmaking and all of that. A little bit more into fringe things, not so much down the middle. So, you saw him as a possible kindred spirit to the young people." The feeling was that the combination of Musker and Hale would help balance out Stevens, Berman, and Rich. "We were sort of a tag team so it was like me as a director and Joe as the producer would be a way for young people to have their voices heard," said Musker.

Mike Giaimo was eager to advance, so he worked on a personal animation test that the review board was happy with. Someone had seen character designs he had done on his own time and mentioned them to Ed Hansen, who then asked Giaimo if he'd like to do a story test. Having just finished a test, he was reluctant to work on another but decided to go for it, using a chapter from Roald Dahl's book *James and Giant Peach* as inspiration, an idea suggested to him by former classmate John Lasseter. This test was equally well-received by the board, so Giaimo became a story apprentice on *Cauldron*, working under story artist Pete Young.

"Pete was really a great board artist," recalled Giaimo. "His drawings were primitive but incredibly appealing. There was something he could put in his boards or in even a character sketch that just had incredible appeal and could really channel a mood, or a suggestion of a scenario. He was a natural-born story person and still a young guy. He was probably thirty-two when I was apprenticing under him. A great teacher. Really kind. Humorous. Acerbic. And made me feel really comfortable in a world that I was *not* comfortable in."

Young worked closely with Vance Gerry in this early stage of

development. "Pete and Vance shared a similar sensibility," recalled Giaimo. "They shared the same style of storytelling and appeal. They were very joined at the hip." In the room next door was Burny Mattinson, finishing up his story work for *The Fox and the Hound*.

Writer Steve Hulett (left) and story artist Pete Young (right).

It became clear to John Musker that Stevens, Berman, and Rich didn't want him around as a fourth director. He'd been imposed on them by management and they weren't happy about it. Despite this, Musker continued to make his voice heard. He remembered: "I was the left-winger, saying, 'Why do all the characters have to look the same?' and 'Why can't we do sort of a new style? Let's make this really a different sort of movie.' And John Lasseter, who was an animator at the time, said, 'You know, Tim [Burton] would be great to do experimental drawings on this movie.' And I knew Tim a little

bit, but he said, 'Have you ever seen Tim's sketchbooks?' which I hadn't seen. So, I looked at Tim's sketchbooks and it was so cool...I went to Joe Hale and I said, 'I think it would be great to have Tim do drawings on this,' and Joe, in this early period, said, 'Yeah let's do it.'" Hale was supportive of Burton's contributions, agreeing with Musker that not every Disney animated film had to adhere to the same house style.

Burton was no longer forced to conform to the Disney style, as he had been as an animator. Now he could unleash his own undiluted imagination. "His ideas for *Cauldron* were just unbelievably fresh," recalled Glen Keane. Said Musker: "The Horned King ...had a set of puppets, in Tim's version. He would consult with his little puppets to decide what he was going to do." Mark Dindal remembered another of Burton's ideas for the Horned King: "Throughout the movie, the horns that he had represented fear and anxiety. And so, as he became more freaked out about what was happening, those things grew and got more and more twisted until he could barely lift his head. It was such an interesting visual idea to represent how those kinds of fears and insecurities can weigh you down."

"We were all thinking, *Oh, this could be an amazing movie*," said Darrell Van Citters. "This could really turn things around."

But the *Cauldron* directors were Hale's friends and contemporaries, and they questioned his choice to let Burton determine the style of the film. Did he really think that's the way a Disney film should look? While the artists responded with enthusiasm, the directors began rejecting Burton's suggestions. The idea of the Horned King's horns growing larger and more twisted confused them. More abstract ideas and imagery weren't their specialty. Musker remembers their reaction to Burton's concept for the Gwythaints, the winged spies of the Horned King: "The Gwythaints, in Tim's version, they were hands with wings so when they would chase the pig down

literally the hands would grab the pig. It was a great, cool, visual idea. Didn't use it. Didn't like it. Didn't get it."

Hale saw an opportunity to take Burton's ideas and "Disneyfy" them by pairing him with a young German artist who'd recently arrived at the Studio, named Andreas Deja. Deja was something of a wunderkind. He was so young, but his portfolio was full of drawings that reflected his knack for channeling a classic Disney approach. Andreas was assigned the task of taking Burton's drawings and conforming them to the Disney design aesthetic. Recalled Deja: "So of course, yes sir! I'm going to try to take Tim's drawings and *ruin them*...so, you try that and add some Disney formulas to Tim's drawings, and it just doesn't work. You can't do it."[189] Burton's work was so unique that it defied Disneyfication.

Other artists also chipped in designs and ideas for the characters in *The Black Cauldron*. "I was doing some designs on Gurgi," said Glen Keane. "I'd done some animation on Gurgi and Eilonwy and I kept showing it to Joe Hale, and [he] kept saying 'no, no.' And he was kind of making fun of me drawing with—as he referred to it—a carpenter's pencil." Mike Giaimo had found inspiration from one of Tim Burton's ideas for the Fair Folk. "[Tim] had done some ideas of the Fair Folk being part vegetable, or organically oriented," said Giaimo. "So, I was riffing off of Tim's idea because I thought, *Well, this is really cool!*" Even producer Joe Hale got into the act, adding a character who was not in the book as a sidekick for the Horned King—a dwarf-like creature named Creeper. Said Hale: "Captain Hook had to have Mr. Smee. It's like Abbot and Costello. You gotta have somebody to play off of."

Gradually, John Musker, writer Steve Hulett, and story artists Ron Clements and Pete Young felt the story was veering too far from the books. Said Musker: "We were trying to use more of the books, have a younger

protagonist, and they were like, 'No it should be like *Star Wars*, older protagonist and kind of forget the books.'" The film's leadership wanted the lead female character, Eilonwy, to be more like a princess and less independent and smart than she is in the books. Clements recalled the mandate given for how to handle the oracular pig, Hen Wen: "The pig must have no personality. It's very important that the pig not have a personality."[190]

Producer Joe Hale found himself caught between the directors (Berman, Stevens, and Rich) and the rest of the crew on several issues. He decided to consult Ron Miller about which direction *he* felt the movie should go. In response to the financial success of a recent European rerelease of *Lady and the Tramp,* Miller voted for "classic Disney" and Hale got in line behind that. Mike Giaimo remembered: "[Hale] actually sat us down and he told us, 'We are going to make a *classic* Disney picture.' But what that meant was *safe.* The Tim Burton designs—as fresh and inventive, as unique as they were—those weren't to be considered really. It was a response [to] the younger group of artists wanting more innovation in the films. He knew we wanted to push the boundaries but that's what he meant when he said, 'a classic Disney film.'" As a result, Hale began to cool toward Burton's work.

Tom Wilhite often kept his door open when he worked late. On occasion, John Lasseter would stop by and the two would chat. "John Lasseter was always sort of floating around," recalled Wilhite. "He seemed to know what was going on at all times. He was great fun, I have to say. I liked his sense of humor. One [night] he came in and said, 'There's a guy you need to meet.'"[191] Lasseter took him down and showed him Tim Burton's designs for *Cauldron.* He hinted that Tim's situation was not going in a positive direction on the project. Wilhite responded strongly to Burton's work and decided that he needed to find a project to explore the uniqueness of Tim's vision. Recalled Wilhite: "The idea was to try to find something that Tim could do

that also I could excuse, and that's how we got to this idea. He had already created *Vincent*. He had a little book of it. Somebody mentioned doing it in stop motion. The idea was to see what those drawings looked like in a three-dimensional situation."[192] Plus, since the medium of stop-motion requires cameras, lighting, and sets, it was more in line with Wilhite's domain of live-action. It would appear less threatening to the animation leadership. Burton was paired with sculptor Rick Heinrichs and the two began working on *Vincent*, labeled on the Studio charge account as a "stop-motion experiment."

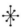

Top: Vincent Malloy and his bizarre inventions from the stop-motion short, Vincent. Bottom: Tim Burton with the puppet cast from his directorial debut.

Vincent Price consults with writer/director Tim Burton and associate producer Rick Heinrichs.

The company announced in the fall issue of *Disney News* that William Robert Yates would be the vice president and executive producer of television for the Studio. Yates had been a television writer and story editor for many years. He had written three movies for *The Wonderful World of Disney* during the '70s. He'd also produced shows like *The Streets of San Francisco* and would have his first Disney production air at the end of 1980, *The Ghosts of Buxley Hall*. The article quoted him as saying, "We have to grow and keep doing different things...we've got to mature."[193] This is ironic, given that Yates would go on to executive produce television remakes of *Escape to Witch Mountain*, *The Apple Dumpling Gang*, and *Pollyanna* as well as the episodic series *Herbie, the Love Bug*, *Zorro and Son*, and *Gun Shy*, a reboot of *The Apple Dumpling Gang*. All three series were cancelled after only six episodes.

The winter issue of *Disney News* teased the upcoming release of the postponed *The Watcher in the Woods*, claiming that "a new tantalizing ending has been filmed for this haunting tale..."[194]

A Forum on
Animation and
Fantasy Filmmaking in the 80's

COLLEGE TOUR SPRING 1981

1981

In early 1981, after spending years of their retirement writing, Frank Thomas and Ollie Johnston's book, *Disney Animation: The Illusion of Life*, was finally published. In it, they outlined the fundamentals and principles of the craft pioneered by their mentors, under the guidance of Walt, and carried on by themselves and their colleagues. The book was packed with production photographs and artwork from every discipline within the Disney animation process. It also gave readers an early glimpse at *The Fox and the Hound* and *The Black Cauldron*, showcasing some of Mel Shaw's pastel pieces. Much like Bob Thomas' *The Art of Animation*, which inspired the current group of young people, *The Illusion of Life* would become the "bible" for subsequent generations of animation artists.

A few months later, a small group of the Studio's artists and filmmakers boarded the company plane and embarked on a tour of the nation's colleges. The goal was to spread the word about the changing tides happening within Disney. Publicist Mike Bonifer had come up with the idea, and Tom Wilhite got behind it, seeing it as an opportunity to connect with a younger demographic, both as audience members and as future employees. "We were trying to send a message to the world that Disney is changing," said Howard Green, one of the members of the tour. "We've got great projects in animation and live action and take another look at Disney. That was the important message."

They delivered their message through panel discussions, Q&A's, and a forty-two-minute film called *Disney on Film*. This showcased the young talent pool currently working at the Studio as well as the established Hollywood filmmakers from outside whose current projects were being made at Disney.

A flier from the Disney on Film college tour.

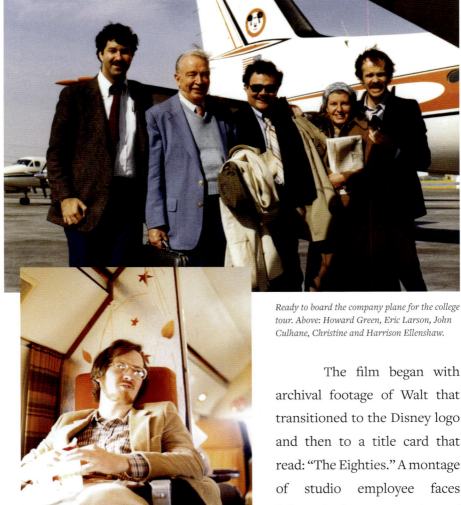

Ready to board the company plane for the college tour. Above: Howard Green, Eric Larson, John Culhane, Christine and Harrison Ellenshaw.

Above: John Musker.

The film began with archival footage of Walt that transitioned to the Disney logo and then to a title card that read: "The Eighties." A montage of studio employee faces followed, showing a variety of ages, genders, and races.

From behind his desk, Tom Wilhite introduced himself to the audience and stated: "I think these days at the Studio are very exciting because we have, for the first time, a lot of people from the outside of the Studio, from all over the film business, new talent as well as our own producers, working on films

for this company. Our plan over the next few years is to increase production from roughly five or six pictures a year to...ten or twelve in the next three or four years. And so what we're doing is looking to a lot of people to bring us ideas and films that we can produce for a wide audience."[195]

He moved to the topic of animation, touching on the legacy of the Nine Old Men, and crediting them for mentoring the new generation of animation talent. The film then transitioned to John Musker, Ron Clements, Tim Burton, and writer Steve Hulett discussing *The Fox and the Hound*. Glen Keane flipped his rough animation drawings for the bear fight sequence, which was shown in a mix of rough and cleaned-up pencil test footage. John Lasseter introduced himself as a story man at the Studio and showed one of his CalArts films, *Nightmare*, which had won a Student Academy Award.

Independent animator Mike Jittlov showcased clips from his groundbreaking short film *The Wizard of Speed and Time*, which inspired the Disney Studio to invite him to make short films for television using his unique combination of high-speed photography and stop-motion animation. By the time the college tour was in progress, Jittlov had already made several films shown as part of two television specials, *Mickey Mouse Jubilee* and *Major Effects*. He never did another project for the Studio.

Wilhite walked us through the live-action films in development at the time. There was a segment on *Tron*, with interviews from Steven Lisberger, Harrison Ellenshaw, and Jean "Moebius" Giraud standing in front of his storyboards for the film. Actor Shelly Duvall introduced clips from *Popeye*. Duvall told of getting a call from Robert Altman, while she was on the set of *The Shining*, offering her the part of Olive Oyl—"the role you were born to play."[196] Charles Martin Smith discussed *Never Cry Wolf*, and the film ended with clips from *Dragonslayer*, introduced by producer Howard W. Koch.

Most fascinating were the projects that were mentioned which

never saw the light of day. First was *Einstein*, which Wilhite said was being developed with actor Richard Dreyfuss in mind. Of the project, he said: "We are looking at the idea of taking Einstein in his early years and combining that with almost...a *Fantasia*-like approach to his concepts of time and space and relativity."[197] Thirty-three-year-old director Allan Arkush introduced his project, a comedy about "the first person to understand how TV was going to change everything that came after it,"[198] called *Perfect Timing*. No further details about the project were given.

One of the more surprising announcements is that Disney was developing *Total Recall*. This was nine years before director Paul Verhoeven and Arnold Schwarzenegger's adaptation of the Phillip K. Dick story arrived in theaters. Screenwriter Ronald Shusett narrated the segment, detailing the success he and his writing partner Dan O'Bannon had with *Alien*, which the duo wrote and produced. He then described their take on *Total Recall* as a "film noir of the future." Knowing how the movie turned out, it's hard to imagine that, in a different universe, it could've been a Disney film.

Wilhite concluded the piece by saying: "I think the Disney of the next few years is really going to be an exciting place, and I think we're open to all kinds of ideas. We're looking for people who really have a passion for filmmaking and have one idea that they really want to do."[199]

Disney on Film is full of moments of insolence and irreverence toward the Disney image, clearly aimed at the college crowd.

As animation writer Steve Hulett talked about the story process, he nervously took a couple large swallows of air. These inhales were punctuated by cartoonish *gulp* sound effects added to the audio. Young Tim Burton gently lampooned a song from *The Fox and the Hound* called "When You're the Best of Friends," with the improvised lyrics: "I'm your best friend, I can shout, and I can cheer. I'm your best friend but stop sniffing my rear."

When Keane's bear fight pencil test footage played, animator Phil Nibbelink said that in order to convincingly animate something as raw and powerful as a bear and a fox fighting, an animator must channel that intensity within themselves. He capped off his speech by saying: "After spending a day drawing this character being vicious and ripping foxes to shreds, we go home and rip our wives to shreds."[200]

In the segment about *Tex*, director Tim Hunter emphasized right from the beginning that S.E. Hinton's book "has elements of sex, violence, [and] drugs," things that Disney "hasn't even acknowledged"[201] in their past films.

Allan Arkush's segment was intercut with shots of young women firing automatic weapons. It was revealed that these are shots from a film he'd made for Roger Corman called *Hollywood Boulevard*. That film consisted mainly of leftover stock footage from Corman's films edited together to make a new narrative. Also intercut into the segment was footage from *Rock n' Roll High School*, another feature Arkush made for Corman, about rebellious high-school students that featured the rock band The Ramones. On his inspiration for creating that film, Arkush said: "I used to have these fantasies of destroying my high school, and I would dream about riding motorcycles up and down the hallways or having a rock group appear in my high school auditorium and play."[202] This was not the kind of inspiration one would expect to hear from the typical Disney director.

Nothing about *Disney on Film* felt the way one would expect a studio publicity piece to feel. There was no montage of great Disney movie moments. No "When You Wish Upon a Star" playing on the soundtrack. No smoothly voiced narration speaking about "Disney magic." No frills or pixie dust. It was raw and down-to-earth.

Another part of Tom Wilhite's initiative to humanize the Disney brand was an exhibition called "Disney Animations and Animators," held at the Whitney Museum of American Art in New York from June through September. Exhibits of Disney animation art were nothing new. In fact, there were several held during Walt's lifetime. But, as historian John Canemaker pointed out in his article "Revisiting 1981: 'Disney Animations and Animators' at the Whitney Museum," in those exhibits it was Walt who "received exclusive credit for what got onto the screen. The army of artists he employed were, for the most part, anonymous."[203]

This was the kind of thing that perpetuated the assumption that Walt drew his own cartoons. Even though he'd put his pencil down very early in his career, and even though his artists were credited at the beginning of each animated film, when audiences thought of animation from Disney, Walt was the only name they knew. In fact, his name became so synonymous with animation that another common misperception was that Walt *invented* the art from, rather than being one of its leading pioneers.

Canemaker continued: "The 1981 Whitney Museum of American Art's 'Disney Animations and Animators' exhibition changed all that. In this high-art venue, every individual artist was named alongside their drawings. Specific animators were cited for their special (nay, extraordinary) contributions to iconic Disney scenes; including crediting their participation in codifying essential animation principles, which certain animators either pioneered or developed to sublime expressive heights."[204]

In their book *Disney Animation: The Illusion of Life*, Frank Thomas and Ollie Johnston continued this practice. This was a book about Disney *animation* written by two Disney animation artists. As a result, Thomas and

Johnston could credit their mentors and colleagues for every piece of artwork. Now artists like Fred Moore, Norm Ferguson, Bill Tytla, Hamilton Luske, Ken Anderson, Bill Peet, Joe Rinaldi, Eric Cleworth, Mel Shaw, and many others, were given a place in the spotlight. The book also put a face on the future, including a photo of each author with their respective apprentices—Thomas with Ron Clements and Johnston with Glen Keane. Of course, Walt was present throughout the book, often referred to in the text. However, the book wasn't about Walt.

As for *Disney on Film*, Walt's only presence was the footage from his television introduction that kicked off the film. Beyond that, the name Disney was only used in reference to the Studio, not the man. "The Walt era was coming to an end," said Wilhite, "at least in terms of the fixation of a lot of the employees there. That was a shifting thing, and I think it was all part of moving away from the single figurehead as the identity."[205]

This growing attention to the art of Disney animation brought a renewed interest from collectors in buying cels and other original artwork. In the late '30s, the Studio had entered into an agreement with the Courvoisier Gallery, allowing them to sell a select number of cels from *Snow White* and other short films. However, World War II brought this partnership to an abrupt end and the value of an animation cel plummeted. Rumors have always persisted about animation artists during Walt's time using the smooth sheets of plastic to surf down the halls of the Animation Building. By the late '50s, Disneyland guests could visit the park's Art Corner and purchase original cels for one to two dollars. And by the early '70s, as has already been mentioned, discarded animation cels could frequently be found dumped into the Studio's trash bins.

But around this time, the Studio created the Disney Original Art Program to sell artwork from their animated films through a specially chosen

roster of art galleries. In the years that followed, the demand grew and cels from the Disney animated features began boasting price tags of several thousand dollars.

Director Walter Murch began writing the script for *Return to Oz* with colleague Gill Dennis, whom he'd previously collaborated with on the script for *The Black Stallion*. For this new project, Murch and Dennis used two of L. Frank Baum's books as source material for their story—*Ozma of Oz* and *The Land of Oz*. Murch said that these two books "were the very first books I read. I was five years old, and I said, 'I'm going to read a grown-up book all by myself.' Meaning a book that had many more words than pictures."[206] They also found inspiration in a 1973 book called *Wisconsin Death Trip*. Said Murch: "It's a collage of photographs and newspaper stories from Wisconsin, around 1890. It's a realistic look at what life was like in that part of the world, just before the turn of the century, very much the world into which a hypothetically real Dorothy would have been born. There was a lot of insanity, disease, barn-burning, and revenge."[207] This enabled them to ground their story in the reality of the situation. What would happen if a family's home was destroyed by a tornado? What if their niece survived it, and would not stop talking about the magical world she had visited?

Murch's vision for the look of that magical world was influenced more by the illustrations from L. Frank Baum's books than from the look of MGM's musical adaptation. Artist W.W. Denslow had illustrated Baum's first book, *The Wonderful Wizard of Oz*, but, after a falling-out between the author and the illustrator, Baum turned to John Rea Neill to illustrate all subsequent *Oz* books. It was these sequel books that had a major impact on Walter Murch as

a child and in turn, made him determined to stick closer to Neill's illustration style. The only element from Neill's work that Murch was reluctant to embrace was the artist's portrayal of the Nome King and his Nome army. Neill had designed the Nomes as short little men with beards and round bodies, something that had become a cliché in contemporary adaptations of fairy tales and myths. Murch came up with the idea that, because the Nomes were "spirits living in rock, [they] should *be* rock, and capable of emerging from it in sometimes human form."[208] He pitched this idea to animator Will Vinton, famous for his stop-motion animation technique called Claymation. Vinton agreed that animating with clay was the perfect way to breathe life into these creatures made from the Earth's minerals and came on board to work on these sequences.

Following Murch's lead, other filmmakers gradually turned to Disney as a viable place to make movies. Scripts and finished films were sent to the Studio for consideration to buy and/or distribute. Recalled Mike Bonifer: "*Starman* [directed by John Carpenter] was an example. And Wilhite couldn't get Ron to spend the money on it. I think it was a seven-million budget or something. That was one they missed." Another one they missed was Terry Gilliam's *Time Bandits*. "We screened it," continued Bonifer. "It was clear there was something there, and I campaigned so hard for that movie, and the Studio just never really picked up many movies. And I think also that was a very bizarre film, but everybody's reaction to it was so strong. That was a disappointment."

The Animation Department made films to promote the company's second theme park at their Orlando resort. EPCOT Center was due to open its gates

in October 1982, and four one-hour specials were in the works to air on the Disney Sunday night program. A young animator named Tad Stones (who joined Disney Studios in 1974 along with Ron Clements) was cutting his teeth as a producer on the specials and enlisted Darrell Van Citters to direct.

Around that same time, Mike Giaimo was having trouble coordinating with his director on *The Black Cauldron*. Recalled Giaimo: "I'll never forget when I presented one of my [story] boards, Rick Rich commented, 'Are we working on the same picture?' I think because I was trying to inject some humor into the board. I guess it wasn't quite his style or what he was looking for. So, I did sort of tank on *Cauldron* because it was not fertile ground for me at all."

This allowed Van Citters to bring Giaimo onto his team, along with a recent hire from CalArts named Joe Ranft. He also grabbed Chris Buck and Mike Gabriel to do animation. Van Citters intended to use the limited animation technique, making his film more akin to Ward Kimball's simple and stylized films than the full animation style of the current features. "It was really fun," said Chris Buck. "I got to stretch some muscles I hadn't done yet, more stylized animation. Real broad." Said Giaimo: "It's interesting that...quite a few people cut their teeth on it—Chris Buck, Mike Gabriel. Ed Gombert did a lot of the story work on it. Joe Ranft did a lot of story work on it. Brian McEntee and myself split the art direction. That was really my first foray into art direction and Brian's, too."

By the time the team had worked their way through most of the animation for two of the specials, the Studio canceled the entire project. Van Citters spoke with Wilhite and proposed taking their completed footage and fashioning it into a new short film. Wilhite approved the idea, and Stones and Van Citters worked on stitching the pieces into a new narrative. Said Giaimo: "So they came up with this concept called *Fun with Mr. Future*. It's about

what the future might be, what it might look like, just in a handful of years from now. So, it dealt with technology that we actually have today, laptops and so on." As a way of bridging the bits of animation, someone suggested that the robotic head used by Walt Disney Imagineering to demonstrate their Audio-Animatronics technology could be used as the film's host. "We had to go through the proper channels to get it, but we did," said Van Citters. "We actually pulled that head over to the main lot, and then we just put a little bow tie on him and shot him. It was ridiculous. So, we made this short that's just made up of comedy relief bits from something else, and we used that to kind of tie it together."

Unbeknownst to Van Citters and his team, the animatronic head they'd used was actually the inner workings of the Abraham Lincoln animatronic from "Great Moments with Mr. Lincoln" at the theme parks. Some traditionalists felt that using Lincoln's skinless robot head for their film was disrespectful. "That was looked at as slightly subversive," said Giaimo. "Taking Disney's animatronic technology and sort of being ironic with it. So, there were definitely some raised eyebrows about it back then. 'Who are these young kids, these young upstarts?'" Van Citters recalled a fair amount of pushback from Walt Disney Imagineering, in particular. "They didn't want us revealing *the secret*. Oh, 'cuz we all know that's really a man as Mr. Lincoln there? And if you didn't know that was Mr. Lincoln's head, you'd...think [it was] just a weird robot head. It was subversive but we weren't trying to stick our finger in anybody's eye. We were just looking for funny things."

The company released five theatrical features throughout 1981. The month of March saw two very different films released two weeks apart. First was

Barney Satin, played by Bill Cosby, in The Devil and Max Devlin.

The Devil and Max Devlin, yet another attempt by Disney to attract a more mature audience. Elliot Gould starred in the film, his second for Disney (after *The Last Flight of Noah's Ark*) with Bill Cosby in the role of Barney Satin (aka the Devil). The project began outside of Disney as a dark horror script by Hammer Films' writer/director Jimmy Sangster, but it stalled in the development process. When Sangster sold it to Disney, Ron Miller assigned Mary Rodgers to rework the script, after her success with *Freaky Friday*. It was another in the short line of PG-rated films for the Studio, complete with a few four-letter words.

The second was a traditional Disney turn-of-the-century drama called *Amy*. The film was originally made for television, formerly titled *Amy-on-the-Lips*. It starred Jenny Agutter as a woman who leaves her husband to teach at a school for deaf and blind children. Striving for authenticity, the Studio hired children from the Riverside School for the Deaf to play the students Amy teaches. Also in the cast was Hollywood stalwart Nanette Fabray, who, in her own life, had overcome a hearing impediment.[209] *Amy*

is a solid G-rated, "safe" Disney production. The film did nothing to change the Disney image amidst this time of reinvention. It's clear that was not the intent of its filmmakers; instead, they set out to tell a heartfelt story about the human spirit.

Jenny Agutter teaches sign language to Otto Rechenberg in Amy.

Disney veteran Vincent McEveety directed *Amy*. It was his last theatrically released film for the Studio. He'd already kept a foot in the television world between making films for Disney, continuing to direct episodes of *Gunsmoke* as well as shows like *Kolchak: The Night Stalker*, *Dallas*, and *Eight Is Enough*. After leaving the Studio, he would shepherd episodes of *Magnum P.I.*, *Hotel*, *Simon and Simon*, and *Murder, She Wrote*. He did return to Disney to direct two episodes of a short-lived television incarnation of the Herbie franchise. *Herbie, the Love Bug*, starring Dean Jones in his third go-around as race car driver Jim Douglas, only lasted five episodes.

Burny Mattinson joined Vance Gerry and Pete Young on the third floor to work on early story development for *The Black Cauldron*. Recalled Mattinson: "I would just take sections of the book, with Mel's setups, and I started boarding—the opening with Dallben and establishing the farm and the boy. That opening sequence was the first one I boarded. And then I went off and started doing Eilonwy in the castle and Taran being thrown into the dungeon. And I started fooling around with the witches also. I was bogging down because we didn't have any models for it. We didn't have anything for what they should look like."

Mattinson went to Ed Hansen and suggested that they contact Milt Kahl—retired and living in San Francisco—to see if he'd be willing to do some rough character designs for the storyboard artists to work off of. To their surprise, Kahl agreed. About two weeks later, Kahl had flown down to the Studio and handed in his drawings. "God, the stuff was marvelous," said Mattinson. "Just beautiful stuff. We were inspired! We had something we could work with! So, then I went to lunch with [Kahl] and Eric. [Milt] did not want to talk to anybody around there. He just wanted to get in and out. So, then we said goodbye to him, and I never saw him again."

Art Stevens, Ted Berman, and Rick Rich were now focused full-time on *Cauldron*. The tensions that had developed between them and the crew on *The Fox and the Hound* had only worsened. Said Mattinson: "We would pitch the boards of our progress, and it was getting kind of testy. They weren't too aware of what we were trying to do even to the point where Mel Shaw got up one day and he says, 'Don't you guys read the outline that we worked out on this stuff?' and 'Haven't you even looked at the pictures?'" Stevens began suggesting story ideas that confounded his artists. Recalled Mattinson:

"I was doing a sequence with Taran finding Eilonwy and they were going through the castle and Art Stevens pulled me aside and he says, 'You know, I see this castle like...*a pulsating brain*. The walls are...pulsating, and you can feel them throbbing.'" Layout artist Dan Hansen recalled: "He'd say things like 'The Horned King's castle could be on the back of a giant mole that would tunnel underground and come up *wherever*!' And another time it was 'The Horned King's castle could be made out of glass walls that could move and undulate.'"

Dan Hansen recalled another incident with Stevens: "We were about to work on that sequence with [King Eidilleg] and [the king] was supposed to do some incantation and there was supposed to be magic and something was to happen. Art came in and he said, 'I just saw the most wonderful program on PBS last night about roses. So, King Eidilleg could wave a rose and this magic could come out.' I remember thinking, *Okay, whatever.* A couple of days later, he came back, and he said, 'I just saw the most wonderful program on PBS last night about butterflies. King Eidilleg could wave this rose and out could come these butterflies!' and...I said, 'So what does this have to do with the rest of the film?' And he said, 'That's the marvelous thing. It doesn't have to have *anything* to do with the rest of the film!' And I said—which was probably really stupid on my part—'Then why are we doing it?' And within a couple of days, I was off of his unit."

Mattinson's waning patience further diminished when the directors bad-mouthed the designs that Milt Kahl had done. "They said, 'Eh, yeah this isn't that good. He's losing it,' and I thought his stuff was beautiful." Despite his frustration, Mattinson vowed to stick with the project and make the best of the situation. However, things came to a boil when the directors criticized Mattinson's storyboard sequence of the introduction of Dallben and Taran. The directors claimed it wasn't ready to go forward into the production

pipeline. Feeling his instincts and abilities were being unfairly challenged, Mattinson exploded. "I blew my cork," remembered Mattinson. "I said to them, 'Hey, you guys come in here and you say this is not ready. You're wrong. It *is* ready. And I've been here long enough that I know when something can go to reels.' And I said, 'I get sick and tired of the dang questions you come in asking.' And I was standing over them. I was loud and adamant and very un-Burny."

Those who regularly interacted with Mattinson knew this behavior was uncharacteristic of this usually jolly man. "Burny was always so up and positive," said Joe Hale. "I used to say if this was medieval times and they stretched Burny on the rack, he'd get off and say, 'You know, I always wanted to be a couple inches taller.'"

Mattinson was certain he'd ruined his career at Disney. When he went home that night, he told his wife, Sylvia—also an artist at Disney—what had happened that day. She reminded him of a project he'd been excited about several years before.

This was an idea that had been in his head for about ten years. In the early '70s, in addition to his animation work at Disney, Mattinson did freelance artwork. One of his clients was a man named Al White, who provided illustrations for books, record albums, and the like. Mattinson was at White's studio when he spotted another project White was creating artwork for—a storyteller record for Disney of Charles Dickens' *A Christmas Carol* with the parts played by Disney characters. Mattinson found the idea charming and thought it would make a great film someday. Staring down the possibility of losing his job, Mattinson thought that perhaps "someday," as

Sylvia suggested, could be today.

Mattinson wrote a two-paragraph note to Ron Miller suggesting the idea. The next day, Miller summoned Mattinson. Like Bob Cratchitt approaching Ebenezer Scrooge for a raise, Mattinson humbly stepped into Miller's office. Miller sat at his desk that was perched on an elevated platform. His head was down, and he was writing intently. Mattinson sat and waited in silence until Miller finally stopped writing and glared down at Mattinson. "What in the hell are you sending me this note for?" he barked and threw the paper at Mattinson. Feeling he had nothing left to lose, Mattinson defended his suggestion. "Well, I think it's a darn good idea," he said back to Miller, who burst into laughter. "I think it's a *great* idea," Miller replied, unable to keep up his ruse any longer. He told Mattinson to start storyboarding it right away. Mattinson couldn't believe his good fortune. Not only was his job at the Studio safe, but he was getting the chance to bring his dream project to life.

In March 1981, Mattinson set to work adapting and visualizing the story. Miller paid him a visit and Mattinson showed him his storyboards for the first section of the film—the introduction of Scrooge through the appearance of Goofy as the Ghost of Jacob Marley. Miller loved what he saw and immediately declared that Mattinson would direct the film. If that wasn't enough of a shock, Miller also said he wanted Mattinson to be handing out scenes to animators in May. That was only a month and half away. To do that, the rest of the film needed to be written and storyboarded and all the voices would have to be cast and recorded.

"I had a lot of help," said Mattinson about this period in the film's

evolution. Locations had to be designed, both as a guide for the storyboarding that needed to be done and for production purposes. Mattinson had sketched some rough suggestions already, so he took them to veteran layout artist Don Griffith (who was busy on *Cauldron*) and asked for help. Griffith obliged. In his spare time, he churned out exquisite pen and ink sketches of the streets of London, Scrooge's counting house, and many more of the key locations in the film. Griffith then recommended a young layout artist named Mike Peraza, who Mattinson welcomed to the team. Peraza initially did concept art then moved on to production layout. Griffith helped with some of the storyboarding, pitching in when Mattinson was stuck on a particular sequence. Rounding out the small story development team was an apprentice writer named Tony Marino, who asked Mattinson if he could help him adapt the album's story. A young animator, Ed Gombert, also was interested in trying his hand at storyboarding. Burny eagerly gave them the opportunity.

The challenge of finding actors to fill the shoes of such icons as Mickey Mouse and Donald Duck was next on Mattinson's plate. Of course, Mickey's original voice was Walt Disney, and he had given up the role long ago to sound designer James MacDonald. MacDonald began playing Mickey in the 1947 featurette *Mickey and the Beanstalk* and continued through *The Simple Things* in 1953. At the time, that short stood as Mickey's last appearance on screen and in turn MacDonald's last performance as the famous mouse. MacDonald had retired from doing the voice but had the foresight to train a new actor for the role in case Mickey ever returned to the screen. That man was MacDonald's apprentice in the Sound Department, Wayne Allwine. "Wayne came in one day with these big aviator sunglasses," remembered Mattinson. "They were mirrored. You couldn't see the eyes. And he came and says, 'Hey, I can do Mickey. Why don't you try me out?'" Allwine nailed the audition and Mattinson had found a new mouse.

Clarence Nash created the voice of Donald Duck, but Nash had retired, and the Studio had replaced him with a new actor who had been voicing the character for a series of Donald Duck Orange Juice commercials. Rather than go with this new actor, Mattinson was determined to return to the original voice, so he took a chance and contacted Nash at home. To Mattinson's surprise, Nash was bored with retirement and thrilled to come in one more time. But when he arrived to record his lines, the team was shocked at how frail he was. "He had a hearing aid and it always seemed to be dropping out," said Mattinson. "He came over to the B Stage. We were wondering, 'What's it going to sound like?' I thought to myself, *The last thing I want to do is go out to that nice old fella and tell him that you just don't have it anymore.* I was sweating bullets. So, the mixer said, 'Clarence, give us a mic check,' and he said—in beautiful Donald Duck voice—'Goddamn it! Son of a bitch!' And everybody just laughed! Oh my God, it's Donald Duck! The original!" This was Nash's final performance as Donald Duck.

But these famous characters were only supporting players in the film. The star of the show was Scrooge McDuck, appearing only once on screen in 1967, voiced by the late actor Bill Thompson. Fortunately for Mattinson, he didn't have to go any further than the turntable in his office to find a new Scrooge. The actor who had played the miserly duck on the *Christmas Carol* record was Alan Young, famous for his lead role in the television show *Mister Ed*. The album had been a passion project for Young. Not only did he perform voices, but he also cowrote the album's script with his friend, actor and writer Alan Dinehart. When Mattinson contacted Young about reprising his role as Scrooge McDuck, Young was delighted.

Thanks to his time spent with Woolie Reitherman on *The Rescuers* and *The Fox and the Hound*, Mattinson felt up to the task of directing actors for the first time. "[Woolie] would bring me out onto the stage," recalled

Mattinson. "I'd be standing behind him and he'd say, 'Well, what do you think?' and I'd just make suggestions and...he gave me a lot of confidence because he was always turning to me and thinking, 'Maybe he has a better way of doing something.' So that got me used to it." It was also something that pulled him out of his comfort zone. "I'm personally an introvert, and I'm always nervous about important people and all that stuff. But somebody had to do it because nobody else in that group wanted to go out and have to face it, so you just say, 'Okay, I'm gonna be the extrovert today and *I'm* going out there.' And finally, I got to be the extrovert for a while. Dealing with them was wonderful and I found the actors to be great to work with."

By May 1981, Mattinson had a complete story reel of *Mickey's Christmas Carol* ready to screen. *The Black Cauldron* was scheduled to screen their story reels on the same day. *Christmas Carol* screened first, and after it was finished, *Cauldron* producer Joe Hale—still sore at Mattinson for telling him off and jumping ship—turned to Mattinson and said with disdain, "To think that this will become the definitive version of *Christmas Carol*."[210] Hale's words stung, but Mattinson didn't let them get him down. Ron Miller had asked him to hand out animation that month, and that's exactly what he intended to do.

Mattinson wasn't the only person to grow frustrated with the *Cauldron* leadership. The directors were becoming notorious for not knowing what they wanted. They were incredibly picky over the work people were doing for them. Animator Dave Block was interested in getting cast onto the unit that would be animating Taran, the film's lead. On his own time, he did a personal animation test of Taran running with his oversized sword then tumbling forward under the weight of it. According to Block: "I went in to show it to Rick Rich, and Rick looks at it and says, 'Well, that's just too broad.' So I took his criticism, I walked out of the office, and I said, 'Gotta get off this

film.' Just like that."

Glen Keane had been playing around with designs and animation tests for many of the film's characters that were consistently rejected by producer Joe Hale. Later, Glen was assigned a production shot of Hen Wen the pig, tasting and rejecting her food. "I thought, *Alright, I'm gonna have so much fun with this scene*," said Keane. "And I did. I had the pig just barely taking a *little teeny little* bit with the end of its teeth and just spitting it out. I did it really broad. I just had the greatest time. Shot it. Sent it. They were furious with me." Keane was called in to Hale's office and told that he was not right for *The Black Cauldron*, and that they no longer needed him. Recalled Keane: "I said, 'I think you're wrong, Joe. I think I've really got something to offer.' 'No thanks,'[said Hale]. 'Why don't you go work with Burny on *Mickey's Christmas Carol*?'"

To Keane, Dave Block, and many other artists, *Christmas Carol* was an oasis in the desert. It was simpler and lighter in tone, plus it gave them the chance to animate these beloved Disney characters. "Just like all of us, they had grown up with Mickey, Donald, and Goofy and wanted to do some of those things," said Mattinson. "They would come down and say, 'Hey, could we work on this?' So I would go to Ed Hansen and say, 'We've got a lot of people that want to work on this,' and he would say, 'Well, these are people that they don't want anyway on the *Cauldron* because they're not delivering what they expect over there.' So, we took everybody they could send our way."

Mattinson's small but mighty team of animators was slowly coming together. Block and Keane animated the majority of Scrooge in the film. Keane also requested to work on Willie the Giant, the character who was cast in the role of the Ghost of Christmas Present. Keane based the giant's awkward movements on his son Max, who was eighteen months old at the

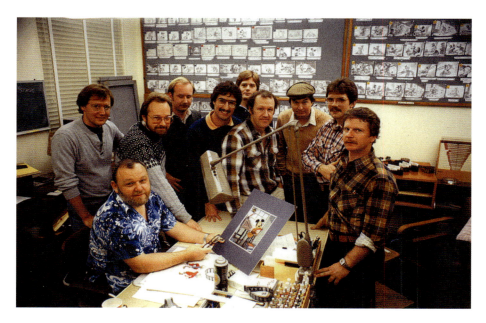

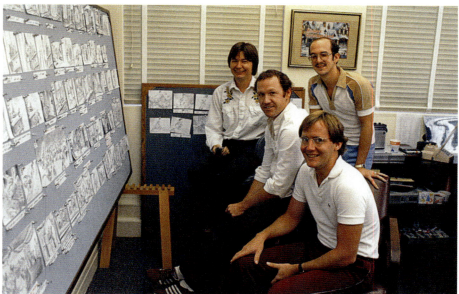

Making Mickey's Christmas Carol. Top: Burny Mattinson (seated), John Lasseter, Rick Hoppe, Ed Gombert, David Block, Barry Temple, Glen Keane, Randy Cartwright, Mark Henn, Tim O'Donnell. Bottom: Randy Cartwright, Glen Keane, John Lasseter and Mike Peraza (standing).

time. Ed Gombert had storyboarded these sequences and, after he finished his story work, Gombert stayed on as an animator, bringing Ratty and Mole from *The Wind in the Willows* back to the screen. Mattinson called up Dale Baer and asked if he would animate the climactic sequence in the cemetery where Scrooge meets the Ghost of Christmas Future, played by Mickey's old nemesis, Pete. Baer left Disney in 1977 and had been working elsewhere since. He was thrilled to be offered this juicy section of the film as well as the chance to work with Mattinson.

The character who proved to be the most challenging was Mickey himself. Mattinson needed someone who could animate the deceptively simple mouse with confidence and ease. One day he saw an animation test of Mickey that was done for *The Emperor and the Nightingale*, a proposed short subject that Mickey was to star in. Mattinson was impressed with the animation and learned that it was done by a young artist named Mark Henn. Henn wasn't even a full-fledged animator yet. He had just come into Larson's training program the previous year and was now trying to get promoted, which was why he had done the Mickey test. It worked. Not only did Mattinson see to it that Mark was promoted to animator, but he gave him the job of being his "Mickey Man."

The team working on *Cauldron* did not feel as though they were in sync with the leadership. *Christmas Carol* was the opposite. Mattinson created an environment of safe collaboration. Said Keane of his experience: "That was so wonderful because we were all kind of abused children coming off of *Black Cauldron*. Mattinson was so welcoming. Everything that he loved, we loved, and he was completely open for us improving the story." After the team would screen their work-in-progress versions of the film, Mattinson and the animators would gather back in his office and openly discuss what was working as well as what could be improved. "It was tremendous

collaboration," said Dave Block. "This is *our* movie. It was never 'This is *my* movie.'"

Then they would review the storyboards for the next sections and make sketches and suggestions on how to strengthen them. "You got this feeling like, 'Okay, *this* is the way Disney animation should be,'" said Keane. And when it came time to issue scenes to individual animators, Mattinson carried over that same spirit. Said Dale Baer: "It's like Woolie. He kinda tells you the gist of what he wants, but he's not going to dictate every single frame. That's the way Mattinson was. 'This is the idea we have right here, let's see what *you* do with it.' And you go off, and you just have fun with it and then you show it to him and there might be little [changes] but nothing major. Nothing like, 'Well, why did you do it this way? You should have done it that way.'"

Baer's comparison of Mattinson to Woolie Reitherman is appropriate. With the education he'd received from Reitherman, it's no wonder Mattinson made the transition to director so smoothly.

Occasionally, Mattinson would have a disagreement with one of the animators. When things would reach a stalemate, he had a secret weapon—Eric Larson. Mattinson would suggest that the animator talk to Larson about their disagreement and, whoever Larson sided with, Mattinson would support that decision. In the time it took the artist to walk up to Larson's office, Mattinson would quickly call him on the phone and tell him which way *he* wanted things to go. Larson would then tell the animator exactly what Mattinson wanted—under the guise of his own personal opinion—and Mattinson would get his way every time.

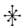

Eric Larson and Burny Mattinson.

The Walt Disney Studios was well-represented in movie theaters during the summer of 1981. The second film in Disney's partnership with Paramount was *Dragonslayer*, released at the beginning of the season. The agreement was that Paramount would distribute *Dragonslayer* domestically, while Disney did so internationally. It was directed by Matthew Robbins and written by Robbins and Hal Barwood, the team who had written *The Sugarland Express* for Steven Spielberg. Shot on location in North Wales, the film was a medieval sword-and-sorcery story that was gritty, violent, and even had brief nudity. It's no wonder that the Disney name on the poster was inconspicuous, located in the credit block at the bottom, rather than above the title, and listed *after* Paramount Pictures. The special effects were top-notch. Through a combination of models and full-sized animatronics, Industrial Light and

Magic created the most believable dragon ever put on film up to that point. For their work, ILM ultimately earned an Oscar nomination. But June 1981 was a crowded month at theaters. *Clash of the Titans*, *Raiders of the Lost Ark*, *Superman II*, *For Your Eyes Only*, and *The Great Muppet Caper* all competed for box-office dollars. Amid heavy competition, *Dragonslayer* was lost in the shuffle. Despite favorable reviews, it did not earn what the Studio had hoped.

The Fox and the Hound was finally released in July. Many of the crew felt that the film was passable. Few felt that it was extraordinary. However, Siskel and Ebert were kind to *The Fox and the Hound*, with Gene Siskel calling it "a sweet and old-fashioned Disney cartoon feature" that to him was "most entertaining." Roger Ebert complimented the work of the new generation of artists, saying that "this new crowd seems to be carrying on in the old tradition."[211]

Actor Kurt Russell—so familiar to Disney audiences from his many appearances in the Studio's films and television programs—provided the voice for adult Copper, the hound dog. But like child actors Ron Howard and Jodie Foster before him, it was time for Russell to shed his wholesome Disney image and mature as an actor. *The Fox and the Hound* would be Russell's last Disney film for some time. The same month, the actor could also be seen in John Carpenter's gritty action film *Escape From New York* and the following year in Carpenter's creature feature *The Thing*.

Through the lens of Disney history, *The Fox and the Hound* stands as a marker of the enormous transition within the Animation Building. It was the last film to involve the remaining Nine Old Men, the Bluth team, the CalArts people from that period, as well as non-CalArts talents like Ron Clements, Bill Kroyer, and Henry Selick. This intersection of artists and generations would never happen again under the Disney roof.

Marc Stirdivant received his first writing credit on a feature film

when *Condorman*, his script based on the novel *The Game of X*, was released in August of the same year. Unfortunately, as was the case with much of the Studio's output, the film was far from a home run. Siskel and Ebert were brutal on the film. "It represents another attempt by Walt Disney Studios to grow up and make a contemporary adventure film that is more than one of their typical trained-raccoon-and-pony shows."[212] The two critics felt the film lacked heart and character development and were livid that when Michael Crawford flew in his Condorman suit, the wires holding him up were painfully visible. They also felt that the film was ordinary and derivative. Said Roger Ebert: "You know it's almost as if Disney tries to do what other people are doing and just kind of misses. Like *The Black Hole* wasn't quite *Star Wars*, this is not quite James Bond. It's a generic version of the same thing."[213]

Stirdivant was also disappointed in certain aspects of the film. "The movie had kind of a goofier, more Disney-esque tone to it than what I was envisioning when I wrote it," he said. "I don't know why that happened. What Jan and I were doing, we were consciously trying to do a Disney *James Bond* and, in my mind at least, what I wrote was more serious than what appeared on the screen. It was written for someone like Gene Wilder. That was kind of our dream casting. I don't know if the Studio ever reached out. The Studio really wasn't involved in hiring stars at that time. The star was supposed to be Disney."

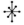

Cameras were rolling on the soundstages of the Burbank lot, shooting the live-action portions of *Tron*. In tandem with this was the production of the film's computer-animated sequences. Since the Disney Studio was not equipped to produce computer animation, the sequences were outsourced

to four studios—Triple-I, MAGI Synthavision, Robert Abel and Associates, and Digital Effects Inc. Because they had storyboarded these key sequences, animators Bill Kroyer and Jerry Rees were responsible for their choreography and execution. To aid Kroyer and Rees, visual effects supervisor John Scheele brought in Bill Tondreau, a pioneer in the field of motion control cameras.

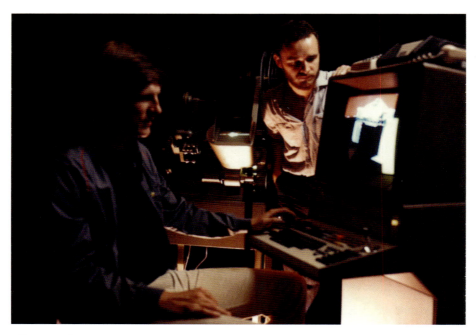

Bill Kroyer and Jerry Rees bringing one of the sinister Recognizers to life for Tron.

These were used extensively in *Star Wars* several years earlier, allowing camera moves to be plotted digitally, giving a greater sophistication to the movements of both the camera and the elements within a shot. "They did not have an adequate motion control system working at that time,' said Scheele of the Disney Studio. "They were a little too in-house. But they saw that and they bought in to the idea of literally paying Bill to come in and he generously implanted the Tondreau software into the Disney operating

system." This allowed Rees and Kroyer to plot out movements on the motion control camera. "That Tondreau system would cough out a sheet of counts," described Scheele. "[They] would transcribe these counts. At the other end at Magi, Chris Wedge [future director of *Ice Age* and *Robots*] would be the

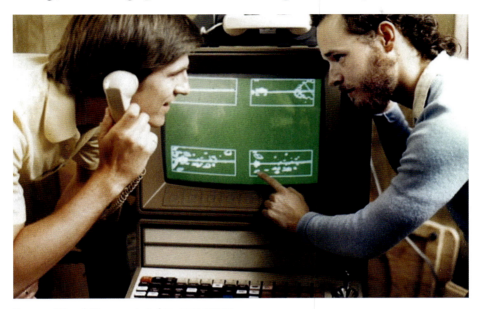

Kroyer and Rees plotting computerized camera movements.

catcher for that data and he would mechanically input it into their system. So in lack of previz or better tools, we were using the Tondreau system on the motion control stand to generate the numbers that would drive the CGI."

As the four outside studios finished their shots, they sent them to Lisberger for review and the *Tron* team would gather with anticipation to watch the new footage. "We were all blown away," recalled John Norton. "These were cutting-edge visuals."

The film's first fully completed sequence—with live-action and computer animation married together—was the light cycle chase. A screening was held for the entire Disney Studio, in the theater that Walt Disney had

built in 1940. Those in attendance saw the future. Everything that Lisberger and his team had been promising came together in this footage, from the art direction to the storytelling to the groundbreaking technique. "No one had ever seen this stuff before," recalled John Norton. "It blew people's minds. Suddenly everybody was loving the film, *including the Animation Department*."

And including Ron Miller. After the realization set in that Disney had a very unique film on their hands, Miller sent a memo to everyone involved with *Tron*. The memo, dated August 31, 1981, reads as follows:

We have determined in our early concept studies that TRON is an extremely strong film idea with every age group—popular equally with men and women. We have also determined however, that it should not be described as a science fiction film and should not be called a computerized movie. These two descriptions begin to limit the film's appeal.

Here is the best way to describe the picture:

TRON is a futuristic adventure which, by employing the most sophisticated, inventive and creative movie-making technology now available, will transport moviegoers into a new and previously unknown and unseen world where time and space seem to defy the laws of logic; where energy lives and breathes; and where an entire micro-civilization thrives. It is an epic adventure about a courageous band of young people pitted against the evil masters of a futuristic computer world and their real work look alike. TRON is in every way a unique theatrical experience that must be seen to [be] believed.

"I guess we were supposed to memorize all that?" mused John Norton today. Although the practical application of Miller's memo was unclear, his

newfound ownership of the project and enthusiasm for the potential success of Lisberger's film was *crystal clear.*

Never Cry Wolf saw its second year of filming in the summer of 1981. Charles Martin Smith recalled: "Just the caribou sequence alone, where I'm running naked with the caribou—we filmed that for four weeks in June one year. We went back the following June and shot another four weeks, just on that one scene." The only other professional actor in the film besides Smith was Brian Dennehy who showed up that summer to shoot his sections of the film. Another visitor was author Farley Mowat himself. Mowat initially wanted nothing to do with Disney or their adaptation of his novel, having been burned before on a filmed version of another one of his books. Eventually, Ballard reached out and was somehow able to convince the author to visit the production. Said Smith: "Once he looked around and saw what we were doing, he fully embraced it. He loved it. He was really, really pleased."

Something Wicked This Way Comes started shooting in the fall, entirely on Disney property. The town-square portion of the backlot was torn down and completely rebuilt as the fictional Green Town, Illinois. Composite sets were built inside the Studio's sound stages. These were sets that had both exteriors and complete interiors so the crew could transition from shooting outside to inside with minimal effort. The field where the evil Mr. Dark's carnival sets up camp was shot at Disney's Golden Oak Ranch in Santa Clarita.

Two-time Academy Award winner Jason Robards was cast as Charles

Halloway. On the commentary track for the 1998 laser disc release of *Something Wicked*, Bradbury stated: "I got to know Sam Peckinpah more than twenty years ago, and Sam always wanted to do *Something Wicked This Way Comes*. He said to me, 'Who do you want to play the father,' and I said Jason Robards. I'd seen his work and admired it for many years and Sam was a good friend of Robards, and we had a number of dinners and lunches, over a period of years, but it didn't work out for me to work with Sam Peckinpah, but Jason Robards remained in mind. When the casting for the Disney film occurred, he was the first name on the list."[214]

The other lead roles in the film were for two young boys. Vidal Peterson was cast as Will, the son of Robards' character, and Shawn Carson played his best friend, Jim. The film's antagonist, the sinister Mr. Dark, was played by British actor Jonathan Pryce in his first American film role. Composer Georges Delerue was hired to write the score and the film was on track for its Christmas '82 release.

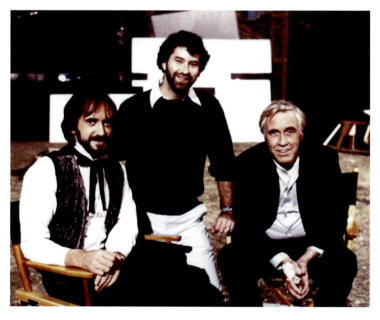

Jonathan Pryce, Howard Green and Jason Robards filming Something Wicked This Way Comes.

— ✳ —

The Watcher in the Woods was finally released to theaters in October 1981. Said director John Hough: "In this version, there's no alien, no other world and you're left with a situation here that's pretty tame. And here comes Karen. She's back here with no real special effects, no real understanding of why. It's really a no-ending. And so, the film was sort of spooky all the way through and at this point it really lost its edge."[215] The new ending the Studio added did little to improve the film's reception. Siskel and Ebert had the following to say about it:

Roger Ebert: *The Watcher in the Woods is an ambitious new movie from the Walt Disney organization. It's a horror film. It deals with the supernatural, with people possessed by voices, with ghost images in mirrors, with weird ray beams of blue light that come zapping out of the forest. That's some of the stuff it deals with. What it's about, I don't know.* The Watcher in the Woods *is confusing and disorganized and frankly, I didn't understand the ending of this movie.*[216]

Bette Davis as the mysterious Mrs. Aylwood in The Watcher in the Woods.

Gene Siskel: *I'm 35 years old. I can't figure out what's going on. How will a 9-year-old? I think when you build up suspense, you do want a payoff. And this film leaves people totally mystified.*[217]

Einstein, a project Tom Wilhite had teased in *Disney on Film,* from the college tour was set to begin filming the following year in Switzerland and Germany. In the winter 1981 issue of *Disney News*, Ron Miller spoke further about the film, saying: "This project will be a first-of-its-kind movie. It's a unique combination of a personal story about one of mankind's greatest figures and spectacular visual interpretation of his concepts."[218] As fascinating as the project was in theory, the Studio never moved forward with it.

With *Tron's* live-action shoot now wrapped, and its computer-animated sequences coming to glorious life, it was time to fulfill the third part of Lisberger's vision—backlit animation. This was the genesis of the whole project, dating back to Lisberger's days in Boston when he and John Norton created their backlit warrior for a radio station commercial. In contrast to the revolutionary technique of animating with a computer, this part would be done the old-fashioned way—by hand, frame by meticulous frame.

With the live actors having been shot in black and white, the special effects animators now added the glowing circuitry and colored energy to the actors' costumes. This was done by painting black, hold-out mattes to allow the backlighting to show through and mask out the parts in the shot that weren't needed. These mattes and backlighting, combined with the black-and-white live-action footage, would be shot on Disney's animation cameras and composited together by exposing the film multiple times. "This required rewinding the film and changing mattes for each special effect in the scene," said John Norton. "Many scenes required twenty, thirty, *sixty exposures.*"

Norton continued: "Inevitably, glitches occurred [which] often showed up as light flashes. At first, everyone was freaked out about what to

do, how to fix it. And then finally someone suggested that we just leave them in, saying after all this is an electronic world. Of course, there's going to be flashes of light. It's in the environment. So they just left it in and it became another special effect."

Lightcycles racing on the Grid in Tron.

All of this painstaking work began to pile up and the team started falling behind on their deadlines. To ease the workload of creating the hold-out mattes, an animation studio in Taiwan was contracted to help. Scenes would be sent to them from the Disney team and then boxes of finished mattes would be shipped back to Burbank. "I remember they got one shipment where they stacked the mattes too soon before they were dry," said John Norton. "So they took the mattes out of the box and it was like a giant brick of mattes that they had to completely redo. They were turning them out so fast, they weren't even letting them dry."

If all of this stress and fatigue was not bad enough, the film's release date was moved from winter of 1982 up to summer, lopping six months off the production schedule. According to John Norton: "The story I heard [was that] Card Walker found out that Don Bluth's movie [*The Secret of NIMH*] was being released that summer, so Card Walker decided, 'You know what? I'm going to try and screw over Don Bluth for what he did to Disney, so I want to have *Tron* released at the same time as *Secret of NIMH*.' And he got his way. So we were already having difficulty finishing with a December release, then everything had to be pushed up six months." Needless to say, director Steven Lisberger was not happy.

Nor was he happy about Ron Miller's decision to invite a group of Wall Street investors to a work-in-progress screening of *Tron*. Recalled John Norton: "In Ron Miller's mind, they're going to see this footage and go nuts and start spreading the word about it and Disney's stock is going to go up and all that. So what happens is they screen it and there was one [investor] who hated it. He really panned it. And of course, having a pan review, even before the movie gets released for a prescreening kind of thing, not good. So that put sort of a damper on it. I know Steve was very upset about that."

DISNEY IN-BETWEEN

1982

Principle photography on *Trenchcoat*, began on location in Malta in January. The movie was a send-up of the spy thriller and boasted Margot Kidder and Robert Hays in the lead roles. It was the first produced screenplay by the writing team of Jeffrey Price and Peter Seaman, formerly titled *Malta Wants Me Dead*.

Night Crossing was being readied for release by its director, Delbert Mann. Mann had been helming television programs and theatrical films since the '50s, winning an Academy Award for his debut film, *Marty*. This put him in the small club of directors who'd won a Best Director Oscar for their first feature. Mann delivered his cut of the film to producers Tom Leetch and Marc Stirdivant then left the Studio, moving on to his next project. This was common for directors of Mann's generation, from the pre-auteur times. At around two and a half hours, there was no way the Studio would release Mann's cut, so Leetch and Stirdivant edited the film down to a more manageable length.

The film was released to theaters in February 1982 and—typical of Disney's attempts to broaden its audience during this time—made little impact. "I saw it a couple times in the theater," said Stirdivant. "It always worked well with audiences, but it didn't do so well in attracting them." As to why the film didn't connect, Stirdivant suggested: "I suspect that combining the Disney name with a fairly dark subject, and a film that looked a little different than what people were normally expecting, *and* that was talking about something as serious as communism. I think sort of pre-Reagan era, pre-the-falling-of-the-wall, maybe people just didn't feel 'that's a topic that

The Strelzyk family's first attempt to escape from East Germany in Night Crossing.

I'm really that interested in or at least I'm not interested in taking my kids to see,' so it didn't have the success that we'd hoped for."

For a film with such ambition, attention to detail, and accuracy, the choice to cast non-German actors in the roles of the two families is difficult to understand. British actor John Hurt, and Americans Beau Bridges and Jane Alexander are excellent actors, but their presence disrupts the authenticity that the film strives for. Unfortunately, critics Siskel and Ebert were unable to look past this aspect.

Roger Ebert: *You ever notice in these films how the bad Germans speak with a German accent and the good Germans are all American and English-speaking people?*[219]

Gene Siskel: *It's pretty much the same old Disney world of unbelievably sweet people who look like they just stepped out of a McDonald's commercial. And one not set in East Germany.*[220]

Gene Siskel: *Disney has always made safe live-action movies set in a benign world.* Night Crossing, *for all of the danger implicit in the situation, is still very safe. These people sound about as counter-revolutionary as if they were plotting how to cut in line at Disney World.*[221]

Like Delbert Mann's first cut of *Night Crossing*, Carroll Ballard's first cut of *Never Cry Wolf* was long. "Something like four and a half hours," recalled actor Charles Martin Smith. "He shot almost a million feet. It was absolutely crazy. Had all this footage and almost all of it without dialogue. Just scenes of me running around and wolves running around and the Inuit guys running around doing strange things. He called me up and he said, 'Yeah, nobody knows what the hell this movie's about. I don't even know what the hell this movie's about.' He said, 'I'm going to put some voice over on it. Why don't you come up here to San Rafael...and let's sit down for a couple of weeks and you and I will write the voice-over and you can read it." Smith

joined Ballard in Northern California and, over the course of a year, the two wrote, recorded, and edited, ultimately creating a new cut of the film.

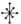

The Studio was preparing for a theatrical rerelease of *Fantasia* (which would eventually be released on April 2, 1982) and had brought in composer Irwin Kostal to conduct a brand-new recording of the film's classical music score in Dolby Stereo. Kostal was no stranger to the Disney lot. Three of his five Academy Award nominations were for arranging, scoring, and conducting music for *Mary Poppins*, *Bedknobs and Broomsticks*, and *Pete's Dragon*. He'd

Music director and composer Irwin Kostal, choreographer Marc Breaux and actor Dick Van Dyke review music for Mary Poppins.

done the same for *West Side Story* and *The Sound of Music* (his two Oscar wins) as well as countless television series and specials from the '40s through

the '60s. It was one of these programs that made Kostal a household name for Burny Mattinson—*Your Show of Shows*. Mattinson recalled: "It was a big extravaganza with Sid Caesar and Imogene Coca. It was on every week, and I would listen to the music and it was like a Broadway show. I thought, *God, that music is really good* and...*if I ever have anything to do with a picture,* that's *the man I would love to have working on my music!*" Imagine Mattinson's surprise when he spotted Kostal eating lunch with sound designer and former voice of Mickey Mouse, James MacDonald. Mattinson, who was friends with MacDonald, went over and said hello, hoping that Jimmy would introduce him to Irwin. Mattinson gushed to Kostal about how much he loved his work and told the composer about *Christmas Carol*. If he would be interested, Mattinson would love to have Kostal do the music. Kostal was delighted at the offer. As soon he completed his work on *Fantasia*, Kostal started to write music for Mattinson.

Kostal worked with Frederick Searles on the opening song, Searles writing the lyrics to accompany Kostal's music. The day came to record that song on the Studio lot. At nine in the morning, a sixty-piece orchestra was assembled as well as a full choir. Mattinson was forbidden to come and listen until Kostal felt comfortable with the results, so Mattinson waited impatiently for about two hours. Finally, Kostal invited him into the scoring stage. "And then they start playing that song with that chorus," recalled Mattinson, "And I was like, 'He's got a song! It sounds great! It's what I want in an opening!' And I said, 'Irwin!' And I grabbed him around his waist—because he was a tall man—and I was just jumping around in the control room with him! And *he* was delighted. *I* was delighted. I think the orchestra people thought we were nuts in there. So, from there on, he just did the whole score."

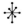

The summer of 1982 brought with it proof that genre filmmaking was here to stay. There were future classics like John Carpenter's remake of *The Thing*; Arnold Schwarzenegger in the epic *Conan the Barbarian*; and the dystopian future of Ridley Scott's *Blade Runner*. There were sequels like *Rocky III*, *The Road Warrior*, and *Star Trek II: The Wrath of Khan*. But once again, the summer would belong to Steven Spielberg with the one-two punch of his suburban ghost story, *Poltergeist*, and the film that would be the reigning box-office champion for years to come, *E.T.: The Extra-Terrestrial*. Both were released in June of that year.

There's no denying that *E.T.* could have been a Disney film. The story was from a child's point of view. Adults were either parents or antagonists, at times only shown in silhouette or extreme close-up. And if one substituted an animal for the alien, there would be little difference between this film and one of the many child/animal stories Disney so often told.

In fact it's interesting to note that *E.T.* shares several conceptual ideas with Disney's 1975 film *Escape to Witch Mountain* and its 1978 film *The Cat From Outer Space*. All three films are about aliens from another world, stranded on Earth and trying to return home. Even more interesting are the similarities between the final climactic resolutions of *E.T.* and *Witch Mountain*. Both films' protagonists escape their pursuers by using telepathic powers to levitate their respective modes of transportation (bicycles in *E.T.* and a Winnebago in *Witch Mountain*) to fly themselves to safety.

But the similarities end there. Even though Spielberg and his colleague George Lucas played in the same genres that Disney films lived in - fantasy, adventure, stories about suburban families, the classic "boy and his dog" paradigm - they elevated the material through a contemporary tone, characters that had faults and vulnerabilities rather than being caricatures, and special effects that were state-of-the-art. In doing so, they made films that

appealed to all ages, redefining what a family film was for a new generation. "Those [movies] are cool and those could be Disney movies but they're not," said John Musker of his feelings at the time. "That's what Disney *should* be doing."

The summer also saw Don Bluth's solo effort come to fruition. On July 2, 1982, *The Secret of NIMH* was released to theaters. It was based on the book, *Mrs. Brisby and the Rats of NIMH* by Robert C. O'Brien. Before Bluth left Disney, he encountered the book on the lot, as it was something Disney had once considered developing. Later, he remembered the story and thought it would make the perfect material for his first feature. The resulting film was a grand entrance for himself and his newly created studio. Roger Ebert referred to the Bluth exodus in his review, saying: *"They used to work for the Disney Studios, but they walked out because they thought the original Disney traditions*

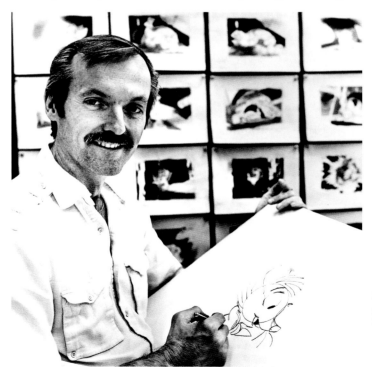

Don Bluth in a publicity photo for The Secret of NIMH.

were no longer being followed and my notion is Walt Disney would've liked The Secret of NIMH."[222]

The quality of the production value was much higher than what Disney had been making. Tonally, while still made for a family audience, it had a darker feel, even showing blood and on-screen deaths. Many Disney artists attended the opening and were impressed by the richness of the film's visuals. For the first time, Disney animation had a competitor who was working on the same plane of quality as it was. The younger generation was inspired by the pressure it put on them, but the old guard was unfazed and continued on, business as usual.

Nothing was business-as-usual about Disney's entry into 1982's busy summer blockbuster season. *Tron* hit screens in July and director Steven Lisberger's vision made many critics sit up and take notice. Siskel and Ebert raved about the film. Gene Siskel enthused: "*Tron* is a whole lot of fun that simply dazzles, and in the process, it also expands our notion of computers and the people who work with them and create them. And that this is a Walt Disney Production is the nicest surprise of all because before *Tron*, Disney films of late have been pathetic, unworthy of the Disney name. With *Tron*, though, Disney is instantly up to date. A truly exciting movie."[223]

However, Roger Ebert would add that "...the characters are one-dimensional at best."[224] Unfortunately, this was the most common criticism thrown at the movie. The film's story and characters did not connect with audiences and it did poorly at the box office. Said John Norton: "My reaction to the finished film was much the same as many of the critics at the time: stunning visuals with a sometimes confusing, not very involving story. So I was disappointed. I think if the story had been figured out properly and better written, it really could've been a blockbuster." Not to mention that if the film had been released during a much less crowded movie season—for example,

Using a jigsaw to shred Kodaliths at the end of production on Tron.

in December, as originally planned—it might have had a better chance at finding an audience. "If we'd been a Christmas film, we would've stood alone," said John Scheele. "We would've been a better film. We could've had a chance to market it better and promote it better and have it look better."

While *Tron* may not have achieved the success director Steven Lisberger and his team had hoped for, John Norton's regard for Lisberger never changed. Norton said of his friend and colleague: "He was the best boss I ever had in my forty-four years in animation. He was wonderful at inspiring artists. He had a great eye and respect for talent and never got in the way of his artists' vision, once he presented the concept. That's very remarkable about him. Something I never experienced at other places."

On July 30, the Studio debuted another unique film, *Tex*, based on S.E. Hinton's young adult novel. Said Hinton, in an article in *Disney News*: "I like the screenplay. It sticks to the book, and a lot of [the] dialogue is mine. It's been a wonderful experience."[225] The film marked a significant departure for the Studio. No fantasy, no special effects, no songs. This was

Emilio Estevez (left) and Meg Tilly (right) console Matt Dillon after a fight with his older brother in Tex.

a realistic drama about two brothers living on their own in Oklahoma. It was a mature and sincere film that dealt with such Disney taboos as sex and drugs. In the same article, screenwriter Charlie Haas said, "Hinton's world is not a sugarcoated fantasy land. The characters have emotional problems that don't always go away."[226] According to director Tim Hunter, Hinton's world and Disney's world could co-exist, saying it's "a lucky convergence that compromise neither the book nor the Studio's high standards for family entertainment."[227]

But just to be safe, the choice was made once again to minimize the Disney name to avoid chasing away a younger demographic. On the movie poster for *Tex*, "Walt Disney Productions" was buried at the bottom. In the film, the Studio's name only appeared in the end credits.

Tom Wilhite was steering the ship in a contemporary and relevant direction, and his efforts were being noticed. Ron Miller screened *Tex* at his house and a few days later, Wilhite received a note from Walt's daughter and Ron's wife, Diane Disney Miller. It said, "As a scion of the Disney family, I just wanted you to know that I think you're doing good things and I like this movie."[228]

Disney held a test screening of Jack Clayton's cut of *Something Wicked This Way Comes*, and the audience response was lukewarm, at best. Clayton was an accomplished director yet his approach was more old-fashioned and the film reflected it. He had made a mood piece, pensive and quietly suspenseful. Recalled cinematographer Stephen Burum: "It was Jack's original concept that he wanted to do this picture very much like he did *The Innocents*, where things are not clear. That the information was not delivered until the end of the

picture...so there was a difference of opinion in this instance."[229] The Studio felt that this kind of ambiguity was not what audiences in 1982 were looking for, as evidenced by the recent success of Steven Spielberg's *Poltergeist*, a film filled with shock value and lots of special effects.

The release date for *Something Wicked This Way Comes* was delayed as new footage was shot, new special effects added,

Mechanical Effects supervisor Isidoro Raponi with tarantula stand-ins from the reshoots for Something Wicked This Way Comes.

and the film was re-edited to tighten its pace. Said Harrison Ellenshaw, special-effects consultant on the film: "It was perceived by the Studio that the audience didn't understand some of the film...so it was to make it a little bit more literal."[230] Bradbury, who had been on the set for much of the shoot, was supportive of the Studio's plan. "We did at least a quarter of the film over," recalled Bradbury. "I said, 'Rebuild the sets, rehire the actors, I'll write the narration, I'll help edit the last reel of the film. Let's do it over and do it right.'"[231]

A small team of artists was brought on to conceptualize and animate

the new special effects sequences, including John Norton, fresh off of *Tron,* and Darrell Rooney, who had previously animated on both *Tron* and *Animalympics.*

In director Jack Clayton's original cut, the Dust Witch—one of the minions of the villainous Mr. Dark—pursues the two lead boys and her giant hand reaches out for them as they scramble to safety through one of the boys' bedroom windows. Said Burum: "The mechanical effects people built a very large mechanical hand. It was wonderful. All the fingers were completely articulated. It bent. It moved in and out. It was very effective in dailies. I guess when they saw it in the context of the picture, they didn't think it was scary enough."[232]

The Studio conceived a new scene, involving the Dust Witch unleashing a horde of tarantulas on the boys, as a way of upping the creepy factor. John Norton and Darrell Rooney were assigned storyboarding duties for this new sequence. "I also watched most of that sequence get shot on set," said Norton. "I think a year or more had passed between Clayton finishing his shooting and the filming of this spider sequence. [The actor who played the main character, Will] had grown a lot. Quite a bit. And now had short dark hair so they had him wear a blond wig for that sequence." The team did everything they could to disguise both boys' maturation but a keen eye can spot the difference in the final film.

Another new sequence that John Norton storyboarded was the arrival of Mr. Dark's Pandemonium Carnival. "It was a sequence where [the] train comes to a stop in an open field at night. The smoke and steam from the train engine transforms into Dark's circus—circus tents and wagons, Ferris wheels, etc. It was all to be done using computer animation but was overly ambitious for the state of the technology at the time, especially in terms of rendering things realistically." As Steven Lisberger had pointed

out to Norton on *Tron*, it was a lot more achievable and cost effective for computers to render geometric objects with straight lines, rather than the organic movement of tent fabric and train engine steam. "I figured out pretty quickly that this sequence was never going to get done," recalled Norton. "The visuals never got beyond the vector line construction of [the] objects. But it was a really fun sequence. It could've been something really cool."

In addition to storyboarding, Norton also did special-effects animation on this new iteration of *Something Wicked*, under the supervision of Lee Dyer, who also supervised the effects animation for *Tron*. Lightning, shattering glass, and bolts of electricity were added to many of the film's sequences, such as the standoff between Mr. Dark and Mr. Halloway in the town library. As Mr. Dark sucks the life out of Halloway, he marks each lost year by tearing a page out of a book. Everything about this scene is strong—from the ornate set to the writing, to Jonathan Pryce's menacing performance, to Clayton's suspenseful staging. To enhance the scene, animated effects were added to each page as it's torn out and thrown to the floor. "I thought no, that's not going to work," said Bradbury. "It's going to look too cheap. Too theatrical. But I was totally wrong. It does work. It enhances the scene and makes it more terrifying."[233]

Cinematographer Jan Kiesser was hired to lead a second unit shoot in Vermont. The team captured footage of autumn leaves and rolling hills that added time and place to the opening sequence. They also filmed the main characters moving through these locations, using stand-ins for the actors. These were used to transition between sequences and to give scale to a film that was shot predominantly on a backlot. Burum could not participate in these reshoots as he was in Oklahoma, shooting Francis Ford Coppola's own adaptations of S.E. Hinton's work, *Rumble Fish* and *The Outsiders*.

Georges Delerue's haunting and pensive score was replaced with a

new, more dynamic score by up-and-coming composer James Horner. When the film was tested again, the changes led to improved audience reactions. Alas, those changes had been made without Clayton's blessing.

Said Ellenshaw: "Sometimes studios feel that nothing should be left to the imagination, so it's always nice when you do have that fact, but that's what is part of the situation here with this film and why it went through so many modifications. It was where to add things that the Studio didn't have the confidence [that] the imagination of the audience would be adequate."[234]

When *Fun with Mr. Future* was finally complete, director Darrell Van Citters held a screening for the crew. He recalled: "Just before I showed it, I got up there and gave a small speech and I said, 'I'd like to thank Ink and Paint and especially Camera, without whom this would still just be a stack of cels.' And Joe Hale's comment was that 'it should have stayed a stack of cels.'" To Van Citters, this was a prime example of the generational gap at the Studio and the lack of tolerance for anything that was outside the norm. "Whether good or bad, they couldn't see value in a different direction," he said. "Everything had to be in this same mold. I think animation's bigger than that. I think Disney was bigger than that."

Unfortunately, the short didn't fare any better outside of the Studio. "Nobody really gave a shit about it," said Van Citters. "It did get released [in October 1982] and only because Joe Ranft had a brother who worked for Pacific Theaters. He talked to somebody there, and Pacific Theaters said, 'Sure, we'll show the short.' So, they ran it in front of a Roy Scheider/Meryl Streep film, *Still of the Night*."

As a producer, Marc Stirdivant had been making television projects for the Studio. One day, a manuscript from the Story Department landed on his desk. It was a soon-to-be-published book called *Who Censored Roger Rabbit* by Gary K. Wolf. The story was about the murder of a comic strip character, Roger Rabbit, and the human private eye, Eddie Valiant, who works to solve the crime. Stirdivant was instantly hooked by the property. "I could see it from the moment I read it," he recalled. "I could see what I thought it should be. So, I immediately picked up the phone and said, 'I want that. You gotta buy that. You gotta buy that *right now*.' And so, the Studio acquired the rights." Wilhite also saw the potential and brought Stirdivant together with Darrell Van Citters. "It became evident that the heart of the movie, it was a buddy picture," said Van Citters. "It was a clown who got no respect, and the guy who didn't respect him, and by the end of the movie, they come together. So, I got somehow attached to that and I think Marc just decided to go with where I thought it could go." Van Citters gathered his go-to team and they began working: Mike Giaimo designing characters, Joe Ranft developing the story, and Chris Buck animating experimental scenes with Giaimo's designs. "It was all very exciting because they wanted to do live action and animation," recalled Buck. "We thought, *That's cool!* The only thing in our heads was more *Mary Poppins*. We didn't really like *Pete's Dragon*. But this had a lot more adult stuff going on."

"I saw it as the coolest thing ever," said Giaimo. "How could it get any better than that? So, I totally immersed myself in it and loved it. Gosh, we all took such ownership of it."

Jiminy Cricket as the Ghost of Christmas Past in Mickey's Christmas Carol.

1983

In February 1983, Ron Miller advanced to the position of CEO at the company after Card Walker retired. Walker stayed on as chairman of the executive committee, and Ray Watson took over as chairman of the board when Donn Tatum retired from that position. Miller continued to maintain his role as president of Walt Disney Productions.

Meanwhile, *The Sword and the Stone* was rereleased to theaters early in the year and with it, a new short called *Winnie the Pooh and the Day for Eeyore*. Story artists Pete Young and Ron Clements, along with writers Steve Hulett and Tony Marino, assembled the story. It was based on A.A. Milne's stories "Eeyore Has a Birthday" and "Pooh Invents a Game and Eeyore Joins In." Unfortunately, studio leadership decided to farm out the remainder of the work to Rick Reinert Productions, a studio outside of Disney. The film itself was passable, but the animation quality was nowhere near the level to which Disney animators could have brought it.

It also represented the end of the era for the original Pooh voice cast. Ralph Wright, John Fiedler, and Paul Winchell returned as Eeyore, Piglet, and Tigger, respectively. But Sterling Holloway (Winnie the Pooh), Sebastian Cabot (narrator), Junius Matthews (Rabbit), and Barbara Luddy (Kanga) had all passed away prior to this film. Replacements for those actors were found, the most notable being Hal Smith—famous for playing Otis the drunk on *The Andy Griffith Show*—as the voice of Pooh.

Trenchcoat was released on March 11, 1983, and was a critical and financial disaster. However, it led to a major opportunity for the film's screenwriters,

Margot Kidder and Robert Hays defeat plutonium smugglers in Trenchcoat.

Jeffrey Price and Peter Seaman. Since *Trenchcoat* was a detective story, Wilhite thought they'd be the perfect fit for the whodunnit aspects of *Roger Rabbit* and assigned them the task of writing a first draft of the script. When Van Citters read it, he was not impressed. "I kind of went into attack mode on it," he recalled. "It seemed very derivative. The way they wrote cartoons was they would call over to the MGM studio and get them to send over old Tex Avery cartoons. So they'd watch them and then they'd crib gags from them." To Van Citters, these writers "didn't understand animation and to make that thing work, I think you had to come from the inside out, not the outside in." Stirdivant said: "Darrell and I wanted to tell a love story between a hard-boiled detective and a goofy cartoon rabbit who became the best of

friends. If we could pull that off, and you could believe that a human being and an animated character could love each other and be the very best of friends, *that* would be the accomplishment. That's what we were trying to do, and they didn't see that."

Seaman and Price wrote another draft, but Van Citters held his ground. This was not the take on the movie that he believed in. Wilhite then turned his attention to another writing team that he thought might be a better fit for *Roger*. And the good news was that a script of theirs was already in production at Disney. Their names were Lowell Ganz and Babaloo Mandel, and the film they'd written was *Splash*.

Producer Brian Grazer had developed the script for *Splash*, a love story between a man and a mermaid. He took it to various studios who showed some interest, but they all passed on the project. Grazer then teamed up with Ron Howard, now an established director. Howard had helmed a handful of television movies and was now directing his second theatrical feature, *Night Shift*, also written by Ganz and Mandel. Grazer met with Howard, Ganz, and Mandel and piqued their interest in his mermaid movie. The team developed a new script for the project and eventually found a home for it at the Ladd Company for Warner Bros. Right at that time, another mermaid movie was making its way around Hollywood. The writer was Robert Towne, Herbert Ross was on board as director, and Warren Beatty was attached to star. The weight of Beatty's mermaid project crushed Grazer's. Out of desperation, Grazer sent their script to Wilhite, who responded to its humor and heart. A few weeks later, he convinced Ron Miller to make it at Disney. The very next day, Grazer and Howard had a deal to make *Splash* and shooting began in April 1983.

The good news was their movie was going forward. The bad news, in Ron Howard's mind, was that it was going forward at *Disney*. Having finally shaken the goody-two-shoes stigma of his childhood acting roles, Howard was certain that he would be dragged back into sticky-sweet, wholesome territory by the Disney executives. They would forbid the more adult aspects of their film's love story and mandate that their mermaid wear a full bathing suit on screen. However, Miller had no intention of sanitizing the project. From the outset, he and Wilhite decided that *Splash* would be released under a new label, one that would allow them to make more mature films and not chase away adult viewers with the presence of the Disney name. The new label would be called Hyperion.

Ganz and Mandel did a few drafts on the *Roger Rabbit* script and Van Citters loved their approach. It had heart, they understood the relationship at the center of the story, and Van Citters found it much funnier than Seaman and Price's version. Stirdivant thought Ron Howard was the perfect choice to direct the live-action, so he approached Howard and producer Brian Grazer. "I said, 'Come on board,'" recalled Stirdivant. "'I got this great project. You're going to want to be part of this,' and he had other things on his plate, so he said no."

Van Citters and Giaimo had seen a stage show called *The Pee-Wee Herman Show*, which was the brainchild of performer Paul Reubens. They found Reubens hysterical and decided he'd be the perfect voice for Roger. They also searched for a director for the live-action portion of the film. "We had John Landis come in," said Van Citters. "He said, 'Why a rabbit? Why not a moose?' I said, 'I don't know. 'Cuz the property started with a rabbit?' He was just a loose cannon, so we didn't go for him. We had Jack Fisk, who was Sissy Spacek's husband. He had just done *Raggedy Man*, and he seemed like more of a soulful guy who might understand the personality part of it

but that didn't fly either. We had brought in Bob Zemeckis. None of us felt like Bob really got it." Stirdivant also courted Steven Spielberg, sending the director a sculpted maquette of Roger Rabbit. Spielberg wrote Stirdivant back, saying how much he loved the project. Ultimately, Zemeckis was hired as the director.

As *Roger Rabbit* evolved, its budget inched past the cost of the average Disney film and Ron Miller began to get cold feet about the film's edgier tone. Much to everyone's disappointment, Miller shelved the project. Van Citters was then assigned to an R&D effort to find an alternative pipeline for making animation that could keep costs down. Van Citters hoped that, through this research, he might find a way to revive *Roger Rabbit* in a more efficient and cost-effective way.

The Disney company was restructured into three divisions—parks, consumer products, and motion pictures. Motion pictures included both television and home video. Ron Miller hired former Fox executive Richard Berger in April 1983 as president of Walt Disney Pictures. Tom Wilhite would now report to Berger. Right off the bat, it was clear that the two didn't see eye to eye. For example, Wilhite was championing *Roger Rabbit* as the next big thing, while Berger saw no potential in the idea.

Another sticking point was *Return to Oz*. Berger responded favorably to the project while Wilhite was on the verge of canceling it. Director Walter Murch's initial script draft had been described as "too weird and cold,"[235] a diagnosis that most felt had not been remedied as the film moved through production. In the early stages of the project, Murch had brought on his friend and *Star Wars* producer Gary Kurtz to produce *Return to Oz* but as the

Studio's confidence wavered, Kurtz was moved into an executive producer role and Paul Maslansky was brought in to get the film back on track.

Berger also took issue with *Splash*. When he was at Fox, Berger had turned the project down and now, finding it on its feet at Disney, expressed his disinterest in the material to Miller. Ron maintained his stance that he wanted to make it, and the film went into production.

Once a disruptor itself, broadcast television now faced a threat to its supremacy from the growing popularity of cable television. In April 1983, in a joint venture between Walt Disney Productions and Westinghouse Broadcasting, The Disney Channel was launched, providing sixteen hours per day of paid family programming. Said Card Walker: "We plan an unprecedented effort in original programming designed for the American family—a startling departure from what is currently available in the home. To that end, our existing library, probably the largest single resource of family films in the world, will give us a strong base to build upon and we will supplement that base by searching the world…for quality programming that is appropriate for our channel."[236]

Something Wicked This Way Comes was finally released on April 29, 1983. This film stood as an interesting example of where the Studio was at the time—caught between old-fashioned storytelling and the new world of special-effects blockbusters. As a result, the film fell short of reaching either audience. However, after many years of trying to get a film of his book off the

The sinister Mr. Dark subjects Will Halloway and Jim Nightshade to the powers of the Dust Witch in Something Wicked This Way Comes.

ground, author Ray Bradbury was thrilled to see it completed. "Out of all this perspiration, we finally made a film that I'm proud of," he said. "Are some of the flaws still there? They most certainly are. But the final thing is a film that I'm glad to tell people to look at. It's a good film. I love it very much."[237]

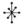

Producer Jonathan Taplin approached Disney with a script about a paleontologist and her husband who discover dinosaurs living in the African jungle. The script was written by Clifford and Ellen Green and was based on the ancient legend of the mokele-mbembe, a water-based creature that many said was, in truth, a surviving brontosaurus. This notion, plus the couple's desire to write a story about a mother's love for her child, inspired their screenplay.

The Greens took the script to director Roger Spottiswoode to see if he'd be interested in the project. Spottiswoode had just directed the political thriller *Under Fire,* which Taplin had produced. The director didn't feel that the Greens' script was right for him at that time. He did see potential in it, however, and handed it to Taplin to see what he could do with it. Wilhite thought the screenplay was good and decided to go forward with it, hiring David Freeman to do a script polish and Bill Norton (whose previous film was *More American Graffiti*) to direct.

Taplin set up shop at Disney. What he witnessed every afternoon from two to four shocked him. "Ron Miller, president of Disney, would play poker for two hours every afternoon with three cronies who had 'producing contracts' at the Studio," said Taplin. Miller seemed more concerned with his card game than he was with his company's brand erosion or its position at the back of the line in Hollywood. Or as Taplin puts it "...that he was running an American icon into the ditch.[238]"

The greatest production challenge for *Baby* would be creating believable, life-sized dinosaurs that could behave and perform with actors. Taplin invited his friend and former *Tron* effects supervisor John Scheele to consult on the early stages of the dinosaur creation. Not only did the two know each other from high school but Scheele had a background in science and paleontology. "My Dad was a museum director and I had all this science background," said Scheele. "My Dad was a great authority on dinosaurs, wrote books on dinosaurs, [and we'd gone] dinosaur digging since I was 4 years old."

Much to Scheele's delight, Taplin also invited his father, William, to consult on the film. "My own parents were both very talented artists in the wonderful city of Cleveland, Ohio," said Scheele. "They were both number 1 and number 2 [students] in the Cleveland Art Institute. At that point, they

were both recruited for *Fantasia*. They didn't come out. They were from working class families and they weren't really fluid enough to uproot and go to California but they looked at it as a dream. It put a little spark in them to always think about what that might have been." Now years later, having finally moved out to California, that dream of walking on to the Disney lot finally came true. "My Dad got a paycheck from Disney," recalled Scheele. "It wasn't that much but it meant a lot to him. To have had that be part of my parents' past and now to have it be fulfilled, it was a dream."

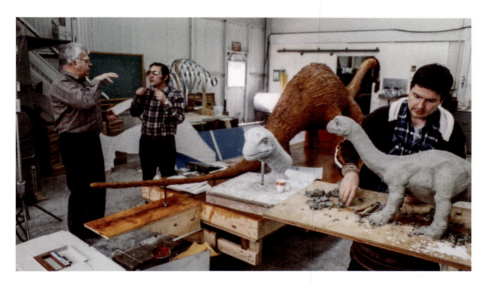

Consultant William Scheele (left) chats with mechanical effects artist Isidoro Raponi while Yarek Alder sculpts a dinosaur for Baby: Secret of the Lost Legend. .

As momentum picked up on the project, Taplin grew frustrated with the Studio's insistence that the visual effects for *Baby* be created in-house, rather than contracting a state-of-the-art effects facility like Industrial Light and Magic. "Up at ILM, there were people in Phil Tippet and others that Jon knew at the time that would've been good candidates for it," said John Scheele.

"Or Rick Baker. In truth, there wasn't any legacy of people who did creature effects like that at all [at Disney]. They did great photographic effects. They did great animation effects. In the theme parks, they do [animatronics] all day long. [But] we didn't have people from WED coming over. That animatronic technology was not coming into play for this kind of picture."

To oversee the design and construction of the dinosaurs, Taplin brought on two mechanical effects artists that had previously been a part of the production of *Something Wicked This Way Comes* - Roland Tantin and Isadoro Raponi. Prior to coming to Disney, Raponi had worked on mechanical effects for the 1976 remake of *King Kong, Close Encounters of the Third Kind* and most recently on the team that brought E.T. to life. His particular connection to the latter film made him seem like the perfect choice.

In *Backstage at Disney*, a documentary that aired on The Disney Channel in 1983, Raponi and Tantin demonstrated their solution for how to bring the baby dinosaur of the film's title to life. The head and tail of the dinosaur were mechanical effects controlled by levers and cables. They were mounted on to an exoskeleton which was then placed on the back of a performer, on all fours. With the combination of the performer's movements and the offscreen manipulation of the mechanical controls, the baby dinosaur came to life.

This solution meant the baby dinosaur was essentially a large puppet. Now the success or failure of the character hinged upon how much subtlety and expression could be conveyed by working cables and levers, rather than through more state-of-the-art means, such as stop-motion animation or animatronics. And without a knowledge or history of creature effects at the Studio as a foundation for their efforts, there was great risk in this approach.

Because of how expensive the special effects would be, the Studio wasn't willing to shell out much for casting, which meant there would be no

big stars. Sean Young, from *Blade Runner,* and William Katt, star of the hit television series *The Greatest American Hero*, were cast in the leads. Patrick McGoohan took on the role of the villain. He had starred in Walt's multipart television thriller *The Scarecrow of Romney Marsh* and the British series *The Prisoner*. McGoohan was excited to be a part of the project, feeling like it had the potential to be a success on par with *E.T.*

Unlike the decision made for *Something Wicked, Baby* was to be shot entirely on location on the Ivory Coast. Jonathan Taplin was able to get the director of photography with whom he worked on *Under Fire*, John Alcott. Taplin knew Alcott was good shooting on location. Said Taplin: "...He was perfect for this kind of location because he didn't use a lot of lighting equipment. He was a much more natural light cinematographer, and he also never complained. He had been Stanley Kubrick's cameraman and they took whatever the conditions were, and they were kind of a self-contained English camera crew who were used to going to all sorts of exotic places." Prior to *Baby* and *Under Fire*, Alcott had won an Oscar for Kubrick's *Barry Lyndon*. One of Alcott's very first jobs was as a clapper loader on Walt Disney's live-action version of *Robin Hood* in 1952.

Tom Wilhite joined the team on their location scout in Africa. When he returned, he encouraged Berger to find a substitute location for Africa, as filming there seemed to him like it would pose a problem. Berger disagreed and thought location shooting would be great for the film.

Carroll Ballard and Charles Martin Smith continued working on the cut for *Never Cry Wolf* at George Lucas' editorial facilities in San Rafael, California. Because of Ballard's improvisational tendencies, and the fact that there

never was an actual shooting draft of the script, they had about forty hours of footage that they now had to cull down into some kind of narrative form. They would finish a cut of the film, Berger and Wilhite would fly up and give them notes, then the executives would return to L.A. Ballard kept cutting version after version, never settling in on one in particular. Miller finally lost

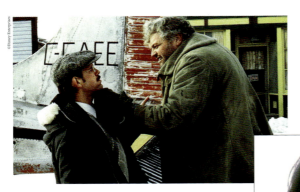

Top: Tyler (Charles Martin Smith) hires pilot Rosie (Brian Dennehy) in Never Cry Wolf.
Bottom: Charles Martin Smith amongst the wolves and caribou.

patience with Ballard's indecisiveness, and it became clear to Wilhite that Ron wanted him fired. Said Wilhite: "So, I got on a plane to go to Berkeley and on the plane up, I was thinking, *What are we going to do with forty hours of exposed film? How are we going to re-cut this movie?*" When Wilhite landed, he called Miller and told him that they couldn't fire Ballard. "He knows the movie," Wilhite said to Miller. "We've screened it enough times that we know that in these cuts there is a viable commercial film. He just has lost track of it, every time he's fiddling with it. So [Miller] said, 'Well, you better be right.'"[239] When Wilhite met with Ballard, he conveyed the faith the Studio had in his film, but also that his time for noodling had come to an end.

There would only be two more screenings before the film would have to be finished. Ballard agreed and completed a cut that was previewed in northern California to great success. Added Charles Martin Smith: "No studio would ever relinquish that kind of control anymore, and Disney wouldn't have done that before, and they wouldn't have done it after. It just happened to be that one particular time in history where the Studio was a little bit adrift, I think."

Never Cry Wolf was released in a limited run on October 7, 1983, about four years after the start of principle photography and under the newly created "Walt Disney Pictures" banner. It would have its wide release on January 27, 1984. The film was generally well-received and did moderate business.

Artistically, *Never Cry Wolf* represents the first great success in Wilhite's plan to turn the tide at Disney and help the Studio grow up. The film pays homage to the Studio's roots in nature stories and documentaries, made with the same improvisatory approach needed to capture life in the wild. It is everything a great Disney movie should be but is told with sophistication and with the singular vision of a filmmaker. The audience is in Ballard's hands. When one thinks of Disney films that came before it, it's hard to believe that *Never Cry Wolf* was made by the same studio.

"It wasn't really a Disney film," said Charles Martin Smith. They didn't really make it. They financed it…but they weren't really involved other than sort of the executives giving some notes. It was very much Carroll Ballard making this movie. It was very much them handing it over to this young, maverick filmmaker from the Bay Area."

Filming was underway in Iowa on a film called *Country*, a contemporary drama about the plight of American farmers. This was a prominent topic in

the headlines of the day and one that connected with its star and producer, Jessica Lange. She had grown up in rural Minnesota and was empathic to the struggles of the farming community. Lange hired William D. Wittliff, writer of *The Black Stallion, Honeysuckle Rose,* and *Raggedy Man,* to write the screenplay as well as direct the film.

Country began shooting in the fall of 1983 and was anything but easy. About two weeks into filming, tensions between Lange and Wittliff escalated to the point where he had to step down as director. Richard Pearce was brought in to replace him. The weather during the shoot was brutal, with freezing rain and temperatures recorded at forty-three degrees below zero. In an interview in *Disney News*, Lange said: "The harshness of the Iowa winter totally dominated the feel of the filming. I think I can speak for everyone when I say that the subfreezing temperature day after day brought home a certain physical reality that matches the economic plight of the Midwestern farmer."[240]

But for Lange, these struggles were worth facing, given the film's importance in her journey to find legitimacy in Hollywood. After making her screen debut in the 1976 remake of *King Kong*, Lange struggled to find serious work. But her double Oscar nomination for the 1982 films *Frances* (Best Female Lead Actor) and *Tootsie* (Best Female Supporting Actor), and her subsequent win for *Tootsie,* finally gave her that legitimacy. "Hollywood is a bizarre place," said Lange. "The way it doles out credibility is very strange. Within a year, I went from having no credibility to being able to produce my own film."[241]

The Disney Channel became home to Disney's extensive film and television

library. To increase viewer interest, the Studio began producing original feature-length films exclusively for the cable network. *Tiger Town*, starring Oscar nominees Roy Scheider and Justin Henry, was the first. Premiering in October, it's the story of a boy who believes he has the power to make the Detroit Tigers win their games.

This new entertainment platform created a period of experimentation and new ideas, thanks to Wilhite's aggressive push to find and cultivate talent. Said publicist Mike Bonifer: "I found that it was a great place to have ideas at the time because you could do a lot of stuff. That's how we were all getting started. People had these ideas for things that weren't exactly in their job description and...we'd find ways to do it."

Bonifer had an idea for a documentary series for The Disney Channel. Every episode would showcase a different Disney animator, writer, actor, Imagineer, etc. Titled *The Disney Family Album*, Bonifer produced and directed the show. For the opening title sequence, he enlisted animator John Lasseter to help him create a concept. Lasseter drew a simple book with the words "Disney Family Album" on it, sitting on a table next to a lamp, and was enthusiastic about using computer animation to bring the sequence to life.

Ron Clements used the opportunity to explore his interest in story by writing scripts for several development projects. One was a long-gestating film called *Hero From Otherwhere*, based on a 1972 book by Jay Williams. Artist Mel Shaw had kicked off the project back in the mid-'70s. He created stacks of concept sketches, fleshing out the science-fiction story of two schoolyard enemies who are transported to a strange fantasy world, where they go head-to-head with a wolf named Fenris. Another of Clements' scripts was called *The Solitaire Creature*, which was part of a proposed anthology show for The Disney Channel called *Future Tense*. None of these projects ever made it to completion.

Animation artists Mike Gabriel, Sue Mantle, Joe Ranft, and Chris Buck made a homemade pilot for a puppet show idea they had for The Disney Channel. "We would do it up in Sue's apartment and we would tape those and submit them and try to get the show off the ground. The shows were so amateurish."

Tim Burton continued to develop more film projects, having had success with his stop-motion short *Vincent*. He would push the boundaries of Disney, and of the accessibility of his own work, with a special for The Disney Channel called *Hansel and Gretel*. Airing on Halloween night of 1983, it was an unusual take on the classic story, combining live-action, stop-motion, puppets, and an all-Asian cast. It was campy, it moved at a glacial pace, and was accompanied by the gentle piano music of Johnny Costa, composer for *Mister Rogers' Neighborhood*. Burton created something wholly unique and unlike anything made anywhere, let alone Disney. After the initial broadcast, the film never aired again. But that didn't stop Burton from trying to get more of his macabre vision realized. He developed and pitched two more holiday specials for the Channel, *Trick or Treat,* written by Delia Ephron, and *The Nightmare Before Christmas*. The Studio passed on both projects.

None of this experimentation would have been possible without a boss who was willing to allow it. Ron Miller was that kind of boss. Recalled Mike Bonifer: "Ron, I think, did a lot of good by staying at a distance and letting people make mistakes and get away with things. We used to make fun of the fact that...he'd play Crazy Eights at lunch with Lou Debney and Jan Williams. There'd be, like, four large men playing Crazy Eights in the executive dining room, and it'd be embarrassing, *but* that let us get away with stuff that a guy that's looking at every line item never would've let go by."

Card Walker was less inclined to let novel ideas brew. Walker was one of the staunchest advocates of the "What would Walt do?" school of thought.

"Card Walker [was] very strict and kind of straight-laced and conservative management that wasn't visionary at all, to our perception," recalled John Scheele. He confronted Miller about much of what Wilhite was doing and questioned whether Tom understood what Disney was about. Thankfully, Miller shielded Wilhite from the scrutiny. "He ran interference with a lot of complaints," said Wilhite. "He really did put up a wall to keep a lot of that stuff away so that we could at least try to do what we were trying to do. I have to say, Ron as a boss, was a terrific person to work for."[242]

Miller's hands-off approach could easily be interpreted as disinterest or a lack of awareness but, according to Wilhite: "Ron knew everything that was going on in that company. So, when we were calling (*Vincent*) a 'stop-motion experiment,' and spending $100,000 on it—and he calls me and says, 'What's this stop-motion experiment?' and I do a lot of fast talking about 'Well, we need to explore different kinds of technology'—he knew *exactly* what was going on, and he let it happen. The same with a lot of things that went on, [like] finishing Darrell Van Citters' *Fun with Mr. Future*."[243]

Miller's afternoon card games continued to anger producer Jonathan Taplin. As an outsider, Taplin had no history or loyalty to Miller. All he saw was a CEO so relaxed and unfazed while his company was in need of attention. Taplin gathered the company's latest financial report and met with his friend Richard Rainwater in Fort Worth, Texas. Rainwater was the chief investment advisor for Bass Brothers Enterprises, owned by four men who had inherited the investment firm from their father. Taplin walked Rainwater through the company's finances, showing Disney to be, as Taplin describes it, "a classically undervalued asset that was badly managed.[244]" Rainwater was impressed but, because of other deals that were in play at the time, he didn't have the finances to invest in the company.

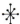

As *Mickey's Christmas Carol* prepared for release, Burny Mattinson assembled the opening credits. There were so many artists who would never get credit on the Studio's films, particularly cleanup artists, which Mattinson could relate to, having been one himself for many years. He decided to create an additional card for the opening titles that would read "With the Creative Talents of." This way, Mattinson could credit the cleanup staff as well as some assistants who did bits of animation on the film but didn't officially have the

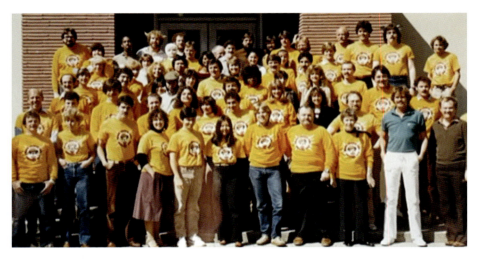

The crew of Mickey's Christmas Carol on the steps of the Animation Building.

title of animator. One name that ended up on this list was John Lasseter. Lasseter had asked to animate scenes of Jiminy Cricket as the Ghost of Christmas Past and Mattinson was happy to oblige, giving Lasseter the section where Jiminy flies out the window with Scrooge in tow. When Mattinson saw Lasseter's initial pass at the scenes, he wasn't completely happy with them

and gave the young animator a list of notes to address. Weeks went by and, not only did the notes not get addressed, but Lasseter was never in his office. Mattinson reassigned the scenes to someone else and Lasseter did no further work on the short. When it came time to assemble the credits, Mattinson was approached by a frustrated artist who said that if Lasseter received a regular animation credit, having done so little work on the film, the crew would not be happy. Mattinson agreed and called Lasseter to his office where he broke the news that he would not be getting an animator credit. Lasseter quietly listened. Mattinson then told him that he would, however, put his name in the "With the Creative Talents of" section.

Lasseter had burned other bridges by this point. Mel Shaw had experienced Lasseter's unreliability as he was developing his *Musicana* project. Lasseter had come on to do story development for the "Mickey and the Nightingale" sequence but never had the time to do much work. His opening titles for *The Disney Family Album* never came to fruition, either. The computer animation technology of the time was not capable of doing what he'd envisioned. This resulted in Lasseter burning through Mike Bonifer's budget before leaving the project altogether. Said Bonifer: "I had like, $15,000 budget for titles, and he spent it all and then I had to beg people to do it for basically free to end up with what's there now."

One of the reasons why Lasseter was so difficult to pin down was his newfound obsession with computer animation. He had seen the work his colleagues had done on *Tron* and to him, it opened up limitless possibilities for how the art of animation could evolve. He also saw the potential in combining hand-drawn animation with computer imagery, an idea that he and his colleagues discussed frequently. Recalled Wilhite: "John obviously was impressed by *Tron* and the potential in it. He wanted to experiment with combining traditional animation with computer backgrounds."[245] Glen Keane

was also bitten by the bug. He recalled: "[On] *Fox and the Hound,* we had *one* stupid multiplane shot in that whole movie and here, [with *Tron*] the whole movie is *all* multiplane. There's got to be a way for us to be able to animate dimensionally. What if we came up with a test?"

Wilhite suggested that Lasseter and Keane use Maurice Sendak's book *Where the Wild Things Are* as the basis for their test. "I was very friendly with Maurice Sendak, had been for probably at that point five or six years," said Wilhite. "Over the years we started talking about maybe doing something with some of his books. We talked about different approaches, maybe doing an omnibus thing with *Where the Wild Things Are, In the Night Kitchen,* and *Outside Over There.* So somewhere in there, when John wanted to try this test, I said, "Well, why don't we use *Where the Wild Things Are* because it might be a way to do double duty, show Maurice something and then also you can experiment with it and it's something identifiable.' So that's what they did."[246]

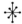

Performances of "The Eddie Show" continued out the windows of the Animation Building. The troupe decided to increase the length of their shows to around ten to fifteen minutes each. The first of these would be a Christmas show. Recalled Chris Buck: "We got cardboard cutouts of Eddie Fisher, Doris Day, Zsa Zsa Gabor and Marlon Brando. We practiced. We rehearsed for a week. We'd do it at night and the guards didn't know what we were doing."

The day of their holiday extravaganza arrived, which also happened to be the same day that a big publicity event was being held on the Studio lot. Said Buck: "The Channel 5 news crew had sent people to come and do some interviews to hype *Mickey's Christmas Carol,* so they were there the

same day as our show. The [Eddie] show was so popular, people wanted to see it again. So, these guys are there to film *Mickey's Christmas Carol* but the word's buzzing around the Studio." The news crew's curiosity was so piqued that they asked to film the encore performance. That evening, Buck and Mike Giaimo watched the news to see if any of the footage of their show would be on the broadcast. As it turned out, they weren't just featured in the story, they *were* the story. "Not a *word* about *Mickey's Christmas Carol*," said Buck. "Mike and I looked at each other like, Uh-oh! What did we do?"

On December 16, 1983, *Mickey's Christmas Carol* was released as a featurette attached to a reissue of *The Rescuers*. The film was warmly received and nominated for an Oscar for Best Short Subject. It was Irwin Kostal who had convinced Burny Mattinson to submit the film for consideration. After it was nominated, the Studio was optimistic about their chances of winning. They prepared ads to run in the industry trade magazines after their anticipated win, congratulating Mickey on receiving an Oscar. This only added more pressure to Mattinson, who was already nervous about the possibility of winning and having to get up in front of millions of television viewers and accept the award.

At the ceremony, Mattinson sat next to fellow nominee Jimmy Picker, who had made a stop-motion short called *A Sundae in New York*. The entire film was done in clay animation with a caricatured figure of then New York City mayor Ed Koch singing "New York, New York." According to Mattinson, Picker wore a tie that had blinking lights on it and was acting like a "big shot." Then to Mattinson's surprise, Picker won the Oscar. Despite not winning, *Mickey's Christmas Carol* is still an important film. It was Mickey Mouse's grand return to the big screen, and it was the new generation of young animators who'd made it happen. "It was neat to know that we were kind of making history," said animator Mark Henn. "That was the first one in

thirty years that Mickey really had a significant role other than a corporate symbol."

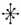

Keane and Lasseter assembled an impressive test for *Where the Wild Things Are*. They worked with MAGI in New York—one of the Studios that provided the computer animation for *Tron*—to create the moving backgrounds, and then Keane animated the characters to match the action. Lasseter was hooked. He dreamed of doing an entire feature with the same techniques. Lasseter had found a novella called *The Brave Little Toaster* by Thomas M. Disch, about a group of abandoned appliances who make a cross-country journey to reunite with their owner. Lasseter felt that the mechanical nature of these characters was perfectly suited to computer animation. He took it to Wilhite, who also saw the potential and bought the rights for Lasseter. They brought on Joe Ranft to develop the story, and the first computer-generated feature film was in the works at Disney animation.

Ed Hansen had heard the complaints about Lasseter's absence on the projects he'd been assigned to. What upset Hansen even more was that Lasseter was developing *Toaster*—an *animated* film—with Wilhite, a *live-action* executive. Animation was Hansen's domain, and he felt Wilhite should stay on his side of the fence. Eventually, Lasseter and his team of Ranft and Brian McEntee pitched *Brave Little Toaster* to Hansen and Ron Miller. Afterward, Wilhite recalled: "Ed and I had a separate meeting with Ron in which I gave the pitch on why we should make this movie and Ed basically gave the pitch on why it wouldn't be a good thing to do. Ron voted for Ed."[247] The project was killed, and Lasseter was fired.

Said Mike Bonifer: "If they had understood what was happening

with *Tron* and Lasseter...they would've given Lasseter a lab to play with. They would've seen that computers were going to change filmmaking, and they would've honored the history of Disney, in that technology was always responsible for the big advancements." It's mind-boggling to think of how different the future of Disney would have been had Miller chosen Wilhite's side. Disney would have made the first computer-animated feature film and would have made it a good ten years before Lasseter eventually did at Pixar. Just like Walt did during his time, Disney would have been leading, rather than following.

At the end of 1983, a completed *Splash* was screened for exhibitors and received an enthusiastic response. The feeling was that Disney finally had a hit, all because Miller and Wilhite had faith in that original script—the script that Berger had passed on when he was at Fox. It was yet another example of how different Wilhite and Berger's tastes and instincts were from each other. Said Wilhite: "When the movie was...clearly going to be a hit, [Berger] attached himself [to it] and wanted to *detach* himself from me. I resigned shortly after the movie was screened for these exhibitors. That's when it was clear Dick had other plans. If I were gone, it was just a better thing. If I hadn't left, I would have been canned at some point."[248] On his way out, Wilhite asked Ron Miller for the rights to *The Brave Little Toaster* and to the name Hyperion, which Miller allowed. There was no reason to deny Wilhite use of the name since the Studio's new adult label had been changed to Touchstone.

PRODUCTION #2531

Background image: Model sheet for Sport Goofy. Inset image: Members of that film's production team. Back row: Jill Stirdivant, Mavis Shafer, Fred Cline, Darrell Van Citters, Dorothy (Aronica) McKim. Middle row: Brett Koth, Susan Craig, Dan Jeup, Kelly Asbury. Front row: Chris Buck, Shelley (Hinton) Buck, Toby Shelton, Ed Gombert.

1984

Walt Disney Productions was chosen by the National Federation of State High School Associations to be the first corporate sponsor of high school sports. The company chose Goofy to be the mascot for the program, and he made public appearances at events like Wimbledon, the Little League World Series and on NCAA Football television programs. He then went international when the French Olympic team selected Goofy as their mascot, in the early '80s. Now known as Sport Goofy, the character became a large merchandising draw, appearing in books, records, and on sporting equipment. Animator turned producer Tad Stones thought an animated film based on Goofy's sporting activities would be a great idea. He developed the story with Joe Ranft and Mike Giaimo and brought Darrell Van Citters on as director. Since Van Citters had already been experimenting on ways of simplifying and streamlining the animation process, he saw *Sport Goofy* as the perfect subject to test out those ideas.

Dorothy McKim became Van Citters' assistant on *Sport Goofy*. Since 1980, she'd been moving through the Studio, in a variety of different roles. After starting in the employment department, she moved into live-action editorial and then to being assistant to the producers of *Five Mile Creek*, an original live-action series being produced for The Disney Channel. One day, she saw a job opening to be Van Citters' assistant. She interviewed and got her first job in the Animation Department. But she quickly learned that this project would be different than those that came before. "Darrell did not want to be part of the Studio," she recalled. "He wanted to branch out." So their small team moved off the Burbank lot and set up shop in a bank building in the neighboring city of Glendale. "It was a really great experience," said

McKim. "There was only a handful of us and we would have so much fun, being away from the Studio." *Sport Goofy* was now the first animated project to be created by Disney artists in an off-property facility.

Twelve hundred Disney shareholders gathered at the Contemporary Resort Hotel in Walt Disney World for the annual stockholders' meeting. In his address to the group, Ron Miller spoke optimistically about the new doors he had opened for the company and about the prosperous times ahead: "With definite signs of the revitalization of our movie business, a fast-growing subscriber base for The Disney Channel, expansion plans for Tokyo, the prospects of a European Disneyland and the solid financial foundation that EPCOT Center assures us, our future remains bright."[249]

Embracing the potential of cable television and expanding the scope and reach of Disney theme parks was indicative of Miller's efforts to push Walt's company in new directions, honoring his father-in-law's penchant for innovation and forward thinking. Now could Miller do the same with the Studio's struggling film division?

Touchstone Films officially launched in February. This new brand "will identify those films appealing to other segments of the movie-going audience," said Ron Miller, as quoted in an issue of *Disney News*. "With Touchstone, we are making a very clear distinction between classical, customary Disney entertainment for the whole family and our diversification into a wider spectrum of films."[250] The same article states that the executive in charge of film production for the Touchstone label would be Richard Berger. There was no mention of Tom Wilhite in any capacity.

The following month, *Splash*, the first release from Touchstone

Films, opened in theaters. As predicted, it was a hit. Critics loved it. The film went on to gross almost $70 million, becoming the tenth highest-grossing film of 1984, beating out Disney's previous top box-office winners *Mary Poppins*, *The Love Bug*, and *The Apple Dumpling Gang*. *Splash*'s screenplay was nominated for a Writers Guild Award and an Academy Award. The film itself was nominated for Best Picture (Comedy or Musical) at the Golden Globes. Miller and Wilhite's efforts to make a Disney film that would connect with a mature audience had finally yielded results. It was unfortunate that Wilhite wasn't there to enjoy the success.

Daryl Hannah (top left) and Tom Hanks (right) from Splash. *Inset: Hanks and Hannah join director Ron Howard (bottom left), Eugene Levy (center) and John Candy (top) for a publicity shot.*

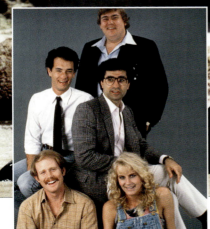

DISNEY IN-BETWEEN

On the exact day that *Splash* was released, Roy E. Disney sent a personal and confidential letter to the company. It was short and to the point: "I hereby resign as a director of Walt Disney Productions."[251] It was the beginning of Roy's campaign to reclaim the company, but he would do it from outside the Studio.

Ron Miller had been quietly courting Paramount executive Michael Eisner to come to Disney and run their motion-picture and television division. Miller was impressed with Eisner during Disney's coproducing ventures with Paramount and was aware of his stellar reputation throughout Hollywood, having had great success in both films and television, shepherding *Saturday Night Fever, Grease,* and *Raiders of the Lost Ark* into theaters. Eisner also launched *Happy Days* and *Laverne and Shirley* on the ABC network. Eisner liked the idea of coming to Disney but only if he could be president and COO. Miller agreed and now had to convince Card Walker that it was a good idea to hire someone from outside the Disney kingdom to run the Studio, something unheard of for the company. Walker's initial response was negative, saying that Eisner couldn't do the job because he didn't know anything about running theme parks. Miller kept pushing and Walker warmed to the idea. Business affairs was called in to start working out the terms of the deal but when another executive adamantly insisted that the position *must* be filled by someone within the company, it triggered Walker's cold feet. He immediately backed out of the deal. Miller had to call Eisner and tell him that Walker had said no.

Baby began production in Africa about the time Wilhite left, and his gut feeling about the folly of shooting on location was proven correct. The production faced countless problems—unseasonably heavy rain, power outages, and a woman in a nearby village being struck and killed by a crew member's car. Director Bill Norton rewrote the script, which many felt was not an improvement, including actor Patrick McGoohan. "By the time we got to Africa, the story had changed so much," recalled Howard Green, the film's unit publicist. "[McGoohan] was upset about it. He started drinking again. He fell off the wagon." To make matters worse, the animatronic dinosaurs that were to be the stars of the show, didn't work. Said Green: "The dinosaurs that they tested on the lot in Burbank worked very well but, when you put them in the rain forest on an uneven surface, they didn't look so good. They weren't meant to go through mud and creeks and stuff like that."

Another of Wilhite's gut feelings proved itself correct when Richard Berger decided to fire Walter Murch as director of *Return to Oz*. Producer Paul Maslansky had been brought in to steady the production but Maslansky's personality did little to steady Murch's nerves. "Paul did an effective job but he's very intense and he rubbed Walter the wrong way," said Kurtz. "Making a movie is an endless series of little decisions and it's all compromise. Nothing you do ever looks quite like what was in your head. Walter was worrying himself into a nervous breakdown."[252]

Said Berger: "I told Walter I had to make a change for his own good and for the sake of the movie. I felt the movie was overpowering him and he was getting sick."[253] As soon as Berger made that decision, news of it spread to Hollywood agents who flooded Berger with names of potential director replacements. But luckily for Murch, he had friends in high places. Berger got a call from George Lucas—colleague and former schoolmate of Murch's—telling him he was making a mistake in removing Murch and that

Top left and right: New incarnations of The Tin Man, Scarecrow and Cowardly Lion that more closely resemble the illustrations of John Rea Neill. Bottom: Billina the chicken and Fairuza Balk take direction from Walter Murch on the set of Return to Oz.

Lucas would personally visit the set of *Return to Oz* to help Murch gain his confidence back. Thanks to this intervention, Murch was able to stay in the director's chair and over the course of several months, was also visited by friends Francis Ford Coppola, Steven Spielberg, and Phillip Kaufman who helped him finish the shoot.[254]

Animator Mark Henn said that he is often asked which of the Disney animated features that he's worked on is his favorite. Said Henn: "Lately I've been saying, 'Well, I can tell you which one *wasn't* my favorite movie.' And that was *The Black Cauldron*." Very few artists talk about the experience with enthusiasm. Dale Baer, as he did on *Christmas Carol*, freelanced on *Cauldron* and recalled how uncomfortable he was returning to the Studio to pick up work. "There

was this weird atmosphere in the building. You could feel it. I couldn't wait to get my scenes turned in, pick up my other ones and get the heck outta there." Relationships between the young artists and the leadership of Art Stevens, Ted Berman, and Rick Rich had worsened throughout *The Fox and the Hound*. During *Cauldron*, it was downright ugly. The more time these men spent in the director's chair, the more it ate at the crew. Most believed that the only reason the three men were even in these positions was because they had simply survived. They were the only ones left of the older generation. The younger crew mocked their choices behind their backs—from uninspired character designs to bland animation, to generic dialogue.

The three directors did not get along with each other, a situation that only furthered tensions. They preferred to do their own sequences independently. Said Ron Clements: "Art [Stevens] became paranoid. His behavior just got a little weird. [He] even took his sequences away privately and did his own thing without even Joe [Hale] or the other directors." Layout artist Dan Hansen added: "All three directors hated each other. They hated what each other was doing. So, they didn't make any attempt to even bring things together." "Nobody wanted to collaborate," recalled Dale Baer. "They all wanted to do their thing in their room by themselves behind closed doors. They never talked to each other. I picked up some scenes from Art one time, and he's just sitting in a little chair and he's talking to the secretary, and he's got his feet up, just relaxed like everything's going so wonderfully smoothly. Even dealing with Ted Berman was difficult. He didn't really know what he wanted, and he would get frustrated. And that's why nothing was making sense in the movie. Nothing was hooking up."

"Joe Hale should have been trying to pull them together, but he wasn't interested in that at all," recalled Dan Hansen. "I remember he'd sit in his office and read books about World War II rather than getting with the

directors and pulling things together. And I think it was this weird, awful combination of people that weren't good enough to be doing what they were doing."

Mike Gabriel remembered that, at the height of the tension between leadership and crew, Hale called all the animators into a room and, according to Gabriel, told them: "Shut up or there's the front gate. I don't want to hear any complaints. I don't want to hear any ideas. No criticism. Shut your mouths and do your work. Or get out."[255] For those who had recently come off the highly collaborative and inclusive *Mickey's Christmas Carol,* this was a terrible culture shock. Said Mark Henn: "For me, I came into [*Cauldron*] expecting to have the same 'Roll up your sleeves, let's all pitch in and make it' and that wasn't the case. It was basically, 'My way or the highway.'"

"If it seems like this was a bad time, it *really* was a bad time," recalled Ron Clements. He would vent his frustrations to his friend Tad Stones. Stones, in turn, told Ron Miller about what Clements was saying, since Miller seemed oblivious to the issues on the floor. Clements wasn't happy about Stones speaking for him, so he decided to go give Miller his own account of the state of morale. Eventually word got back to Joe Hale that someone was bad-mouthing him to Ron Miller. Clements felt incredibly guilty and went to Hale's office to confess. Hale was so angry that he put Clements on probation, along with John Musker, who had previously been removed as *Cauldron*'s fourth director. According to Clements: "We were put in a room, and we continued to work on the story for a little while with everybody knowing that nothing we did would ever make it into the movie." And that's exactly what happened, even though the two were developing sequences that many found more entertaining than what was actually being included in the movie.

The frustration and low morale also got under the skin of effects animator Mark Dindal. He and his colleague Steve Starr wrote up their

version of a manifesto. It was their assessment of all the problems at the Studio and what they felt were the best ways to fix them. They were able to get a meeting with Ron Miller to share their feelings, but the only thing that came of it was angering Ed Hansen, since they hadn't consulted him before meeting with Miller.

Head of Animation Ed Hansen and his assistant Joanne (inset).

Dindal realized that his attempts to make things better had hit a dead end. Like so many of the young people before him, that cold splash of reality gave way to cutting loose and venting his creativity through other means. Such as the nun toss—hurling a dummy dressed as a nun down the hallway to see how far they could get her to fly. Or initiating new hires by seating them in a wheeled office chair and pushing them at full speed down the hall. Once the new recruit [usually male] had crashed into the door at the end, they'd pick him up and throw him into the women's restroom. Someone rigged the elevator button with a blast cap, giving Ron Miller quite the start when he pushed it. Ed Hansen's secretary, Joanne, received a shellacked piece of pizza through inter-office mail that had her name spelled out in onions on top. When one of his fellow effects animators was out on vacation,

Dindal and friends bought several rolls of children's wrapping paper and wallpapered his office, meticulously cutting around the light fixtures just like the professionals.

Don Hahn had been doing cleanup animation since *The Fox and the Hound*, but decided his talents lay more on the management side. He became "the guy with the clipboard" on *Cauldron*, going from office to office, checking in on the artists.

Nigel Hawthorne, voice actor from The Black Cauldron, performs for animator Andreas Deja.

The two top animators on the production were Andreas Deja and animator Phil Nibbelink. Deja animated much of the film's two leads, Taran and Eilonwy, while Nibbelink took the darker side, animating the Horned King and his minion, Creeper. Nibbelink also took charge of an ambitious

sequence early in the film where the dragon-like Gwythaints, sent by the Horned King, attack and capture Hen Wen from Taran. These two animators were seen as the golden boys of the production. Someone even caricatured the two of them touching the finger of God, in a parody of Michelangelo's *Creation of Adam*. However, in the drawing, God was producer Joe Hale.[256] Animators Mike Gabriel and Kathy Zielinski came into their own animating the three witches for *Cauldron*. Mark Henn and Dave Block concentrated on the sidekicks, Fflewddur Fflam and Gurgi.

Ron Clements had been a lifelong Sherlock Holmes fan and while working on *The Rescuers*, discovered the *Basil of Baker Street* book series by Eve Titus. The books detailed the adventures of mouse versions of Sherlock Holmes and Dr. Watson, named Basil and Dr. Dawson, respectively. Clements thought the books would be the perfect basis for a Disney animated film and brought them to producer Joe Hale's attention. Hale then pitched the idea to Ron Miller, Mel Shaw, Ed Hansen and Burny Mattinson, who all agreed that there was potential for a great film. Miller asked Mel Shaw to start developing it right away and suggested that John Musker, who was still in *Cauldron* jail, join Shaw to get the project up on its feet. "I think they saw *Basil of Baker Street* as a way that some of the malcontents from *Black Cauldron* were able to step away," said Musker. He grabbed Clements, Vance Gerry, Pete Young, and Steve Hulett and they got to work.

Musker and his team eventually pitched their take on *Basil* to Ron Miller. "It was kind of a loopier version of it," recalled Musker. "Basil was a little closer to John Cleese. We had an opening that was a parody of *Citizen Kane*. And Dawson was a veteran of the Afghan Wars. He was in a hospital

for shell-shocked war veterans, and he was telling the story in flashbacks. We showed it to Ron Miller, and he didn't like it at all." "*Where's the goddamn warmth?*" he barked. Miller then enlisted Burny Mattinson to help the team get their story into shape and eventually made Mattinson a director on the project. In a repeat of what happened on *Cauldron*, there were two camps as far as the direction the story should take. Musker's leaned toward farce, while Mattinson's leaned toward a more classic approach, closer in tone to Disney's adaptation of *The Wind in the Willows*. Miller made the decision to go with Mattinson's take, frustrating Musker. But work continued and the next time they showed the project to Miller, he was much happier with it.

Musker and Mattinson experienced more friction when it came time to choose a composer for *Basil*. Mattinson had been working on a sequence that took place in a bar, with a female mouse singing a song on stage. As a placeholder, he was using a song written by Henry Mancini, from the musical *Darling Lili*. Mattinson initially approached Irwin Kostal to write the final song but, since he was already using Mancini's music as inspiration, Kostal suggested contacting the man himself. Mancini was interested in writing a song for this section, as well as scoring the entire film, but Musker was adamant that they use another composer. Ron Miller weighed in on the subject and took Mattinson's side once again. Musker had a strong conviction that Mancini was not the right sound for their film.

Story development sketches for Basil of Baker Street by veteran artist Vance Gerry.

Top: Directors John Musker, Dave Michener and Burny Mattinson review storyboards for Basil of Baker Street. Middle: Mattinson pitches storyboards to Vincent Price in preparation for a recording session. Bottom left: An early story illustration by Mel Shaw, before Ratigan's appearance was beefed up by animator Glen Keane. Bottom right: Actors Val Bettin (Dr. Dawson) and Barrie Ingham (Basil) with their sculpted counterparts.

The Disney Channel premiered several new programs. Two movies debuted, *Gone Are the Days*, starring Harvey Korman, and *Love Leads the Way*, with Timothy Bottoms and Eva Marie Saint, directed by *Night Crossing*'s Delbert Mann. Mike Bonifer's documentary series *The Disney Family Album* also aired, beginning with an episode dedicated to legendary voice actor Clarence "Ducky" Nash, voice of Donald Duck. Future episodes would profile the Sherman Brothers, Peter and Harrison Ellenshaw, Walt Disney Imagineering, Disney story men, and each of the surviving Nine Old Men.

A new animated film debuted at Disneyland in July, as part of the preshow for the Circle-Vision 360 attraction. *All Because Man Wanted to Fly* was hosted by Orville the Albatross from *The Rescuers* and outlined the history of air travel. Footage from older Disney cartoons was intercut with newly produced animation of Orville. This new footage marked the first use of a new process called animation photo transfer. This was a new way to transfer animators' drawings onto cels, developed by Disney's Still Department manager, Dave Spencer. Although the Xerox process in use at the Studio since *101 Dalmatians* had the benefit of capturing the animators' drawings exactly, it did have its problems. The transferred lines would often cast shadows onto the background underneath, as well as flake off of the cels, requiring constant cleaning. Spencer's APT process essentially meant photographing the drawings and developing them directly onto the sheets of celluloid. As a result, the lines were crisp, they couldn't flake, and they cast no shadow. Just as hand-inking had been replaced by the Xerox process, APT would unseat Xeroxing as the Studio's method of generating animation cels. APT had been tested in one sequence from *Mickey's Christmas Carol* the previous year. The

Studio intended to use it for several sequences on *The Black Cauldron* and the entirety of *Basil of Baker Street*.

There had only been a few times since the passing of Walt that the Studio opened its doors to outsiders. The two most significant instances were the hiring of young animation talent in the early '70s, to keep the Disney animation flame lit, and Wilhite's insistence on infusing the live-action ranks with fresh filmmaking talent. But in 1984, an uninvited outsider was trying to force their way through the gates. Corporate raider Saul Steinberg announced his plans to take over the Disney company. He had the capital to buy the required amount of stock and, once purchased, he planned to take the company private, carving up the various divisions—animation, live-action, theme parks, etc.—and selling them off to recoup the costs. The Disney Studio was in danger of total annihilation.

Steinberg would not succeed. Producer Jonathan Taplin received a phone call from his friend Richard Rainwater, of Bass Brothers Enterprises, whom Taplin had previously tried to interest in investing in Disney, after his frustration with Ron Miller's afternoon card games. Also on the call was Sid Bass himself, and the two men informed Taplin that they were *now* in a position to save Disney. They would sell their Orlando-based real estate company to Disney for around $200 million in stock which, between their holdings and the Disney family's, would make it almost impossible for Steinberg to do his deal. Taplin contacted Ray Watson, Disney's chairman of the board, and he, Rainwater, and Bass were able to make the transaction. Sure enough, this blocked Steinberg from his takeover play, and he backed down.

The Studio was still ripe for a takeover, with some rumors suggesting that Roy Disney Jr. might be interested in staging a coup. This led to Card Walker, Ron Miller, and Ray Watson inviting Roy back into the company. They gave Roy a seat on the board and the title of vice chairman of the board. Roy's lawyer, Stanley Gold, who was also given a seat on the board, began talks with Miller about finding a position for Roy and for Roy's previous attorney, Frank Wells. Meanwhile, Miller resumed his talks with Michael Eisner about becoming Disney's COO. Eisner considered bringing along his colleague from Paramount, president of production Jeffrey Katzenberg.

With all the talk of changes in management, the board, led by Ray Watson, asked Ron Miller to resign. Feeling betrayed, Miller confronted the board and reminded them of his dedication to, and his leadership of, the company. His fury was met with silence. Neither Watson, Gold, nor Roy had anything to say to him. About two weeks later, the board voted unanimously to put Eisner and Wells in charge of Walt Disney Productions.

During this period of upheaval and internal shifts, animator Mike Gabriel was taking a walk around the lot with his friend, assistant animator Rick Farmiloe. "Everything seems different," he remarked to Farmiloe. Gabriel continued: "All of a sudden, everything felt dead and cold. It just felt like something vanished. And I just said, 'Can't you feel the shift? Something's changed and it's never gonna go back. It's gone. It left.' And it felt like Disney wasn't there anymore."

On September 24, 1984, Frank Wells and Michael Eisner arrived at the Disney lot in Burbank for their first day of work—Eisner as CEO and Wells as president. They were joined by Jeffrey Katzenberg, who would be serving as

chairman of Walt Disney Studios.

Eisner and Wells gathered the entire staff of the company on the town square set from *Something Wicked This Way Comes,* ironic given the amount of anxiety and skepticism with which the employees viewed these two outsiders. "It was an odd sense of 'these guys aren't one of us,'" recalled Mike Gabriel. "They're a whole different breed of cat. These guys are slick, urban lawyer types. High-falutin.' High threat. Nobody's wearing a cardigan and saying, 'Hey, you want to go to the tea room for cakes?'" Eisner and Wells expressed their enthusiasm for joining the company. According to Burny Mattinson, the two "got up on the podium and they were saying how great the traditions were and 'We're gonna keep the Disney tradition.'"

But the truth behind that promise was that Eisner had no firsthand knowledge of what the Disney name meant. He had not grown up with Disney movies or theme parks or *The Wonderful World of Disney* television program. In fact, he had very little in common with Walt Disney. Whereas Walt was raised on the farms of America's heartland and went to public schools, Eisner grew up in apartment buildings throughout New York City and attended private schools.

But now as the new keeper of the Disney flame, Eisner had to immerse himself in the Studio's history and culture. As he learned about Walt the man, he came to admire Walt's perseverance in life and in business, as well as his originality and creativity. Eisner saw himself as a creative leader as well. To him, this was something he did have in common with Walt.

Now for the first time in the history of the Walt Disney Studio, people from outside the Disney family, and outside of the Disney culture, were sitting in the top spots of the company. Eisner and Katzenberg's primary task was to reinvigorate the Studio's live-action division. This was a world they understood, and had already achieved success in, so they were a natural fit

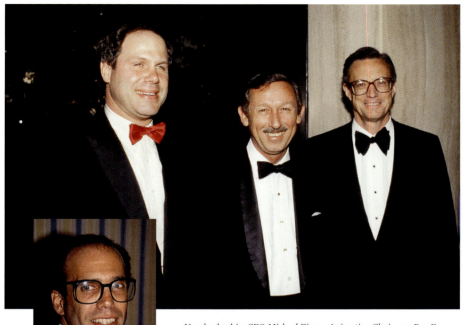

New leadership: CEO Michael Eisner, Animation Chairman Roy E. Disney, President Frank Wells, and Walt Disney Studios Chairman Jeffrey Katzenberg (inset).

for that job. Animation was a different matter. Neither of these men had any experience with the medium. Dave Block recalled: "Jeffrey Katzenberg said to us, 'I don't know what to do with you.' He made no bones about it. Didn't understand animation. Didn't know anything about it. Didn't know if we were going to be around a year from now."

But when Eisner had secured his CEO position and asked Roy E. Disney what he wanted to do at the company, Roy asked to oversee animation. "Roy said, 'If animation is well, the Studio is well,' and he became chairman of the Animation Department," recalled effects animator, producer and author Dave Bossert. "Roy Disney saved Disney animation," said John Musker. "Michael and Jeffrey came, and they didn't know anything about animation, and Roy really spoke up about it. He hadn't been too involved in the production of the animated films to that point [but] he had been around

the culture of it for so long." "I kind of grew up in it," said Roy at the time, "although I was never an animator. I know the process; I understand what it is they do, which is really quite different from any other form of filmmaking. It takes forever to make an animated film and in the patience factor, I was unlike the people who were not used to taking that kind of time."[257] Even though there wasn't a Disney at the top of the company, there was now a Disney at the heart.

Eisner and Wells immediately changed the atmosphere at the Burbank lot. No longer would it be a place of long lunches, strolls around the backlot, or afternoon games of Crazy Eights. The general laissez-faire attitude that had been the Disney way for so long would not be tolerated anymore.

Nor would any part of the Studio that could be considered extraneous or wasteful. Dave Bossert recalled: "Michael Eisner and Frank Wells started doing an assessment of all the assets and departments and who was doing what. One of the first things to go was the Still Camera Department." As the years had gone by, the importance of this department had lessened and now it barely had a function. "They were staff photographers," continued Bossert. "They'd sit around the entire day but at five o'clock, if somebody came to the Studio and they needed a photographer, *bang*, they'd click into overtime. [Eisner and Wells] literally took all the equipment, put it on a soundstage, sold it all, and laid everybody off." Although the Still Camera Department had been a fixture on the lot for so long—and one of the primary stops on Burny Mattinson's delivery route in his early days as a traffic boy—nothing was sacred during this time of change.

Miller's staff producers were all let go. Most of them found a home

in series television. Former child actor Kevin Corcoran became a coproducer and assistant director on *Simon and Simon, Murder, She Wrote,* and *Sons of Anarchy*, to name a few. Jerome Courtland moved into directing, helming episodes of hit shows like *The Love Boat, Fantasy Island, Dynasty,* and *Knots Landing*. Tom Leetch worked for a brief time as a production manager for programs like *Northern Exposure*. Jan Williams left the industry altogether.

A few days after the new regime began, the Studio released *Country* into theaters. This was the second film under the Touchstone banner and would earn Jessica Lange her third Oscar nomination. At the time, Lange would be only the second actor nominated for their work in a Disney film, the first being Julie Andrews for *Mary Poppins*.

Jeffrey Katzenberg turned his attention to the Studio's Christmas 1984 release, *The Black Cauldron*. "The picture was pretty well along when the new regime came in," said Burny Mattinson. "We had seen the pencil test in the theater and I don't think anybody was impressed by it." Katzenberg hated it, much to the delight of some of the younger artists who had been criticizing it from the beginning. Said Mike Gabriel: "The new guys came in and when they said, 'This looks like crap,' we're like, 'Yeah, finally somebody can see it.'"

Roy Disney had been unhappy with some of the violence in the film as well as the dark tone. After seeing the film, Katzenberg shared Roy's distaste. For example, in this version of the film's climax, when the Horned King uses the cauldron to resurrect his army of the dead, one of the skeletal warriors attacks a human henchman, leading to a particularly gruesome death scene animated by Phil Nibbelink. "I had this really long and complicated scene of a [human warrior] landing on the ground and shaking and all his

A production cel (top) and story sketch (bottom) of the undead army from the climax of The Black Cauldron.

flesh bubbling and boiling and dripping off," recalled Nibbelink. "It was a lot of work and a lot of drawings and very complicated. And they got it all the way to color and that's when Katzenberg came in and took a look at the movie and the first thing he said is, 'Well, we gotta cut that scene out 'cuz my two-year-old will be frightened by it.'"[258]

Katzenberg then demanded the film be reedited and told producer Joe Hale to show him the film's outtakes. For Hale, this was further proof of Katzenberg's ignorance of the animation process since there are no outtakes or extra footage in animation like there are in a live-action film. Katzenberg

remained undeterred. The film's release was delayed until the following summer while the film was trimmed down and new dialogue written.

For the Christmas season of 1984, the Studio was rereleasing *Pinocchio* to theaters and planned on adding Tim Burton's latest live-action short film, *Frankenweenie*, to the bill. Burton's film was a reimagining of the Frankenstein story, his version being about a suburban boy who resurrects the family dog from the dead. But when Burton's short received a PG rating from the Motion Picture Association of America, Disney backed away from it, having no interest in releasing a PG short in front of the beloved G-rated classic. Frustrated, Burton left the Studio.

Sparky the dog meets his bride in Frankenweenie, Tim Burton's final project with Disney (for a while).

Eisner and Katzenberg resurrected *Who Framed Roger Rabbit* and brought back the team of Darrell Van Citters, Marc Stirdivant, Mike Giaimo, and Chris Buck. Due to Stirdivant piquing his interest a few years ago, Steven Spielberg joined the project as a producer and wanted Robert Zemeckis to return as director. This brought back all of Van Citters' original issues with the early scripts for the project. "Bob [Zemeckis] liked Seaman and Price's scripts better," said Van Citters, "which shows you the fundamental difference between us. And that's where I had differences of opinion with both of them." According to Mike Giaimo: "We had story meetings with Zemeckis and [Seaman and Price] and the biggest schism was really about tone and the character of Roger. And how Darrell and Marc Stirdivant saw it was that Roger was really a very genuine character. He was only the big clown [when he was] on stage. Roger would really have pathos. Basically, Zemeckis saw him as a clown. You could just maybe cursively bow to moments of sadness but really he's a clown and this thing's gonna be played broadly. Darrell saw it as something a little different."

Spielberg and Zemeckis took issue with some of the choices the team had made about Roger's design and voice. Said Van Citters: "First, [Zemeckis] wanted to make Roger Rabbit like Michael J. Fox, so we had to redesign him. They all laughed at us for using Paul Reubens as the voice of Roger Rabbit, who I think brought a lot of heart to it. Paul would've been a perfect choice."

The friction between Van Citters and the new leadership also involved the larger creative vision for the film. Van Citters recalled a comment Spielberg made about how he felt the animation should look. "He says, 'Well, Disney animation never stops moving.' I said [to Spielberg], 'Well, you know Chuck Jones, who I know you admire a lot, makes use of holds all the time.' (In animation, a "hold" is when the movement of a character stops and only one drawing is exposed on film, to convey a pause in the action.) I didn't

even go into the fact that Disney is full of holds in all of their movies. *All of their movies.*" Van Citters put together a presentation about these animation fundamentals and showed it to Spielberg and Zemeckis. Recalled Chris Buck: "So [Darrell is] showing some of the great Chuck Jones films where a character holds for quite a bit of time in this great pose. It's all part of Warner Bros.' style. And Spielberg goes, 'No, no! That's not it at all!' He kept saying Warner Bros. but they didn't really understand the essence of Warner Bros."

Van Citters' fate was sealed when he screened his film *Sport Goofy* for Spielberg, who wanted to see what Van Citters' work was like. "It was done on a budget," said Giaimo about *Sport Goofy*. "It was a cross between full and limited. So, a guy like Spielberg is looking at it, and it doesn't have all the bells and whistles of a feature, in terms of its look. And just the questions [Spielberg] was asking as we were going through the reels: 'Well, how come there's only this many characters in this scene?' and 'Why is this character not moving?' He was asking...these technical questions. You could see what was important to him. I do remember that screening and I was...shrinking in my seat. You could feel it. And it was hard [for Spielberg] to look through it and to see Darrell's capabilities and the zest and the energy and spirit that he had, let alone the storytelling. [Spielberg] thought this guy couldn't handle a feature or these characters." After that, the original *Roger* team was taken off the project. Within a year to two, they would all leave Disney.

After *Sport Goofy*, Mike Giaimo returned to storyboarding, teaming up with Joe Ranft to develop stories for some smaller projects being shepherded by Dave Michener. The one that the team really took to was an adaptation of the Christopher Columbus story, starring Mickey Mouse in the title role. "The story really came from publishing,' recalled Mike Giaimo. "They came up with idea and they were going to put the money up for it. And I remember when they showed us some of their initial concepts, I was like, 'Oh my God,

it's so lame. What a stupid idea!' But Giaimo, Ranft and Michener got to work and were able to find the entertainment in the idea. "I think it was Joe's wit that made kind of a pedestrian project interesting and humorous," continues Giaimo. "Joe was just so infectious with his sense of humor and we both really clicked and came up with ideas and boarded little sections and it turned out to be, I would say not brilliant, but relatively entertaining. I think that is the sign of true brilliance. A testament to Joe. When you can take something that's really mediocre, and make it fresh and interesting, that's brilliance!"

Story artist Joe Ranft.

Unfortunately, when the team pitched their storyboards to Katzenberg, he didn't share the team's enthusiasm. Recalled Giaimo: "Katzenberg didn't want to do it and the sensibility of those guys at the time, in terms of the Studio as a whole, was 'We're not doing *any* period films, live-action *or* animation.' Everything was contemporary for them. When you look at all the films they did—*Down and Out in Beverly Hills, Oliver & Company*—that's the sensibility. I don't even know if [Katzenberg] went through the

whole pitch because his mind was made up even before that." Giaimo, Ranft and Michener were disappointed that the film wouldn't be moving forward, as were two of its biggest fans, Eric Larson and Burny Mattinson, the latter having hoped to direct the project.

For Eisner and Katzenberg, the jury was still out as far as the fate of Disney animation. Production was shut down on all projects while the executives assessed. About three weeks later, Roy called Burny Mattinson to tell him that Eisner and Katzenberg wanted to meet with the *Basil* team to see what they were working on. "Roy was with us, so that was fortunate," recalled Mattinson of the meeting. "We had a pitch board which had the complete story. We had pictures. They weren't really interested in the pictures." John Musker said: "And here's Jeffrey, and he's like a creature from another planet. So, we're showing him these boards and we had a sequence in a barroom. It's a Victorian bar and there's a chanteuse who sings a song that starts innocently and gets a little bawdy. When Jeffrey saw it, he's like, 'Okay, now that song. Why can't we take that song and say to Michael Jackson, "Michael, make that your own"? And we're like, *What*? It's like we knew we weren't in Kansas anymore. [Eisner] was like, 'Okay, you got the adventure, and you got the comedy, but what's gonna make us cry?' He said, 'If you can find a way to make us cry, you got a home run.'"

The *Basil* team then took Eisner and Katzenberg to story artist Vance Gerry's room. Mattinson remembers: "When we were walking over there, Eisner had said to me, 'So how much is this gonna cost?' and I said, 'Well, probably like thirty million,' thinking about how our movies had been around thirty or forty million. He says, 'Like hell. It's gonna be ten million. That's all

you've got.' He says, 'How long is that going to take?' and I said, 'Well, it's going to take about three years to do it,' and he says, 'Nope, you've got one year.'"

Gerry pitched his storyboards to the two executives. Recalled Mattinson: "Eisner was kind of looking around the room as he was pitching it and Jeffery, his foot was wiggling back and forth. And he was kind of looking around too and I thought, *'Oh God, we're losing them.'"* Once the presentation was over, the *Basil* team was excused and Eisner, Katzenberg, and Roy spoke privately. About a half hour later, Roy called Mattinson to tell him that they liked the project and wanted to move forward with it. "He said they were so excited by seeing the story reels because they felt they could get their hands on the picture and make changes before it got into full production and they thought this was a great opportunity for *them* to be involved." Also, before leaving Paramount, Eisner and Katzenberg had put a film called *Young Sherlock Holmes* into production, which they felt had enormous potential, so they had already been immersed in the world of Sherlock Holmes.

Roy said he wanted Mattinson to be the producer on the film. "I was the old-timer, along with Ed Hansen," said Mattinson. "Everybody else—Ron and John—they were all young people. He didn't know any of them. So, I think that's probably why he put me in as producer, so I could talk to him." He also confided in Mattinson about how important the presentation they'd just given was to the future of the Studio. "He said, 'It's good that you guys got through it, and they liked what they saw because they had said that if they didn't have a good viable thing to get behind, they were going to shut it down.' They were going to drop animation and just reissue and do live action. That was what was at stake. They were so disappointed in *Cauldron*."

Mattinson and Musker had split the movie's sequences between each other to direct. Now that Mattinson was a producer and been ordered

by Eisner to finish the film in a year with a third of the budget he thought they'd have, his schedule was loaded with meetings. He went to Ed Hansen and asked to add Ron Clements as a third director. Mattinson had been so impressed with Ron's story work on the film that he thought Clements would be the perfect choice. Hansen agreed and Clements received a promotion. Dave Michener approached Mattinson about working with them on *Basil*, after his Christopher Columbus featurette was shelved by Katzenberg. Michener joined the team and also became a director on the film.

Production on *Basil of Baker Street* ramped up. Animators Mark Henn, Dave Block, and Glen Keane all joined the team, happy to be working with Mattinson again. Voices were cast and recorded. For the title character of Basil, British actor Barrie Ingham was cast. Ingham poured his enthusiasm and energy into the role. Recalled Mattinson: "He'd get so excited by it that he'd forget there was a microphone. He'd be holding the script and he'd start walking around the stage. 'Wait a minute, guys! We got to get some way to follow him around.' They brought in a boom mic and there'd be another guy pushing it around for him. And I was following him around the room. At the end of that day...I was exhausted!"

The villain of the film was Professor Ratigan, a rat who wanted the world to believe he was really a mouse. Initially, he was conceived as a sniveling, scrawny character. For inspiration, Mattinson looked at Vincent Price's performance in the 1950 film *Champagne for Caesar*. Price's character is pompous and conniving with a tendency toward the flamboyant. His performance was filled with contrasts—movement to stillness, quiet anger to explosive outbursts. The animators were also inspired by the performance, particularly Glen Keane, who began sketching a totally different approach for Ratigan, turning him into a hulking, broad-shouldered archvillain. Price was approached about playing the part and he accepted enthusiastically.

Price came in for his first recording session. Mattinson, Ron Clements, and John Musker were all behind the glass with the sound engineer and Price was out on the stage at the microphone. According to Mattinson, as Price

Caricature of John Musker by Rick Farmiloe, capturing a troubled recording session with Vincent Price.

performed his lines, "John kept stopping and said, 'No, no. Why don't you do it this way.' And then [Vincent would] try it again and then [John would] come back and say, 'No, no' and it was going back and forth, back and forth. And finally, Vincent blew up. 'I've done it thirty-five different ways! What do you want me to do?'" Mattinson called for a lunch break and assured Price that he was doing a great job. When they resumed the session, Mattinson proposed staying out on the stage with Price and reading opposite him.

Price was relieved and said that would be very helpful for him. "I thought I could short-circuit some of that stuff that was coming from in the booth," continued Mattinson. "So, we started going through the stuff again and he was wonderful." Thanks to Mattinson's patient and personable approach, Price ended the session in high spirits. "After the recording session, he said to me, 'You know, this was fun! I really enjoyed it.' He said, 'Call me anytime.' And so that worked out, but boy, that was a close call."

Since 1940, all Disney animated features, television shows, and shorts had been made in the Animation Building on the Burbank lot. It was built *for* animation, long before Walt was making live-action films. But toward the end of 1984, Jeffrey Katzenberg held a meeting with the Animation Department. "And he says, and I quote, 'I want your building,'" recalled Dave Block. "And he informs us that we will be moving. He's taking the building for live-action films and they're going to find a new place for us. Boy, was that a bummer. So that went down really lousy." To make the move official, Roy Disney sent a memo on December 17 describing the move as "a three-year temporary relocation." They would move down the road to a building across the street from Walt Disney Imagineering that had been used by the team that had recently built Tokyo Disneyland. Being kicked off the Studio lot felt like the beginning of the end. It seemed only a matter of time before Disney animation would be shut down for good.

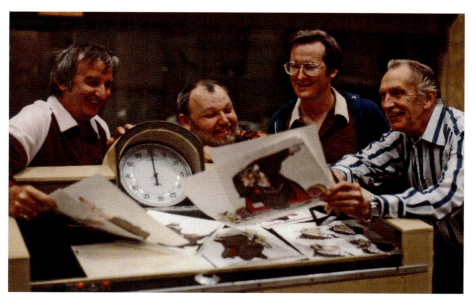

Vincent Price revels in Ratigan's villainy with directors Dave Michener, Burny Mattinson and John Musker.

1985

On a rainy day in early 1985, the Animation Department moved to their new facility on Flower Street in Glendale, just a few minutes' drive from the Studio lot. The new building was miserable. It was still halfway through construction. The artists' boxes and furniture were moved in as construction crews worked around them. There was no heat in the building, so they sat at their desks bundled up in coats. "They were such great workers, all the animation people," said Burny Mattinson. "Ten minutes after they got the furniture, they were setting up and they were starting to work. They were an incredible crew. Bless their hearts."

The production team for *The Black Cauldron* stayed in the Animation Building on the lot to finish the film and their working conditions weren't much better. Artists such as Dave Bossert and Tony DeRosa stayed until the bitter end to help paint cels for the film. "They had a few of us in this big empty hallway, with a few people in an office here or there," recalled DeRosa. "And up above they were doing demo because they were emptying out the building and reformatting all the walls, making them executive offices. So you'd hear all this banging and shaking going on." After a morning of cel painting, DeRosa would set his work aside to dry and head to lunch. "You'd come back and see the cels and there were all these black dots, like soot. And it was the air vents above, that probably had Walt's cigarette smoke from 50 years, raining down on your cels." Eventually, as DeRosa and the remaining artists completed their work, they too packed up and moved to Flower Street.

Once *The Black Cauldron* had finally wrapped, the crew gathered on the steps of the Animation Building to take a group photo, commemorating

Effects artist David Bossert prepares to paint cels for The Black Cauldron.

The crew celebrates the wrap of The Black Cauldron with a group photo.

DISNEY IN-BETWEEN

its completion. After a few pictures were snapped, producer Joe Hale—who had no good feelings toward Katzenberg—suggested something special for the next take. Said Mark Henn: "He was like, 'Let's do another one! Alright, everybody, let's flip off Katzenberg. Give him the finger!' And we're like, 'Joe, uh, we still have to work here and would *like* to work here!' I mean he was seriously encouraging everybody, 'Come on, give him the bird!'"

Roy Disney became more intimately involved in the animation process. A short blurb in *Disney News* stated that he had returned to "active management in the company, providing overall guidance and direction to Disney's expanding Animation Department."[259] It also stated that Roy hoped to increase the speed of production to make one animated film every eighteen months. Said Mattinson: "Roy would come over I'd say every other day and look at dailies or whatever we had to show him, and he'd give his two cents

Roy E. Disney watches over the legacy of Disney Animation.

here and there. It was very good. He was easy to work with."

Like his Uncle Walt, Roy was a chain-smoker. "Roy would come into the building [and] he would put his cigarettes out in…the potted plants," recalled Dorothy McKim, who had now moved into animation production management. "All that mossy stuff that they would put around [the plants] would start smoldering. So we always had to make sure that there was somebody there that could put that out." This led to McKim being put on ashtray duty, making her responsible for always having one handy and offering it to Roy as needed. "I don't think he knew that was my job," said McKim. "He was very personable and nice. I didn't mind being the ashtray holder [for] Roy Disney."

On the live-action side, there were still some leftover movies from the Tom Wilhite and Richard Berger regimes that were due for release.

Baby: Secret of the Lost Legend premiered from Touchstone Films on March 22, 1985. Described on the movie poster as "The greatest adventure ever born," the actual film fell short of that. "I was not that happy with it," said producer Jonathan Taplin. "I was disappointed with the special effects. It was workman-like but it didn't rise. I had been used to movies that were all very director-driven, [having worked] with Scorsese and Spottiswoode. Bill Norton was a director for hire. He did the best he could. There was nothing totally inspired about it, but a lot of that had to do with just the grief of every day having to work with animatronics that weren't really working that well."

A few months later, *Return to Oz* arrived in theaters. Although the film was much truer to Baum's original books, it bore no resemblance to the beloved 1939 classic, a fact that likely confused viewers. Said director

Tik Tok and Dorothy Gale interrogate a Wheeler about the ruined Emerald City in Return to Oz.

Walter Murch: "One of the sticks it was beaten with was how dare you make a sequel to *The Wizard of Oz*? And how dare you make it in the way you made it? I knew in advance that it was risky.[260] Without the relief of songs and the more openly artificial, vaudevillian approach of the 1939 *Wizard*, I think it suffered at the box office."[261] This was unfortunate because there is much to enjoy about the film. The cast is wonderful, there are some truly thrilling sequences, and the film's art direction and special effects are stunning, the latter being nominated for an Oscar the following year. Murch gives his final thoughts on the film: "*Return to Oz* was a project that was dear to my heart. I initiated it and I'm very glad to have made the film, which I think is wonderful and strange in a way that is true to the spirit of the original Oz books."[262]

Return to Oz opened on the same day as 20th Century Fox's *Cocoon*, Ron Howard's follow-up to *Splash*. *Cocoon* was a huge hit and became one of the top ten grossers of the year. In fact, the summer movie season of 1985 was full of box-office smashes. *The Goonies* came out two weeks before *Return to Oz*, and the previous month saw Sylvester Stallone star in the massive hit *Rambo: First Blood Part II*. In the beginning of July, Steven Spielberg and Robert Zemeckis brought *Back to the Future* to theaters, which would stay at

the No. 1 spot for several months and end up as the top moneymaker of the year. The summer was quite crowded.

Several weeks after *Back to the Future*, *The Black Cauldron* was finally released. It was the Studio's twenty-fifth animated feature, and their first to be rated PG. The poster for *Cauldron* proudly announced that the movie was "seven years in the making." The press information boasted that the film took ten years to make. It's odd to think that there was once a time when the length of a film's production was seen as equal to its quality (and something to boast about). "It was in production for an awful long time," said Howard Green. "It was a struggle, and I don't know why it took so long to make that movie. And I think at the time it was outrageously expensive at $24 million or something like that."

Producer Joe Hale offered his assessment of the film's theme in an article from the summer 1985 issue of *Disney News* magazine: "The message behind the film is that you never know who your friends are. All throughout the picture, the character Gurgi tries to make friends with Taran, who keeps him at a distance. Taran never really appreciates Gurgi until the little furry fellow sacrifices his life for him. This is something that is common during war, when you never really know, once you get into a combat situation, what

Mischievous Gurgi searches for munchings and crunchings in The Black Cauldron.

guys will lay their lives on the line for someone else."[263]

Critics and audiences reacted mildly to the film. "I don't think anyone was impressed by it," said Burny Mattinson. "We were all kind of disappointed." Said Howard Green: "It's not a great film. It's a compromised film." Darrell Van Citters added: "We used to have...inside baseball arguments about what was the worst movie, *Aristocats* or *Robin Hood*. And then *Black Cauldron* came out and sealed the deal. No contest." But surprisingly, Roger Ebert gave the film a favorable review: "I'm happy to say that I really did like this movie because one minute, I was sitting there thinking profound film-critic-type thoughts about the future of animation, the next minute I was really into the story and having a good time."[264] Another positive reaction to the film was from *The Chronicles of Prydain* author himself, Lloyd Alexander. "He wrote me a nice letter after the movie," said Howard Green. "He'd seen the movie in New York, and he said he really liked it."

Rumors have always circulated about the footage that was cut from the film and how, if at all, it would've affected the final product. A few deleted scenes have been included on home video releases but nothing that would've had much bearing on the story. However, a set of storyboards sold by Heritage Auctions several years ago gives a glimpse at one excised sequence that could've impacted the film's tone and story in a major way.

The sequence would've followed the film's prologue. After learning the history of the cauldron through narration, we would've seen the Horned King on horseback, burning the countryside with torches. The short sequence ended with the tiny Fair Folk escaping the flames by retreating underground.

First of all, this would've opened the film on action. Instead, in the final film, we come out of the opening narration and transition into more verbal exposition given by Dallben, mentor of the film's protagonist. Second, it would've let the audience see events that are only spoken about in the

final version. In the introduction of Dallben, he mentions the Fair Folk, stating that "you don't see any of them around." Later in the film, the main characters meet the Fair Folk in an underground hideout and their king asks, 'Is the burning and killing still going on up there?' This deleted sequence would've given needed context to their plight.

Lastly, it would've added more weight and menace to the Horned King. In the final version, characters *tell* us how evil he is, being described as a "black-hearted devil" at one point. But this sequence would've *shown* us why he's feared. It also would've shown the film's villain taking an active role in his plan. Without it, the character simply sits in his castle waiting for things to happen.

Whether these storyboards were ever put into production, or if they were removed early in the film's development, is unknown. But if this deleted sequence— or something similar to it—had been kept in, all of the above information would've been supported by action and given a more dynamic framing to the story.

It also begs the question of why it was removed. Was it a result of timid leadership? Or was it a victim of Katzenberg's eleventh-hour editorial knife? Was it part of the executive's plan to lighten the darkness of the film, much like his removal of animator Phil Nibbelink's scene of the death of a human soldier at the hands of the Cauldron Born?

A handful of painted cels from Nibbelink's animation of that grisly death can be found online and it is certainly grotesque. One can understand why Katzenberg raised an eyebrow at it. There's no question that, if included in the film, it would've stood as one of the most gruesome moments in Disney animation history. But from a story standpoint, demonstrating what the Cauldron Born are capable of helps raise the threat of their march out of the Horned King's castle. The audience would see that they can kill in a

A story vignette from a deleted prologue showing The Horned King and his army burning villages in search of the Black Cauldron.

particularly grim manner, so there is much at stake for the land of Prydain and our protagonists. Without Nibbelink's scene, they're just a bunch of walking skeletons. Maybe a little creepy to look at but with seemingly no threat to anyone.

The Black Cauldron is truly a product of this liminal time in the Studio's history. It's caught between the desire to bring more of an edge to the Disney image yet it suffers from a lack of commitment to fully embrace that desire. After years of anticipation and buildup, changes in leadership, and the pressure of reinventing Disney animation for a contemporary audience, the film ended up being mediocre.

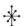

After *Baby*, Jonathan Taplin produced a second feature for the Studio called

My Science Project. It was the last in a series of science-themed comedies to come out of Hollywood that summer. Universal had *Weird Science* on August 2, Tri-Star Pictures released *Real Genius* on August 7, and *My Science Project* debuted a mere two days later, on August 9. Being third in line (or fourth if one includes *Back to the Future,* released the month before this trio of films) was not great for the inferior film. "I mean, the young cast was pretty good," recalled Taplin. "[Director Jonathan] Betuel was a good writer, but he wasn't a great director."

My Science Project is about a high school kid who finds a device from an alien planet in a local junkyard. The device warps time and space and part of the film's climax includes a tyrannosaurus rex being transported into the high school gym. Once again, Taplin brought on John Scheele as visual effects supervisor, as well as Scheele's father. Their paleontological expertise would come in handy once more.

"The studio was more open on this picture to bringing in good talented people," said Scheele. "Rick Baker did come in as a consultant." On Baker's recommendation, Disney hired a team of artists to design and sculpt two versions of the T-rex: a life-size head, for the actors to perform against, as well as a smaller scale, full-body rod puppet for wider shots. "The work was still so-so though," added Scheele. "We were really excited about making it but it didn't end up looking that great on film. Part of the problem was it was lit kind of like a TV movie. I remember Jonathan [Taplin] saying to me afterwards, 'It's really unfortunate but that just doesn't look that great. It's too openly lit.'"

One interesting side note about *My Science Project* involves actor and *Easy Rider* auteur Dennis Hopper. In the film, Hopper plays the science teacher of the four high school student protagonists. Like Hopper in real life, his character is an ex-hippie, and writer/director Betuel pulls out every cliché

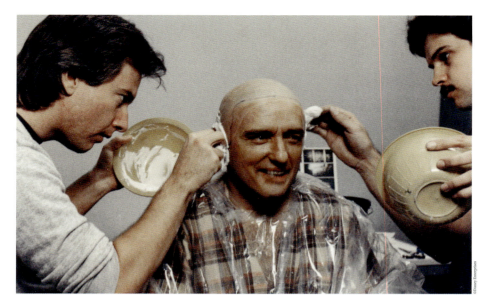

*The special effects of My Science Project.
Top: Makeup artist Rick Baker casts a mold of actor Dennis Hopper's head.
Middle: A team sculpts the life-size tyrannosaurus rex used in the film's climax.
Bottom: Publicity still of Dennis Hopper opening a time-space warp.*

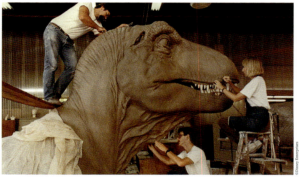

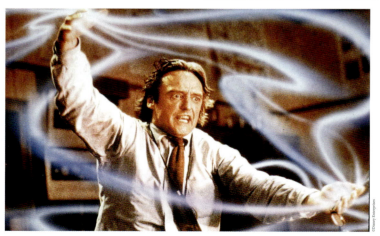

in the book to remind the audience of this. Between the character ranting about his distrust of "the pigs," spouting hippie slang like "psychedelic," "Can you dig it?" and "flower power," plus owning a lava lamp and driving a spray-painted VW bus, Hopper's character is every bit the cartoon hippie that had appeared in *The Love Bug*.

To add insult to injury, Hopper even appears dressed like his character Billy from *Easy Rider*. *My Science Project* is about a high school kid who finds a device from an alien planet in a local junkyard. The device warps time and space, and in one scene, Hopper gets caught in the device's energy and disappears. As the film wraps up, Hopper's character returns from his time warp, having been transported back to the '60s. He now sports the same long hair, bushy mustache, hat, shell necklace and fringed leather jacket that he wore in his groundbreaking directorial debut. Hopper seems to be enjoying the joke but seeing the man who signaled the start of the new Hollywood reduced to a punch line is a surprising reminder of how much things had changed culturally since *Easy Rider*.

In his final words about the film, producer Jonathan Taplin said, "It was what it was. Quite frankly, for me it was a job. And after that, I didn't do any other pictures that were a job."

As *Basil of Baker Street* moved through production, the film's length came into question and a few sequences had to be cut. One segment had Basil interrogating a stool pigeon and another had little Olivia being kidnapped by Ratigan disguised as a policeman. Mark Henn and Dave Block were about a third of the way through animating the latter sequence when it was removed from the picture. For Block, this was adding insult to injury. Not only had

they gotten kicked off the lot into a less-than-desirable location, but a large amount of his animation had now been flushed down the toilet.

On a visit back to the Studio lot, Block ran into an old colleague named Michael Webster. According to Block: "[Webster] says, 'I'm putting together a new division. Michael Eisner has ordered it and I'm putting the staff together. It's the first time Disney has ever done Saturday morning cartoons. Going to be Disney TV Animation. And I'm looking for someone from the feature division to go to Japan and train the Studio that we're gonna hire. Think about it.'" Block thought about it and decided to leave the feature Animation Department and get in on the ground floor of this new division.

The first two television shows from this new animation studio were *The Wuzzles* on CBS and *The Adventures of the Gummi Bears* on NBC. Both programs premiered on Saturday morning, September 14, 1985. Block's colleague, Michael Webster, was the executive in charge of production for both series. *Fun with Mr. Future* producer Tad Stones had already left the feature animation division to be producer, story editor, and writer on *Gummi Bears*. Another animator who joined the television animation team was Toby Shelton, a CalArts grad who had been an assistant animator on *Mickey's Christmas Carol*, *The Black Cauldron*, and *The Great Mouse Detective*. Of his time working on features as an assistant animator, Shelton said: "I thought I had more to offer than that. I wanted to wear more hats and challenge myself. They were starting up a TV division, so I went over there and started as a character designer on the first season of *Duck Tales*."[265] That show was an adventure series inspired by the world of Duckburg, created by comic artist Carl Barks.

According to Mark Henn, working on *Basil of Baker Street* "was a lot of fun and Ron and John, of course they learned under Burny, of his open collaboration. Everybody can pitch an idea if it makes it better. We're all about making it better." And to ensure that everyone had a voice in making it better, John Musker and Ron Clements created a new step in the process of making Disney animation. As had always been the case, once a sequence was approved in storyboards, it would move into the layout phase, where the cinematic aspects of the sequence in question would be worked out—camera position, camera movement, screen composition, etc. Ron and John created a step called a storyboard turnover. Layout artist Dan Hansen described the meeting: "They would get together whoever the head animators were going to be on that sequence and the head of layout. It might have the lead story person. It would have the art director, whoever the head of background was. They would go through it scene by scene by scene. 'Okay, here's the [story] board but what could we do that's going to make it better?' And that was an amazing thing. Over the next couple of pictures, it became a really big thing."

This was a change from the days of *The Aristocats, Robin Hood*, and *The Rescuers* where the animators were at the top of the food chain and everything in the film was designed to support and showcase their work. Dan Hansen recalled: "John and Ron, they decided no. The animators are amazing, but they are only *part* of making the film." Animators bring the characters to life, which is integral to the success of any animated story. However, elements such as narrative structure and cinematic storytelling cannot be sacrificed for the benefit of one discipline over the others. Musker and Clements' efforts balanced out all departments and allowed each one to shine in correct proportion to each other. This led to strong collaboration and allowed ownership of the movie from all involved.

The *Basil* team continued pushing for more sophisticated storytelling

by folding computer animation into the hand-drawn process. *The Black Cauldron* had been the first to integrate computer animation, but it was primarily used to animate props such as Princess Eilonwy's floating bauble, which would have been too time-consuming for an artist to do by hand. Recalled Dave Bossert: "[The bauble] was basically a sphere, but that sphere was created on an HP desktop computer and the images were printed out on bond paper and we in the effects department wound up taping them up on animation paper so that they could be xeroxed and inked and painted."

For *Basil,* they went beyond that and, taking a cue from Glen Keane and John Lasseter's *Where the Wild Things Are* test, used it to free up the camera and bring a dimensionality to the film's climax. The ambitious sequence saw an aerial chase between Basil and Ratigan transition into a confrontation between hero and nemesis amongst the massive gears and chains inside London's Big Ben. To convincingly animate these mechanical inner workings—with accurate perspective, solidity of mass and volume, and sharp and consistent outlines—would have been impossible to achieve by hand. Layout artist Mike Peraza, animator Phil Nibbelink, and effects artist Tad Gielow, spearheaded the efforts to create the inside of the clock in the computer so that the characters and the camera could move in perfect perspective.

The fall 1985 issue of *Disney News* checked in with Michael Eisner and Frank Wells, a year after taking their seats at the company. "Our job is to bring ourselves into the twentieth century while keeping that tradition [established by Walt],"[266] said Wells. The article stated that Eisner intended to increase the company's film output to somewhere between twelve to

Top: An expression sheet of Basil from The Great Mouse Detective, *drawn by Glen Keane. Bottom: The interior of Big Ben, the most extensive use of computer animation in a Disney film at the time.*

DISNEY IN-BETWEEN

fifteen films per year.

As a result, Eisner and Katzenberg had many new film projects in the works. They planned a remake of a 1932 French comedy called *Boudu suave des eaux* (*Boudu Saved from Drowning*) about a vagrant who is rescued by a wealthy man. The film would star Bette Midler, who had signed with Disney in February to appear in films as well as a development/production deal for her company, Miss M Productions. Also in the works was *Off Beat*—a comedy about a man posing as a police officer—and a holiday-themed film called *Father Christmas*.

To generate new ideas for future animated films, Eisner and Katzenberg held what they called the Gong Show. This was a session where directors and story artists would gather to pitch ideas. The executives had a miniature gong with them and, if a person's pitch wasn't well-received, they got gonged. The meetings were held on Saturday mornings which, according to Mike Giaimo, "*no one ever did* in those days. You *never* worked on a Saturday or Sunday before Eisner and Katzenberg. There was hardly such a thing as overtime. So that was a new cultural world to us."

Giaimo recalled a couple of ideas that got gonged: "I remember Ted Berman pitched *That's Disney!* or something [like that]. Basically taking the best of Disney clips because *That's Entertainment* wasn't that far back, which was a tribute to MGM Studios. Mel Shaw had worked on an idea called *Musicana*. That was sort of suggested. Maybe we should resuscitate that." Burny Mattinson recalled Rick Rich, Ted Berman, and Joe Hale developing an adaptation of T.H. White's book *Mistress Masham's Repose*, the story of a girl discovering a community of Lilliputians in post-World War II England. "They had done a lot of drawings for it. I thought it had a lot of promise. Well, Katzenberg was so apparently irritated with the outcome of *Cauldron*. They went and pitched the board to Jeffrey and Jeffery [gave a] thumbs-down on

it. Even if they were presenting *Gone with the Wind*, he would've given [a] thumbs-down! And they were all, one after another, let go."

The Gong Show became a regular event and subsequent sessions yielded more positive results. Said Burny Mattinson: "Pete Young came up with *Oliver & Company* and I believe Ron Clements came up with *The Little Mermaid*. So, there were some really good positive things that did come out of there. It became more casual, and it was much nicer. They were a little bit more encouraging with you rather than giving you gongs."

Story artist Pete Young's pitch of *Oliver & Company*—a contemporary retelling of *Oliver Twist* with dogs and cats on the streets of New York City—moved into development. Young and animator George Scribner worked together on the story and eventually it was decided the two would direct the project. Unfortunately, soon after this decision was made, Pete Young passed away at the very early age of thirty-seven. "So sad," said Dorothy McKim, production manager on *Oliver & Company*. "Such a great guy. It was devastating. George was distraught. Do we keep this movie going?" As easy it would've been at this early stage to shelve the project, it was decided that to honor Young, the film would continue and Scribner would stay on as director.

Roy Disney hired Peter Schneider to be vice president of animation in in October 1985. Schneider had come from the theater world and, in the beginning, worked alongside the current VP, Ed Hansen. But Hansen suspected that he was being edged out of the job. The feeling was that Roy wanted someone younger and more open-minded about new technologies and processes, such as a stronger integration of computers. As *Basil* started winding down, Hansen decided to retire.

Said Don Hahn: "Katzenberg was a motor, and he was a machine of a man and brought a discipline to the process. Peter Schneider was a lot of nervous energy and brought an *impatience* to the process but also a love of theater and creative people."[267] The price for gaining more experienced and aggressive leadership from the outside was that their decisions were more often based on budgets and marketability rather than the best creative choice.

As producer of *Basil*, Burny Mattinson always had Schneider in his ear, making sure that the film came in on time and on budget. "Peter was becoming absolutely obnoxious," recalled Burny. "We had still a lot of stuff in Ink and Paint and that's when Peter was going around [saying], 'Jeffery thinks you're a fucking idiot. You'll never make it on time.' To me. Personally. He was always on my case." Schneider had Mattinson meet him in the Ink and Paint Building on the lot every Friday to see how much film footage was painted that week and to assess how much was left. Said Mattinson: "I'd come over and the girls would say, 'Oh, this scene has got an awful lot of [camera moves] in it.' And he'd say, 'Burny, do something then.' So, I'd look at their problem and say, 'Fine, just shoot it straight at this field.' Just to get it done. But that went on there *every* Friday."

Mattinson had been working to scale down *Basil* so it would fit into the financial box into which Eisner had placed it. Katzenberg and Schneider doubted Mattinson could do it. They rebudgeted the film from $10 million to a slightly more comfortable $18 million. Katzenberg called Mattinson into his office to discuss the situation. Roy was there, along with the team who worked with film budgets. Said Mattinson: "Katzenberg said, 'You're going to be over budget on this picture.' And I said, 'No, we're not going to be over budget.' And he said something that provoked me to say: 'We got to have quality in here. We can't chintz on this thing.' And he says, 'Don't you wave that *quality* finger at me! If you can't bring it in for eighteen million, you're

going to be out of a job, and you're not going to ever work in this business again.' I was like, 'Jesus!' I said, 'We will work within eighteen million.' And he says, 'You better.' He was very upset."

The song that Henry Mancini had written for the bar sequence in *Basil* had been recorded by Shani Wallis, known for playing Nancy in the 1968 film *Oliver!* A good portion of the sequence had been animated but, according to Mattinson, "Katzenberg wanted a popular singer. 'No, let's get somebody who's known. We want names.' Melissa Manchester at that time had a name. She said, 'Well, I won't do it unless I *write* the song.' So, she wrote her song, sang it, and I played [them] for Katzenberg, both Shani Wallis and that one. He said, 'I don't care.' He says, 'You can have what you want, but I want something that has a name on it, personally.' So, I acquiesced. And I kick myself because I liked Shani Wallis. I liked her version best. I liked Mancini's song the best. But it's one of those compromises you make so everybody feels good."

Paramount Pictures released Eisner and Katzenberg's *Young Sherlock Holmes* film and, to their disappointment, the film underperformed. This put the commercial viability of the famous detective into question. The executives had seen Holmes as an asset at first, but now they wanted to remove any reference to the character and his world. Recalled John Musker: "Suddenly they're like…Sherlock Holmes is box office poison. So…the posters couldn't have him wearing a deerstalker hat. He couldn't have a magnifying glass. That went to the title, too. 'Baker Street' suggests Sherlock Holmes. So, there was a list of titles generated and they picked *The Great Mouse Detective*. Everyone hated it."

Burny Mattinson and John Musker returned from London, where they had recorded the voice for Olivia, the little mouse who asks Basil to find her missing father. The voice actor's name was Susanne Pollatschek and

she had a natural appeal and a wonderful Scottish accent. The team found both her and her performance endearing. Jeffery Katzenberg, not so much. "He said he wanted to change the voices, the costumes, everything," said Mattinson. "I finally came to Roy, and I said, 'Roy, we just came back from England. We got this wonderful girl's voice. And Jeffrey's having trouble. We need to do something about it.' So, we went over there to his office. Roy started off and he says, 'I understand you want to change the voices on this picture and some of the dialogue you don't like. What's your problem with these things?' [Jeffrey] says, 'I just don't like it. I want to change everything because I don't think we have an audience for this picture the way it is. *Basil of Baker Street*? Who's going to know what Basil is? It's an herb.' And he said, 'I don't like [the line of dialogue that says] *nefarious Professor Ratigan*. Nefarious? What's *nefarious*?' And Roy says, 'Well, the kids can look it up in the dictionary.' [Jeffrey] didn't want anything to do with England. Especially the girl. He wanted an American voice. Roy said, 'No, we're not going to change the voices, and we're not going to change the wordage.' That was the end of the meeting and Roy started walking out. I followed Roy, and Katzenberg came up to me and he says, 'Well, you won *this* one.'"

As word spread about Katzenberg's meddling, members of the crew became frustrated, particularly about the film's title change. The sentiment was that the title was bland and ordinary. Animator and story artist Ed Gombert chose to vent his feelings by way of a prank. Gombert found some company letterhead and created a fake memo from the desk of Peter Schneider. In it, he announced that, in the spirit of *Basil's* title change, *all* the Disney animated classics would be getting new titles. For example, *Snow White and the Seven Dwarfs* would become *Seven Little Men Help a Girl* and *Pinocchio* would now be known as *The Little Wooden Boy Who Became Real.* Said John Musker: "I thought it was so funny. I didn't even notice Peter

Schneider's name was on it. [I thought] Michael and Jeffrey have got to know about this, so I anonymously sent it in company mail *to each of them*. So, later that day, I hear Mark Hester, assistant director. He's like, 'You know, Peter's totally on the warpath. His name was on it. He wants to fire whoever wrote that.' And I think, *'Oh no, I just got Ed Gombert fired!"*

Recalled Mattinson: "Peter sent somebody over [to the lot]...but they couldn't get it away from the execs that got copies of it. And those that didn't, they called Peter and they *wanted* to get a copy of it. They thought it was real! And that's when he called everybody, *everybody,* into the theater. He read them a riot act and it was not without 'Fucking this' and 'Who was the fucking bastard that did that.' He had the four-veiner." Despite Schneider's hysterics, no one admitted to any knowledge of the responsible parties. Gombert and Musker were safe.

The last few months of 1985 saw two more live-action films released under the Walt Disney Pictures banner. *The Journey of Natty Gann* debuted on September 27. It starred John Cusak and Meredith Salenger in a Depression-era story about a young girl who treks from Chicago to Washington state to reunite with her father who has gone looking for work. After years of negative reviews of Disney live-action films, Siskel and Ebert finally found one they could praise. Gene Siskel said that *Natty Gann* had "undeniable entertainment value,"[268] and Roger Ebert added that the film was "so much better than the average teenage or family picture."[269]

Unfortunately, the Studio's next release found the critics returning to their old ways. *One Magic Christmas* (formerly *Father Christmas*) arrived in theaters on November 22 and the two critics were less than enthusiastic. In

Top: John Cusack and Meredith Salenger in The Journey of Natty Gann. Bottom: Mary Steenburgen in One Magic Christmas..

the film, Mary Steenburgen played a downtrodden wife and mother who, in the wake of several tragedies, learns the meaning of Christmas from an angel named Gideon, played by Harry Dean Stanton. Steenburgen enjoyed making the film, saying: "In the case of *One Magic Christmas*, much of what I loved about it was working with Phillip Borsos. He directed *The Grey Fox*, which was one of the simplest, sparsest, most beautifully made films I've seen. I really wanted to work with him, and because of him, it was a joyous experience making that film."[270] Siskel and Ebert also praised the collaboration between the actor and the director, as well the efforts of the entire cast and crew. Said Ebert: "From a technical point of view, it's a well-made movie but it's such a tragic miscalculation in terms of the screenplay."[271] Siskel agreed, saying: "*One Magic Christmas* is a very strange movie. It's unbelievably downbeat to the point it really gets on one's nerves....I felt totally manipulated by this movie."[272] Ebert closed their review by adding: "I walked out of the movie just thankful they didn't have a family dog because it probably would've been run over."[273]

These two films brought the Studio's slate for 1985 to a total of four films released under the Disney name and only two under the Touchstone label—*Baby* and *My Science Project*. That ratio would change significantly the following year and into the future.

1986

The year kicked off with the new regime's first box-office hit—*Down and Out in Beverly Hills*. The remake of the French film *Boudu Saved from Drowning* was released on January 31 from Touchstone Films. It was a huge success. The film starred Nick Nolte, Bette Midler, and Richard Dreyfuss. Midler and Dreyfuss had both been in the midst of career slumps after having made a strong impact in Hollywood early on. Midler had received an Oscar nomination for her performance in 1979's *The Rose*. Dreyfuss appeared in commercial hits like *American Graffiti*, *Jaws*, and *Close Encounters of the Third Kind* and had won an acting Oscar for *The Goodbye Girl* in 1978. *Down and Out in Beverly Hills* reinvigorated their careers and both actors went on to make many films for the Studio.

The poster for *Down and Out* was indicative of the changes in the way the Studio would market their films in this new era. The actors' names appear in large, bold type *above* the credit block. In the past, Disney never marketed their films by leveraging the names of the stars. Also, the look of the poster is pure '80s, with a background of a powder blue sky and pastel pink palm trees, reflecting the contemporary feel of the film. And in the bottom left corner, sat an R. It was the first-ever R rating for a Disney film.

It was clear that Eisner and Katzenberg saw great potential in the Touchstone brand for making a wide variety of films and were taking full advantage of it. Two more films under the banner were released in the first half of the year. *Off Beat*, starring Judge Reinhold and Meg Tilly, arrived in theaters in April and was a critical and financial flop. The next film fared much better. *Ruthless People* was another R-rated comedy, starring Danny

Richard Dreyfuss and Bette Midler get career boosts with Down and Out in Beverly Hills.

DeVito and Bette Midler. The story was about DeVito's character rejoicing in the kidnapping of his wife (Midler) whom he'd been planning to murder. *Ruthless People* was directed by Jim Abrahams, Jerry Zucker, and David Zucker, the brains behind irreverent comedies like *Airplane* and the *Police Squad* television series. Also in active production for Touchstone were *The Color of Money* and *Tough Guys*.

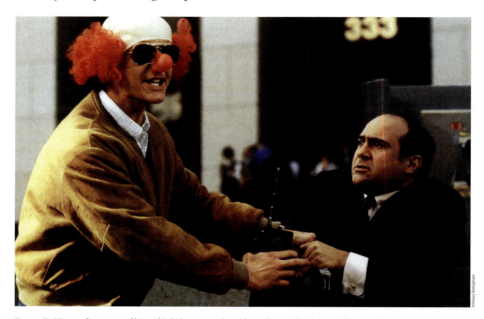

Danny DeVito confronts one of his wife's kidnappers, played by Judge Reinhold, in Ruthless People.

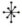

Michael Eisner revived the Disney Sunday night television series in February 1986. The new incarnation was called *The Disney Sunday Movie*. Eisner was the on-camera host for each episode, symbolically stepping into Walt's shoes. The series received a twenty-three-episode order and about half of those episodes would be original movies. The premiere episode was

Help Wanted: Kids, starring Cindy Williams. Other episodes would feature early performances by future stars such as Scott Bakula, Patrick Dempsey, and Keanu Reeves. Some of the behind-the-camera talent included horror director Wes Craven (*Casebusters*); Mick Garris (*Fuzzbucket*), who would later write the script for Disney's *Hocus Pocus*; and James Mangold, future writer/director of *Walk the Line*, *Logan*, and *Ford v Ferrari*, who penned the film *The Deacon Street Deer*.

Original filmed entertainment for The Disney Channel continued. A ten-part miniseries, *Return to Treasure Island*, debuted in the spring. *Return* picked up the story of Jim Hawkins ten years after Walt's 1950 movie ended and starred British actor Brian Blessed in the role of the infamous Long John Silver.

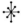

The Great Mouse Detective hit theaters on July 2. The reviews were good, but audience response was lukewarm. Merchandise had been created to correspond with the release but, since it had been made before the film's title change, it was all branded as *Basil of Baker Street*. By the time Jeffrey Katzenberg changed his mind about the title, it was too late to amend the products, so they had to be scrapped. Because of Katzenberg's decision to pull back on the Sherlock Holmes elements, the film's marketing materials got watered down. The dominant visual on the poster, for a film called *The Great MOUSE Detective,* was not a mouse. The centerpiece is a head-to-toe illustration of the film's basset hound character. Also on the poster, Basil swings from a rope tied to the lettering, but he wears a nondescript blue suit. This told the viewer nothing about the character or why he was such a great detective. As a result, the advertising did little to generate excitement

Production stills from The Great Mouse Detective. Top: The nefarious Professor Ratigan. Bottom: Basil and Dawson learn about the mysterious disappearance of Olivia Flaversham's father.

for the movie.

But *The Great Mouse Detective* is a charming and witty film. It's everything *The Black Cauldron* is not. Its humor is smart, its characters are entertaining and uniquely defined, the animation is inventive and surprising, and its story is simple and tight. Historically, it's significant to the evolution of Disney animation. With John Musker and Ron Clements as part of the directing team, it was the first feature film helmed by members of the new generation. And it would put in place the artistic leadership who continued to make the Studio's animated features for years to come.

Besides *Mouse Detective*, there would only be one other film released from Walt Disney Pictures that year. *Flight of the Navigator*, an independent production that Disney had bought the distribution rights to, arrived in theaters on August 1. The remainder of the films for 1986 would be from Touchstone, making a total of five, once again being the majority of the Studio's releases for that year.

Tough Guys and *The Color of Money* were the last two movies of 1986. *Tough Guys* reunited screen legends Burt Lancaster and Kirk Douglas in an action comedy about two old-school gangsters who are released from prison only to find that they don't fit in to the modern '80s world. With the release of *Tough Guys*, Touchstone Films was rebranded as Touchstone Pictures.

Tom Cruise and Paul Newman star in The Color of Money, director Martin Scorsese's sequel to The Hustler.

The Color of Money was a follow-up to the classic film, *The Hustler*. Paul Newman returned to the role of pool shark Fast Eddie Felson. It

DISNEY IN-BETWEEN

425

was directed by Martin Scorsese, and costarred Tom Cruise, fresh off the enormous success of *Top Gun* earlier that year. The combination of *Top Gun* and *The Color of Money* launched Cruise into movie stardom. Newman won his first and only Best Actor Oscar for his role in the film, which was also the first win in that category for a Disney movie.

In September, the Studio released a new short film in only two theaters. One was at Disneyland and the other at EPCOT Center in Walt Disney World. *Captain Eo*, a 3D film starring Michael Jackson, directed by Francis Ford Coppola, produced by George Lucas, and sponsored by Kodak, premiered at the Magic Eye Theater and the Journey into Imagination pavilion. In a blurb from *Disney News*, Michael Eisner said: "All of us at Walt Disney Productions are delighted that Michael Jackson, George Lucas, and Francis Ford Coppola, and an extraordinary group of filmmakers have joined together to create this pioneering motion picture event. We wish to enhance Disney's role as a technical innovator now and in the future. State-of-the-art technology is… being used in the design of the two theaters that will showcase this unique sight, sound, and environmental experience."[274]

The second season of *The Disney Sunday Movie* premiered in the fall. From September through the end of the year, nine original movies aired. Some of these included appearances by child actors like Annabeth Gish, Candace Cameron, and Jason Bateman, as well as alums from the hit movie *The Goonies,* Sean Astin and Jeff Cohen. There were big names like Ed Asner,

Tony Randall, Carrie Fisher, and René Auberjonois. Disney veteran Vincent McEveety helmed one of the films, as did actor Beau Bridges. The movie *The B.R.A.T. Patrol* was an early writing effort from Chris Carter, who would go on to create the cultural phenomenon *The X-Files.*

As the year came to a close, Universal Pictures and Steven Spielberg's Amblin Entertainment released Don Bluth's second animated feature, *An American Tail.* It was the story of a family of mice who emigrate from Russia to New York. *An American Tail* did huge business during the holiday season, making almost triple what *Great Mouse Detective* had. The film's song "Somewhere Out There" was nominated for an Oscar. Linda Ronstadt and James Ingram rerecorded it for radio, and it became a hit on adult contemporary stations. Spielberg and the Studio also spent a decent amount of money to market the film. Unlike what happened with *The Great Mouse Detective,* they made a deal to sell toys based on the film's characters at a fast-food chain. Said Ron Clements: "They had a tie-in with McDonald's, which was the first time they ever did stuff like that. *An American Tail* actually set the template for the way to sell these kinds of movies and then Disney kind of followed that."

The final box-office tally for *An American Tail* exceeded the grosses of any Disney animated feature in the history of the company. Jeffrey Katzenberg's curiosity was piqued upon seeing how lucrative animation could be. Said Mark Henn: "We heard the story of Jeffery going on vacation in Hawaii. He took Frank and Ollie's book [*Disney Animation: The Illusion of Life*] with him and read it cover to cover. Jeffery really wanted to learn what this business was all about. So, to his credit, he really did." When Katzenberg returned from his vacation, Glen Keane said he was "a changed man. Suddenly, he's there at the Studio all the time." Added Dorothy McKim: "He was almost like another director. Very hands on."

The year 1986 marked twenty years without Walt Disney. Although the Studio's future looked bright, things would never be the same. This was also the year that Walt Disney Productions was renamed The Walt Disney Company. Even though it had gone public back in the 1950s, the new name made it overtly clear that it was now a part of corporate America. Make no mistake, it was no longer an independently run family business. It wasn't Walt Disney's studio or production facility. It hadn't been for the last two decades, even though many behaved as though it was.

Thankfully, there was still a Disney in the company's leadership. Even though Roy Jr. had a presence during the '70s—directing films and being on the company's board—he was underestimated, much like his father, whose accomplishments were often outshined by Walt. But also like his father, Roy had humility and patience, allowing him to observe and plan. His dedication to his uncle and the values he stood for enabled him to use this quiet strength to reclaim and restore the integrity of his family name. He more than proved that he was anything but the "idiot nephew."

"[Roy] was comfortable," said effects animator Dave Bossert. "He had a pile of dough. He could've just sailed and lived as a gentleman the rest of his life in perfect comfort. And he opted not to do that. He cared too much about the family business. If it wasn't for Roy doing that…this company wouldn't be as huge as it is now."

Roy E. Disney surrounded by character maquettes from Fantasia 2000, a continuation of his uncle's legacy.

Aftermath

Michael Eisner and Jeffrey Katzenberg continued to run with the Touchstone label, allowing them to attract major Hollywood talent, both in front of and behind the camera, leading to big box office, award recognition, and a renewed reputation in the industry. The Studio released ten films in 1987. Only one of them, *Benji the Hunted*, was released through Walt Disney Pictures. The rest—*Outrageous Fortune*, *Adventures in Babysitting*, *Stakeout*, *Can't Buy Me Love*, *Three Men and a Baby*, and *Good Morning, Vietnam*—were released under Touchstone. Three of the top box-office grossers for the year were from this list—*Stakeout* at No. 8, *Good Morning, Vietnam* at No. 4, and *Three Men and a Baby* at No. 1. For his lead role in *Good Morning, Vietnam*, Robin Williams won a Golden Globe and received his first Oscar nomination. Two years later, he would receive his second nomination for *Dead Poets Society*, also a Touchstone film.

In the coming years, Eisner and Katzenberg would increase Disney's live-action film output with the creation of a second distribution arm—Hollywood Pictures—as well as the acquisition of the independent production company Miramax.

Who Framed Roger Rabbit finally hit theater screens in the summer of 1988. It was a smash. Released through Touchstone Pictures and Steven Spielberg's Amblin Entertainment, the film boasted the most sophisticated combination of live-action and animation ever achieved. The characters moved in three-dimensional space, with shadows and highlights to make them look as real as if they were actors on the set. Robert Zemeckis remained on the project as director, and maverick animator Richard Williams supervised

The reign of Touchstone: Stakeout (top), Good Morning, Vietnam (middle) and Three Men and a Baby (bottom).

the animation. Along with its financial success, it was critically acclaimed and nominated for six Academy Awards. It won for Best Visual Effects, with Williams receiving a Special Achievement Oscar.

Bob Hoskins struggles to hide Roger in Who Framed Roger Rabbit.

For Darrell Van Citters and Marc Stirdivant, it was difficult to celebrate the final film. They'd been so passionate about their take on the project. Once they saw how far from that vision the final film had strayed, it was disappointing. "Not that the movie wasn't successful the way it was, but I didn't really enjoy it," said Stirdivant. "I would've rather the emphasis be on the heart of the story and the friendship element." Added Van Citters: "If you look at what [clothes] they put Roger in, he's wearing a clown suit. It was about the silliness and the concept of live and animation and worrying about the tones and highlights. [To us,] it was never about the special effect; it was about the characters. I still haven't seen the movie to date because I didn't like where it went."

The Studio's next full-length animated film was the realization of the late Pete Young's Gong Show pitch. *Oliver & Company* was released in November 1988 and directed by George Scribner. It was considered a step up at the box office, making about twice what *The Great Mouse Detective* had. And it smacked of everything Katzenberg had tried to turn *The Great Mouse Detective* into. It was set in present-day New York. It had an urban attitude courtesy of Dodger, a dog with a bandana, sunglasses and the voice of Billy Joel. The film's songs were written and performed by artists and musicians from the world of pop music.

Next up for animation was another film made from a Gong Show pitch. This one truly revived Disney animation and put it at the head of the pack. *The Little Mermaid*, directed by John Musker and Ron Clements, returned Disney to its fairy tale roots as well as its rich history of iconic and timeless songs. Howard Ashman and Alan Menken received three Academy Award nominations, two for their songs "Under the Sea" and "Kiss the Girl" and one for Menken's instrumental score. Menken would win for score and the team for "Under the Sea."

Ashman and Menken didn't just write catchy tunes or sweet ballads to be peppered between story moments. Given their experience in the theater world with their off-Broadway hit *Little Shop of Horrors*, they chose to approach the project as a traditional "book" musical, where the songs expand and advance the story. This was the kind of musical Walt Disney had been passionate about making after the success of *Mary Poppins*. He tried with *The Happiest Millionaire* and *The One and Only, Genuine, Original Family Band*, as did his successors with *Bedknobs and Broomsticks* and *Pete's Dragon*. But it was Ashman and Menken who truly created the "Disney Musical."

Musker and Clements' direction of *The Little Mermaid*, along with Jeffrey Katzenberg's renewed commitment and Peter Schneider's aggressive

push, launched the new renaissance of Disney animation. Mike Giaimo and his classmates at CalArts used to wonder if or when an animation renaissance would happen. It was happening now.

Don Hahn moved from being" "the guy with the clipboard," on *The Black Cauldron* and *The Great Mouse Detective* to associate producer of *Who Framed Roger Rabbit*. He later became a producer, overseeing some of Disney's biggest animated hits: *Beauty and the Beast, The Lion King, The Hunchback of Notre Dame*, and *Atlantis: The Lost Empire*. He received the first-ever Best Picture Oscar nomination for an animated feature when *Beauty and the Beast* was nominated by the Motion Picture Academy in 1992.

Dorothy McKim continued rising through the ranks of animation, becoming production manager on *Beauty and the Beast, The Lion King,* and *Pocahontas* and then director of production on later films like *Tarzan* and *The Emperor's New Groove*. She made the move into producing, beginning with the 2007 feature film *Meet the Robinsons* as well as several theatrical shorts, including the Oscar nominated *Get a Horse!* She also won back-to-back Emmys for producing Disney's *Prep & Landing* holiday franchise for the ABC network.

The work of animators Glen Keane, Mark Henn, and Andreas Deja during this renaissance period made them legendary in the world of animation. Considered to be three of the greatest modern animators, they brought to the screen characters that now stand side by side with those created by Walt and his artists, in particular the Nine Old Men. Keane supervised the animation for the characters of Ariel, Beast, Aladdin, Pocahontas and Tarzan. Henn oversaw Belle, Jasmine, Young Simba, Mulan, and Tiana. And Deja breathed life into King Triton, Gaston, Jafar, Scar, and Stitch.

Future supervising animators Ruben Aquino (Ursula and Adult Simba), Kathy Zielinski (Frollo from *The Hunchback of Notre Dame*), and Tony

DeRosa (Nala in *The Lion King* and Zeus from *Hercules*) cut their teeth on *Mickey's Christmas Carol* and *The Black Cauldron*.

Dan Hansen and Dave Bossert would go on to be artistic supervisors, in layout and effects animation, respectively. Both would also go on to be artistic coordinators. Hansen would fill that role on *Aladdin, Pocahontas, Hercules* and *The Emperor's New Groove*, and Bossert for the short *Runaway Brain* and the theatrical feature *Fantasia 2000*.

During Walt's time, animation directors typically came from the animator ranks, like Hamilton Luske, Clyde Geronimi, Wilfred Jackson, and Woolie Reitherman. This practice continued after Walt, beginning with John Musker and Ron Clements.

Animator Mike Gabriel moved into directing after working in Story and Animation on *Oliver & Company*. Gabriel helmed *The Rescuers Down Under* and *Pocahontas* and later earned an Academy Award nomination for his 2004 animated short *Lorenzo*.

Mark Dindal continued animating special effects for Disney, eventually becoming the effects supervisor on *The Little Mermaid*. After that, he directed the animated sequences for Disney's live-action adventure *The Rocketeer* and then the animated feature *Cats Don't Dance* for Warner Bros. He returned to Disney to direct the cult classic *The Emperor's New Groove*, and the Studio's first fully computer-animated feature, *Chicken Little*.

Chris Buck animated many projects outside of Disney then returned to the Studio as a supervising animator on *Pocahontas*. Following that, he began a prestigious directing career starting with *Tarzan* and then the Sony Pictures Animation film *Surf's Up*. He returned yet again to Disney and developed and directed the smash hits *Frozen* and *Frozen 2*. Joining Buck on the *Frozen* series was his longtime friend and colleague Mike Giaimo. Mike had returned to Disney as art director on *Pocahontas*, then moved onto *Frozen*

in that same capacity and then onto *Frozen 2* as production designer.

Darrell Van Citters never returned to Disney. Said Mike Giaimo: "He's the only person I know who had real Disney training from that time who, when he left in '86, never went back."

"I didn't feel like there was anything to go back to," said Van Citters. "I freelanced for commercials for, I guess it was about three years, and then I did a bunch of Warner Bros. commercials and they wanted me to come in-house, so I became the creative director there. We did commercials, we did a short, we did the *Hair Jordan* spot." In the early '90s, Van Citters formed his own studio, Renegade Animation, and continues to produce independent animation.

Other future directors like Gary Trousdale and Kirk Wise (*Beauty and the Beast, The Hunchback of Notre Dame, Atlantis: The Lost Empire*), Rob Minkoff (*The Lion King*) and Kevin Lima (*A Goofy Movie, Tarzan, Enchanted*) started out in the animation ranks on *The Black Cauldron* and *The Great Mouse Detective*.

Eric Larson, despite his retirement, still had an office at the Studio, remaining a part of Disney animation up through production on *The Little Mermaid*. But as schedules tightened and the pressure for success grew, the artists found it difficult to find time to visit with him. Mark Henn recalled: "I remember one time, I stopped in his office, and he was looking at one of those big, long group photographs of the staff from the Hyperion Studio that he had, and he told me, 'You know, you guys are every bit as talented as the guys I'm looking at in this picture.'" And that fact was a direct result of Larson's patience and persistence in training this new generation. "Eric was such an open door for

any new young artist coming into Disney," said Glen Keane. "He really was the reason for Disney animation continuing on because of...his personality. The way he was. Because it's a pretty scary, intimidating art form to suddenly have to pick up and learn if you don't have somebody willing to teach you like that and break it down." "He trained all of us," said Chris Buck. "Really, Eric was *the guy*. He was the guy with us, in the trenches. If I had had the chance of going back and saying 'thank you' at the time, I wish I would have."

It's worth remembering some of the comments made by these younger artists during their early years at the Studio. "*We didn't want to redefine Disney, we just wanted to reclaim Disney,*" said Mike Gabriel. "*Is it possible that the moviegoing audience could get as excited for animation as they did for these live-action films?*" asked John Musker.

With *The Little Mermaid, Beauty and the Beast, Aladdin,* and *The Lion King,* the generation mentored by Eric Larson and the last of the Nine Old Men, did exactly what they'd dreamed of—reclaimed the greatness of Disney animation.

They told stories with deeper emotion and stronger dramatic stakes. They raised the level of cinematic storytelling. They created animated films that could stand next to live-action films and achieve the same success and garner the same respect. And they made it safe for anyone over thirteen, with or without a child in tow, to enjoy a Disney animated film.

Art Stevens left Disney in the middle of production on *The Black Cauldron*, and it marked the end of his career in the animation industry. Neither Joe Hale nor Ted Berman worked again, either. Only Rick Rich kept making animated features, having modest success with *The Swan Princess* in 1994.

He would go on to make video sequels to that film as well as direct-to-video animated Bible stories.

Don Bluth continued producing animated features independently, with colleagues Gary Goldman and John Pomeroy. His head-to-head battle with Disney raged on, releasing *The Land Before Time*—his second collaboration with Spielberg—at the same time as *Oliver & Company* and then *All Dogs Go to Heaven* during the same season as *The Little Mermaid*. These films would not repeat *An American Tail's* victory over Disney, but Bluth produced and directed six more animated features, having great success with the film *Anastasia* for Fox.

Don Bluth's colleague Gary Goldman continued working with him, but Pomeroy left in the early '90s and returned to Disney to be a supervising animator for the character of John Smith in *Pocahontas*. Ironically, he worked side by side with Glen Keane once again, who was supervising the character of Pocahontas. "I didn't talk to [John Pomeroy] again until I was on *Pocahontas*," said Keane. "I [was] asked who should be doing John Smith and I said, 'I think John Pomeroy would really do that well, and I would love to work with John again' so he came back. It was wonderful to be reconnected." According to Keane, any past animosity between the two was gone.

In addition to Pomeroy, many of the original team who had made the exodus with Bluth had now left *him*. Lorna Cook also returned to Disney after a call from producer Don Hahn, asking her to animate on *Beauty and the Beast*. Said Cook: "I told Don Hahn, 'Yeah, you bet. Love to.' I had to then immerse myself and integrate myself into the gang over there. But it started my animation career once again at Disney. I didn't know what position I'd get. I thought, *Am I going to be a supervising animator?* James Baxter... was the supervising animator for Belle and I was on his team." Cook later transitioned into the Story Department for *The Lion King* and *Mulan* and then

left to storyboard and direct for other studios.

And Don Bluth himself stepped back on to the Disney lot in 2018, just shy of forty years since he'd walked out. Bluth was preparing to write his memoirs and wanted to walk the halls of Walt's Animation Building one more time to get into the right frame of mind. Not only did he locate the sites of his past workspaces and visit the reconstructed office of Walt, but he was also reunited with former colleagues Ron Clements, Howard Green, and Burny Mattinson. If ever there was a reunion that could go wrong quickly, it was this one. But as the saying goes, time heals all wounds and Bluth was welcomed with smiles and handshakes from these three men. He even sat down for lunch with Green and Mattinson, swapping stories of the Nine Old Men and the old days together.

Regardless of the friction that surrounded Don Bluth, his talent, passion, and contribution to the art of animation—at Disney and beyond—deserves respect and appreciation.

Tim Burton became one of Hollywood's most successful and sought-after directors. His stories about dark loners appealed to millions of people on the fringe and brought the Goth movement out of the shadows and into popular culture. Ironically, he would later return to Disney to make his stop-motion project, *The Nightmare Before Christmas,* originally pitched to, and rejected by, the Studio. Burton would also bring box-office success to Disney with his rebooted and reimagined feature-length, stop-motion version of *Frankenweenie* as well as live-action remakes of *Alice in Wonderland* and *Dumbo.*

It's inevitable that at some point someone would've made a feature film using computer animation had Disney not made *Tron*. But the fact remains that they did it first, during a time when the technology was seen as nothing more than a tool for generating flying logos and animated shorts for film festivals. Writer/director Steven Lisberger's creative vision, and Tom Wilhite's ability to see the potential of that vision, took a fledgling technology and used it to break new ground.

"I tell people [there are] two ways of looking at [*Tron*]," said former Disney publicist Mike Bonifer. "One is the traditional linear storytelling way; in which case it was mediocre at best. There's another lens that you could look at that film through and say that it was arguably the most successful motion picture in history." Indeed, the ripples created by *Tron* would eventually change the face of entertainment. But it took time for those ripples to reach the shore.

Computer animation appeared in music videos, commercials, and title sequences throughout the '80s. The technology evolved in the world of special effects, featured in sequences from films like *Young Sherlock Holmes* and *The Last Starfighter*. By the '90s, films like *Terminator 2: Judgment Day* and *Jurassic Park* would prove the technology's ability to sustain an audience's belief through an entire film. And of course, John Lasseter and his team at Pixar were able to show that computer animation could tell a complete story and convey emotion with the success of the first full-length computer-animated feature, *Toy Story*. Today, one is hard-pressed to find a major Hollywood release that doesn't boast some amount of computer animation. It can all be traced back to Steven Lisberger, Tom Wilhite, and *Tron*.

From hand-inking to Xerox to APT, Disney animation continually searched for better and more efficient ways of turning black-and-white animation drawings into color. Their newest innovation was tested in a scene from *The Little Mermaid* then used for the entirety of Disney's next animated film, *The Rescuers Down Under*. The Computer Animation Production System—or CAPS—allowed animation drawings to be scanned into a computer, digitally inked and painted, and then composited onto the painted backgrounds, eliminating the need for traditional animation camera stands. CAPS opened up the possibilities for more complex camera movements and allowed for a wider range of color palettes and more sophisticated use of tones and shadows. The technology was developed through a partnership with Disney animation and Pixar and the team won a Scientific and Engineering Oscar from the Motion Picture Academy for their work.

This technology evolved from the process used by Glen Keane and John Lasseter to combine hand-drawn animated characters with computer-generated backgrounds for their *Where the Wild Things Are* test years earlier. But its origins can be found even before that, in a system proposed by Jerry Rees called the computer oriented production system. When Rees left Disney after *Tron*, he began collaborating with animator Brad Bird and *Star Wars* and *Return to Oz* producer Gary Kurtz on an animated feature based on the classic crime-fighting comic "The Spirit" by Will Eisner. Taking what he'd learned about computer animation on *Tron*, Rees developed his idea for combining pencil and paper with computers and began discussing it with potential partners. Eventually, word of the technology got back to his former colleagues at Disney. Said Rees: "Then they did the *Wild Things* test and the history books [say] 'that's where it started.'" Because of this incident, Rees and team no longer had proprietary ownership of the idea.

Disney's CAPS technology would be used for all of their animated films for the next fourteen years, and digital ink and paint and compositing would become standard for all studios making hand-drawn animated features.

Tom Wilhite did eventually see *The Brave Little Toaster* to fruition. After leaving Disney, he started his own production company, Hyperion Pictures, and immediately contacted Jerry Rees to direct *Toaster*. Rees worked with Joe Ranft and Brian McEntee on a script and the team shopped the project around. They piqued the interest of Disney Channel executive Jim Jimirro, who offered to buy the television and video rights. They were able to raise the money they needed and the film moved forward, but with a smaller budget than originally anticipated. This meant the film would have to be animated traditionally, rather than with computers, and it would have to be produced in Taiwan to keep costs down. Wilhite felt an obligation to John Lasseter and called him to let him know how things were moving forward. According to Wilhite, Lasseter was "perfectly fine, professional. But I know it was hurtful. I know that." *The Brave Little Toaster* was given a limited theatrical release and then premiered on The Disney

The appliances from The Brave Little Toaster.

Channel in July 1987.

Rees' approach to voice casting for *Toaster* had a lasting impact on the future of animation voice recording. Rather than use grounded actors who might reach too far for a cartoonish voice, Rees realized that actors skilled in improvisation would, in his words, "take the crazy thing and make it believable. They were used to being onstage and going, 'You're a radish and you're in love with a carrot. Go!'" For the voices in *Toaster*, he hired alumni from the improv troupe the Groundlings (Deanna Oliver, Phil Hartman and Jon Lovitz). For his next film, *Back to Neverland* (part of an attraction at the Disney MGM Studios theme park), he put Robin Williams at the center of the film and gave his unstoppable improvisatory talents free reign. This inspired Rees' colleagues—John Musker and Ron Clements—to do the same for their 1992 film *Aladdin*, casting Williams, and recording hours and hours of the actor's rapid-fire ad-libbing, to create the manic and lovable Genie. Today,

Robin Williams and director Jerry Rees filming Back to Neverland.

Rees' idea of using performers from the world of improvisation and sketch comedy has become commonplace for animated films.

Wilhite's Hyperion Pictures continued creating both animation and live-action projects. In animation, he would produce the features *Rover Dangerfield* and *Bebe's Kids* as well as many television series, such as *Life with Louie* and *The Proud Family*, the latter airing on The Disney Channel.

Tom Wilhite does not get enough credit for his efforts to change the Disney image during the early '80s. He pushed against the staunch reverence for the Disney legacy and the paralysis caused by it. He believed in and cultivated the in-house talent as well as put out a welcome mat for the rest of Hollywood. And of course, he opened new possibilities for the future of Disney films by creating Touchstone Pictures with Ron Miller, something that Michael Eisner and Jeffrey Katzenberg used to great advantage in the early stages of their tenure. Course correcting a massive ship like Disney is not something that can happen overnight and because Wilhite was the first one to take the wheel, the perception is that he didn't do enough. But without the foundation of change that he set in motion, the dramatic shifts that happened in the company after his time would not have been possible, or have happened as swiftly.

Over the years, Roy E. Disney revived several of his uncle's shelved projects. He realized Walt's desire to make another concert feature by producing *Fantasia 2000*, which had its world premiere on the first day of the new millennium. A third *Fantasia* was discussed, and Roy produced several new segments for it, but the project never came to be. The completed shorts were released on video (*One by One*) and theatrically (*The Little Matchgirl*).

Roy also produced another short, *Destino*, in 2003. This was a collaboration between Walt Disney and Salvador Dali that never saw completion while Walt was alive. Both *The Little Matchgirl* and *Destino* were nominated for Academy Awards.

Eisner and Katzenberg's Gong Show pitch meeting continued on a regular basis and was opened up to animation artists at every level of the Studio, giving them a forum for their ideas to be heard. *Pocahontas* (1995) and *Hercules* (1997) both started life as Gong Show pitches. And the humble *Caricature Show*, hosted by Gail Warren and curated by John Musker in 1979, continues to this day, at Walt Disney Animation Studios. The annual event debuts on April 1 and can be viewed throughout the halls of the Studio for the entire month.

Animation artists Dave Block, Tad Stones, Toby Shelton, and John Norton continued developing new animated series for Walt Disney Television Animation. Hit shows like *Chip 'n' Dale's Rescue Rangers, Tale Spin, Darkwing Duck* and *Goof Troop* solidified the division's reputation as a thriving sister studio to Walt Disney Feature Animation. In addition, other Disney institutions that were born during this transitional time, like The Disney Channel and Walt Disney Home Video, would only grow stronger and more vital in the coming years.

The 1970s saw the creation of the Walt Disney Archives and the reorganization and expansion of the Animation Research Library. According to a video on the website for the company's D23 Fan Club, the Archives currently boast a collection of 10,000 costumes, over 38,000 props, and countless millions of Studio documents and photographs. The company

embarked on a massive reconstruction project in 2015. The project restored Walt's office back to its original configuration. And, because of the meticulous cataloguing by Dave Smith back in 1970, virtually every piece of paper, furniture, and memorabilia that had been in Walt's office at the time of his death was returned to its rightful place.

Since its renaming by Don Hahn, and the archiving initiative that he was a part of back in 1976, the Animation Research Library (ARL) has grown to include over 65 million pieces of traditional animation art. They also keep an ever-growing collection of digital art, estimated at around 4.5 petabytes in size. Both the traditional and digital are housed in a state-of-the-art facility in Glendale, California. The ARL continues as a resource for Disney employees as well as museums and institutions looking to host exhibits of Disney animation art and history. According to their mission statement: "The ARL believes in the power of art and storytelling to inspire creativity, to foster an appreciation for this art form, and to ignite the imaginations of future generations."[275]

Dale Baer's animation career continued to thrive, working for studios like Bill Melendez Productions and Hanna-Barbera. He maintained his relationship with Disney as well, both as a freelance artist and through his own studio, Baer Animation Company. *Who Framed Roger Rabbit*, *Beauty and the Beast*, and *The Lion King* all boast Baer's heartfelt touch. Returning full-time to Walt Disney Animation Studios, Dale was the supervising animator for the flamboyant villain Yzma from *The Emperor's New Groove*. His work on that character won him an Annie Award for Outstanding Individual Achievement for Character Animation. He continued in a supervising

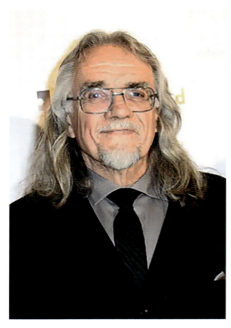

Animator Dale Baer at the 2001 Annie Awards.

capacity on both hand-drawn and computer-animated features (*Meet the Robinsons, Princess and the Frog, Winnie the Pooh*) and animated on many of the Studio's short films (*How to Hook Up Your Home Theater, The Ballad of Nessie, Get a Horse*).

As one of a small group of traditional animators left at the Burbank studio, Dale used paper and pencil to develop characters for computer-animated films like *Wreck-It Ralph, Frozen*, and *Moana*. He would hand-animate exploratory scenes to help build the personalities and explore the range of performance for key characters, providing valuable inspiration and information to the computer modelers, riggers, and animators.

During his last few years with Disney and then into his retirement, Baer taught the fundamentals of classic hand-drawn animation at CalArts, handing the baton to a new generation of artists, as it had been handed to him by the Nine Old Men. Dale passed away in January 2021.

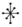

Burny Mattinson continued working in the Story Department along with Vance Gerry. Through concept work and storyboarding, the two men helped build the stories for *Beauty and the Beast, Aladdin, The Lion King, Hercules,*

Mulan, and *Tarzan*, among others. Gerry's last project for Disney was early development work for a project called *Sweating Bullets*, which became the film *Home on the Range*. Gerry passed away in 2005.

Burny Mattinson served as story consultant on the 2011 feature *Winnie the Pooh* and 2014's *Big Hero 6* and 2022's *Strange World*. In 2018, he became the longest full-time employee in the history of Disney, overtaking the former record holder, Imagineer John Hench. At the time of this book's publication, Mattinson celebrated seventy years with the company. Not bad for a traffic boy.

Burny passed away on February 27, 2023 at the age of 87.

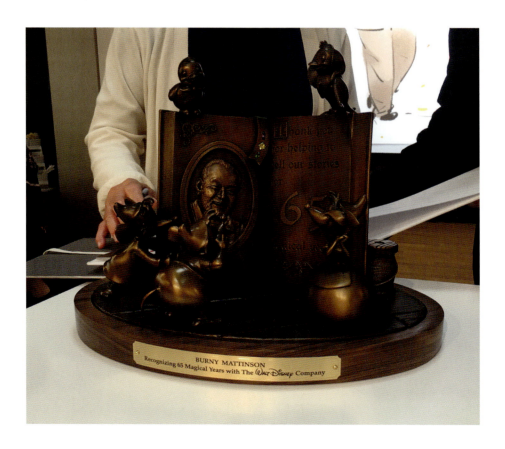

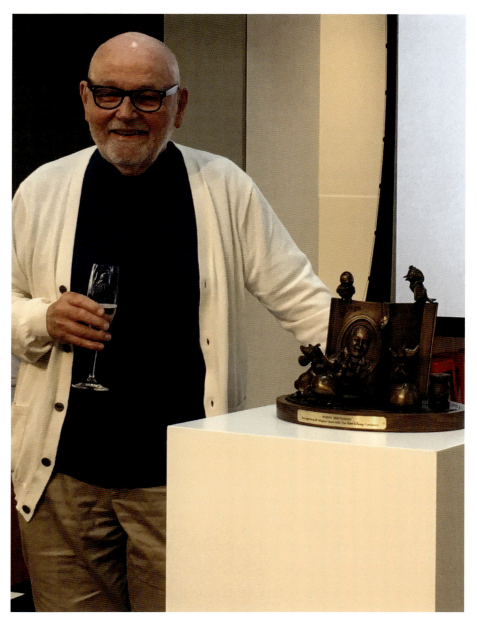

Burny Mattinson's custom service award from 2018, commemorating 65 years with The Walt Disney Company.

DISNEY IN-BETWEEN

Conclusion

The fear of change is one of the most fundamental aspects of the human experience. When our accepted ways are questioned by new and radical ideas, we instinctively hold on tight to what we know. We fear that everything we believe to be true and right may crumble. If we let go, are we betraying those who taught us and who helped shape our beliefs? Are we admitting that we are no longer relevant?

To the leadership of the Walt Disney Studio, giving in to change meant letting go of Walt himself, someone who they loved dearly. Loosening their grip meant letting go of his memory, of his significance. As a result, they made decisions that were viewed as timid at best and complacent at worst. They acted under the best of intentions but ultimately arrested the development of the Studio.

As proven by the words of the young people who came to the Studio during this time, letting go of Walt was never what they wanted. They were pushing for a synthesis of the old with something new. Ironically, in their battles with those who purported to be defenders of Walt, these young people were upholding the most fundamental of Walt's values—progress, forward thinking, and embracing change.

Another irony lies in the fact that the old guard's heel-digging and stubbornness actually motivated great change.

Without the conflicts that led to Don Bluth's exodus, Disney would have continued without competition in the animated family film space, perhaps leading to further complacence with no incentive to make better films.

If John Lasseter had not been fired, Disney leadership may have blocked further exploration of computer animation, leaving the door open for someone else to make the first computer-animated feature, which may have been inferior to *Toy Story*, keeping computer animation as a novelty rather than the industry standard that it has become today.

Had Burny Mattinson, Glen Keane, Mark Henn, Ron Clements, and John Musker never rebelled against the dysfunctional leadership of *The Black Cauldron*, they wouldn't have made *The Great Mouse Detective* and, without that film to convince Michael Eisner and Jeffrey Katzenberg otherwise, Disney animation may have been shut down for good.

And if Eisner had never kicked feature animation off the Studio lot in favor of the live-action division, the animation teams would not have developed the burning desire to redeem and prove themselves by creating the Disney animation renaissance with *The Little Mermaid, Beauty and the Beast, Aladdin*, and *The Lion King*.

These are just a few examples of how outcomes may have differed. It's impossible to say for sure. But it's a testament to how our struggles often create prosperity. How there is value in remembering our low points as well as our high points. And that there is necessity in the in-betweens as well as the extremes.

Endnotes

1. Animation Research Library Oral History Project: "An Interview with Animator/Layout Artist/Writer/Producer Joe Hale — with guest Andreas Deja." Filmed on 1/27/11.
2. Paul F. Anderson. *Jack of All Trades: Conversations with Disney Legend Ken Anderson*. 1st ed. Theme Park Press, 2017, p336.
3. Dave Smith. *The Quotable Walt Disney*. 1st ed. New York: Disney Editions, 2001, p221.
4. Bob Thomas. *Building a Company: Roy O. Disney and the Creation of an Entertainment Empire*. 1st ed. New York: Hyperion, 1998, p7.
5. Dave Smith. *The Quotable Walt Disney*. 1st ed. New York: Disney Editions, 2001, p20.
6. John G. West and Bob McLain. *Walt Disney and Live Action: The Disney Studio's Live-Action Features of the 1950s and 60s*. 1st ed. Theme Park Press, 2016, p175.
7. Ibid, p5893.
8. Ibid, p195.
9. James B. Stewart. *Disney War*. 1st ed. New York: Simon and Schuster, 2005, p42.
10. Ibid, p43.
11. Dave Smith. *The Quotable Walt Disney*. 1st ed. New York: Disney Editions, 2001, p93.
12. Bob Thomas. *Building a Company: Roy O. Disney and the Creation of an Entertainment Empire*. 1st ed. New York: Hyperion, 1998, p300.
13. Ibid, p300.
14. Disney Files on Demand: Exclusive Content from Disney Vacation Club. "Disney Studio Tour—Suite 3H, Walt's Office."
Becky Cline: Walt Disney Archives Director and Ryan March: Disney Files Magazine Editor. 2020.
15. Author Unknown. "Studio Preparing Screenplay Based on North's 'Rascal.'" *Disney News*, Vol. 1, No. 4. September/October/November 1966, p8.
16. Disney Files on Demand: Exclusive Content from Disney Vacation Club. "Disney Studio Tour—Suite 3H, Walt's Office."
Becky Cline: Walt Disney Archives Director and Ryan March: Disney Files Magazine Editor. 2020.
17. Bob Thomas. *Building a Company: Roy O. Disney and the Creation of an Entertainment Empire*. 1st ed. New York: Hyperion, 1998, p301.
18. Ibid, p313.
19. Ibid, pp313–314.
20. Dave Smith. *The Quotable Walt Disney*. 1st ed. New York: Disney Editions, 2001, p139.
21. Kurt Russell. *The Age of Believing: The Disney Live-Action Classics*. Directed by Peter Fitzgerald. Los Angeles, CA: Turner Classic Movies, 2008.
22. Peter Biskind. *Easy Riders, Raging Bulls*. 1st ed. New York: Simon and Schuster, 1998, p23.
23. Ibid–, p30.
24. John G. West and Bob McLain. *Walt Disney and Live Action: The Disney Studio's Live-Action Features of the 1950s and 60s*.
1st ed. Theme Park Press, 2016, p306.
25. Ibid, p307.
26. Ibid, p314.
27. Ibid, 315.
28. Author interview
29. Ibid.
30. Ibid.
31. Ibid.
32. Ibid.
33. The Walt Disney Archives: *Pete's Dragon and the U.S.A.*, screenplay by Seton I Miller, 12/10/57.
34. Ibid..
35. Ibid.
36. The Walt Disney Archives: *Pete's Dragon and the U.S.A.*, screenplay by Noel Langley, 4/23/58.

37 Ibid.
38 The Walt Disney Archives: *Pete's Dragon* story outline, Version 1 Myles Wilder and William Raynor, no date.
39 The Walt Disney Archives: *Pete's Dragon* story outline by William Raynor and Myles Wilder, 10/25/68.
40 *Born to Be Wild: The Story of Easy Rider*. Produced by Nick Freand Jones. UK: BBC Studios, 1995.
41 Ibid.
42 Ibid.
43 Ibid.
44 *That Loveable Bug*. Directed by Mark Young. Burbank, CA: Buena Vista Home Entertainment and Sparkhill Productions, 2003.
45 Ibid.
46 *America Lost and Found: The BBS Story*. Directed by Greg Carson. New York, NY: The Criterion Collection, 2010.
47 Robert B. Sherman and Richard M. Sherman. *Walt's Time*. 1st ed. Santa Clarita, CA: Camphor Tree Publishers, December 1998, p166.
48 Angela Lansbury. "The Interviews." Television Academy Foundation, September 15, 1998.
49 Ibid.
50 Jennifer Keishin Armstrong. *Mary and Lou and Rhoda and Ted: And all the Brilliant Minds Who Made 'The Mary Tyler Moore' Show a Classic*. 1st ed. New York: Simon and Schuster, 2013, p85.
51 Bob Thomas. *Building a Company: Roy O. Disney and the Creation of an Entertainment Empire*. 1st ed. New York: Hyperion, 1998, p326.
52 Ron Howard and Clint Howard. *The Boys*. 1st ed. New York, New York: Harper Collins, 2021, p196.
53 Ibid, p206.
54 Ibid, p205.
55 Ibid, p197.
56 Paul F. Anderson. *Jack of All Trades: Conversations with Disney Legend Ken Anderson*. 1st ed. Theme Park Press, 2017, p325.
57 Ibid, p330.
58 Ibid, p331.
59 Animation Research Library Oral History Project: "An Interview with Animator, Story Artist, Supervising Animator Dave Michener—with guests Burny Mattinson, Ron Clements, and John Musker." Filmed 1/17/13.
60 Ibid.
61 Ibid.
62 Mary Walsh and Fox Carney: Animation Research Library.
63 Robert B. Sherman and Richard M. Sherman. *Walt's Time*. 1st ed. Santa Clarita, CA: Camphor Tree Publishers, December 1998, p166.
64 Ibid.
65 Ibid, p11.
66 Lavalle Lee. "Exclusive Don Bluth and Gary Goldman Interview." *Traditional Animation*. October 25, 2015.
67 Author unknown. "In and Around Walt Disney Productions." *Disney News,* Vol. 8, No. 3. June/July/August 1973, p18.
68 *1974 Behind-the-Scenes Featurette*. "Island at the Top of the World," anniversary ed. DVD. Burbank, CA: Buena Vista Home Entertainment, 2004.
69 James Garner and Jon Winokur. *The Garner Files: A Memoir*. 1st ed. Simon and Schuster, 2012, p259.
70 Ibid.
71 John Canemaker. *Walt Disney's Nine Old Men and the Art of Animation*. 1st ed. New York: Disney Editions, 2001, p122–123.
72 Animation Research Library Oral History Project: "An Interview with Effects Animator Ted Kierscey—with guest Dale Baer." Filmed on 5/31/12.
73 Heidi Guedel. *ANM8RX—A Female Animator: How Laughter Saved My Life*. 1st ed. Nebraska: iUniverse Inc, 2003, p250.
74 Ibid, p249.
75 Author unknown. "The Filming of 'Two Against the Arctic.'" *Disney News,* Vol. 9, No. 2, March/April/May 1974, p16.
76 Jeff Bond. Liner Notes. "'The Black Hole:' Original Motion Picture Soundtrack Special Edition." Intrada, 2011, p3.
77 John Hough. Audio Commentary. *Escape to Witch Mountain,* special ed. DVD. Directed by John Hough, 1975. Burbank, CA: Buena Vista Home Entertainment, 2003.
78 Ibid.
79 *Conversations with John Hough*. "Escape From Witch Mountain," special ed. DVD. Directed by John Hough, 1975. Burbank, CA: Buena Vista Home Entertainment, 2003.
80 John Hough. Audio Commentary. *Escape to Witch Mountain,* special ed. DVD. Directed by John Hough, 1975. Burbank, CA: Buena Vista Home Entertainment, 2003.
81 Ibid.
82 Ibid.
83 Ibid.

84 A Look Back With the Gang. "The Apple Dumpling Gang." DVD. Directed by Mark Young. Burbank, CA: Buena Vista Home Entertainment and Sparkhill Productions, 2003.

85 Animation Research Library Oral History Project: "An Interview with Producer Don Hahn—with guest Roger Allers." Filmed on 9/22/11.

86 Making the 'Escape.' Directed by Mark Young. Burbank, CA: Buena Vista Home Entertainment and Sparkhill Productions, 2003.

87 A Look Back with Jodie Foster. "Freaky Friday," DVD. Directed by Gary Nelson, 1977. Burbank, CA: Buena Vista Home Entertainment, 2004.

88 Author interview: Gary Nelson, September 2016.

89 Author interview: Don Bluth, July 2018.

90 www.mccallstudios.com

91 The Walt Disney Archives: Jerome Courtland memo re: Joe Raposo, 9/15/75.

92 The Walt Disney Archives: *Pete's Dragon* first draft by Malcolm Marmorstein, 9/22/75.

93 *A Look Back with Jodie Foster.* "Freaky Friday," DVD. Directed by Gary Nelson, 1977. Burbank, CA: Buena Vista Home Entertainment, 2004.

94 Author interview: Don Bluth, July 2018.

95 Ibid.

96 Animation Research Library Oral History Project: "An Interview with Animator, Story Artist, Supervising Animator Dave Michener—with guests Burny Mattinson, Ron Clements, and John Musker." Filmed 1/17/13.

97 Heidi Guedel. *ANM8RX—A Female Animator: How Laughter Saved My Life.* 1st ed. Nebraska: iUniverse Inc, 2003, p241.

98 Animation Research Library Oral History Project: "An Interview with Animator, Story Artist, Supervising Animator Dave Michener—with guests Burny Mattinson, Ron Clements, and John Musker." Filmed 1/17/13.

99 Ibid.

100 Animation Research Library Oral History Project: "An Interview with Effects Animator Ted Kierscey—with guest Dale Baer." Filmed on 5/31/12.

101 John G. West and Bob McLain. *Walt Disney and Live Action: The Disney Studio's Live-Action Features of the 1950s and 60s.* 1st ed. Theme Park Press, 2016, p5913.

102 Animation Research Library Oral History Project: "An Interview with Producer Don Hahn—with guest Roger Allers." Filmed on 9/22/11.

103 Ibid.

104 Wikipedia. "No Deposit, No Return." January 8, 2022.

105 Ibid.

106 The Walt Disney Archives: William Morris Agency memo re: Ray Bolger a Doc Terminus, 3/9/76.

107 The Walt Disney Archives: Memo re: Jack Elam as Merle Gogan and Russ Tamblyn.

108 Author interview: Sean Marshall, July 2018.

109 Author interview: Sean Marshall, July 2018.

110 Animation Research Library Oral History Project: "An Interview with Producer Don Hahn —with guest Roger Allers." Filmed on 9/22/11.

111 Ibid.

112 Author interview: Don Bluth, July 2018.

113 Ibid.

114 Author interview: Sean Marshall, July 2018.

115 Ibid.

116 *Brazzle Dazzle Effects: Behind Disney's Movie Magic.* "Pete's Dragon" High-Flying Edition DVD. Burbank, CA: Walt Disney Studios Home Entertainment, 2009.

117 Author interview: Sean Marshall, July 2018.

118 *Brazzle Dazzle Effects: Behind Disney's Movie Magic.* "Pete's Dragon" High-Flying Edition DVD. Burbank, CA: Walt Disney Studios Home Entertainment, 2009.

119 Author interview: Sean Marshall, July 2018.

120 Tammy Tuckey. "The Tiara Talk Show: Episode 121, Sean Marshall." YouTube video, 14:26. August 22, 2018, URL

121 Animation Research Library Oral History Project: "An Interview with Animator/Layout Artist/Writer/Producer Joe Hale—with guest Andreas Deja." Filmed on 1/27/11.

122 Author interview: Sean Marshall, July 2018.

123 Author interview: Don Bluth, July 2018.

124 Author interview: Sean Marshall, July 2018.

125 Ibid.

126 Wikipedia. "The Shaggy D.A." January 4, 2022.

127 Ibid.

128 Ibid.

129 J.W. Rinzler. *The Making of Star Wars.* 1st ed. New York: Del Rey Books, 2007, p84.

130 Ibid, p12.

131 Author Unknown. "Don Tait: Master Disney Storyteller." *Disney News*, Vol. 14, No. 4. September/October/ November 1979, p14.
132 Heidi Guedel. *ANM8RX—A Female Animator: How Laughter Saved My Life*. 1st ed. Nebraska: iUniverse Inc, 2003, p259.
133 Ibid, p326.
134 Ibid, p327.
135 Don Bluth Instagram post, 12/16/19.
136 Heidi Guedel. *ANM8RX—A Female Animator: How Laughter Saved My Life*. 1st ed. Nebraska: iUniverse Inc, 2003, p328.
137 Ibid., p333.
138 Animation Research Library Oral History Project: "An Interview with Producer Don Hahn—with guest Roger Allers." Filmed on 9/22/11.
139 Author interview: Don Bluth, July 2018.
140 Ibid.
141 Animation Research Library Oral History Project: "An Interview with Producer Don Hahn - with guest Roger Allers." Filmed on 9/22/11.
142 Author interview: Don Bluth, July 2018.
143 Ibid.
144 Author interview: Sean Marshall, July 2018.
145 Peter Ellenshaw, with Bruce Gordon and David Mumford. *Ellenshaw Under Glass or Going to the Matte for Disney*. 1st ed. Santa Clarita, CA: Camphor Tree Publishers, April 2003, p274.
146 Ibid, p277.
147 Author interview: Don Bluth, July 2018.
148 *Making the 'Return' Trip*. Directed by Mark Young. Burbank, CA: Buena Vista Home Entertainment and Sparkhill Productions, 2003.
149 Ibid.
150 Ibid.
151 Animation Research Library Oral History Project: "An Interview with Producer Don Hahn—with guest Roger Allers." Filmed on 9/22/11.
152 Heidi Guedel. *ANM8RX— A Female Animator: How Laughter Saved My Life*. 1st ed. Nebraska: iUniverse Inc, 2003, p337.
153 "The North Avenue Irregulars/The Last Wave/Agatha/Norma Rae/Get Out Your Handkerchiefs," *Sneak Previews*, Gene Siskel and Roger Ebert, season 2, episode 11, WTTW National Productions, 2/22/79.
154 Animation Research Library Oral History Project: "The Early Studio Caricature Shows— with John Musker, also Mike Gabriel, Allen Gonzales, Bill Matthews and Gale Musker." Filmed on 10/24/13.
155 Ibid.
156 Author interview: Chris Buck, February 2015.
157 Heidi Guedel. *ANM8RX —A Female Animator: How Laughter Saved My Life*. 1st ed. Nebraska: iUniverse Inc, 2003, p338.
158 Ibid, p339.
159 Author interview: Don Bluth, July 2018.
160 Ibid.
161 Animation Research Library Oral History Project: "An Interview with Producer Don Hahn— with guest Roger Allers." Filmed on 9/22/11.
162 Ron Clements and John Musker Interview: Tom Wilhite. 9/14/17.
163 Wikipedia. "The Watcher in the Woods." February 19, 2022.
164 Dave Smith. *The Quotable Walt Disney*. 1st ed. New York: Disney Editions, 2001, p211.
165 Ibid, p131.
166 Peter Ellenshaw, with Bruce Gordon and David Mumford. *Ellenshaw Under Glass or Going to the Matte for Disney*. 1st ed. Santa Clarita, CA: Camphor Tree Publishers, April 2003, p277.
167 Ron Clements and John Musker Interview: Tom Wilhite. 9/14/17.
168 Ibid.
169 Ken Horii. "'The Black Hole' to Premiere before Christmas." Disney News, Vol. 14, No. 4. September/October/ November 1979, p2.
170 "The Electric Horseman/Cuba/Going In Style/The Black Hole/All That Jazz," *Sneak Previews*, Gene Siskel and Roger Ebert, season 3, episode 15, WTTW National Productions, 12/27/79.
171 Peter Ellenshaw, with Bruce Gordon and David Mumford. *Ellenshaw Under Glass or Going to the Matte for Disney*. 1st ed. Santa Clarita, CA: Camphor Tree Publishers, April 2003, p287.
172 Ibid.
173 Ron Clements and John Musker Interview: Tom Wilhite, 9/14/17.
174 Ibid.
175 Ibid.

176 Ron Clements and John Musker Interview: Tom Wilhite, 9/14/17.
177 "Soldier of Orange/The Human Factor/Coal Miner's Daughter/The Europeans," *Sneak Previews*, Gene Siskel and Roger Ebert, season 3, episode unknown, WTTW National Productions, 3/13/80.
178 John Hough. Audio Commentary. *The Watcher in the Woods*, DVD. Directed by John Hough,1980. Troy, MI: Anchor Bay Entertainment, 2002.
179 Author interview: Andy Gaskill, September 2021.
180 John Hough. Audio Commentary. *The Watcher in the Woods*, DVD. Directed by John Hough, 1980. Troy, MI: Anchor Bay Entertainment, 2002.
181 Ibid.
182 Author interview: Andy Gaskill, September 2021.
183 Author interview: Ron Clements, September 2011.
184 Ron Clements and John Musker Interview: Tom Wilhite, 9/14/17.
185 Michael Ondaatje. *The Conversations: Walter Murch and the Art of Editing Film*. 1st ed. New York: Alfred A. Knopf, 2002, p285.
186 Ibid.
187 New York Times News Service, Disney's 'Return to Oz' continues Baum legend, Aljean Harmetz, *Dallas Morning News*, Sunday June 23, 1985, pp 1C, 4C, 5C.
188 Ron Clements and John Musker Interview: Tom Wilhite, 9/14/17.
189 Andreas Deja: Walt Disney Feature Animation. *The Black Cauldron* panel—Burny Mattinson, Ron Clements, John Musker, Mike Gabriel, Andreas Deja, Lisa Keene, Dale Baer, and Ted Kierscey, moderated by Stephen Anderson, 1/6/12.
190 Author interview: Ron Clements, July 2015.
191 Ron Clements and John Musker Interview: Tom Wilhite, 9/14/17.
192 Ibid.
193 Author Unknown. "In and Around Walt Disney Productions." *Disney News*, Vol. 15, No. 4. September/October/November 1980, p16.
194 Ibid, p17.
195 Tom Wilhite: *Disney on Film*, 1981.
196 Shelly Duvall: *Disney on Film*, 1981.
197 Tom Wilhite: *Disney on Film*, 1981.
198 Allan Arkush: *Disney on Film*, 1981.
199 Tom Wilhite: *Disney on Film*, 1981.
200 Phil Nibbelink: *Disney on Film*, 1981.
201 Tim Hunter: *Disney on Film*, 1981.
202 Allan Arkush: *Disney on Film*, 1981.
203 John Canemaker. "Revisiting 1981: 'Disney Animations and Animators' at the Whitney Museum." John Canemaker's Animated Eye, May 15, 2017.
204 Ibid.
205 Ron Clements and John Musker Interview: Tom Wilhite, 9/14/17.
206 Michael Ondaatje. *The Conversations: Walter Murch and the Art of Editing Film*. 1st ed. New York: Alfred A. Knopf, 2002, p286.
207 Ibid, pp290–292.
208 Ibid, pp292–293..
209 Author Unknown. "Let's Go to the Movies: 'Amy.'" *Disney News*, Vol. 16, No. 2. March/April/May 1981, p8.
210 Author interview: Burny Mattinson, 1/6/16
211 "Force: Five/Escape From New York/Gates of Heaven/On the Right Track/The Fox and the Hound," *Sneak Previews*, Gene Siskel and Roger Ebert, season 4, episode 37, WTTW National Productions, 7/16/81.
212 "Victory/Condorman/Loulou/Under the Rainbow," *Sneak Previews*, Gene Siskel and Roger Ebert, season 4, episode 40, WTTW National Productions, 8/6/81.
213 Ibid.
214 Ray Bradbury. Audio Commentary. *Something Wicked This Way Comes*, Laser disc. Directed by Jack Clayton, 1983. Burbank, CA: Buena Vista Home Video, 1996.
215 John Hough. Audio Commentary. *The Watcher in the Woods*, DVD. Directed by John Hough, 1980. Troy, MI: Anchor Bay Entertainment, 2002.
216 "Halloween II/Priest of Love/Chanel Solitaire/The Watcher in the Woods" *Sneak Previews*, Gene Siskel and Roger Ebert, season 5, episode 7, WTTW National Productions, 11/5//81.
217 Ibid.
218 Author Unknown. "Walt Disney Productions Highlights." *Disney News*, Vol. 17, No. 1. December/January/February 1981/82, p17.
219 "One From the Heart/Night Crossing/Montenegro/Shoot the Moon," *Sneak Previews*, Gene Siskel and Roger Ebert, season 5, episode 20, WTTW National Productions, 2/28/82.
220 Ibid.

221 "One From the Heart/Night Crossing/Montenegro/Shoot the Moon," *Sneak Previews*, Gene Siskel and Roger Ebert, season 5, episode 20, WTTW National Productions, 2/28/82.

222 "The Secret of NIMH/The Devil's Playground/Gregory's Girl/TRON," *Sneak Previews*, Gene Siskel and Roger Ebert, season 5, episode 37, WTTW National Productions, 7/8/82.

223 Ibid.

224 Ibid.

225 Leonard Maltin. "Film Clips: 'Tex' and 'Never Cry Wolf.'" *Disney News*, Vol. 18, No. 1. December 1982, January/February 1983, p17.

226 Ibid.

227 Ibid.

228 Ron Clements and John Musker Interview: Tom Wilhite, 9/14/17.

229 Stephen Burum. Audio Commentary. *Something Wicked This Way Comes*, Laser disc. Directed by Jack Clayton, 1983. Burbank, CA: Buena Vista Home Video, 1996.

230 Harrison Ellenshaw. Audio Commentary. *Something Wicked This Way Comes*, Laser disc. Directed by Jack Clayton, 1983. Burbank, CA: Buena Vista Home Video, 1996.

231 Ray Bradbury. Audio Commentary. *Something Wicked This Way Comes*, Laser disc. Directed by Jack Clayton, 1983. Burbank, CA: Buena Vista Home Video, 1996.

232 Stephen Burum. Audio Commentary. *Something Wicked This Way Comes*, Laser disc. Directed by Jack Clayton, 1983. Burbank, CA: Buena Vista Home Video, 1996.

233 Ray Bradbury. Audio Commentary. *Something Wicked This Way Comes*, Laser disc. Directed by Jack Clayton, 1983. Burbank, CA: Buena Vista Home Video, 1996.

234 Harrison Ellenshaw. Audio Commentary. *Something Wicked This Way Comes*, Laser disc. Directed by Jack Clayton, 1983. Burbank, CA: Buena Vista Home Video, 1996.

235 Aljean Harmetz. "Disney's 'Return to Oz' continues Baum legend." *New York Times News Service/The Dallas Morning News*. June 23, 1985,. pp1C, 4C, 5C.

236 Author Unknown. "Disney on Cable." *Disney News* Vol. 17, No. 4. September/October/November 1982, p28.

237 Ray Bradbury. Audio Commentary. *Something Wicked This Way Comes*, Laser disc. Directed by Jack Clayton, 1983. Burbank, CA: Buena Vista Home Video, 1996.

238 Jonathan Taplin. *The Magic Years: Scenes from a Rock and Roll Life*. 1st ed. Heyday, 2021, p236.

239 Ron Clements and John Musker Interview: Tom Wilhite, 9/14/17.

240 Author Unknown. "Let's Go to the Movies: 'Country.'" *Disney News*. Vol. 19, No. 4. September/October/November 1984, p24.

241 Philip Wuntch. "Jessica Lange: From 'King Kong' to 'Country,' this actress has arrived." *The Dallas Morning News*. October 7, 1984, pp1C, 8C.

242 Ron Clements and John Musker Interview: Tom Wilhite, 9/14/17.

243 Ibid.

244 Jonathan Taplin. *The Magic Years: Scenes from a Rock and Roll Life*. 1st ed. Heyday, 2021, p239.

245 Ron Clements and John Musker Interview: Tom Wilhite, 9/14/17.

246 Ibid.

247 Ibid.

248 Ibid.

249 Author Unknown. "Walt Disney Production Highlights." *Disney News*, Vol. 19, No. 3. June/July/August 1984, p23.

250 Ibid.

251 James B. Stewart. *Disney War*. 1st ed. New York: Simon and Schuster, 2005, p48.

252 Aljean Harmetz. "Disney's 'Return to Oz' continues Baum legend." *New York Times News Service/The Dallas Morning News*. June 23, 1985.

253 Ibid.

254 Ibid.

255 Author interview: Mike Gabriel, February 2015.

256 Author interview: Tony DeRosa, July 2017.

257 Chuck Davis. "Disney Taking the Right Steps with 'Company' Coming." *The Dallas Morning News*. Date unknown, pp1, 6.

258 Phil Nibbelink interview. *The Look Back Machine* podcast. "History of Steven Spielberg's Amblimation." Interviewed conducted by Jake Cannon, 8/19/21.

259 Author Unknown. "Walt Disney Production Highlights: Roy Disney Resumes Active Role." *Disney News*, Vol. 20, No. 2. March/April/May 1985, p24.

260 Michael Ondaatje. *The Conversations: Walter Murch and the Art of Editing Film*. 1st ed. New York: Alfred A. Knopf, 2002, p285.

261 Ibid, p290.

262 Ibid, p280.

263 Ellen Voelckers. "Let's Go to the Movies: 'The Black Cauldron.'" *Disney News*, Vol. 20, No. 3. June/July/August 1985, p27.

264 "The Heavenly Kid/The Man with One Red Shoe/Explorers/The Black Cauldron", *At the Movies*, Gene Siskel and Roger Ebert, season 3, episode 42, Tribune Entertainment, 7/20/85.

265 Author interview: Toby Shelton, November 2014.

266 Leonard Shannon. "Michael Eisner and Frank Wells: New Management Disney Style." *Disney News*, Vol. 20, No. 4. September/October/November 1985, p14.

267 Animation Research Library Oral History Project: "An Interview with Producer Don Hahn—with guest Roger Allers." Filmed on 9/22/11.

268 "Better Off Dead/The Journey of Natty Gann/Commando", *At the Movies*, Gene Siskel and Roger Ebert, season 4, episode 4, Tribune Entertainment, 10/5/85.

269 Ibid,

270 Leonard Shannon. "Mary Steenburgen: Bringing Magic Back to Christmas." *Disney News,* Vol. 21, No. 1. December 1985, January/February 1986, p9.

271 "Fever Pitch/One Magic Christmas/Santa Claus: The Movie/Starchaser: The Legend of Orin," *At the Movies*, Gene Siskel and Roger Ebert, season 4, episode 11, Tribune Entertainment, 11/23/85.

272 Ibid,

273 Ibid.

274 Author Unknown. "Projections." *Disney News*, Vol. 21, No. 1. December 1985, January/February 1986, p12.

275 Animation Research Library statement provided by Mary Walsh.

Bibliography

BOOKS

Dave Smith. *The Quotable Walt Disney*. 1st ed. New York: Disney Editions, 2001

Christopher Finch. *Winnie the Pooh: A Celebration of the Silly Old Bear*. 1st ed. New York: Disney Editions, 2011

Peter Ellenshaw, with Bruce Gordon and David Mumford. *Ellenshaw Under Glass or Going to the Matte for Disney*. 1st ed. Santa Clarita, California: Camphor Tree Publishers, April 2003

Didier Ghez. *They Drew As They Pleased: The Hidden Art of Disney's Early Renaissance (The 1970s and 1980s)*. 1st ed. San Francisco, California: Chronicle Books, 2019

J.W. Rinzler. *The Making of Star Wars*. 1st ed. New York: Del Rey Books, 2007

Mindy Johnson. *Ink and Paint: The Women of Walt Disney's Animation*. 1st ed. Glendale, California: Disney Editions, 2017

Burton on Burton, edited by Mark Salisbury. 1st ed. London: Faber and Faber Ltd, 1995

John Canemaker. *Walt Disney's Nine Old Men and the Art of Animation*. 1st ed. New York: Disney Editions, 2001

John G. West and Bob McLain. Walt Disney and Live-Action: The Disney Studio's Live-Action Features of the 1950s and 60s. 1st ed. Theme Park Press, 2016

Paul F. Anderson. *Jack of All Trades: Conversations with Disney Legend Ken Anderson*. 1st ed. Theme Park Press, 2017

Matthew Kennedy. *Roadshow: The Fall of Film Musicals in the 1960s*. 1st ed. New York: Oxford University Press, 2014

James Robert Parish. *Fiasco: A History of Hollywood's Iconic Flops*. 1st ed. Hoboken, New Jersey: John Wiley & Sons, Inc, 2006

Walt's People - Volume 9, edited by Didier Ghez. 1st ed. Xlibris Corporation, 2010

Jennifer Keishin Armstrong. *Mary and Lou and Rhoda and Ted: And all the Brilliant Minds Who Made 'The Mary Tyler Moore' Show a Classic*. 1st ed. New York: Simon and Schuster, 2013

Michael Ondaatje. *The Conversations: Walter Murch and the Art of Editing Film*. 1st ed. New York: Alfred A. Knopf, 2002

James B. Stewart. *Disney War*. 1st ed. New York: Simon and Schuster, 2005

Peter Biskind. *Easy Riders, Raging Bulls*. 1st ed. New York: Simon and Schuster, 1998

Bob Thomas. *Building a Company: Roy O. Disney and the Creation of an Entertainment Empire*. 1st ed. New York: Hyperion, 1998

Heidi Geudel. *ANM8RX - A Female Animator: How Laughter Saved My Life*. 1st ed. Nebraska: iUniverse Inc, 2003

Charles Tranberg. *Walt Disney and Recollections of the Disney Studios: 1955-1980*. 1st ed. Albany, Georgia: BearManor Media, 2012

Leonard Maltin. *The Disney Films*. 1st revised ed. New York: Crown Publishers, 1984

Neal Gabler. *Walt Disney: The Triumph of the American Imagination*. 1st ed. New York: Vintage Books, 2007

James Garner and Jon Winokur. *The Garner Files: A Memoir*. 1st ed. Simon and Schuster, 2012

Steve Hulett. *Mouse in Transition*. 1st ed. Theme Park Press, 2014

Jonathan Taplin. *The Magic Years: Scenes from a Rock and Roll Life*. 1st ed. Heyday, 2021

Ron Howard and Clint Howard. *The Boys*. 1st ed. New York, New York: Harper Collins, 2021

Robert B. Sherman and Richard M. Sherman. *Walt's Time*. 1st ed. Santa Clarita, California: Camphor Tree Publishers, December 1998

DVDs/DOCUMENTARIES

John Hough. Audio Commentary. *The Watcher in the Woods,* DVD. Directed by John Hough. 1980. Troy, MI: Anchor Bay Entertainment, 2002

John Hough. Audio Commentary. *Escape to Witch Mountain,* special ed. DVD. Directed by John Hough. 1975. Burbank, CA: Buena Vista Home Entertainment, 2003

Conversations with John Hough. "Escape From Witch Mountain," special ed. DVD. Directed by John Hough. 1975. Burbank, CA: Buena Vista Home Entertainment, 2003

Making the 'Escape.' Directed by Mark Young. Burbank, CA: Buena Vista Home Entertainment and Sparkhill Productions, 2003

Ike Eisenmann, John Hough and Kim Richards. Audio Commentary. *Return from Witch Mountain*, special ed. DVD. Directed by John Hough. 1978. Burbank, CA: Buena Vista Home Entertainment, 2003.

Making the 'Return' Trip. Directed by Mark Young. Burbank, CA: Buena Vista Home Entertainment and Sparkhill Productions, 2003

A Look Back with Jodie Foster. "Freaky Friday," DVD. Directed by Gary Nelson. 1977. Burbank, CA: Buena Vista Home Entertainment, 2004

That Loveable Bug. Directed by Mark Young. Burbank, CA: Buena Vista Home Entertainment and Sparkhill Productions, 2003

Ray Bradbury, Stephen Burum and Harrison Ellenshaw. Audio Commentary. *Something Wicked This Way Comes*, Laserdisc. Directed by Jack Clayton. 1983. Burbank, CA: Buena Vista Home Video, 1996

Making a 'Splash.' Directed by Barbara Toennies. Burbank, CA: Buena Vista Home Entertainment and EMC West, 2002

Ron Howard, Brian Grazer, Lowell Ganz and Babaloo Mandel. Audio Commentary. *Splash*, anniversary ed. DVD. Directed by Ron Howard. 1984. Burbank, CA: Buena Vista Home Entertainment, 2004

Through The Black Hole. "The Black Hole" DVD. Burbank, CA: Buena Vista Home Entertainment, 2004

The Age of Believing: The Disney Live-Action Classics. Directed by Peter Fitzgerald. Los Angeles, CA: Turner Classic Movies, 2008

Disney Animation: The Illusion of Life. Directed by William Reid. Burbank, CA: Walt Disney Productions, 1981

Backstage at Disney. Directed by Tom Leetch. Burbank, CA: Walt Disney Productions, 1983

The Family Band Album. "The One and Only Genuine Original Family Band" DVD. Burbank, CA: Buena Vista Home Entertainment, 2004

1974 Behind-the-Scenes Featurette. "Island at the Top the World," anniversary ed. DVD. Burbank, CA: Buena Vista Home Entertainment, 2004

A Look Back With the Gang. "The Apple Dumpling Gang" DVD. Directed by Mark Young. Burbank, CA: Buena Vista Home Entertainment and Sparkhill Productions, 2003

Brazzle Dazzle Effects: Behind Disney's Movie Magic. "Pete's Dragon" High-Flying Edition DVD. Burbank, CA: Walt Disney Studios Home Entertainment, 2009

Born to Be Wild: The Story of Easy Rider. Produced by Nick Freand Jones. UK: BBC Studios, 1995

America Lost and Found: The BBS Story. Directed by Greg Carson. New York, NY: The Criterion Collection, 2010

VIDEOS

Lavalle Lee. "Exclusive Don Bluth and Gary Goldman Interview." *Traditional Animation.* October 25, 2015. https://www.traditionalanimation.com/2015/don-bluth-gary-goldman-interview/

Tammy Tuckey. "The Tiara Talk Show: Episode 121, Sean Marshall." YouTube video, 14:26. August 22, 2018. URL

"5 Fascinating Facts About the Walt Disney Archives." D23: The Official Disney Fan Club.

Angela Lansbury. "The Interviews." *Television Academy Foundation.* September 15, 1998.

Disney Files on Demand: Exclusive Content from Disney Vacation Club. "Disney Studio Tour - Suite 3H, Walt's Office." Becky Cline: Walt Disney Archives Director and Ryan March: *Disney Files* Magazine Editor. 2020

ARTICLES

Jeff Bond. Liner Notes. "'The Black Hole:' Original Motion Picture Soundtrack Special Edition." Intrada. 2011.

Scott Michael Bosco. Liner Notes. "The Watcher in the Woods" DVD. Anchor Bay. 2002.

Disney News

Author Unknown. "Studio Preparing Screenplay Based on North's 'Rascal.'" *Disney News* Vol. 1, No. 4. September/October/November 1966. P8

Author Unknown. "In and Around Walt Disney Productions: Wonderful World of Disney." *Disney News* Vol. 6, No. 3. June/July/August 1971. P15

Author Unknown. "Bedknobs and Broomsticks." Disney News Vol. 7, No. 1. December 1971, January/February 1972. PP6-7

Author Unknown. "In and Around Walt Disney Productions: Movies." Disney News Vol. 7, No. 1. December 1971, January/February 1972. PP14-15

Author Unknown. "The Biscuit Eater." *Disney News* Vol. 7, No. 2. March/April/May 1972. P12

Author Unknown. "In and Around Walt Disney Productions." *Disney News* Vol. 7, No. 2. March/April/May 1972. P14-15

Author Unknown. "In and Around Walt Disney Productions." Disney News Vol. 7, No. 3. June/July/August 1972. PP18-19

Author Unknown. "In and Around Walt Disney Productions." *Disney News* Vol. 7, No. 4. September/October/November 1972. PP18-19

Ron Miller. "Disney Film and TV Production at an All-Time High." *Disney News* Vol. 8, No. 1. December 1972, January/February 1973. P11-13

Author unknown. "In and Around Walt Disney Productions." *Disney News* Vol. 8, No. 3. June/July/August 1973. P18-19

Author Unknown. "In and Around Walt Disney Productions." Disney News Vol. 8, No. 4. September/October/November 1973. PP20-21

Author Unknown. "In and Around Walt Disney Productions." *Disney News* Vol. 9, No. 1. December 1973, January/February 1974. PP20-21

Author unknown. "The Filming of 'Two Against the Arctic.'" *Disney News* Vol. 9, No. 2. March/April/May 1974. P14-16

Author Unknown. "In and Around Walt Disney Productions." *Disney News* Vol. 9, No. 3. June/July/August 1974. PP16-17

Author Unknown. "In and Around Walt Disney Productions." *Disney News* Vol. 9, No. 4. September/October/November 1974. PP16-17

Author Unknown. "The Nine Stages of an Emporium Playhouse." *Disney News* Vol. 10, No. 1. December 1974, January/February 1975. PP10-13

Author Unknown. "In and Around Walt Disney Productions." *Disney News* Vol. 10, No. 1. December 1974, January/February 1975. PP16-17

Author Unknown. "In and Around Walt Disney Productions." *Disney News* Vol. 10, No. 2. March/April/May 1975. PP16-17

Author Unknown. "In and Around Walt Disney Productions." *Disney News* Vol. 10, No. 3. June/July/August 1975. PP16-17

Author Unknown. "In and Around Walt Disney Productions." *Disney News* Vol. 10, No. 4. September/October/November 1975. PP16-17

Author Unknown. "In and Around Walt Disney Productions." *Disney News* Vol. 11, No. 1. December 1975, January/February 1976. PP16-17

Author Unknown. "The Ranch That Went Hollywood!" *Disney News* Vol. 11, No. 4. September/October/November 1976. PP9-11

Author Unknown. "In and Around Walt Disney Productions." *Disney News* Vol. 11, No. 4. September/October/November 1976. PP16-17

Author Unknown. "In and Around Walt Disney Productions." *Disney News* Vol. 12, No. 4. September/October/November 1977. PP16-17

Author Unknown. "In and Around Walt Disney Productions." *Disney News* Vol. 13, No. 1. December 1977, January/February 1978. PP16-17

Author Unknown. "In and Around Walt Disney Productions." *Disney News* Vol. 13, No. 2. March/April/May 1978. PP16-17

Author Unknown. "In and Around Walt Disney Productions." *Disney News* Vol. 13, No. 3. June/July/August 1978. PP16-17

Author Unknown. "In and Around Walt Disney Productions." *Disney News* Vol. 13, No. 4. September/October/November 1978. PP16-17

Laurel Whitcomb. "The Disney Archives." *Disney News* Vol.14, No. 1. December 1978, January/February 1979. PP5-6

Ken Horii. "'The Black Hole' to Premiere before Christmas." Disney News Vol. 14, No. 4. September/October/November 1979. P2

Author Unknown. "Don Tait: Master Disney Storyteller." *Disney News* Vol. 14, No. 4. September/October/November 1979. P14

Author Unknown. "In and Around Walt Disney Productions." *Disney News* Vol. 14, No. 4. September/October/November 1979. P16-17

Author Unknown. "In and Around Walt Disney Productions." *Disney News* Vol. 15, No. 1. December 1979, January/February 1980. PP16-17

Author Unknown. "The Watcher in the Woods." *Disney News* Vol. 15, No. 2. March/April/May 1980. P12

Author Unknown. "In and Around Walt Disney Productions." *Disney News* Vol. 15, No. 2. March/April/May 1980. PP16-17

Author Unknown. "In and Around Walt Disney Productions." *Disney News* Vol. 15, No. 4. September/October/November

1980. PP16-17

Author Unknown. "In and Around Walt Disney Productions." *Disney News* Vol. 16, No. 1. December 1980, January/February 1981. PP16-17

Author Unknown. "Let's Go to the Movies: 'Amy.'" *Disney News* Vol. 16, No. 2. March/April/May 1981. P8

Author Unknown. "Walt Disney Productions Highlights." *Disney News* Vol. 17, No. 1. December/January/February 1981/82. P17

Author Unknown. "Walt Disney Productions Highlights." *Disney News* Vol. 17, No. 3. June/July/August 1982. PP16-17

Author Unknown. "Disney on Cable." *Disney News* Vol. 17, No. 4. September/October/November 1982. P28

Leonard Maltin. "Film Clips: 'Tex' and 'Never Cry Wolf.'" *Disney News* Vol. 18, No. 1. December 1982, January/February 1983. PP16-18

Author Unknown. "Walt Disney Production Highlights." *Disney News* Vol. 18, No. 3. June/July/August 1983. P2

Author Unknown. "Walt Disney Production Highlights." *Disney News* Vol. 19, No. 4. September/October/November 1983. P22

Lige Rushing. "The Art of Animation: Collecting Thoughts." *Disney News* Vol. 20, No. 1. December 1983, January/February 1984. PP6-7

Author Unknown. "The Disney Channel to Premiere Second Feature Film in the Spring." *Disney News* Vol. 19, No. 2. March/April/May 1984. P20

Author Unknown. "Walt Disney Production Highlights." *Disney News* Vol. 19, No. 2. March/April/May 1984. PP24-25

Author Unknown. "Walt Disney Production Highlights." *Disney News* Vol. 19, No. 3. June/July/August 1984. PP23-24

Margery R. Lee. "Goofy About Sports." *Disney News* Vol. 19, No. 3. June/July/August 1984. P10

Jim Fanning. "APT: Animation's New Future." *Disney News* Vol. 19, No. 4. September/October/November 1984. PP4-5

Author Unknown. "Walt Disney Production Highlights." *Disney News* Vol. 19, No. 4. September/October/November 1984. P20

Author Unknown. "Let's Go to the Movies: 'Country.'" *Disney News* Vol. 19, No. 4. September/October/November 1984. P24

Mike West. "FH5+2: Formula for Good Time Jazz." *Disney News* Vol. 20, No. 1. December 1984, January/February 1985. PP10-11

Jim Fanning. "Let's Go to the Movies: 'Baby.'" *Disney News* Vol. 20, No. 1. December 1984, January/February 1985. P22

Author Unknown. "Walt Disney Production Highlights: Roy Disney Resumes Active Role." *Disney News* Vol. 20, No. 2. March/April/May 1985. P24

Author Unknown. "Walt Disney Production Highlights: Roy Disney Resumes Active Role." *Disney News* Vol. 20, No. 2. March/April/May 1985. P24

Ellen Voelckers. "Let's Go to the Movies: 'The Black Cauldron.'" *Disney News* Vol. 20, No. 3. June/July/August 1985. PP26-27

Author Unknown. "Walt Disney Production Highlights." *Disney News* Vol. 20, No. 3. June/July/August 1985. PP32-33

Author Unknown. "Projections." *Disney News* Vol. 20, No. 4. September/October/November 1985. PP12-13

Leonard Shannon. "Michael Eisner and Frank Wells: New Management Disney Style." *Disney News* Vol. 20, No. 4. September/October/November 1985. PP14-15

Leonard Shannon. "Mary Steenburgen: Bringing Magic Back to Christmas." *Disney News* Vol. 21, No. 1. December 1985, January/February 1986. PP6-10

Author Unknown. "Projections." *Disney News* Vol. 21, No. 1. December 1985, January/February 1986. PP12-13

Author Unknown. "Projections." *Disney News* Vol. 21, No. 2. March/April/May 1986. P36

Author Unknown. "Projections." *Disney News* Vol. 21, No. 3. June/July/August 1986. P35

Author Unknown. "Theme Parks." *Disney News*. Vol 21, No. 4. September, October, November 1986. P4

Aljean Harmetz. "Disney's 'Return to Oz' continues Baum legend." *New York Times News Service/The Dallas Morning News*. June 23, 1985

Philip Wuntch. "Jessica Lange: From 'King Kong' to 'Country,' this actress has arrived." The Dallas Morning News. October 7, 1984. Pp 1C, 8C

Chuck Davis. "Disney Taking the Right Steps with 'Company' Coming." *The Dallas Morning News*. Date unknown. Pp 1, 6

INTERNET

Unknown author. "Lost and Found: *The Watcher in the Woods*." BFI Film Forever. Unknown date. http://old.bfi.org.uk/sightandsound/feature/49702

The Watcher in the Woods - IMDB

John Culhane. "The Old Disney Magic." The New York Times. August 1, 1976.

John Canemaker. "Revisiting 1981: 'Disney Animations and Animators' at the Whitney Museum." John Canemaker's Animated Eye. May 15, 2017.

Jodi Whisenhunt. "Tiggerific Tuesday Disney Trivia: Sport Goofy." Magical Mouse School House. June 9, 2014.

Jim Hill. "The Disney Halloween Special You Never got to see: Tim Burton's 'Trick or Treat.'" Jim Hill Media. October 25, 2010.

Brian Krosnick. "Disney Canned the Best Theme Park Concept it Ever Had. Here's Why." Theme Park Tourist. July 30, 2015

Splash - IMDB

Country - IMDB

Natty Gann - IMDB

Ward Kimball - IMDB

A Salute to Alaska - IMDB

Cyde Geronimi - IMDB

Wilfred Jackson - IMDB

Hamilton Luske - IMDB

Norman Tokar - IMDB

James Algar - IMDB

Harry Tytle - IMDB

Bill Walsh - IMDB

Winston Hibler - IMDB

Ron Miller - IMDB

Michael O'Herlihy - IMDB

Maurice Tombragel - IMDB

Gary Nelson - IMDB

Joseph McEveety - IMDB

Vincent McEveety - IMDB

Bernard McEveety - IMDB

Frank Phillips - IMDB

Robert Schiffer - IMDB

Tom Leetch - IMDB

Cotton Warburton - IMDB

John B. Mansbridge - IMDB

Hal Gausman - IMDB

Emile Kuri - IMDB

Ted Berman - IMDB

Art Stevens - IMDB

Robert Butler - IMDB

Bedknobs and Broomsticks - IMDB

Robin Hood - IMDB

Jules Engel - IMDB

Roy E. Disney - IMDB

Fred MacMurray - IMDB

Cloris Leachman - IMDB

Frank Paris - IMDB

Rosemary Anne Sisson - IMDB

Jerome Courtland - IMDB

Don Chaffey - IMDB

Charles Jarrott - IMDB

John Hough - IMDB

Don A. Duckwall - IMDB

Joe Raposo - IMDB

Al Kasha - IMDB

Joel Hirschhorn - IMDB

Barbara Harris - IMDB

Jodie Foster - IMDB

Jim Dale - IMDB

Jim Luske - IMDB

Joe Hale - IMDB

Jan Williams - IMDB

Kevin Corcoran - IMDB

Jeb Rosebrook - IMDB

Don Tait - IMDB

Peter Ellenshaw - IMDB

Harrison Ellenshaw - IMDB

Mel Shaw - IMDB

Eric Cleworth - IMDB

Julius Svendsen - IMDB

Hal King - IMDB

Cliff Nordberg - IMDB

Donovan's Kid - IMDB

Shadow of Fear - IMDB

Gerry Day - IMDB

Animalympics - IMDB

John Norton - IMDB

Michael Nankin - IMDB

David Wechter - IMDB

Leon Harris - IMDB

Never Cry Wolf - IMDB

Walter Much - IMDB

Popeye - IMDB

Dragonslayer - IMDB

Take Down - IMDB

Running Brave - IMDB

Gill Dennis - IMDB

William Robert Yates - IMDB

James MacDonald - IMDB

Kurt Russell - IMDB

Jason Robards - IMDB

Trenchcoat - IMDB

Delbert Mann - IMDB

Irwin Kostal - IMDB

The Secret of NIMH - IMDB

Tex - IMDB

Darrell Rooney - IMDB

Lee Dyer - IMDB

Winnie the Pooh and the Day for Eeyore - IMDB

Something Wicked This Way Comes - IMDB

Roger Spottiswoode - IMDB

Bill Norton - IMDB

Jonathan Taplin - IMDB

Roland Tantin - IMDB

Isidoro Raponi - IMDB

Baby: Secret of the Lost Legend - IMDB

John Alcott - IMDB

William D. Wittliff - IMDB

Tiger Town - IMDB

Mickey's Christmas Carol - IMDB

Sundae in New York - IMDB

Mike Jittlov - IMDB

Alan Arkush - IMDB

Gone Are the Dayes - IMDB

Love Leads the Way - IMDB

The Disney Family Album - IMDB

Weird Science - IMDB

Real Genius - IMDB

Back to the Future - IMDB

The Wuzzles - IMDB

The Adventures of the Gummi Bears - IMDB

Tad Stones - IMDB

Toby Shelton - IMDB

Michael Webster - IMDB

Down and Out in Beverly Hills - IMDB

The Journey of Natty Gann - IMDB

One Magic Christmas - IMDB

Bette Midler - IMDB

Richard Dreyfuss - IMDB

Off Beat - IMDB

Ruthless People - IMDB

Return to Treasure Island - IMDB

The Great Mouse Detective - IMDB

Flight of the Navigator - IMDB

Tough Guys - IMDB

The Color of Money - IMDB

An American Tail - IMDB

Good Morning, Vietnam - IMDB

Who Framed Roger Rabbit - IMDB

Oliver and Company - IMDB

Don Hahn - IMDB

Dorothy McKim - IMDB

Glen Keane - IMDB

Andreas Deja - IMDB

Mark Henn - IMDB

Ruben Aquino - IMDB

Kathy Zielinksi - IMDB

Tony DeRosa - IMDB

Dan Hansen - IMDB

Dave Bossert - IMDB

Mike Gabriel - IMDB

Mark Dindal - IMDB

Chris Buck - IMDB

Mike Giaimo - IMDB

Darrell Van Citters - IMDB

Marc Stirdivant - IMDB

Gary Trousdale - IMDB

Kirk Wise - IMDB

Kevin Lima - IMDB

Don Bluth - IMDB

Gary Goldman - IMDB

John Pomeroy - IMDB

Richard Rich - IMDB

Lorna Cook - IMDB

Tim Burton - IMDB

The Brave Little Toaster - IMDB

Tom Wilhite - IMDB

Burny Mattinson - IMDB

Ron Howard - IMDB

Clint Howard - IMDB

The Wild Country - IMDB

www.mccallstudios.com

Floyd Norman. "Toon Tuesday: Remembering Fred Lucky of WDFA's Story Department." Jim Hill Media. June 11, 2007.

Unknown author. "A Passion For Drawing." Donald W. Graham. 2005.

Wikipedia. "20,000 Leagues Under the Sea (1954 film)." May 15, 2021.

Wikipedia. "Chouinard Art Institute." December 13, 2020.

Wikipedia. "Pete's Dragon (1977 film)." July 4, 2021.

Wikipedia. "The Aristocats." June 30, 2021.

Wikipedia. "Rural Purge." June 20, 2021.

Wikipedia. "James Nelson (sound editor)." June 22, 2021.

Wikipedia. "Treasure Island (1950 film). June 16, 2021.

Wikipedia. "Richard Rainwater." January 11, 2021.

Wikipedia. "Robert Bass." May 30, 2021.

Wikipedia. "Sid Bass." December 14, 2020.

Wikipedia. "The Walt Disney Company." July 5, 2021.

Wikipedia. "Walt Disney Pictures." March 5, 2022.

Wikipedia. "List of Walt Disney Pictures Films." March 4, 2022.

Wikipedia. "List of Touchstone Pictures Films." February 19, 2022.

Wikipedia. "Walt Disney Anthology Television Series." July 2, 2021.

Wikipedia. "Hong Kong Disneyland." July 4, 2021.

Wikipedia. "1978 Orange Bowl." January 4, 2021.

Wikipedia. "Dave Smith (Archivist)." January 25, 2021.

Wikipedia. "Bedknobs and Broomsticks." June 23, 2021.

Wikipedia. "No Deposit, No Return." January 8, 2022.

Wikipedia. "The Devil and Max Devlin." December 27, 2021.

Wikipedia. "Tron." January 19, 2022.

Wikipedia. "The Shaggy D.A." January 4, 2022.

Wikipedia. "The Watcher in the Woods." February 19, 2022.

Wikipedia. "Computer Animated Production System." February 18, 2022.

Wikipedia. "1971 in Film." March 2, 2022.

Wikipedia. "1981 in Film." February 28, 2022.

Wikipedia. "1982 in Film." March 5, 2022.

Wikipedia. "1985 in Film." March 5, 2022.

Wikipedia. "1987 in Film." February 25, 2022.

Wikipedia. "American Zoetrope." March 3, 2022.

Wikipedia. "L. Frank Baum." February 21, 2022.

http://jimhillmedia.com/guest_writers1/b/leo_n_holzer/archive/2010/12/15/former-disney-ceo-ron-miller-recalls-his-own-quot-tron-quot-legacy.aspx

http://floydnormancom.squarespace.com/blog/2014/3/19/the-amazing-pete-young

PANELS/ORAL HISTORY

Animation Research Library Oral History Project: "An Interview with Animator/Layout Artist/Writer/Producer Joe Hale - with guest Andreas Deja." Filmed on 1/27/11

Animation Research Library Oral History Project: "An Interview with Effects Animator Ted Kierscey - with guest Dale Baer." Filmed on 5/31/12

Animation Research Library Oral History Project: "An Interview with Producer Don Hahn - with guest Roger Allers." Filmed on 9/22/11

Animation Research Library Oral History Project: "An Interview with Animator, Story Artist, Supervising Animator Dave Michener - with guests Burny Mattinson, Ron Clements, and John Musker." Filmed 1/17/13

Animation Research Library Oral History Project: "The Early Studio Caricature Shows - with John Musker, also Mike Gabriel, Allen Gonzales, Bill Matthews and Gale Musker." Filmed on 10/24/13

Walt Disney Feature Animation: *The Black Cauldron* panel - Burny Mattinson, Ron Clements, John Musker, Mike Gabriel, Andreas Deja, Lisa Keene, Dale Baer and Ted Kierscey, moderated by Stephen Anderson. 1/6/12

The El Capitan Theater: *The Black Cauldron* panel - Dave Bossert, Richard Kraft, Jim Coleman, Andreas Deja, Joe Hale, moderated by Don Hahn. 10/15/15

The El Capitan Theater: *Tron* panel - Bruce Boxleitner, Steven Lisberger, moderated by Bill Kroyer.

Walt Disney Feature Animation: Bill Kroyer, guest speaker. 10/5/18

Mary Walsh and Fox Carney - Animation Research Library

PODCASTS

The Look Back Machine podcast, "History of Steven Spielberg's Amblimation," Jake Cannon, Phil Nibblelink interview, 8/19/21

INTERVIEWS

Ron Clements and John Musker Interview of Tom Wilhite - September 2017

By the Author

Al Kasha - August 2016

Andy Gaskill - September 2021

Annie McEveety - July 2017

Mike Bonifer - September 2018

Howard Green - March 2015, September 2018

Burny Mattinson - July 2010, July 2011, August 2011, November 2012, July 2013, November 2014, December 2015, January 2016,

Charles Martin Smith - December 2016

Chris Buck - February 2015

Dale Baer - September 2010, August 2011, November 2014

Dan Hansen - December 2014

Darrell Van Citters - May 2016

Dave Block - December 2014

Dave Bossert - January 2015

Don Bluth - July 2018

Dorothy McKim - October 2021

Gary Nelson - September 2016

Glen Keane - February 2016

Jeb Rosebrook - August 2017

Jerry Rees - March 2016

Joe Hale - October 2015

John Musker - September 2011, June 2015

John Norton - October 2021

John Scheele - February 2023

Jonathan Taplin - August 2019

Lorna Cook - May 2017

Marc Stirdivant - August 2016

Mark Dindal - January 2015

Mark Henn - September 2014, November 2014

Mike Gabriel - February 2015

Mike Giaimo - April 2015

Ron Clements - September 2011, July 2015, June 2019

Sean Marshall - July 2018

Toby Shelton - November 2014

Tony DeRosa - July 2017

THE WALT DISNEY ARCHIVES DOCUMENTS

Pete's Dragon and the U.S.A. (*'Forever After'*) treatment by Seton I. Miller, story by S.S Field and Seton I. Miller

Pete's Dragon and the U.S.A screenplay by Seton I Miller, 12/10/57

Pete's Dragon and the U.S.A. Screenplay by Noel Langley, 4/23/58

Pete's Dragon story outline, Version 1 Myles Wilder and William Raynor', no date

Pete's Dragon story outline by William Raynor and Myles Wilder, 10/25/68

Pete's Dragon first draft treatment by Malcom Marmorstein, 7/9/75

Jerome Courtland memo re: Joe Raposo, 9/15/75

Pete's Dragon first draft by Malcom Marmorstein, 9/22/75

Pete's Dragon revised screenplay by Malcom Marmorstein, 10/24/75

William Morris Agency memo re: Ray Bolger a Doc Terminus, 3/9/76

Memo re: Jack Elam as Merle Gogan and Russ Tamblyn

Pete's Dragon revised draft by Malcom Marmorstein, 3/29/76 (with revisions from 4/30/76 - 10/13/76)

SISKEL AND EBERT

Sneak Previews

"The North Avenue Irregulars/The Last Wave/Agatha/Norma Rae/Get Out Your Handkerchiefs," *Sneak Previews*, Gene Siskel and Roger Ebert, season 2, episode 11, WTTW National Productions, 2/22/79

"The Electric Horseman/Cuba/Going In Style/The Black Hole/All That Jazz," *Sneak Previews*, Gene Siskel and Roger Ebert, season 3, episode 15, WTTW National Productions, 12/27/79

"Soldier of Orange/The Human Factor/Coal Miner's Daughter/The Europeans," *Sneak Previews*, Gene Siskel and Roger Ebert, season 3, episode unknown, WTTW National Productions, 3/13/80

"Force: Five/Escape From New York/Gates of Heaven/On the Right Track/The Fox and the Hound," *Sneak Previews*, Gene Siskel and Roger Ebert, season 4, episode 37, WTTW National Productions, 7/16/81

"Victory/Condorman/Loulou/Under the Rainbow," *Sneak Previews*, Gene Siskel and Roger Ebert, season 4, episode 40, WTTW National Productions, 8/6/81

"Halloween II/Priest of Love/Chanel Solitaire/The Watcher in the Woods," *Sneak Previews*, Gene Siskel and Roger Ebert, season 5, episode 7, WTTW National Productions, 11/5//81

"One From the Heart/Night Crossing/Montenegro/Shoot the Moon," *Sneak Previews*, Gene Siskel and Roger Ebert, season 5, episode 20, WTTW National Productions, 2/28/82

"The Secret of NIMH/The Devil's Playground/Gregory's Girl/TRON," *Sneak Previews*, Gene Siskel and Roger Ebert, season 5, episode 37, WTTW National Productions, 7/8/82

At the Movies

"The Heavenly Kid/The Man with One Red Shoe/Explorers/The Black Cauldron", *At the Movies*, Gene Siskel and Roger Ebert, season 3, episode 42, Tribune Entertainment, 7/20/85

"Better Off Dead/The Journey of Natty Gann/Commando", *At the Movies*, Gene Siskel and Roger Ebert, season 4, episode 4, Tribune Entertainment, 10/5/85

"Fever Pitch/One Magic Christmas/Santa Claus: The Movie/Starchaser: The Legend of Orin", *At the Movies*, Gene Siskel and Roger Ebert, season 4, episode 11, Tribune Entertainment, 11/23/85

Photo Credits

Pg. 12— Movie producer and cultural icon Walt Disney, 1965. HO Images / Alamy Stock Photo

Pg. 14— Caricatures of Walt's Nine Old Men (plus artist Ken Anderson) drawn by Mel Shaw. From the collection of Jerry Rees.

Pg. 17— Burny Mattinson's high school ID card. Courtesy of Ellen Siirola

Pg. 20— Walt Disney strenuously acts out his characters' roles in story conference. RBM Vintage Images / Alamy Stock Photo

Pg. 25— Animation Building floorplan, From the author's collection.

Pg. 30— American animator and producer Walt Disney hosting his television show Walt Disney's Wonderful World of Color; Photo12/7e Art/NBC / Alamy Stock Photo

Pg. 33— The American film producer Walt Disney (1901-1966) behind his movie camera; Sueddeutsche Zeitung Photo / Alamy Stock Photo

Pg. 34— Walt Disney and Roy O. Disney, co-founder of The Walt Disney Company and the older brother of Walt Disney, circa 1962; PictureLux / The Hollywood Archive / Alamy Stock Photo

Pg. 37— Director Wolfgang Reitherman (left) and Directing Animator John Lounsbury (right) candid posing with Animation models during production of The Jungle Book 1967; Masheter Movie Archive / Alamy Stock Photo

Pg. 39— Yvette Mimieux & Dean Jones Film: Monkeys, Go Home! (1967) Characters: Maria Riserau, Hank Dussard Director: Andrew V Mclaglen 02 February 1967; Cinematic / Alamy Stock Photo

Pg. 44— (top) Studio letterhead from 1967. From the author's collection

Pg. 44— (bottom left) Walt Disney with Songwriters Robert B. Sherman (left) and Richard M. Sherman circa 1964 publicity for Walt Disney Records (photo courtesy of Richard and Robert Sherman) Masheter Movie Archive / Alamy Stock Photo

Pg. 44— (bottom right) Lesley Ann Warren & John Davidson Film: The Happiest Millionaire (1967) Characters: Cordy & Angie Duke Director: Norman Tokar 23 June 1967; Cinematic Collection/ Alamy Stock Photo

Pg. 46— The One and Only Genuine Original Family Band. Directed by Michael O'Herlihy. Year: 1968; Album / Alamy Stock Photo

Pg. 50— (top) Studio letterhead from 1968. From the author's collection

Pg. 50— (bottom) Henry Silva, Edward G. Robinson & Dick Van Dyke Film: Never A Dull Moment (1968) Characters: Frank Boley, Leo Joseph Smooth & Jack Albany Director: Jerry Paris 26 June 1968; Cinematic Collection/ Alamy Stock Photo

Pg. 56— Poster courtesy of Heritage Auctions, HA.com

Pg. 58— Easy Rider (1969) Dennis Hopper, Peter Fonda & Jack Nicholson; FlixPix / Alamy Stock Photo

Pg. 58— Dennis Hopper, Jack Nicholson, Peter Fonda, Easy Rider (1969); Allstar Picture Library Ltd / Alamy Stock Photo

Pg. 61— Herbie, The Love Bug, 1968; Allstar Picture Library Limited. / Alamy Stock Photo

Pg. 61— Dean Jones, Michele Lee, "The Love Bug" 1968 Walt Disney Productions; PictureLux / The Hollywood Archive / Alamy Stock Photo

Pg. 64— Images courtesy of Heritage Auctions, HA.com

Pg. 69— Scene with Kurt Russell Film: The Computer Wore Tennis Shoes (1969); United Archives GmbH / Alamy Stock Photo

Pg. 70— Bedknobs and Broomsticks concept painting, Courtesy of Heritage Auctions, HA.com

Pg. 72— Photograph Courtesy of Steven Gordon

Pg. 75— The Andy Griffith Show, CBS/ Danny Thomas Enterprises/ RGR Collection/ Mary Evans/ Alamy Stock Photo

Pg. 75— Eddie Albert, Eva Gabor, publicity photo for "Green Acres" TV series, circa 1968; PictureLux / The Hollywood Archive / Alamy Stock Photo

Pg. 79— Ron Howard, Clint Howard, Vera Miles & Steve Forrest Film: The Wild Country (1970); Cinematic Collection/ Alamy Stock Photo

Pg. 80— Unused poster concept for Bedknobs and Broomsticks, from the author's collection.

Pg. 85— Story and character development sketches for Robin Hood; from the author's collection

Pg. 90— Angela Lansbury at the premiere of 'Bedknobs & Broomsticks' held at the Odeon, Leicester Square. 7th October 1971; Trinity Mirror / Mirrorpix / Alamy Stock Photo

Pg. 92— Self-caricatures by Frank Thomas and Ollie Johnston; from the author's collection.

Pg. 97— Self-caricature by Milt Kahl. From the author's collection

Pg. 98— Fred MacMurray & Cloris Leachman Film: Charley and The Angel (1973); Cinematic Collection/ Alamy Stock Photo

Pg. 100— (top) Pre-production artwork from The Island at the Top of the World; Courtesy of Heritage Auctions, HA.com

Pg. 100— (left and below) Storyboards (artist unknown); from the author's collection.

Pg. 103— One Little Indian, (1973) Disney, Pictured: Jodie Foster; Entertainment Pictures / Alamy Stock Photo

Pg. 107— Development artwork; courtesy of Heritage Auctions, HA.com

Pg. 108—Winnie the Pooh illustration by E.H. Shepard (1926), Pooh and Piglet walking away in the woods; private collection.

Pg. 113—NBC/Wonderful World Disney, Two Against the Arctic (1974); Historic Images

Pg. 114—(left) Meine Baeren Und Ich Bears I, Patrick Wayne Der Vietnamveteran Bob Leslie (Patrick Wayne) adoptiert drei mutterlose; United Archives GmbH / Alamy Stock Photo

Pg. 114—(right) Feb 15, 1974; San Francisco, CA, USA; Ken Berry, Helen Hayes and Stefanie Powers star as Willoughby Whitfield, Mrs. Steinmetz, and Nicole Harris in the family adventure/comedy 'Herbie Rides Again' directed by Robert Stevenson; Entertainment Pictures / Alamy Stock Photo

Pg. 119— David Hartman, Mako, Donald Sinden, Agneta Eckemyr & David Gwillim Film: The Island at The Top Of The World (1975), Director: Robert Stevenson; Cinematic Collection / Alamy Stock Photo

Pg. 120— Tim Conway & Don Knotts Film: The Apple Dumpling Gang (1978), Director: Norman Tokar; Cinematic Collection / Alamy Stock Photo

Pg. 123— Photographs courtesy of Jerry Rees

Pg. 124— "American Graffiti" Charles Martin Smith 1973 Universal Pictures; PictureLux / The Hollywood Archive / Alamy Stock Photo

Pg. 124—(right) Herschel Bernardi & Charles Martin Smith Film: No Deposit, No Return (1976), Director: Norman Tokar; Cinematic Collection/ Alamy Stock Photo

Pg. 128— Photo of Moviola at Walt Disney Studios; private collection

Pg. 141— Photograph courtesy of Jerry Rees

Pg. 144— Photograph courtesy of Eddie Goral

Pg. 149— Jodie Foster and David Niven on the set of "Candleshoe" at Compton Wynyates house, Warwickshire, (1976); Trinity Mirror / Mirrorpix / Alamy Stock Photo

Pg. 150—Directing Animator John Lounsbury (right) candid posing with Animation models during production of The Jungle Book 1967; Masheter Movie Archive / Alamy Stock Photo

Pg. 152— Photograph courtesy of Steven Gordon.

Pg. 153—Actor and musician Jim Dale pictured at his home (1974); Trinity Mirror / Mirrorpix / Alamy Stock Photo

Pg. 154— Helen Reddy, Australian pop singer in 1978; Pictorial Press Ltd / Alamy Stock Photo

Pg. 161— (top) Photograph courtesy of Heritage Auctions, HA.com

Pg. 161— ((bottom) Story sketches from the author's collection

Pg. 163— Photograph from the author's collection

Pg. 164— Photo from Joe Hale Collection; Pete's Dragon (1977) crew photo

Pg. 165— Story sketches from the author's collection

Pg. 168— Story sketches from the author's collection

Pg. 169— Story sketches from the author's collection

Pg. 170— Jodie Foster as Annabelle Andrews in Freaky Friday (1977); RGR Collection / Alamy Stock Photo

Pg. 182— Photograph courtesy of Howard Green

Pg. 187— Photograph courtesy of Jerry Rees

Pg. 194— Photograph courtesy of Jerry Rees

Pg. 196— Frank Thomas and Ollie Johnston look over character models from The Fox and the Hound, (1981); Cinematic Collection/ Alamy Stock Photo.

Pg. 200— Peter Ellenshaw, The Black Hole, 1979; Collection Christophel / Alamy Stock Photo

Pg. 208— Poster concept art courtesy of Heritage Auctions, HA.com

Pg. 210— Der Sieg der Sternenkinder aka. Return from Witch Mountain, USA 1978 Director: John Hough Actors/Stars: Bette Davis, Christopher Lee, Kim Richards; United Archives GmbH / Alamy Stock Photo

Pg. 211— According to their father's wishes, the unlikely twin brothers Wild Billy (Jim Dale) and Eli must face a competition with tests of courage and skill in order to inherit the family fortune, Hot Lead and Cold Feet (1978); United Archives GmbH / Alamy Stock Photo

Pg. 212— Photograph courtesy of Jerry Rees

Pg. 214— Photograph courtesy of Howard Green

Pg. 219— Photographs courtesy of Howard Green

Pg. 220— Poster art from the collection of Chad Frye

Pg. 226— Caricature from the collection of Jerry Rees

Pg. 227— Photograph courtesy of Glen Keane

Pg. 233— Photograph courtesy of Jerry Rees

Pg. 243— Photograph courtesy of Mike Gabriel

Pg. 244— (left) Le trou noir The Black Hole 1979 Real Gary Nelson Robert Forster. Collection Christophel/ Alamy Stock Photo

Pg. 244— (right) Dr Le Trou Noir (The Black Hole) de Gary Nelson 1979 USA avec Maximilian Schell science-fiction, robot, technologie, vaisseau spatial; TCD/Prod.DB / Alamy Stock Photo

DISNEY IN-BETWEEN

Pg. 244— (bottom) The Black Hole, (1979), The USS Palomino at the edge of the black hole; Collection Christophel / Alamy Stock Photo

Pg. 248— The Black Hole, (1979), concept art, courtesy of Heritage Auctions, HA.com

Pg. 251— Photographs courtesy of Mike Gabriel

Pg. 252— Photograph courtesy of John Scheele

Pg. 257— Photograph courtesy of John Norton

Pg. 260— Kodalith print courtesy of Heritage Auctions, HA.com

Pg. 264— Photograph courtesy of Ed Ghertner

Pg. 265— Photograph courtesy of Mike Gabriel

Pg. 266— Photograph courtesy of Ed Ghertner

Pg. 267— Photograph courtesy of Ed Ghertner

Pg. 268— Photographs courtesy of Jerry Rees

Pg. 272— Photograph courtesy of Howard Green

Pg. 273— Photograph courtesy of Heritage Auctions, HA.com

Pg. 275— The Black Cauldron, (1985), concept art courtesy of Heritage Auctions

Pg. 276— The Black Cauldron, (1985), concept art courtesy of Heritage Auctions

Pg. 278— Photograph courtesy of Steven Gordon

Pg. 282— (top) Scene from the animation movie Vincent by Tim Burton, 1982; colaimages / Alamy Stock Photo

Pg. 282— Prod DB Â© Walt Disney / DR VINCENT (VINCENT) de Tim Burton 1982 USA avec Tim Burton (realisateur) sur le tournage dessin anime; TCD/Prod.DB / Alamy Stock Photo

Pg. 283— Photograph courtesy of Howard Green

Pg. 284— Disney on Film flier, from the author's collection

Pg. 286— Photographs courtesy of Howard Green

Pg. 296— Bill Cosby, The Devil and Max Devlin, (1981); Cinematic Collection/ Alamy Stock Photo

Pg. 297— Jenny Agutter teaches sign language to Otto Rechenberg in Amy, (1981); Entertainment Pictures / Alamy Stock Photo

Pg. 306— Photographs courtesy of Burny Mattinson

Pg. 309— Photograph courtesy of Burny Mattinson

Pg. 312— *Photograph courtesy of Jerry Rees*

Pg. 313— Photograph courtesy of Jerry Rees

Pg. 316— Photograph courtesy of Howard Green

Pg. 317— Bette Davis as the mysterious Mrs. Aylwood in The Watcher in the Woods, (1980), United Archives GmbH / Alamy Stock Photo

Pg. 319— Light Cycles, Tron, (1982), AJ Pics / Alamy Stock Photo

Pg. 322— Mit dem Wind nach Westen, (Night Crossing) USA (1982), Regie: Delbert Mann; United Archives GmbH / Alamy Stock Photo

Pg. 325— Mary Poppins (1964) [L-R] Music Director Irwin Kostal, Choreographer Marc, Breaux, Dick Van Dyke; RGR Collection / Alamy Stock Photo

Pg. 328— The Secret of NIMH, (1982) Director: Don Bluth; Album / Alamy Stock Photo

Pg. 330— Photograph courtesy of John Scheele

Pg. 331— Emilio Estevez, Matt Dillion, Meg Tilly in Tex, (1982); Cinematic / Alamy Stock Photo

Pg. 333— Photograph courtesy of Howard Green

Pg. 338— Artwork courtesy of Heritage Auctions.

Pg. 340— Trenchcoat (1983), Margot Kidder, Robert Hays Die Krimiautorin Mickey Raymond (Margot Kidder) faehrt nach Malta; United Archives GmbH / Alamy Stock Photo

Pg. 345— Jonathan Pryce, Pam Grier, Vidal Peterson, Shawn Carson, Something Wicked This Way Comes, (1983); Cinematic Collection/ Alamy Stock Photo

Pg. 347— Photograph courtesy of John Scheele

Pg. 350— (left) Charles Martin Smith, Brian Dennehy, Never Cry Wolf, 1983; Cinematic Collection / Alamy Stock Photo

Pg. 350— (right) Still from "Never Cry Wolf" Charles Martin Smith © 1983 Buena Vista Pictures/ PictureLux / The Hollywood Archive / Alamy Stock Photo

Pg. 356— Photograph courtesy of David Block

Pg. 362— Sport Goofy model sheet courtesy Heritage Auctions, HA.com; photograph courtesy of Darrell Van Citters

Pg. 365— (top left) Daryl Hannah in Splash (1984), Director: Ron Howard; Photo 12 / Alamy Stock Photo

Pg. 365— (right) Tom Hanks in Splash (1984), Regie: Ron Howard, TOM HANKS, Stichwort: Gestrandet, Strand, Schiffbrüchiger, Überlebender; United Archives GmbH / Alamy Stock Photo

Pg. 365— (bottom left) Studio Publicity Still from "Splash" Director Ron Howard, Tom Hanks, John Candy, Eugene Levy, Daryl Hannah © 1984 Touchstone Pictures Photo Credit: Jean Pagliuso; PictureLux / The Hollywood Archive / Alamy Stock Photo

Pg. 368— Photographs courtesy of Heritage Auctions, HA.com

Pg. 371— Large photograph of Ed Hansen courtesy of Eddie Goral

Pg. 371— Inset photograph courtesy of David Block
Pg. 372— Photograph courtesy of Heritage Auctions, HA.com
Pg. 374— Story sketches courtesy of Heritage Auctions, HA.com
Pg. 375— Photos courtesy of Burny Mattinson; artwork from the author's collection
Pg. 380— Michael Eisner, Roy E. Disney, and Frank Wells at The Variety Club's "Big Heart" Awards May 31, 1987. Credit: Ralph Dominguez/MediaPunch; MediaPunch Inc / Alamy Stock Photo
Pg. 380— (insert) Jeffrey Katzenberg attending a party in New York City. June 1995 Credit: Walter McBride/MediaPunch; MediaPunch Inc / Alamy Stock Photo
Pg. 383— The Black Cauldron (1985), production cel and story sketch courtesy of Heritage Auctions, HA.com
Pg. 384—Persephone and Sparky, Frankenweenie (1984); © Walt Disney Pictures, Allstar Picture Library Limited. / Alamy Stock Photo
Pg. 387— Photograph courtesy of Mike Gabriel
Pg. 391— Caricature courtesy of Rick Farmiloe
Pg. 393— Photograph courtesy of Burny Mattinson
Pg. 394— Photograph courtesy of David Bossert
Pg. 396-397— The Black Cauldron (1985) crew photograph courtesy of Steven Gordon
Pg. 398— Roy E. Disney with a storyboard for OLIVER & COMPANY behind him (2010); RGR Collection / Alamy Stock Photo
Pg. 400— Return to Oz (1985) Pons Maar, Fairuza Balk Credit Disney RTOZ 002FOH; Moviestore Collection Ltd / Alamy Stock Photo
Pg. 401— Taran and Gurgi, The Black Cauldron (1985); © Disney Enterprises, Cinematic / Alamy Stock Photo
Pg. 404— The Black Cauldron (1985) story sketch courtesy of Heritage Auctions, HA.com
Pg. 406— (top and middle) Photograph courtesy of John Scheele
Pg. 406— (bottom) American actor Dennis Hopper in the movie My Science Project (1985), USA 1985; United Archives GmbH / Alamy Stock Photo
Pg. 411— Glen Keane drawings courtesy of Heritage Auctions, HA.com
Pg. 411— Basil, Detective Prive The Great Mouse Detective (1986) de Ron Clements et Burny Mattinson d'apres le livre "Basil of Baker Street" de Eve Titus & Paul; ©Disney Enterprises TCD/Prod.DB / Alamy Stock Photo
Pg. 418— (top) Studio Publicity Still from "The Journey of Natty Gann" John Cusack, Meredith Salenger © 1985 Walt Disney Pictures All Rights Reserved; PictureLux / The Hollywood Archive / Alamy Stock Photo
Pg. 418— Mary Steenburgen, Full-Length Portrait, on-set of the Film, "One Magic Christmas", Walt Disney Productions, Buena Vista Distribution, (1985); Glasshouse Images / Alamy Stock Photo
Pg. 420— Down and Out in Beverly Hills (1989) Richard Dreyfuss and Bette Midler DAOB 007; Moviestore Collection Ltd / Alamy Stock Photo
Pg. 422— Ruthless People (1986), Judge Reinhold and Danny DeVito; RUP 003FOH; Moviestore Collection Ltd / Alamy Stock Photo
Pg. 424— (top) Basil, Detective Prive The Great Mouse Detective (1986) de Ron Clements et Burny Mattinson d'apres le livre "Basil of Baker Street" de Eve Titus & Paul; TCD/Prod.DB / Alamy Stock Photo
Pg. 424—(bottom) Basil, Detective Prive The Great Mouse Detective (1986) de Ron Clements et Burny Mattinson d'apres le livre "Basil of Baker Street" de Eve Titus & Paul; TCD/Prod.DB / Alamy Stock Photo
Pg. 425— Tom Cruise and Paul Newman, The Color of Money, (1986); © Touchstone, Maximum Film / Alamy Stock Photo
Pg. 429— Fantasia 2000, USA 1999, Roy E. Disney mit Modellen von Figuren aus dem Film; United Archives GmbH / Alamy Stock Photo
Pg. 430— (top) Emilio Estevez & Richard Dreyfuss Film: Another Stakeout (1993) Director: John Badham 23 July 1993; ©Touchstone, Cinematic / Alamy Stock Photo
Pg. 430— (middle) Robin Williams, Good Morning Vietnam, (1987); ©Touchstone, AJ Pics / Alamy Stock Photo
Pg. 430— (bottom) Ted Danson, Tom Selleck, Steve Guttenberg, and baby, Three Men and a Baby, (1987); ©Touchstone, Cinematic / Alamy Stock Photo
Pg. 432— Bob Hoskins and Roger Rabbit, Who Framed Roger Rabbit (1988); ©Touchstone Pictures, Photo 12 / Alamy Stock Photo
Pg. 442— Lampy, Toaster, Blanky, Kirby, Radio, The Brave Little Toaster (1987); © Disney, AJ Pics / Alamy Stock Photo
Pg. 443— Photograph courtesy of Jerry Rees.
Pg. 447— Dale Baer, Photograph Personal Collection
Pg. 448- 449— Photographs by the author.

Index

Page numbers in *italics* indicate illustrations.

A

ABC network, 19, 27, 366, 434
Abrahams, Jim, 422
The Absent-Minded Professor (film), 38, 58, 66, 101, 114, 265
Academy Awards and nominations
 Alcott, John, 349
 Andrews, Julie, 382
 Beauty and the Beast, 434
 Bedknobs and Broomsticks, 91, 199
 The Black Hole, 247
 Bonnie and Clyde, 43
 Computer Animation Production System (CAPS), 441
 Cruickshank, Art, 221
 Destino, 445
 Dragonslayer, 310
 Dreyfuss, Richard, 421
 Ellenshaw, Peter, 199, 221
 Fiddler on the Roof, 91
 Foster, Jodie, 134
 Gabriel, Mike, 435
 Get a Horse!, 434
 Harris, Barbara, 133
 Henry, Justin, 353
 Industrial Light and Magic, 310
 The Island at the Top of the World, 119, 199
 It's Tough to be a Bird, 65
 Kasha and Hirschhorn, 131
 Kostal, Irwin, 325
 Lange, Jessica, 352, 382
 Lansbury, Angela, 71
 Lee, Danny, 221
 The Little Matchgirl, 445
 The Little Mermaid, 433
 Lycett, Eustace, 221
 Mann, Delbert, 323
 Mary Poppins, 199, 382
 Men Against the Arctic, 38
 Mickey's Christmas Carol, 359
 Midler, Bette, 421
 Murch, Walter, 271
 Newman, Paul, 426
 Pete's Dragon, 198
 Picker, Jimmy, 359
 Return to Oz, 400
 Scheider, Roy, 353
 "Somewhere Out There" (song), 427
 Splash, 365
 20,000 Leagues Under the Sea (live-action film), 16, 53
 Who Framed Roger Rabbit, 432
 Williams, Robin, 431

 Winnie the Pooh and Tigger Too, 119
Adventures in Babysitting (film), 431
Adventures in Music: Melody (educational short), 63
The Adventures of Bullwhip Griffin (live-action film), 39
The Adventures of Gallegher (television series), 48
The Adventures of Ichabod and Mr. Toad (animated film), 37, 38
The Adventures of the Gummi Bears (television series), 408
"The Age of Not Believing" (song), 89
Agutter, Jenny, 296, 297
Airplane (film), 422
Airport 1975 (film), 160
Aladdin (film), 435, 437, 443, 447, 451
Albert, Eddie, 74, 75
Albertson, Jack, 219
Alcott, John, 349
Alda, Alan, 133
Alder, Yarek, 347
Aldridge, James, 115
Alexander, Jane, 324
Alexander, Lloyd, 179, 180, 197, 275, 402
Alex Theater, Glendale, California, 67
Algar, James, 37, 40, 112–113, 133, 167
Alice in Wonderland (animated feature), 16, 19, 38
Alice in Wonderland (live-action remake), 193, 439
Alien (film), 288
All Because Man Wanted to Fly (Disneyland film), 376
All Dogs Go to Heaven (film), 438
Allen, Irwin, 115
Allen, Lewis, 250
Allers, Roger, 226
All in the Family (television series), 74
Allwine, Wayne, 302
Alonzo Hawk (character), 114
Alphonse's (restaurant), 29
Altman, Robert, 274, 287
Amblin Entertainment, 427, 431
American Graffiti (film), 104–105, 124, 124, 271, 421
An American Tail (film), 427
American Zoetrope (studio), 105
Amy (film), 296–297, 297
Amy-on-the-Lips (television film), 296
Anastasia (film), 438
Anderson, Bill, 40, 49, 153, 167
Anderson, Ken
 The Aristocats, 36
 caricature, 14
 Catfish Bend, 105, 107, 145
 in *Disney Animation* (book), 291
 Disney (Walt)'s final visit to Studio, 14
 Hahn and, 151
 impact on Disney animation, 81–84
 101 Dalmatians, 82–83

Pete's Dragon, 162, 165, 168, 169, 173
The Rescuers, 106
Robin Hood, 81, 85
Scruffy, 105, 107
Snow White and the Seven Dwarfs, 82
Story Department, 135, 140
Xerox-based art direction style, 129
Anderson, Leroy, 151
Anderson, Stephen, 6–7
Andrews, Julie, 382
The Andy Griffith Show (television series), 74, 75, 77, 78, 339
Animalympics (animated feature), 226, 227, 256, 334
animated films. *see also specific films*
 Computer Animation Production System (CAPS), 441–442
 improv performers, 443–444
 process, 82–83, 409
 voice casting, 74
Animation Building
 animators, 23
 in Baer's childhood aspirations, 31
 The Black Cauldron vignettes, 179
 D Wing floorplan, 26
 "The Eddie Show," 264, 264–265, 358–359
 frozen in time, 212
 Katzenberg's use for live-action films, 392
 library, 223–224, 445, 446
 Mickey's Christmas Carol crew, 356
 Miller's office, 269
 Morgue, 86–87
 The Penthouse (men's-only club), 142–143, 185–186
 as predominantly male environment, 184
 Story Department, 24
 traffic room, 23
 Tron, 257
 Walt Disney's office, 24, 269, 446
Animation Camera Department, 27
Animation Department
 administration, 23–24
 The Black Cauldron, 275–276
 civil war within, 194–195, 230, 370–371
 Cook in, 147
 daily routine, 265–269, 268
 Disney (Roy E.) as chairman, 380, 380–381, 398, 398–399
 Duckwall as manager, 126–127
 EPCOT Center promotional films, 293–294
 increasing staff, 67–68, 71
 independent/pirate-flag attitude, 182
 pranks, 371–372
 publicity photo, 194
 relocation to Flower Street, 392, 395
 research for, 223
 Stevens and Berman as leaders, 217
 trainees, 71, 84, 86–87, 93–94, 95, 110–111
 Tron, 256, 257–258
 volleyball games, 267, 268, 269
animation photo transfer (APT), 376–377
Animation Research Library (ARL), 223–224, 445, 446.
 see also Morgue
Animation Studio, 140
animator's extremes, 10–11

animatronics, 348, 367, 399
ANM8RX (Guedel memoir), 110, 216, 229
Anne of a Thousand Days (film), 116
Annie Awards, 446, 447
The Apartment (film), 101
Apocalypse Now (film), 271
The Apple Dumpling Gang (live-action film), 120
 cast, 121
 director, 121, 125
 sequel, 238
 set, 267
 success, 121, 238, 365
 television remake, 283
 writer, 183
APT (animation photo transfer), 376–377
Aquino, Ruben, 434
archives, 75, 445. *see also* Morgue
The Aristocats (animated feature), 36, 74, 129, 130, 203, 402
Arkush, Allan, 288, 289
ARL (Animation Research Library), 223–224, 445, 446.
 see also Morgue
Armstrong, Louis, 217
Arnold, Gary, 152–153
Art of Animation (Disneyland exhibit), 31
The Art of Animation (B. Thomas book), 32
The Art of Walt Disney (Finch book), 123
Asbury, Kelly, 362
Ashman, Howard, 433
Asner, Ed, 133, 427
Astin, John, 133
Astin, Sean, 427
The A-Team (television series), 221
Atlantis: The Lost Empire (film), 434, 436
Auberjonois, René, 427
Audio-Animatronics technology, 295
Aurora Productions, 230
The Avengers (British television series), 116, 237
Avery, Tex, 227, 340

B

Baby: Secret of the Lost Legend (film)
 animatronic dinosaurs, 348, 367, 399
 casting, 348–349
 filming, 349, 367
 location, 349, 367
 premiere, 399
 story, 345–346, 367
 under Touchstone label, 419
 visual effects, 347, 347–348, 399
background morgue, 152
backlit animation, 257, 261, 318–319
backlot. *see* Burbank lot
Backstage at Disney (documentary), 348
Back to Neverland (film), 443, 443
Back to the Future (film), 400–401, 405
Baer, Dale
 Anderson (Ken) and, 84
 Annie Award, 446, 447
 Bakshi and, 175–176
 Banjo the Woodpile Cat, 175
 Beauty and the Beast, 446

DISNEY IN-BETWEEN

The Black Cauldron, 368–369
Bluth and, 148, 174, 176
as CalArts instructor, 447
childhood, 30–31
death, 447
on destruction of cels, 112
on Disney box-office strategy, 125
on Disney lot, 126
Disney (Walt)'s death and, 30
The Emperor's New Groove, 446
Guedel and, 95–96
hand-animation, 447
as inbetweener, 84
on Johnston and Thomas, 142
on Kahl, 144
on King (Hal), 203
on Larson, 143
later career, 446–447
The Lion King, 446
Lounsbery and, 94, 106, 140, 142–143, 151
Mickey's Christmas Carol, 307, 308
Morgue visit, 86
on movie budgets, 129
Pete's Dragon, 173
promoted to animator, 109
on Reitherman, 127, 128, 215
retirement, 447
Robin Hood, 84, 94, 205
on Stevens (Art), 205
on Studio's creative rut, 130
as supervising animator, 446–447
as trainee, 84, 86
Who Framed Roger Rabbit, 446
Winnie the Pooh and Tigger Too, 109
Baer Animation Company, 446
Bailey, Pearl, 219
Bakalyan, Richard, 64, 73
Baker, Rick, 348, 405, 406
Bakshi, Ralph, 175–176
Bakula, Scott, 423
Balk, Fairuza, 368
The Ballad of Nessie (short), 447
Ballard, Carroll
 The Black Stallion, 250
 Never Cry Wolf, 250, 261–262, 315, 324–325, 349–351
 Something Wicked This Way Comes, 273
Bambi (animated feature)
 crew, 37, 97, 139
 dark moments, 70, 143, 202, 240
 reuse of animation from, 151
 success, 18
Banjo the Woodpile Cat (Bluth's animated short), 137, 174–175, 191–192, 230
Barbash, Bob, 115
Barks, Carl, 65, 408
Barry Lyndon (film), 349
Barwood, Hal, 309
Basil of Baker Street (film project). *see The Great Mouse Detective*
Basil of Baker Street (Titus book series), 373
Bass, Sid, 377
Bass Brothers Enterprises, 355, 370

Bateman, Jason, 426
Batman (television series), 66, 73
Baum, L. Frank, 271–272, 292, 399
Baxter, James, 438
The Bears and I (film), 99, 114, *114*
Beat Generation, 41–42
Beatty, Warren, 42–43, 105, 341
"The Beautiful Briny Sea" (song), 89
Beauty and the Beast (film), 434, 436, 437, 438, 446, 447, 451
Bebe's Kids (film), 444
Bedknobs and Broomsticks (musical)
 animation, 76
 assistant camera operator, 158
 cast, 71–72, 89, 90, 91
 combining live-action with animation, 91, 160, 162
 concept painting, 70
 filming, 72
 as *The Magic Bedknob*, 45, 47, 61, 71
 poster concept, 80
 premiere, 90
 release, 88
 running time, 88–89
 songs, 88–89, 91, 325, 433
 thirtieth anniversary DVD release, 91
Beekman Theater, New York, 60
Beiman, Nancy, 123
Beineix, Jean-Jacques, 273
Benji the Hunted (film), 431
Benson, Robby, 274
Benton, Robert, 42
Berger, Richard
 Baby, 349
 Never Cry Wolf, 350
 Return to Oz, 343, 367–368
 Splash, 344, 361
 Touchstone Films, 364
 as Walt Disney Pictures president, 343
 Who Framed Roger Rabbit, 343
Berman, Ted
 Animation's old guard and new blood, 217, 225, 232, 242, 243, 369
 The Black Cauldron, 273, 276, 277, 278, 281, 298, 369
 character traits, 205, 215
 The Fox and the Hound, 205, 215, 216, 224, 225, 232, 240, 242–243, 369
 Gong Show, 412–413
 It's Tough to Be a Bird, 64, 65
 on Kimball's team, 64, 65, 76
 Reitherman and, 206, 215
 retirement, 437
Bernardi, Herschel, 124, 125
Berry, Ken, 74, 114
Bettin, Val, 375
Betuel, Jonathan, 405, 407
The Beverly Hillbillies (television series), 74
Bickham, Jack, 121
Big Hero 6 (film), 448
Big Red (theatrical drama), 38, 121
Bill Melendez Productions, 446
Bird, Brad
 Animalympics, 226
 Animation Department publicity photo, *194*

478 INDEX

Buck as assistant, 224, 232
as CalArts student, 122, 123, *123*, 155–156
clashes with Stevens and Berman, 216
fired by Studio, 225, 232
frustration with Bluth, 225
hired by Studio, 6, 187
Lisberger Studios, 226
self-caricature, *226*
The Small One, 191, 193
"The Spirit" project, 441
The Biscuit Eater (live-action feature), 88
Bixby, Bill, 121
Blackbeard's Ghost (live-action film), 14, 38, 39, 51, 57, 66
The Black Cauldron (film), *401*
 animation photo transfer, 377
 artists, 275–280, *278*, 294, 304–305, 372, *372*–373,
 382–383, 394, 395, 408, 435, 436
 climax, 382–383, *383*
 computer animation, 410
 crew photo, 395, *396–397*, 398
 deleted seqences, 402–404, *404*
 in *Disney Animation* (Thomas and Johnston book), 285
 internal tensions, 298–300, 304–305, 307, 368–371, 451
 Katzenberg's changes, 382–384, 403
 leadership, 276, 277, *278*, 279–280, 281, 294, 298–300,
 304–305, 369–370
 message, 401–402
 production team, 395, 434
 publicity, 401
 release, 382, 384, 401–402
 reviews, 402
 Shaw's pastel drawings, 179, 275, *275*, *276*
 story, 179–180, 197
 storyboards, 298–300, 402–404
 as Thomas and Johnston's passion project, 179–180,
 196, 202
 voice actors, *372*
 working conditions, 395
 writer, 197, *278*, 280
"The Black Ferris" (Bradbury story), 272
The Black Hole (film)
 art directors, 199–200
 casting, 217–218
 climax, *248*
 development, 115, 130
 directors, 183–184, 200, 209, 210–211
 ending, 222
 filming, 218
 matte painting department, 200–201
 PG rating, 246
 premiere, 246
 preview, 246
 producer, 183, 210
 production designer, 199, 210–211
 production illustrator, 254
 publicity, 244–245, 247
 reviews, 246–247, 311
 scenes from, *244*
 as *Space Probe One*, 115, 130, 182–184
 special-effects team, 221
 story, 245, 247
 teaser, 245

visual effects team, *252*
writers, 182–184, 199–200, 201, 210, 221–222, 247
The Black Stallion (film), 250, 292, 352
Blade Runner (film), 327, 349
Blair, Mary, 213
Blessed, Brian, 423
Block, Dave
 on animators' schedules, 267
 The Black Cauldron, 275, 304–305, 373
 Disney TV Animation, 408
 The Fox and the Hound, 201, 214
 The Great Mouse Detective (formerly *Basil of Baker
 Street*), 390, 407–408
 hired by Studio, 186–187
 on Katzenberg, 380, 392
 on Larson, 188, 190, 191
 Mickey's Christmas Carol, 305, 306, 308
 Pete's Dragon, 187
 photos by, *356*, *371*
 pranks, 266
 Walt Disney Television Animation, 445
Bluth, Don
 All Dogs Go to Heaven, 438
 An American Tail, 427
 Anastasia, 438
 Animation Department civil war, 194–195, 202, 225,
 230, 439
 Animation Department publicity photo, *194*
 Animation's old guard and new blood, 7, 141, 148, 190,
 192–193
 Baer and, 148, 174, 176
 Banjo the Woodpile Cat, 137, 174–175, 191–192, 230
 The Black Cauldron, 197
 on CalArts, 155, 195
 CalArts graduates and, 230
 character traits, 174, 191, 195, 230
 Clements and, 111, 173, 174–175, 203, 439
 Cook and, 147–148, 173, 174, 228
 as directing animator, 136–137, 148
 as director, 157, 162, 202
 Don Bluth Productions, 230
 The Fox and the Hound, 225, 310
 Guedel and, 96, 109, 110, 228
 Hahn as assistant director for, 215–216
 as inbetweener, 28–29, 87
 independent films, 111, 137, 438
 The Land Before Time, 438
 live-action reference, 225
 as mentor, 95, 96, 109, 111, 173, 174
 Miller and, 148, 174, 192, 202, 218, 230–231
 Pete's Dragon, 162, 173–174
 The Piper, 111, 137
 Pomery, Goldman, and, 137, 147–148, 192, 438
 promoted to animator, 87–88, 109
 on Reitherman, 127–128
 Reitherman and, 157, 202
 The Rescuers, 136–137
 resignation from Disney, 228, 230–231
 return to Disney lot (2018), 439
 rumors about his departure, 218
 The Secret of NIMH, 320, 328, *328*–329
 Sleeping Beauty, 28–29, 87

DISNEY IN-BETWEEN

479

The Small One, 189–191, 193–194, 195, 203
Thomas (Frank) and, 88
Winnie the Pooh and Tigger Too, 109
The Boatniks (film), 121, 158
Bolger, Ray, 153
Bonanza (television series), 67
Bond, Johnny, 23, 184–185
Bonfires and Broomsticks (Norton book), 45
Bonifer, Mike
 Animation Department and, 182
 on The Disney Channel, 353
 The Disney Family Album, 353, 357, 376
 Disney on Film (college tour), 285
 on Lasseter, 360–361
 on Miller, 354
 Publicity Department, 180–181
 on Studio misses, 293
 on *Tron*, 257, 440
 on Wilhite, 249
Bonnie and Clyde (film), 42–43, 59, 105
Booke, Sorrell, 133
Borgnine, Ernest, 217
Borsos, Phillip, 419
Bossert, Dave
 The Black Cauldron, 394, 395, 410
 on Disney (Roy E.), 380, 428
 on Eisner and Wells, 380
 later career, 435
Bottoms, Joseph, 217
Bottoms, Timothy, 376
Boudu suave des eaux (*Boudu Saved from Drowning*), 412.
 see also Down and Out in Beverly Hills
Boxleitner, Bruce, 259, 260
A Boy Called Nuthin' (television film), 39, 77
Boyd, Jack, 71, 263
The Boys (Howard brothers' memoir), 77
The Boy Who Talked to Badgers (television film), 133
Bradbury, Ray, 272, 272–273, 316, 333, 335, 345
Brady, Jack, 87
Brando, Marlon, 264, 358
The B.R.A.T. Patrol (television film), 427
The Brave Little Toaster (Disch novella), 360
The Brave Little Toaster (film), 360, 442, 442–443
Breaux, Marc, 325
The Bridge on the River Kwai (film), 146
Bridges, Beau, 324, 427
Bridges, Jeff, 260
Brooks, James, 73
Brosnan, Pierce, 212
Buck, Chris
 Burton and, 233–234
 as CalArts student, 165
 The Disney Channel puppet show pilot, 354
 Doctor of Doom, 234
 "The Eddie Show," 358–359
 EPCOT Center promotional films, 294
 The Fox and the Hound, 225, 232–233, 241, 242–243
 Gabriel and, 234
 hired by Studio, 212, 212, 213
 as inbetweener, 224
 on lack of respect for directors, 243
 on Larson, 437

 later career, 435
 Sport Goofy, 362
 volleyball games, *268*
 Who Framed Roger Rabbit, 337, 385, 386
Buck, Shelley (Hinton), 362
Buckley, Jack, 71
Buena Vista (distribution company), 21–22, 180, 274
Buford, Gordon, 57
Burbank lot
 Bedknobs and Broomsticks, 72
 Disney Feature Animation crew, 6
 relaxed atmosphere, 126
 sets, *265*, 265–266, *266*, *267*
 soundstages, 16
Burman, Paul Lucien, 105
Burns, Alan, 73
Burton, Tim
 Alice in Wonderland, 439
 The Black Cauldron, 278–280, 281
 Buck and, 233–234
 as CalArts student, 165
 career after Disney, 439
 caricatures by, 224, 233
 Disney on Film, 287, 288
 Doctor of Doom, 234
 Dumbo, 439
 The Fox and the Hound, 232–233, 287, 288
 Frankenweenie, 384, *384*, 439
 Gabriel and, 234
 Hansel and Gretel, 354
 hired by Studio, 212
 leaving Disney, 384
 Luau, 233, 234, 243, 251
 The Nightmare Before Christmas, 354, 439
 not conforming to Disney style, 233–234, 278–279, 281
 Trick or Treat, 354
 Vincent, 282, *282*, 283, 354
 volleyball games, 268
Burum, Stephen, 332–333, 334, 335
Butler, Robert, 66, 88, 211–212
Buttons, Red, 154, 160
Buttram, Pat, 74
Buzzi, Ruth, 133

C

Cabot, Sebastian, 339
Caesar, Sid, 326
The Caine Mutiny (film), 101
California Institute of the Arts (CalArts)
 animation approach, 97
 Character Animation program, 6, 122–124, *123*, 155, 165
 creation of, 62–63, 76, 91, 95
 Disney (Roy O.) and, 62–63, 76, 91
 Disney artists as faculty, 122
 first wave at Studio (1977), 6, 187, *187*–196, *194*
 fourth wave at Studio (1980), 262–264
 Keane as student, 96, 111
 Nightmare (Lasseter film), 287
 School of Film Graphics, 96–97
 second wave at Studio (1978), *212*, 212–213

student behavior, 76
Call It Courage (*The Wonderful World of Disney* program), 99
Camelot (musical), 44
Camera Department, 23, 158, 184, 336
Cameron, Candace, 426
Cameron, Ian, 99
"Candle on the Water" (song), 132, 198
Candy, John, *365*
Canemaker, John, 104, 290
Cannes Film Festival, 60
Can't Buy Me Love (film), 431
CAPS (Computer Animation Production System), 441–442
Captain Eo (3D film), 426
Car, Boy, Girl (story idea), 57. *see also The Love Bug* (film)
Caricature Show, 223–224, 445
Carothers, A.J., 44, 45, 48–49, 153
Carpenter, John, 293, 310, 327
Carrighar, Sally, 112
Carry On (British film series), 153
Carson, Shawn, 316
Carter, Chris, 427
Carter, Jimmy, 256
Cartwright, Randy, 7, *141*, 233, 243, *251*, *306*
Casebusters (television film), 423
Casey Bats Again (short), 26
The Castaway Cowboy (film), 103–104, 183
Casting Department, 117
Catfish Bend (film project), 105, *107*, 145
The Cat From Outer Space (film), 327
Cats Don't Dance (film), 435
CBS network, 73–74, 408
Cedeno, Mike, *123*
cels
 sales of, 291–292
 shredding of, 112
CGI. *see* computer animation
Chaffey, Don, 115, 159, 161, 163–164, *164*
Champagne for Caesar (film), 390
Champlin, Charles, 152, 166–167
Channel 5 news, 358–359
Charley and the Angel (film), 98, 99, 101
Charlie, the Lonesome Cougar (live-action film), 38, 39
Charlotte's Web (animated feature), 175
Charo (singer/actor), 214, *214*
Chicken Little (film), 435
"Chim Chim Cher-ee" (song), 89, 132
Chip 'n' Dale's Rescue Rangers (television series), 445
Chouinard Art Institute, 28, 62, 71, 84, 95
Christmas at Candleshoe (film), 148–149, *149*
Christmas at Candleshoe (Innes book), 148
A Christmas Carol (film). *see Mickey's Christmas Carol*
A Christmas Carol (storyteller record), 300, 303
The Chronicles of Prydain (Alexander book series), 197, 275, 402
Cinderella (animated feature), 16, 31, 38
Cinderella (live-action film), 193
CinemaScope, 63
Citizen Kane (film), 373
civil rights movement, 42
Clark, Les, 14, 36
Clash of the Titans (film), 310
Claymation, 293

Clayton, Jack, 272, 273, 332–336
Cleese, John, 373
Clemens, Brian, 237
Clements, Ron
 Aladdin, 443
 on *An American Tail* tie-ins, 427
 Animation Department civil war, 194, 225
 as animation director, 435
 on Animation Studio generation gap, 140
 on appeal of Walt Disney Studio, 126
 The Black Cauldron, 179, 197, 280, 281, 370, 451
 Bluth and, 111, 173, 174–175, 203, 218, 439
 on CalArts talent, 155
 childhood, 31–32
 in *Disney Animation* (book), 291
 Disney on Film, 287
 Disney (Walt)'s death and, 31–32
 The Fox and the Hound, 197, 239–241, 287, 310
 Gong Show, 413, 433
 The Great Mouse Detective (formerly *Basil of Baker Street*), 373, 389, 390, 391, 409, 424
 Hero From Otherwhere, 353
 The Little Mermaid, 413, 433
 Nine Old Men and, *141*, 143, 144
 passion for story, 156, 197
 Pete's Dragon, 173, 174, 197
 The Rescuers, 146, 147, 156, 179, 197, 239, 373
 on rivalries, 143
 The Solitaire Creature, 353
 on Stevens, 369
 Thomas and, 110–111, 142, 291
 as trainee, 110–111, 112
 Winnie the Pooh and the Day for Eeyore, 339
Clemmons, Larry, 138, 145–146, 201, 205, 215
Cleworth, Eric, 37, 203, 204, 291
Cline, Fred, 362
Clio Award, 227
A Clockwork Orange (film), 91
Close Encounters of the Third Kind (film), 178, 348, 421
Coca, Imogene, 326
Cocoon (film), 400
Cohen, Jeff, 427
"Colonel Bogey March" (song), 146
The Color of Money (film), 422, 425, *425*–426
Columbia Pictures, 183. *see also Easy Rider*
Comic Strip Department, 147
Compass Players (improvisational theater troupe), 133
computer animation
 The Black Cauldron, 410
 The Brave Little Toaster, 360
 Chicken Little, 435
 Computer Animation Production System (CAPS), 441–442
 The Disney Family Album, 357
 The Great Mouse Detective (formerly *Basil of Baker Street*), 410, 411
 hand-animated exploratory scenes, 447
 Something Wicked This Way Comes, 334–335
 Tron, 256–261, 311–312, 313, 357, 360, 440
Computer Animation Production System (CAPS), 441–442
The Computer Wore Tennis Shoes (film), 66–67, 69, 88, 211
Conan the Barbarian (film), 327

Condorman (film), 311
A Connecticut Yankee in King Arthur's Court (Twain book), 183
Consumer Products and Publishing Department, 181
The Conversation (film), 271
The Conversations (Ondaatje book), 271
Conway, Tim, 73, *120, 121*
Cook, Lorna
 Animation Department civil war, 194
 Beauty and the Beast, 438
 Bluth, Pomeroy, Goldman friendship, 147–148
 Bluth as mentor, 95, 173, 174, 191, 192, 228
 career after Disney, 438–439
 Filmation, 95
 The Lion King, 438
 marriage to Pomeroy, 228
 Mulan, 438
 Pete's Dragon, 173
 resignation from Disney, 228, 229–230
 return to Disney, 147, 438
 The Small One, 191
 as trainee, 95
Coppola, Francis Ford
 American Graffiti, 104–105
 American Zoetrope (studio), 105
 Apocalypse Now, 271
 Captain Eo, 426
 The Conversation, 271
 The Godfather, 105
 The Godfather Part II, 271
 as inspiration, 232
 Murch and, 271, 368
 The Outsiders, 335
 Rumble Fish, 335
Corcoran, Kevin, 168, 209, *268*, 382
Corman, Roger, 78, 289
Cosby, Bill, 296, *296*
Costa, Johnny, 354
Couffer, Jack, 250
counterculture revolution, 42
Country (film), 351–352, 382
Courtland, Jerome, 115, 131, 168, 209, 382
Courvoisier Gallery, 291
Cox, Wally, 73
Craig, Susan, 362
Craven, Wes, 423
Crawford, Michael, 311
Crosby, Bing, 47
Cruella De Vil (character), 110–111
Cruickshank, Art, 117, 221
Cruise, Tom, 425, 426
Culhane, John, *286*
Cusak, John, 417, *418*

D

D23 Fan Club, 445
Dad, Can I Borrow the Car? (theatrical short), 75–76
DaGradi, Don, 57, 59, 89
Dahl, Roald, 277
Dale, Jim, 153, *153*, 159–160, 211, *211*
Dali, Salvador, 445

Dallas (television series), 297
Darby O'Gill and the Little People (film), 38, 58, 240
Dark Carnival (Bradbury screenplay), 272
Darkwing Duck (television series), 445
Darling Lili (musical), 374
Davidson, John, 44
Davis, Bette, 209–210, *210*, 317
Davis, Marc, *14*, 28, 36
Davy Crockett (television show), 38, 101
Day, Doris, 264, 358
Day, Gerry, 221–222
The Deacon Street Deer (film), 423
Dead Poets Society (film), 431
Dear World (Broadway show), 72
Debney, Lou, 354
Deja, Andreas, 280, 372, *372*, 373, 434
Delerue, Georges, 316, 335–336
Dempsey, Patrick, 423
Dennehy, Brian, 315, 350
Dennis, Gill, 292
Denslow, W.W., 292
De Palma, Brian, 105
DeRosa, Tony, 395, 434–435
Deschanel, Caleb, 250, 261
Destino (short), 445
The Devil and Max Devlin (film), 296, *296*
DeVito, Danny, 421–422, *422*
Dick, Phillip K., 288
Dickens, Charles, 300, 413
The Dick Van Dyke Show (television show), 49, 73
Digital Effects Inc., 312
Dillon, Matt, *331*
Dindal, Mark, 262–263, 266, 279, 370–371, 372, 435
Dinehart, Alan, 303
Directors Guild, 27
Directors Guild Theater, Los Angeles, 43
disaster movies, as dying genre, 115
Disch, Thomas M., 360
Disney, Roy E. "Roy Jr." (Walt's nephew)
 as Animation Department chairman, 380, *380*–381, 398, 398–399, 413
 on Animation Department's relocation, 392
 ashtray holder, 399
 The Black Cauldron, 382
 campaign to reclaim Disney, 366
 character traits, 428
 Destino, 445
 Fantasia 2000, 444
 with *Fantasia 2000* maquettes, *429*
 The Flight of the Grey Wolf, 167
 The Great Mouse Detective (formerly *Basil of Baker Street*), 388, *389*
 lawyer, 176
 as live-action committee member, 40, 167
 producing films for television, 91, 167
 resignation from Disney, 176–177, 366
 reviving Walt's shelved projects, 444–445
 Studio takeover rumors, 378
 True-Life Adventures, 26
 as vice chairman of the board, 378
 The Wonderful World of Disney, 99
Disney, Roy O. "Roy Sr." (Walt's brother)

Buena Vista (distribution company), 21
California Institute of the Arts (CalArts), 62–63, 76, 91
as chairman of the board and CEO, 55, 62
character traits, 428
death, 91
Disney (Walt) and, 27, 29, 34, 41
live-action committee, 40, 167
on pioneering spirit, 19
preserving Disney legacy, 41
as Walt Disney Studio head, 35, 40, 55
Disney, Walt, 12, 20, 30, 34
animated features, 15–16, 18
Animation Building library, 223
Animation Building office, 24, 446
animation credit, 290
animation process, 24, 83
The Aristocats, 36
behind camera, 33
biography, 32
character traits, 17–18, 19, 21, 178
death, 11, 13, 14–15, 30–32
death, aftermath at Studio, 35–45
Destino, 445
directors and, 24, 26
Disneyland, 29, 63
distaste for leadership by committee, 40
family relationships, 26–28, 29
filming live-action reference for animators, 193
final visit to Studio, 13–14
on his role, 35
Hollywood studio system, 19, 21
innovation, 18, 19, 41, 63
interaction with animators, 143
legacy, 6, 7, 11, 41
live-action development process, 24, 26
live-action filmmaking, 16
Michener and, 28
as Mickey Mouse voice, 302
military-training films, 18
musical productions, 44–45, 47
Nine Old Men and, 35–36
on not sugarcoating stories to protect children, 240
office archives, 75, 446
101 Dalmatians, 29
paycheck, 22
on reasons for Disney success, 40–41
The Scarecrow of Romney Marsh, 349
sequels, 238
shelved projects revived by Roy Jr., 444–445
and Sherman Brothers, 44, 45
smoking habit, 22–23
story men and, 24, 26, 59
A Thrill a Minute with Jack Albany, 49
Tombragel and, 48
Warburton and, 53
Winnie the Pooh featurettes, 119
"Disney Animations and Animators" (exhibition), 290
Disney Animation: The Illusion of Life
(Thomas and Johnston book), 263, 285, 290–291, 427
The Disney Channel
Backstage at Disney, 348
The Brave Little Toaster, 442–443

The Disney Family Album, 353, 357, 376
Disney's film and television library, 352–353
Five Mile Creek, 363
Hansel and Gretel, 354
launch, 344
original films, 353, 376, 423
proposed projects, 353–354
The Proud Family, 444
Running Brave, 274
Take Down, 274
Disney company. *see* Walt Disney Productions
The Disney Family Album (documentary series), 353, 357, 376
Disney Feature Animation, 6–7
Disneyland
All Because Man Wanted to Fly (film), 376
Art Corner, 291
Art of Animation exhibit, 31
Captain Eo (3D film), 426
Circle-Vision 360 attraction, 376
construction, 101
Discovery Bay (planned), 118
employee family days, 51
The Golden Horseshoe Revue attraction, 38
Imagineering team, 36
The Island at the Top of the World dioramas, 118
Magic Eye Theater, 426
Main Street Electrical Parade, 197–198
musicals, 45
Pirates of the Caribbean, 14, 36
planning phase, 17
Walt Disney's focus on, 29, 63
Disneyland (television show), 38
Disneyland After Dark (television special), 51
Disneyland Goes to the World's Fair, 38
Disney MGM Studios theme park, 443
Disney Miller, Diane, 27, 32, 332
Disney News magazine
Algar on nature films, 113
The Black Cauldron article, 401–402
on Disney (Roy E.), 398
Eisner and Wells article, 410, 412
Eisner on *Captain Eo* (3D film), 426
on *The Island at the Top of the World*, 99
Lange interview, 352
Miller on *Einstein*, 318
Miller on state of the Studio (1972), 93
Miller on Touchstone Films, 364
on *Pete's Dragon*, 198
on Tait's career, 183
Tex article, 331–332
The Watcher in the Woods teaser, 283
Yates as vice president and executive producer
of television, 283
Disney on Film (college tour and film), 284, 285–289, 291, 318
Disney Original Art Program, 291–292
Disney Slugs (baseball team), 235
Disney Studios. *see* Walt Disney Studio
The Disney Sunday Movie (television series), 422–423, 426–427
Disney TV Animation, 408
Distribution Department, 180
Doctor Dolittle (musical), 43
Doctor of Doom (Burton film), 234

DISNEY IN-BETWEEN

483

Dolby Stereo, 325
Donald Duck (character), 65, 302, 303, 376
Donald Duck Orange Juice commercials, 303
Don Bluth Productions, 230
Donovan's Kid (television film), 221
Double Indemnity (film), 101
Double Trouble (film project). *see No Deposit, No Return*
Douglas, Kirk, 273, 425
Douglas, Peter, 273
Dover, Bill, 24, 48
Down and Out in Beverly Hills (film), 387, 412, 420, 421
Dragnet (television series), 73
Dragonslayer (film), 274, 287, 309–310
Dreyfuss, Richard, 288, 420, 421
Duck Tales (television series), 408
Duckwall, Don, 126–127, 189, 231
Dumbo (animated feature), 18
Dumbo (live-action remake), 439
Dunaway, Faye, 42
Duvall, Shelly, 287
Dyer, Lee, 335
Dynasty (television series), 382

E

Easy Rider (film), 57–60, 58, 105, 405, 407
Ebert, Roger, reviews by
 The Black Cauldron, 402
 The Black Hole, 246
 Condorman, 311
 The Fox and the Hound, 310
 The Journey of Natty Gann, 417
 Midnight Madness, 253
 Night Crossing, 324
 The North Avenue Irregulars, 222
 One Magic Christmas, 417, 419
 The Secret of NIMH, 328–329
 The Shaggy D.A., 167
 Tron, 329
 The Watcher in the Woods, 317
Eckemyr, Agneta, 119
"The Eddie Show," 264, 264–265, 358–359
Eight-Ball Express (film project), 48
Eight Is Enough (television series), 297
Einstein (film project), 288, 318
Eisenmann, Ike, 117–118, 209, 221
Eisner, Michael
 assessment of assets and departments, 381–382, 388
 Captain Eo, 426
 changing Disney atmosphere, 381
 courted by Miller, 366, 378
 as Disney CEO, 378–381, 380, 410, 412
 Disney (Walt) comparisons, 379
 The Disney Sunday Movie (television series), 422–423
 Disney TV Animation, 408
 Dragonslayer, 274
 elimination of departments and staff, 381–382
 film output goals, 410, 412
 Gong Show (pitch sessions), 412, 445
 The Great Mouse Detective (formerly *Basil of Baker Street*), 388–390, 414, 417, 451

Hollywood Pictures, 431
 ignorance of animation process, 380
 Miramax, 431
 as Paramount Pictures CEO, 274
 Popeye, 274
 reinvigorating live-action division, 378–380
 Touchstone Films/Touchstone Pictures, 421, 431, 444
 Who Framed Roger Rabbit, 385
 Young Sherlock Holmes, 389, 415
Eisner, Will, 441
Elam, Jack, 73, 77, 153, 211
The Electric Company (television series), 131
Elfego Baca (television series), 48
Ellenshaw, Christine, 286
Ellenshaw, Harrison
 The Black Hole, 200–201, 221, 222
 The Disney Family Album, 376
 Disney on Film (college tour), 286
 family ties, 158
 Something Wicked This Way Comes, 333, 336
 Tron, 256–257, 260, 287
Ellenshaw, Peter, 200
 Academy Awards and nominations, 199
 Bedknobs and Broomsticks, 199
 The Black Hole, 199–200, 210–211, 221, 222, 245, 247, 248
 The Disney Family Album, 376
 family ties, 158
 The Island at the Top of the World, 199
 Mary Poppins, 199
 memoir, 200
 Museum of Modern Art exhibition, 245
 painting by, 100
Emerson, John, 254
Emil and the Detectives (film), 48
The Emperor and the Nightingale (proposed short subject), 307
The Emperor's New Groove (film), 6, 434, 435, 446
Enchanted (film), 436
Engel, Jules, 96–97
Engman, Andy, 23–24
EPCOT Center, 198, 293–294, 364, 426
Ephron, Delia, 354
Ermine, David, 249, 272, 273
Escapade in Florence (television special), 38, 48
Escape From New York (film), 310
Escape to Witch Mountain (film)
 cast, 117–118, 126, 221
 Courtland as producer, 168
 E.T. compared to, 327
 Hough as director, 116–118
 release, 121
 sequel (*see Return From Witch Mountain*)
 success, 130
 television remake, 283
Estevez, Emilio, 331
E.T. (film), 327, 348
European Disneyland, 364
Evans, Robert, 274
The Exorcist (film), 104, 110, 237
Experimental Prototype Community of Tomorrow, Florida, 14
extremes (animation), 10–11

F

Fabray, Nanette, 296
The Facts of Life (television series), 221
Family Affair (television series), 52
The Family Band. see The One and Only, Genuine, Original Family Band
The Family Circus (comic strip), 96
Fantasia (film)
 artists, 97, 127, 347
 Musicana as follow-up, 216–217
 rerelease, 325, 326
 "The Sorcerer's Apprentice" segment, 37
 story men, 139
 success, 18
Fantasia 2000 (film), *429*, 435, 444
Fantasy Island (television series), 382
Farmiloe, Rick, 378, *391*
Father Christmas. see One Magic Christmas
"Feed the Birds" (song), 89, 199
Ferguson, Norm, 291
Fiddler on the Roof (film), 91
Fiedler, John, 339
Field, S.S., 54
Filmation animation studio, 88, 95, 124, 175
Finch, Christopher, 123
Fisher, Carrie, 427
Fisher, Eddie, 264, *264*, 358
Fisk, Jack, 342–343
Fitzgerald, Ella, 217
Five Mile Creek (The Disney Channel live-action series), 363
The Flight of the Grey Wolf (television film), 167
Flight of the Navigator (film), 425
Florida, 14. *see also* EPCOT Center; Walt Disney World
The Flying Nun (television series), 168
Flynn, Joe, 73
Follow Me, Boys! (film), 38, 41
Fonda, Peter, 57, 58, *58*, 105
Ford, John, 51
Ford v Ferrari (film), 423
Forrest, Steve, 77, *79*
Forster, Robert, 217, 244
For Your Eyes Only (film), 310
Foster, Jodie
 background, 134
 Christmas at Candleshoe, 149, *149*
 on Disney loyalty, 126
 Freaky Friday, 134, *170*, 171–172
 Menace on the Mountain, 134
 Napoleon and Samantha, 134
 One Little Indian, 102, *103*, 134
 Taxi Driver, 134
Fox. *see* 20th Century Fox
Fox, Michael J., 385
The Fox and the Hound (film)
 actors, 310
 animators, 6, 190–191, *196*, 196–197, 202, 204–205, 216, 219, 224–225, 227–228, 229, 231–233, 239, 242–243, 263
 cast, 219
 climactic sequence, 241–242
 directors, 213–215, *214*, 224, 303–304
 in *Disney Animation* (Thomas and Johnston book), 285

in *Disney on Film*, 287, 288–289
 internal tensions, 215–216, 224–225, 228, 276, 298, 369
 live-action reference, 214, 225
 mass resignation of artists, 231–232
 multiplane shot, 358
 Nordberg as supervising animator, 204
 opening sequence, 232
 plans for, 180
 release, 310
 reviews, 310
 songs, 213–214, *214*, 288
 story, 201–202, *205*, 239–241, 275
 writers, 197
Frances (film), 352
Francis (Tea Room proprietor), 265
Frankenberger, Sue, 243
Frankenweenie (film), 384, *384*, 439
Freaky Friday (film), 133–134, 167, *170*, 171–172, 198
Freaky Friday (Rodgers book), 133
Freeman, David, 346
The French Connection (film), 91
French New Wave, 42
Fritz the Cat (animated film), 175
Frozen (film), 435–436, 447
Frozen 2 (film), 435–436
Frye, Chad, 220
"full animation" (technique), 65
Funicello, Annette, 38
Fun with Mr. Future (short film), 294–295, 336, 355
Future Tense (proposed anthology show), 353
Fuzzbucket (television film), 423

G

Gabor, Eva, 74, *75*
Gabor, Zsa Zsa, 358
Gabriel, Mike
 Academy Award nominations, 435
 The Black Cauldron, 370, 373, 382
 The Disney Channel puppet show pilot, 354
 Disney Slugs (baseball team), 235
 on Eisner and Wells, 379
 EPCOT Center promotional films, 294
 The Fox and the Hound, 241, 242
 hired by Studio, 218, 234
 on Lasseter, 234–235
 later career, 435
 Luau, 234, 243, 251
 photos by, *265*, *387*
 on upheaval and internal shifts, 378
 wanting to reclaim Disney, 235, 241, 437
Gallico, Paul, 105
The Game of X (Sheckley novel), 207, 311
Gang, Tyre & Brown (law firm), 176
Gann, Ernest K., 206
Ganz, Lowell, 341, 342
Garner, James, 73, 102–104
Garris, Mick, 423
Gaskill, Andy
 Animation's old guard and new blood, *141*
 The Fox and the Hound, 191
 Giaimo as assistant, 224

as trainee, 112, 174
Tron, 258, 259
The Watcher in the Woods, 254
Winnie the Pooh and Tigger Too, 109
Gausman, Hal, 53
gender bias, 111, 184–186
George, Jim, 109, 141
Geppetto (character), 86–87
Geronimi, Clyde, 36, 435
Gerry, Vance
 The Black Cauldron, 277–278, 298
 career overview, 135, 447–448
 death, 448
 The Fox and the Hound, 205
 The Great Mouse Detective (formerly *Basil of Baker Street*), 373, 374, 388–389
 The Jungle Book, 135
 Mattinson and, 135, 139, 146
 Reitherman and, 135, 139
 The Rescuers, 146
 The Small One, 188
 Story Department, 447–448
Get a Horse! (short), 434, 447
Get Smart (television series), 51, 133
Ghertner, Ed, photos by, 264, 266, 267
The Ghosts of Buxley Hall (television film), 283
Giaimo, Mike
 animation test, 277
 on backlot, 265
 The Black Cauldron, 277, 278, 280, 281, 294
 as CalArts student, 165
 caricatures by, 224
 Christopher Columbus story, 386–388
 "The Eddie Show," 264, 264–265, 358–359
 on Eisner, 412
 Fun with Mr. Future, 294–295
 Gong Show, 412
 hired by Studio, 212, 212
 as inbetweener, 224
 on Katzenberg, 387–388, 412
 later career, 435–436
 Sport Goofy, 363, 386
 on Studio being stuck in the past, 212, 213, 235
 Who Framed Roger Rabbit, 337, 342, 385
Gielow, Tad, 410
Gilliam, Terry, 293
Gilligan's Island (television series), 51, 74, 133
Ginsberg, Allen, 41
Giraud, Jean "Moebius," 259, 287
Gish, Annabeth, 426
The Gnome-Mobile (live-action film), 37, 39, 51, 66
The Godfather Part II (film), 271
Gold, Stanley, 176, 378
Golden Globes and nominations
 Foster, Jodie, 172
 Harris, Barbara, 133, 172
 Jarrott, Charles, 116
 Kasha and Hirschhorn, 198
 Lansbury, Angela, 91
 Leachman, Cloris, 101
 Pete's Dragon, 198
 Splash, 365

Williams, Robin, 431
The Golden Horseshoe Revue (Disneyland attraction), 38
The Golden Horseshoe Revue (*Disneyland* episode), 38
Golden Oak Ranch, 17, 61, 62, 159, 270, 315
Goldman, Gary
 Animation Department publicity photo, 194
 Animation's old guard and new blood, 141
 Bluth, Pomeroy, and, 137, 147–148, 192, 438
 Cook and, 147–148
 promoted to animator, 109
 resignation from Disney, 228
 The Small One, 191
 as trainee, 95
 Winnie the Pooh and Tigger Too, 109
Gombert, Ed
 Animation's old guard and new blood, 141
 EPCOT Center promotional films, 294
 The Great Mouse Detective (formerly *Basil of Baker Street*), 416–417
 Mickey's Christmas Carol, 302, 306, 307
 Sport Goofy, 362
Gone Are the Days (The Disney Channel film), 376
Gong Show (pitch sessions), 412–413, 433, 445
The Goodbye Girl (film), 421
Good Morning, Vietnam (film), 430, 431
Goof Troop (television series), 445
Goofy (character), 86, 363–364
A Goofy Movie (film), 436
The Goonies (film), 400, 427
Goral, Eddie, photos by, 144, 371
Gordon, Gordon, 21
Gordon, Steven, 72, 152, 278, 396–397
Gottfredson, Floyd, 22
Gould, Elliot, 296
The Graduate (film), 43
Graham, Don, 62
Grammy Awards and nominations, 133, 154
Grand Theft Auto (film), 78
Grauman's Chinese Theater, 177, 181
Grazer, Brian, 341, 342
Grease (film), 366
The Greatest American Hero (television series), 349
"The Greatest Star of All" (song), 132
The Great Gatsby (film), 273
"Great Moments with Mr. Lincoln" (Disney theme parks attraction), 295
The Great Mouse Detective (formerly *Basil of Baker Street*)
 advertising, 423–424
 An American Tail comparisons, 427
 animation photo transfer, 377
 animators, 202, 390, 408, 416, 436
 budget, 388–389, 414–415
 computer animation, 410, 411
 crew, 434
 deleted sequences, 407–408
 Eisner and Katzenberg's review, 388–390
 expression sheet, 411
 initial pitch, 373–374
 Katzenberg's meddling, 388, 414–415, 416, 423, 433
 leadership, 389–390, 393, 414–415, 424
 music, 374, 415
 open collaboration, 409

486 INDEX

production stills, *424*
recording sessions, *391*, 391–392
release, 423
reviews, 423
significance in Disney animation, 424, 451
storyboards, *375*
story development sketches, *374*
title, 415, *416*, 423
voice actors, *375*, 390–392, *391*, *393*, 415–416
The Great Muppet Caper (film), 310
Green, Clifford, 345–346
Green, Ellen, 345–346
Green, Howard
 Baby, 367
 The Black Cauldron, 401, 402
 Bluth and, 439
 Disney on Film (college tour), 285, *286*
 Herbie Goes Bananas, 239
 hired by Studio, 165–166
 photos by, *214*, *219*, *272*, *283*, *286*, *333*
 Publicity Department, 180–182
 Something Wicked This Way Comes, 316
Green Acres (television series), 74, *75*
The Grey Fox (film), 419
Greyfriars Bobby (film), 115
Griffith, Andy, *75*
Griffith, Don, 135–136, 138, 302
Gross Gallery, 110
Groundlings (improv troupe), 443
Guedel, Heidi
 Animation Department publicity photo, *194*
 Animation's old guard and new blood, *141*
 Banjo the Woodpile Cat, 191–192
 Bond and, 184–185
 The Fox and the Hound, 216, 229
 on gender bias, 184–186, 191
 on Kahl, 145
 memoir, 110, 216, 229
 resignation from Disney, 228–229
 Robin Hood, 96
 The Small One, 191
 as trainee, 95–96, 109–110
 Winnie the Pooh and Tigger Too, 109–110
Guess Who's Coming to Dinner (film), 43
Gun Shy (television series), 283
Gunsmoke (television series), 67, 102, 297
Gwillim, David, *119*

H

Haas, Charlie, 271, 332
Hackett, Buddy, 114
Hahn, Don, *152*
 Animation Department civil war, 195
 on assistand director role, 215–216
 Beauty and the Beast, 438
 The Black Cauldron, 372, 434
 on Bluth, 192, 230–231
 on Katzenberg, 414
 later career, 434
 Morgue, 151–152, 156–157
 Oscar nomination, 434

on Schneider, 414
on Studio as sleepy, 125
Hajee, Bill, *141*, *194*
Hale, Joe
 Bedknobs and Broomsticks, 160
 The Black Cauldron, 273, 276–277, 279–281, 304, 305,
 369–370, 373, 383, 398, 401–402
 Disney (Walt)'s death and, 13
 as generation gap example, 336
 Gong Show, 412–413
 The Great Mouse Detective (formerly
 Basil of Baker Street), 373
 It's Tough to Be a Bird, 64, 65
 Katzenberg and, 398
 let go from Disney, 413
 Mary Poppins, 160
 on Mattinson, 300
 Pete's Dragon, 160–162, *161*, 163–164
 retirement, 437
 The Watcher in the Woods, 254, 276–277
Half a Sixpence (musical), 43
Hamada, Terry, 243
Hamm, Sam, 262
Hammer Films, 296
Hamner, Earl, 39
Hanks, Tom, 365
Hanna-Barbera, 124, 175, 446
Hannah, Daryl, 365
Hannah, Jack, 122
Hansel and Gretel (The Disney Channel special), 354
Hansel and Gretel (musical), 45, 47
Hansen, Dan, 135–136, 299, 369–370, 409, 435
Hansen, Ed, *371*
 Animation Department discord, 145, 225, 228–230,
 360, 371
 The Black Cauldron, 298
 The Brave Little Toaster, 360
 Giaimo and, 277
 The Great Mouse Detective (formerly *Basil of Baker Street*),
 373, 389, 390
 Mickey's Christmas Carol, 305
 retirement, 413
The Happiest Millionaire (musical), 44, *44*, 45, 48, 101, 121, 433
Happy Days (television series), 366
Harper, Valerie, 133
Harris, Barbara, 133–134, 171–172
Harris, Leon, 254
Harris, Phil, 74, 145, *214*
Hartman, David, *119*
Hartman, Phil, 443
Harvey, Chuck, *141*, *194*
Haskett, Dan, 187, 191
The Haunting (Wise story), 237
Have Gun—Will Travel (television series), 51, 52–53
Hawley, Lowell, 47
Hawthorne, Nigel, 372
Hayes, Helen, 114, *114*, 149
Hays, Robert, 323, 340
Hayworth, Rita, 53
Hee Haw (television series), 74
Heinrichs, Rick, 254, 277, 282, 283
Hello, Dolly! (musical), 43

Help Wanted: Kids (television film), 423
Hench, John, 448
Henn, Mark
 The Black Cauldron, 368, 370, 373, 398, 451
 The Fox and the Hound, 263
 The Great Mouse Detective (formerly *Basil of Baker Street*), 390, 407, 409
 on Katzenberg, 427
 on Larson, 436
 as legendary animator, 434
 Mickey's Christmas Carol, 306, 307, 359–360
 as Studio trainee, 262, 263
Henry, Justin, 353
Hepburn, Katharine, 149
Herbie, the Love Bug (television series), 283, 297
Herbie Goes Bananas (film), 181, 220, 238–239
Herbie Goes to Monte Carlo (film), 168, 181
Herbie Rides Again (film), 99, 114, *114*
Hercules (film), 435, 445, 447
Hero From Otherwhere (film project), 353
Herrmann, Bernard, 274
Hester, Mark, 417
Hibler, Chris, 183, 200, 210
Hibler, Winston
 career overview, 38
 death, 167
 family on lot, 158, 180
 live-action films, 37, 38, 40
 retirement, 115
 Space Probe One, 115, 183
Hill, Albert Fay, 183
Hill, Walter, 273
Hinton, S.E., 271, 289, 331–332, 335
hippie movement, 42, 57–60
Hirschhorn, Joel, 131, 132, 153–154, 198
Hitchcock, Alfred, 53
Hocus Pocus (film), 423
Hogan's Heroes (television series), 66
Hog Wild (television movie), 168
Holloway, Sterling, 339
Hollywood Boulevard (film), 289
Hollywood Pictures, 431
Hollywood studio system, 19, 21, 270
Home on the Range (film), 448
Honeysuckle Rose (film), 352
Hope, Bob, 138
Hoppe, Rick, 306
Hopper, Dennis
 Easy Rider, 57, 58, *58*, 60, 105, 405, 407
 My Science Project, 405, 406, 407
Horner, James, 336
Hoskins, Bob, 432
Hotel (television series), 297
Hot Lead and Cold Feet (film), 166, 211, *211*–212, *267*
Hough, John
 The Black Hole (*Space Probe One*), 130, 200, 209
 Escape to Witch Mountain, 116–118, 130
 The Legend of Hell House, 237
 Return From Witch Mountain, 209
 The Watcher in the Woods, 236–237, 254, 255
Howard, Clint, 77, *79*
Howard, Jean, 77

Howard, Rance, 77, 78
Howard, Ron
 The Andy Griffith Show, 74, *75*, 77
 Cocoon, 400
 Night Shift, 341
 Splash, 341–342, 365
 Who Framed Roger Rabbit, 342
 The Wild Country, 77–78, *79*
How to Hook Up Your Home Theater (short), 447
Hulett, Steve, 278, 280, 287, 288, 339, 373
The Hunchback of Notre Dame (film), 434, 436
Hunter, Tim, 271, 289, 332
Hurt, John, 324
Hyperion Studio/Hyperion Pictures, 342, 361, 436, 442, 444

I

"I Am Woman" (song), 154
I Captured the King of the Leprechauns (television special), 38
Ice Age (film), 313
Icebound Summer (Carrighar book), 112
"I'd Like to Be You for a Day" (song), 198
The Illusion of Life (Thomas and Johnston book). *see Disney Animation: The Illusion of Life*
Imi, Tony, 236
The Incredible Journey (animal feature), 37, 53
Industrial Light and Magic, 347
Ingham, Barrie, 375, 390
Ingram, James, 427
Ink and Paint Building, 185, 265
Ink and Paint Department, 82–83, 152, 336, 414
Innes, Michael, 148
The Innocents (film), 273, 332
In the Heat of the Night (film), 43
In the Night Kitchen (Sendak book), 358
Invitation to the Dance (film), 272
In Which Pooh and Piglet Go Hunting and Nearly Catch a Woozle (Milne story), 108
The Island at the Top of the World (live-action film), 99, 100, 118–119, *119*, 158
The Istanbul Express (film project), 207
It's a Small World, 213
It's Tough to Be a Bird (animated short), 63, 64, 65, 75
"It Won't Be Long 'Til Christmas" (song), 45
Iwerks, Don, 270
Iwerks, Ub, 82, 270

J

Jackson, Jay, 243
Jackson, Michael, 388, 426
Jackson, Wilfred, 36, 435
Jaeckel, Richard, 238
James and Giant Peach (Dahl book), 277
Jarrott, Charles, 116
Jaws (film), 177–178, 421
Jefferds, Vince, 181
Jesus Christ Superstar (rock musical), 132
Jeup, Dan, 362
Jiminy Cricket (character), 338, 356
Jimirro, Jim, 442

Jittlov, Mike, 287
Jiuliano, Emily, *141, 194*
Joanne (Ed Hansen's assistant), 371, *371*
Joel, Billy, 433
Johnson, Lynn-Holly, 255
Johnston, Ollie
 Animation's old guard and new blood, 7, *141*, 180, 206, 213, 263
 The Black Cauldron, 179–180, 196
 CalArts and, 97
 caricature, *14*
 Clements and, 110–111
 Cook and, 147
 as directing animator, 36, 109
 Disney Animation: The Illusion of Life (book), 263, 285, 290–291, 427
 Disney (Walt)'s death and, 13, 30
 The Fox and the Hound, 190–191, 196, *196*–197, 202, 204
 Kahl and, 146
 Keane as assistant, 147, 291
 Kierscey and, 71
 Mattinson and, 87, 93
 as mentor, 71, 87, 93, 144
 The Rescuers, 136, 146, 155–156, 173, 215
 retirement from animating, 202–203
 Robin Hood, 84, 87, 93
 self-caricature, *92*
 story development, 138
 Thomas (Frank) and, *144*
 Winnie the Pooh and Tigger Too, 109
 work schedule, 142
"Jolly Holiday" (song), 89
Jones, Anissa, 52
Jones, Chuck, 385, 386
Jones, Dean
 Blackbeard's Ghost, 38
 Herbie, the Love Bug, 297
 The Love Bug, 59, 60, 61
 The Million Dollar Duck, 266
 Monkeys, Go Home!, 39
Jones, Tom, 181
Journey Back to Oz (animated feature), 175
The Journey of Natty Gann (film), 417, *418*
A Journey to Matecumbe (Taylor book), 48
Juiliano, Emily, 191
The Jungle Book (animated feature)
 animators, 29–30, 37
 leadership, 36, 37, 127
 performers, 74, 77
 release, 39
 scenes reused in *Robin Hood*, 129
 storyboards, 135
 success, 67–68
Junior Bonner (film), 183
Jurassic Park (film), 440
Justice, Davey, 55

K

Kael, Pauline, 43
Kahl, Milt
 The Black Cauldron, 298, 299
 CalArts and, 97, 123
 caricature, *14*
 character traits, 13, 144–146
 as directing animator, 36, 109
 Disney (Walt)'s death and, 13
 fortieth anniversary party, 142–143
 Johnston and, 146
 as mentor, 93, 109–110, 144
 Michener assisting, 29, 83, 144–145
 Reitherman and, 129, 145–146
 The Rescuers, 136, 145–146, 215
 rivalries, 143
 self-caricature, *97*
 sexism, 110, 191
 story development, 138
 Thomas (Frank) and, 146
 Winnie the Pooh and Tigger Too, 109–110
Kasha, Al, 131, 132, 153–154, 160, 198
Katt, William, 349
Katzenberg, Jeffrey
 assessment of assets and departments, 388
 The Black Cauldron, 382–384, 403, 412
 character traits, 414
 Christopher Columbus story, 387–388, 390
 Gong Show (pitch sessions), 412–413, 445
 The Great Mouse Detective (formerly *Basil of Baker Street*), 388–389, 414–415, 416, 417, 433, 451
 Hollywood Pictures, 431
 ignorance of animation process, 380, 383
 learning about/commitment to animation, 427–428, 433–434
 Miramax, 431
 reinvigorating live-action division, 378–380
 Touchstone Films/Touchstone Pictures, 421, 431, 444
 as Walt Disney Studios chairman, 378–380, *380*
 Who Framed Roger Rabbit, 385
 Young Sherlock Holmes, 389, 415
Kaufman, Phillip, 368
Kay, Alan, 227
Keane, Bil, 96
Keane, Glen, *227*
 animation inspiration, 227–228
 Banjo the Woodpile Cat, 137, 175
 The Black Cauldron, 179, 196, 202, 279, 280, 305, 451
 Bluth and, 137, 173–174, 175
 at CalArts, 96, 111
 computer animation, 358
 in *Disney Animation* (book), 291
 Disney on Film, 287, 289
 The Fox and the Hound, 190–191, 204–205, 216, 227–228, 232–233, 241–242, 263, 287, 289, 358
 The Great Mouse Detective (formerly *Basil of Baker Street*), 202, 375, 390, 411
 Henn as assistant, 263
 as inbetweener, 136
 as Johnston's assistant, 147, 196, 202, 291
 on Katzenberg, 427
 Larson and, 111, 136, 437
 as legendary animator, 434
 Mickey's Christmas Carol, 305, 306, 307, 308
 Nine Old Men and, *141*, 143, 206
 Pete's Dragon, 173–174

Pocahontas, 438
Pomeroy and, 136, 228, 438
on Reitherman, 127, 140, 204–205, 217
The Rescuers, 136, 146, 173
The Small One, 189, 190
on Thomas and Johnston, 142
as trainee, 111–112, 136
Where the Wild Things Are (animation test), 358, 360, 410, 441
Keane, Max, 305, 307
Keene, Glen, 7
Kelly, Gene, 159, 272
Kelsey, Dick, 70
Kennedy, John F., 42
Kerouac, Jack, 41
Kesey, Ken, 262
Key, Alexander, 116
Kidder, Margot, 323, *340*
Kierscey, Ted, *72*
 Animation's old guard and new blood, 71, *141*
 as head of small effects department, 263
 on Kahl, 145
 on Kimball's retirement, 104
 Morgue visit, 86–87
 special-effects animation, 86–87
 as trainee, 71, 84, 86
Kiesser, Jan, 335
Kimball, Ward
 Academy Award, 65
 Adventures in Music: Melody, 63
 animation style, 294
 Bedknobs and Broomsticks, 76, 91
 caricature, *14*
 Dad, Can I Borrow the Car?, 75–76
 as director, 36
 It's Tough to Be a Bird, 63, *64*, 65
 The Magical World of Disney (television series), 63
 The Mouse Factory, 94–95
 Pacifically Peeking, 65
 Pinocchio, 63
 retirement, 104, 205
 A Salute to Alaska, 63, 65
 Scrooge McDuck and Money, 65
 as staunch nonconformist, 63, 65, 104, 277
 with team, *64*
 Toot, Whistle, Plunk and Boom, 63
King, Bob, 181
King, Hal, 203, 204
King, Martin Luther, Jr., 42
King Kong (1976 remake), 348, 352
Kirk, Tommy, 38
"Kiss the Girl" (song), 433
Kletter, Richard, 262
Knight Rider (television series), 221
Knots Landing (television series), 382
Knotts, Don, 74, *75*, 120, 121, 125, 211
Koch, Ed, 359
Koch, Howard W., 287
Kodak, 426
Kodaliths, 260, 261
Kolchak: The Night Stalker (television series), 297
Korman, Harvey, 238, 376

Kostal, Irwin, 131, 198, 325, 325–326, 359, 374
Koth, Brett, 362
Kovacs, Laszlo, 59
Kress, Earl, 197
Kroyer, Bill
 Bluth and, 193
 The Fox and the Hound, 191, 226, 310
 leaving Disney, 226
 Lisberger Studios, 226
 as trainee, 187
 Tron, 258, 259, 312, 312–313, *313*
Kroyer, Sue, *243*
Kubrick, Stanley, 349
Kuri, Emile, 53
Kuri, John, 121, 125
Kurtz, Gary, 343–344, 367, 441
Kushner, Donald, 256

L

Ladd Company, 341
Lady and the Tramp (animated feature), 15–16, 127, 203, 281
Lakota, 274
Lancaster, Burt, 425
Landau, Richard, 115
The Land Before Time (film), 438
Landis, John, 342
The Land of Oz (Baum book), 292
Lane, Chris, 135
Lange, Jessica, 352, 382
Langley, Noel, 54
Lanpher, Dorse, *141*
Lansbury, Angela, 71–72, 88, 89, *90*, 91
Lanzisero, Joe, *123*
Larson, Eric
 Animation's old guard and new blood, 7, *141*
 Bambi, 143
 caricature, *14*
 character traits, 13, 187–188
 Christopher Columbus story, 388
 as directing animator, 36, 109
 Disney (Walt) and, 143
 Disney on Film (college tour), *286*
 Disney (Walt)'s death and, 13
 It's Tough to Be a Bird, 65
 The Jungle Book, 29–30
 Keane and, 111, 136
 Kierscey and, 71
 Mattinson and, 29–30, 94, 188, 308, 309
 Mickey's Christmas Carol, 308
 101 Dalmatians, 29
 retirement, 436
 Sleeping Beauty, 188
 The Small One, 188–190, 191
 The Sword and the Stone, 29
 training program, 94, 95, 110, 111, 122, 136, 137, 140, 144, 155, *187*, 187–188, 203, 213, 262–263, 436–437
 Winnie the Pooh and Tigger Too, 109
Lasseter, John
 The Black Cauldron, 278–279
 The Brave Little Toaster, 360–361, 442
 burning bridges, 357, 360

Burton and, 281
as CalArts student, 122, *123*, 155, 165, 234, 287
computer animation, 357, 360–361
The Disney Family Album, 353, 357
Disney on Film, 287
Disney Slugs (baseball team), 235
fired from Studio, 360, 451
The Fox and the Hound, 241
Giaimo and, 277
hired by Studio, 234–235
Mickey's Christmas Carol, 306, 356–357
Musicana, 357
Nightmare, 287
Pixar, 361, 440
Toy Story, 440, 451
Where the Wild Things Are (animation test), 358, 360, 410, 441
Wilhite and, 281, 357
The Last Flight of Noah's Ark (film), 207, 235, 296
The Last Picture Show (film), 91
The Last Starfighter (film), 440
Laverne and Shirley (television series), 366
Lay, Tom, 135
Leachman, Cloris, *98*, 101, 238
Leave It to Beaver (television series), 121
Lee, Christopher, 209–210, *210*
Lee, Danny, 117, 221
Lee, Michelle, 60, *61*
Leetch, Tom
 career after Disney, 382
 Freaky Friday, 167
 Night Crossing, 235–236, 323
 One Little Indian, 167
 The Secrets of the Pirate's Inn, 53, 167
 Snowball Express, 167
 The Watcher in the Woods, 236–237
Lefler, Doug, 6, *123*
The Legend of Hell House (film), 116, 237
The Legend of Lobo (animal feature), 37
Leibovitz, Annie, 6
Lelean, Vera, 185
Leslie, Robert Franklin, 114
Levy, Eugene, *365*
Life with Louie (television series), 444
Lima, Kevin, 436
"limited animation" (technique), 65
Lindsey, George, 74
The Lion King (film), *434*, *435*, *436*, *437*, *438*, 446, 447, 451
Lisberger, Steven
 Lisberger Studios, 226–227, 256, 257
 Tron, 226–227, 256–260, 287, 313–314, *315*, 318, 320, 329, 331, 334–335, 440
Lisberger Studios, 226–227, 256, 257
The Little Matchgirl (short), 444, 445
The Little Mermaid (film), 413, *433*, *435*, *436*, *437*, *438*, 441, 451
Little Shop of Horrors (off-Broadway hit), 433
The Littlest Horse Thieves (film), 116
The Living Desert (documentary film), 21–22
Lloyd, Peter, 259
Logan (film), 423
Logan, Bruce, 257
Lorenzo (animated short), 435

Lorraine (Reitherman's secretary), 151
Los Angeles Conservatory of Music, 62
The Los Angeles Times, 152, 166–167, 271
The Lost Ones (Cameron novel), 99
Lounsbery, John
 Baer and, *94*, 106, *140*, *142*
 Bluth and, 28–29
 caricature, *14*
 death, 151
 as directing animator, 36
 as director, 106, *150*
 health issues, 140
 The Jungle Book, 37
 Kierscey and, 71
 Larson and, *94*, 188
 as mentor, *94*, 96, 109
 The Rescuers, 140, *150*
 Sleeping Beauty, 28–29
 Winnie the Pooh and Tigger Too, 106, 109, *140*, *150*, 204
 work-life balance, 142–143
The Love Boat (television series), 382
The Love Bug (live-action film), *61*. *see also Herbie, the Love Bug; Herbie Goes Bananas; Herbie Goes to Monte Carlo; Herbie Rides Again*
 cast, 60, *61*, 89
 characters, 407
 creative team, 57–59, 72
 Easy Rider comparison, 57–61
 as franchise, 238
 photobomb, *144*
 poster, *56*
 success, 60, 121, 365
Love Leads the Way (The Disney Channel film), 376
Lovitz, Jon, 443
Luau (live-action short), 233, 234, 243, *251*
Lucas, George
 American Graffiti, 104–105, 271
 American Zoetrope (studio), 105
 Captain Eo, 426
 editorial facilities, 349–350
 Murch and, 271, 367–368
 redefining family films, 327–328
 Star Wars, 134, 178, 201, 247
 THX 1138, 105, 271
Lucille (Miller's secretary), 157
Luddy, Barbara, 339
Ludwig, Arlene, 180
Ludwig, Irving, 165–166, 180
Luske, Hamilton, 36, 63, 65, 158, 291, 435
Luske, Jim, 158
Lycett, Eustace, 221

M

MacBird, Bonnie, 227
MacDonald, James, 302, 326
MacManus, Dan, 71
MacMurray, Fred, 66–67, *98*, *99*, 101, 114
The Magical World of Disney (television series), 28, 63
The Magic Bedknob (film project).
 see Bedknobs and Broomsticks
The Magic Bedknob (Norton book), 45

DISNEY IN-BETWEEN

491

MAGI Synthavision, 312, 313, 360
Magnum P.I. (television series), 297
Main Street Electrical Parade (Disney parks attraction), 197–198
Major Effects (television special), 287
The Making of Star Wars (Rinzler book), 178
Mako (actor), 119
Malta Wants Me Dead (film). *see Trenchcoat*
Mame (Broadway show), 71
Man and the Moon (*The Magical World of Disney* television special), 63
Manchester, Melissa, 415
Mancini, Henry, 374, 415
Mandel, Babaloo, 341, 342
Mangold, James, 423
Man in Space (*The Magical World of Disney* television special), 63
Mann, Delbert, 323, 376
Mannix, Daniel P., 180
Mansbridge, John, 253, 271
Mansbridge, John B., 53, 59
Mantle, Sue, 354
The Man Who Fell to Earth (film), 201
The Many Adventures of Winnie the Pooh (feature film), 119
The Many Loves of Dobie Gillis (television series), 73
Margolin, Leslie, 122, 123, 185–186
Marino, Tony, 302, 339
Marketing Department, 181, 244
Marmorstein, Malcolm, 131–132, 209
Mars and Beyond (*The Magical World of Disney* television special), 63
Marshall, Sean, 154–155, 159–164, 163, 197–198
Martin, Pete, 32
Marty (film), 323
Mary Poppins (live-action film)
 Academy Awards and nominations, 382
 cast, 89
 combining live-action with animation, 160, 162
 creative team, 38, 57, 58, 59, 72, 89
 leadership, 38, 51
 music, 45, 89, 199, 325, 325
 personality, 89
 Pete's Dragon comparisons, 198–199
 premiere, 62
 publicity campaign, 198
 rerelease, 255
 success, 44, 121, 365
The Mary Tyler Moore Show (television series), 73–74
Maslansky, Paul, 344, 367
Matthews, Junius, 339
Mattinson, Burny
 on Anderson (Ken), 81
 Animation Building floorplan sketch by, 26
 on Animation Department, 395
 The Black Cauldron, 298–300, 382, 402, 451
 Bluth and, 439
 on Bond, 184
 character traits, 300, 304
 Christopher Columbus story, 388
 on Cleworth, 203, 204
 death, 448
 on Disney (Roy E.), 398–399

 on Disney (Walt), 22–23
 Disney (Walt)'s death and, 13, 15, 30, 35
 on Eisner and Wells, 379
 The Fox and the Hound, 201–202, 205, 219, 278, 303–304
 Gong Show, 412–413
 The Great Mouse Detective (formerly *Basil of Baker Street*), 373, 374, 375, 388–392, 393, 409, 414–416, 417
 high school ID card, 17
 as inbetweener, 23, 26, 29–30
 Johnston and, 87, 93
 The Jungle Book, 29–30
 on Kahl, 146
 Kierscey and, 71
 Larson and, 29–30, 94, 188, 308, 309
 later career, 447–448
 as longest full-time employee in the history of Disney, 448, 448, 449
 Mickey's Christmas Carol, 300–308, 306, 326, 356–357, 359
 on Nine Old Men, 35
 101 Dalmatians, 29
 promotion to animator, 87
 Reitherman and, 36, 127, 129, 135, 138, 148, 205, 215, 303–304, 308
 The Rescuers, 135, 146, 148, 303–304
 Robin Hood, 87, 93–94
 Sleeping Beauty, 28, 29
 The Small One, 188–189, 190
 on *Star Wars*, 178
 on Stevens (Art), 205–206
 Story Department, 135, 138–139, 447–448
 on Studio after Walt's death, 35, 36, 41
 on Studio as utopia, 17
 on Svendsen, 203, 204
 The Sword and the Stone, 29
 Thomas (Frank) and, 93–94, 134–135
 as traffic boy, 15, 16, 22–23, 381
 Winnie the Pooh and Tigger Too, 134–135
 on *Your Show of Shows*, 326
Mattinson, Sylvia, 147, 300–301
Maverick (television series), 73
May, Elaine, 133
Mayberry R.F.D. (television series), 74
McCall, Robert T., 130, 199
McCormick, Maureen, 274
McDonald, Richard, 273
McDonald's, movie tie-ins, 427
McEntee, Brian, 262, 294, 360, 442
McEveety, Annie, 51–52, 67, 103, 157, 158, 166
McEveety, Bernard, 51, 67, 88, 103, 114, 221
McEveety, Joseph, 51, 65–67, 88, 103, 157, 166
McEveety, Stephen, 157
McEveety, Vincent
 Amy, 297
 The Biscuit Eater, 88
 The Castaway Cowboy, 103
 Charley and the Angel, 99
 The Disney Sunday Movie, 427
 television work, 51, 67, 297
 The Watcher in the Woods, 255
 Westward Ho the Wagons!, 51
McGavin, Darren, 73, 211, 221

McGoohan, Patrick, 349, 367
McGowan, Tom, 36
McGreevey, John, 235–236
McGreevey, Michael, 66, 88, 235
McHale's Navy (television series), 73
McKim, Dorothy (Aronica)
 on Disney (Roy E.), 399
 Emmy Awards, 434
 Five Mile Creek, 363
 on Katzenberg, 427–428
 later career, 434
 Oliver & Company, 413
 Sport Goofy, 362, 363–364
 on Studio culture, 267, 269
 on Young (Pete), 413
McQueen, Steve, 183
McRae, Bob, 151
Mead, Syd, 259
Meet the Robinsons (film), 6, 434, 447
Menace on the Mountain (television film), 134
Men Against the Arctic (short), 38
Menken, Alan, 433
Meredith, Judi, 51
MGM Studios, 183, 227, 292, 340, 412
Michener, Dave
 on Anderson (Ken), 83–84
 Christopher Columbus story, 386–388, 390
 The Fox and the Hound, 201, 215, 219
 The Great Mouse Detective (formerly *Basil of Baker Street*), 375, 390, 393
 as Kahl's assistant, 29, 83, 144–145
 Robin Hood, 84
 Sleeping Beauty, 28, 29
Mickey and the Beanstalk (featurette), 302
Mickey Mouse (character), 18, 82, 302, 386–387, 390. *see also Mickey's Christmas Carol*
The Mickey Mouse Club (television show), 31, 38, 101
Mickey Mouse comic strip, 22, 38
Mickey Mouse Jubilee (television special), 287
Mickey's Christmas Carol (film), 300–308
 Academy Award nomination, 359
 actors, 302–303
 animation photo transfer, 376
 animators, 301–302, 305–308, 306, 356–357, 408, 435
 characters, 302–303, 305, 338, 356
 credits, 356
 crew, 356
 importance, 359–360
 music, 326
 publicity, 358–359
 release, 359
Midler, Bette, 412, 420, 421, 422
Midnight Madness (film), 253
Miles, Vera, 73, 77, 79, 103, 103
Miller, Diane Disney, 27, 32, 332
Miller, Linda, 191, 194
Miller, Ron
 allowing experimentation, 354–355
 Animation Department pranks, 371
 The Black Cauldron, 196, 281, 370
 The Black Hole (*Space Probe One*), 130, 183, 184, 199–200, 210–211, 245, 246, 250

Bluth and, 148, 174, 192, 202, 218, 230–231
The Brave Little Toaster, 360–361
card games, 346, 354, 355, 377
as CEO, 339
character traits, 131, 269
deep-sea fishing trips, 269
The Devil and Max Devlin, 296
Disney (Roy E.) and, 378
Disney (Walt) and, 27–28
efforts to broaden audience, 253
Einstein, 318
Eisner and, 366, 378
family on lot, 158
as film producer, 37, 38–39, 49, 115, 125, 167
The Fox and the Hound, 202, 215
Freaky Friday, 133, 167
The Golden Horseshoe Revue, 38
The Great Mouse Detective (formerly *Basil of Baker Street*), 373–374
hiring Berger, 343
I Captured the King of the Leprechauns, 38
The Last Flight of Noah's Ark, 207
as live-action committee member, 40
McEveety (Annie) and, 157
Mickey's Christmas Carol, 301, 304
The Misadventures of Merlin Jones, 39
The Monkey's Uncle, 39
Never a Dull Moment, 49
Never Cry Wolf, 262, 350
Night Crossing, 235, 236
Penthouse and, 186
Pete's Dragon, 131, 173
preserving family environment of Studio, 157
as president of Walt Disney Productions, 339
profit-sharing program, 270
resignation requested by board, 378
Ride a Wild Pony, 115
The Secrets of the Pirate's Inn, 167
Shaw and, 139
The Small One, 189, 190
Splash, 341, 342, 344, 361, 365
staff producers let go under Eisner and Wells, 381–382
on state of the Studio (1972), 93
Stirdivant and, 236
stockholders' meeting, 364
Studio discord and, 230–231, 370–371
television projects, 38, 49, 51
Tex, 332
Touchstone Films/Touchstone Pictures, 364, 444
Tron, 256–257, 314–315, 320
Vincent, 355
volleyball games, 268, 269
The Watcher in the Woods, 237
"What would Walt do?" inertia, 213
Who Framed Roger Rabbit, 343
Wilhite and, 247–248, 355
The Wonderful World of Disney, 91
Zorro, 38
Miller, Seton I., 54
The Million Dollar Duck (film), 266
Mills, Billy, 274
Milne, A.A., 108, 119, 339. *see also Winnie the Pooh*

Mimieux, Yvette, *39*, 218, 222
Minkoff, Rob, 436
Miracle of the White Stallions (film), 48
Miramax (production company), 431
The Misadventures of Merlin Jones (film), *39*, 66, 238
Miss Bianca (Sharp book), 106
Miss M Productions, 412
Mister Ed (television series), 303
Mister Peepers (television series), 73
Mister Rogers' Neighborhood (television series), 354
Mistress Masham's Repose (White book), 412
Moana (film), 447
Moby Duck (character), 65
Monkeys, Go Home! (live-action film), *39*, *39*, 48
The Monkey's Uncle (film), *39*, 238
Montreal International Film Festival, 43
Moon Pilot (film), 48, 51
Moore, Bill, 122
Moore, Fred, 291
Moore, Mary Tyler, 73–74
More American Graffiti (film), 250, 346
Morgan, Harry, 73, 101
Morgue, 86–87, 151–152, 156–157
"The Morning After" (song), 131
Morris, Bruce, 122, *123*, 187
Mortimer, John, 273
Motion Picture Association of America, 149, 384
The Mouse and His Child (musical), 175
The Mouse Factory (television series), 93, 94–95
Mouseketeers, 164, 221
Moviola film editing machine, 127–128, *128*, 174, 204, 206, 215
Mowat, Farley, 250, 315
Mrs. Brisby and the Rats of NIMH (O'Brien book), 328
Mueller, Peter, 226
Mulan (film), 438, 448
Murch, Walter, 271–272, 292–293, 343–344, 367–368, *368*, 400
Murder, She Wrote (television series), 297, 382
Museum of Modern Art, 245
Musicana (*Fantasia* follow-up), 216–217, 412
music morgue, 152
Musker, Gale. *see* Warren, Gale
Musker, John, *286*
 Aladdin, 443
 Animation Department publicity photo, *194*
 as animation director, 435
 on Berman, 205
 The Black Cauldron, 276–281, 370, 373, 451
 on Bluth, 193–194, 195
 with CalArts new hires, 212
 as CalArts student, 122–123, *123*, 155
 Caricature Show, 223–224, 445
 childhood, 32
 on dark moments in Disney movies, 240
 on Disney (Roy E.), 380
 Disney (Walt)'s death and, 32
 on Eisner and Katzenberg, 380
 The Fox and the Hound, 239, 241–242, 287
 The Great Mouse Detective (formerly *Basil of Baker Street*), 373–374, *375*, 388, 389, 391, *391*, 393, 409, 415, 416–417, 424
 on Hale, 277

hired by Studio, 6, *187*, 187–188
The Little Mermaid, 433
Luau, 243
on mass resignation of artists, 231
reclaiming Disney legacy, 437
on Reitherman, 128–129
on Rich, 216
The Small One, 189, 190, 191, 193–194, 195
on Spielberg and Lucas movies, 328
as Studio intern, 155
Van Citters as assistant, 224
volleyball games, *268*
Warren (Gale) and, 223–224
Mustang (*The Wonderful World of Disney* program), 99
My Fair Lady (musical), 44
My Family Is a Menagerie (Sunday night television show episode), 39
My Science Project (film), 404–407, *406*, 419
My Three Sons (television series), 52, 101

N

Nabors, Jim, 75
Nancy (television series), 168
Nankin, Michael, 253
Napoleon and Samantha (film), 88, 134
Nash, Clarence "Ducky," 303, 376
National Federation of State High School Associations, 363
National Organization for Women (NOW), 186
NBC network, 408
Neill, John Rea, 292–293, 368
Nelson, Gary
 The Black Hole, 210–211, 217–218, 246
 The Boy Who Talked to Badgers, 133
 on Disney loyalty, 126
 Freaky Friday, 133–134, 172
 Have Gun—Will Travel, 52–53
 on the Penthouse, 186
 The Secrets of the Pirate's Inn, 51, 52–53
 on *Star Wars*, 177, 178
Nelson, Jim, 177, 178
Nelson, Sam, 53
Never a Dull Moment (film), 49, *50*
Never Cry Wolf (film), 261–262, 287, 315, 324–325, 349–351, *350*
Never Cry Wolf (Mowat novel), 250, 315
Newman, David, 42
Newman, Paul, *425*, 426
The New Mickey Mouse Club (television series), 151, 164, 221
The New Republic (magazine), 43
The Newsreel (internal newsletter), 213
Newton, Brett, 243
Newton-John, Olivia, 154
Nibbelink, Phil, 289, 372–373, 382–383, 403–404, 410
Nichols, Mike, 133
Nicholson, Jack, 58
Night Crossing (film), 235–236, 322, 323–324
Nightmare (film), 287
The Nightmare Before Christmas (film), 354, 439
Night Shift (film), 341
Nikki, Wild Dog of the North (narrative nature story), 38
Nine Old Men. *see also* Clark, Les; Davis, Marc; Johnston,

Ollie; Kahl, Milt; Kimball, Ward; Larson, Eric; Lounsbery, John; Reitherman, Woolie; Thomas, Frank
caricatures, 14
as directing animators, 136–137
Disney (Walt) and, 32, 35–36, 143
The Disney Family Album, 376
last film, 310
legacy, 287
as mentors, 86, 87, 437
retirement, 217
young animators and, 6–7, 140, 141, 143
Niven, David, 124–125, 149, 149
No Deposit, No Return (film), 124, 124–125, 149, 152–153, 166, 168
Nolte, Nick, 421
Nordberg, Cliff
death, 204
The Fox and the Hound, 204
The Rescuers, 146, 147
The Small One, 188–189, 191, 193, 203
North, Sterling, 39
The North Avenue Irregulars (Hill book), 183
The North Avenue Irregulars (live-action film), 222, 266, 266
Northern Exposure (television series), 382
Norton, Bill, 346, 367, 399
Norton, John
Lisberger Studios, 226–227, 257
Something Wicked This Way Comes, 334–335
Tron, 258, 259–260, 263, 313, 314, 318–320, 329, 331, 334–335
Walt Disney Television Animation, 445
Norton, Mary, 45
NOW (National Organization for Women), 186
Nowak, Paul, 123
Now You See Him, Now You Don't (live-action film), 88, 211

O

O'Bannon, Dan, 288
O'Brien, Clay, 103
O'Brien, Robert C., 328
O'Connor, Ken, 205
O'Donnell, Tim, 306
Off Beat (film), 412, 421
O'Herlihy, Michael, 47
Old Yeller (film), 58, 168, 238, 240
Oliver! (film), 415
Oliver, Dale, 141
Oliver, Deanna, 443
Oliver & Company (film), 387, 413, 433, 435, 438
Oliver Twist (Dickens novel), 413
Olivier, Sir Laurence, 153
Ondaatje, Michael, 271
The One and Only, Genuine, Original Family Band (musical), 45, 46, 47, 51, 53, 66, 433
One by One (short), 444
One Hour in Wonderland (television program), 19
101 Dalmatians (animated feature), 29, 32, 36, 82–83, 129–130, 238
O'Neill, Jennifer, 217–218
One Little Indian (film), 102–103, 103, 134, 167
One Magic Christmas (formerly *Father Christmas*), 412, 417,
418, 419
Orville the Albatross (character), 376
Oscars. *see* Academy Awards and nominations
Oswald the Lucky Rabbit, 18
Outrageous Fortune (film), 431
Outside Over There (Sendak book), 358
The Outsiders (Hinton novel), 335
Ozma of Oz (Baum book), 292

P

pace of production, 242–243, 264
Pacifically Peeking (television episode), 65
Pacific Theaters, 336
Paine, Debbie, 69
Palmer, Ted, 87
Paniolo. see The Castaway Cowboy
Paramount Pictures, 273, 274, 309–310, 366, 389, 415
The Parent Trap, 24, 148, 180
Paris, Frank, 101–102, 115, 182–183, 207, 210, 249
Paris, Jerry, 49
The Patty Duke Show (television series), 51, 73
Pearce, Richard, 352
Peckinpah, Sam, 316
Peet, Bill, 29, 291
The Pee-Wee Herman Show (stage show), 342
Pelletier, Louis, 48
Penn, Arthur, 42–43
The Penthouse (men's-only club), 142–143, 185–186
People magazine, 245
Peraza, Mike, 302, 306, 410
Perfect Timing (project), 288
Perkins, Anthony, 217
Perri (narrative nature story), 38
Perry Mason (television series), 67
Peter Pan (animated feature), 16, 65, 193
Peterson, Ken, 23
Peterson, Vidal, 316
Pete's Dragon (musical)
animation team, 173–174, 187, 197
casting, 153–154, 211
character development sketches, 169
choreography, 154–155
combining live-action with animation, 160–163, 161, 163
Courtland as producer, 168
director, 159, 161, 164
filming, 159–164, 163, 164
Mary Poppins comparisons, 198–199
music, 131, 132, 199, 325, 433
as *Pete's Dragon and the U.S.A.*, 54–55, 131
pre-production images, 161
publicity campaign, 198
release, 197–198
set, 159, 265, 265
story, 131–132, 198–199
story sketches, 161, 165, 168, 169
success, 198
Petticoat Junction (television series), 73
Phillips, Frank, 52–53, 118, 158, 161, 253
Picker, Jimmy, 359
Pinewood Studios, England, 237, 254, 255
Pinocchio (animated feature)

DISNEY IN-BETWEEN

495

dark moments, 240
as inspiration, 15, 31, 32
Kelsey as art director, 70
Kimball as directing animator, 63
rereleases, 31, 32, 218, 384
special-effects animation, 86–87
success, 18
The Piper (Bluth's animated feature), 111, 137
Pirates of the Caribbean (Disneyland attraction), 14, 36
Pit Ponies (film project). *see The Littlest Horse Thieves* (film)
Pixar, 361, 440, 441–442
Placerita Canyon, 17
Plane Crazy (short), 151–152
Plummer, Elmer, 122, *123*
Pocahontas (film), 434, 435, 438, 445
Police Squad (television series), 422
Pollatschek, Susanne, 415–416
Pollyanna (film), 24, 148, 168, 180, 283
Poltergeist (film), 327, 333
Pomeroy, John
 Animation Department publicity photo, *194*
 Animation's old guard and new blood, *141*
 Bluth, Goldman, and, 137, 147–148, 192, 438
 Cook and, 147–148, 228
 Keane (Glen) and, 136, 228, 438
 Pete's Dragon, 173–174
 Pocahontas, 438
 The Rescuers, 136, 146, 147
 resignation from Disney, 228
 The Small One, 189, 190, 191
 Winnie the Pooh and Tigger Too, 109
Popeye (film), 274, 287
"Portobello Road" (song), 89
The Poseidon Adventure (disaster film), 115, 131, 132, 154
Powers, Stefanie, 114
Prep & Landing (television series), 434
Price, Jeffrey, 323, 340–341, *342*, 385
Price, Vincent, *283*, *375*, 390–392, *391*, *393*
Prima, Louis, 74
Prince John (character), 87
Princess and the Frog (film), 447
The Prisoner (television series), 349
product tie-ins, 181
The Proud Family (television series), 444
Provine, Dorothy, 50
Pryce, Jonathan, 316, *316*, 335
Publicity Department, 180–182, 239
Puerto Vallarta, Mexico, 238–239

R

Radio City Music Hall, 88, 197
Rafelson, Bob, 59
Raggedy Ann and Andy (animated feature), 131, 175, 186
Raggedy Man (film), 342, 352
Raiders of the Lost Ark (film), 310, 366
Rainwater, Richard, 355, 377
Rambo (film), 400
Ramones (band), 289
Randall, Florence Engel, 237
Randall, Tony, 427
Ranft, Joe, *265*, 387

The Brave Little Toaster, 360, 442
caricatures by, 224
Christopher Columbus story, 386–388
The Disney Channel puppet show pilot, 354
EPCOT Center promotional films, 294
Fun with Mr. Future, 336
Luau, 243, 251
Sport Goofy, 363
Who Framed Roger Rabbit, 337
Raponi, Isidoro, *333*, *347*, 348
Raposo, Joe, 130–131
Rascal (North book), 39
Rawhide (television series), 67
Raynor, William, 54–55
Real Genius (film), 405
Rebel Without a Cause (film), 51
Rechenberg, Otto, *297*
Reddy, Helen, 154, *154*, 159–160
Reem, Lee, 181
Rees, Jerry
 Animation Department publicity photo, *194*
 Animation's old guard and new blood, *141*, 224–225
 Back to Neverland, 443, *443*
 The Brave Little Toaster, 442–443
 with CalArts new hires, *212*
 as CalArts student, 122, *123*, 155–156
 collection, *226*
 computer oriented production system, 441
 foreword by, 6–7
 The Fox and the Hound, 224–225, 232, 241–242
 hired by Studio, 187
 Luau, 233, 234, 243
 photos by, *187*
 The Small One, 191
 "The Spirit" project, 441
 Tron, 258, 259, *312*, 312–313, *313*
 volleyball games, 268
Rees, Rebecca, 187
Reeves, Keanu, 423
Reinhold, Judge, 421, *422*
Reitherman, Woolie
 Animation's old guard and new blood, 7, 140, *141*, 203, 204–205
 The Aristocats, 36
 Berman and, 206
 Bluth and, 157, 192, 202
 caricature, 14
 as director, 36, 127–129, 308, 435
 Fantasia, 127
 The Fox and the Hound, 180, 201, 202, 204–205, 213–215, 214, 216, 219, 303–304
 Gerry and, 135
 as Goofy animator, 86
 Hahn as assistant director for, 215–216
 The Jungle Book, 37, 135
 Kahl and, 145–146
 Lady and the Tramp, 127
 Lounsbery and, 142–143, 151
 Mattinson and, 148, 303–304, 308
 Moviola use, 127–128, 204, 206, 215
 Musicana, 216–217
 101 Dalmatians, 36

as pilot, 151
as producer, 36, 127
The Rescuers, 106, 139, 145–146, 147, 155–156, 215, 303–304
retirement, 217
reusing animation, 151
Robin Hood, 81, 145, 205
role in Animation Department, 127–129
sexism, 191
Stevens (Art) and, 205–206
Story Department, 135, 138
story development approach, 138, 139
taste in filmmaking, 214–215
Winnie the Pooh and Tigger Too, 106, 204
World War II, 127
Remington Steele (television series), 212
Renegade Animation, 436
The Rescuers (animated film)
animation, 135–137, 146–147, 173, 197
characters, 238, 376
"Colonel Bullfrog" sequence, 145–146, 215
director, 150, 303–304
release, 179
rerelease, 359
sequences cut for length, 155–156
Shaw's pastels, 139–140
songs, 145–146
story, 106, 135, 140, 148, 156, 239
style and tone, 130
The Rescuers (Sharp book), 106
The Rescuers Down Under (film), 435, 441
Return From Witch Mountain (film), 208, 209–210, *210*, 238
Return to Oz (film)
characters, 293, 368, 400
leadership, 271–272, 292–293, 343–344, 367–368, *368*
release, 399–400
story, 292–293, 343
Return to Treasure Island (television miniseries), 423
Reubens, Paul, 342, 385
Rich, Rick
The Black Cauldron, 273, 276, 277, 278, 281, 294, 298, 304, 369
The Fox and the Hound, 215–216, 224, 242, 369
Gong Show, 412–413
lack of respect from young aimators, 243, 369
let go from Disney, 413
life after Disney, 437–438
The Swan Princess, 437
Richards, Kim, 117–118, 126, 209
Rick Reinert Productions, 339
Ride a Wild Pony (film), 115–116, 168
Rinaldi, Joe, 291
Rinzler, J.W., 178
Riverside School for the Deaf, 296
RKO Radio Pictures, 21
The Road Warrior (film), 327
Robards, Jason, 315–316, *316*
Robbins, Matthew, 309
Robert Abel and Associates, 245, 312
Robin Hood (animated feature)
animation team, 87, 93–94, 96, 205
concept, 81

influence on Clements, 156
lack of creativity, 130
release, 104
reuse of old animation scenes, 129, 145
reviews, 402
story and character development, 85
story team, 84, 203
Robin Hood (live-action film), 349
Robinson, Edward G., 50
Robots (film), 313
Rocco, Alex, 238
The Rocketeer (film), 435
Rock n' Roll High School (film), 289
The Rocky Horror Picture Show (rock musical), 132
Rocky III (film), 327
Rodgers, Mary, 133, 296
Roeg, Nicholas, 201
Rogers and Cowan (PR agency), 181, 245
Romero, Cesar, 73, 88
Ronstadt, Linda, 427
Rooney, Darrell, 334
Rooney, Mickey, 154, 160, 221
Roosevelt, Franklin Delano, 32
The Rose (film), 421
Rosebrook, Jeb, 182–184, 199–201, 210, 211, 221–222, 247
Ross, Herbert, 341
Rover Dangerfield (film), 444
Rowe, Tom, 36
Rumble Fish (Hinton novel), 335
Runaway Brain (film), 435
Running Brave (film), 274
Russell, Kurt
The Computer Wore Tennis Shoes (film), 66, 69
Dad, Can I Borrow the Car?, 75–76
on Disney (Walt), 41
Escape From New York (film), 310
The Fox and the Hound, 310
Medfield trilogy, 66, 114, 238
Now You See Him, Now You Don't, 88
The Thing, 310
Ruthless People (film), 421–422, *422*

S

Sabin, Amy, 243
Sabin, Harry, 123, 243
The Saga of Andy Burnett (television series), 168
Saint, Eva Marie, 376
Salenger, Meredith, 417, *418*
Saludos Amigos (film), 18
A Salute to Alaska (*Walt Disney's Wonderful World of Color* television episode), 63, 65
Sangster, Jimmy, 296
Saturday Night Fever (film), 366
Savage Sam (film), 238
Scapino (Broadway production), 153
The Scarecrow of Romney Marsh (television film), 349
Schallert, William, 73
Scheele, John
Baby, 346–347, *347*
My Science Project, 405
photos by, *252*, *330*, *347*, *406*

on Studio apprenticeship system, 270
Tron, 260–261, 312, 330, 346
on Walker, 355
Scheele, William, 346–347, 347, 405
Scheider, Roy, 336, 353
Schell, Maximilian, 217, 244
Schiffer, Robert, 53, 253, 271
Schneider, Bert, 59
Schneider, Peter, 413–414, 416–417, 433–434
Schwarzenegger, Arnold, 288, 327
Scorsese, Martin, 105, 134, 399, 425, 426
Scott, Ridley, 327
Scotti, Vito, 238–239
Scribner, George, 413, 433
Scrooge McDuck (character), 65, 303
Scrooge McDuck and Money (theatrical short), 65
Scruffy (film project), 105, 107
Seaman, Peter, 323, 340–341, 342, 385
The Searchers (film), 51
Searles, Frederick, 326
Sebast, Dick, 109
The Secret of Boyne Castle (television film), 49, 66
The Secret of NIMH (film), 320, 328, 328–329
The Secrets of the Pirate's Inn (television film), 49, 51–53, 167
Selick, Henry, 187, 254, 277, 310
Sendak, Maurice, 358
sequels, 238. *see also specific films*
Sesame Street (television series), 131, 272
sexism, 110, 184–186
Shadow of Fear (television film), 221
Shafer, Mavis, 362
The Shaggy D.A. (film), 166–167, 168, 183, 238
The Shaggy Dog (film), 38, 101, 168, 238, 265
Shannon, Leonard, 180
Sharp, Margery, 106
Shaw, Mel
 background, 139
 The Black Cauldron, 179, 275, 275, 276, 298, 404
 in *Disney Animation* (book), 291
 drawings by, 14, 148, 201, 241, 275, 275, 276, 285
 The Fox and the Hound, 201, 205, 219, 241
 The Great Mouse Detective (formerly *Basil of Baker Street*), 373, 375
 Hero From Otherwhere, 353
 Musicana, 216–217, 357, 412
 The Rescuers, 139–140
 The Small One, 190
Sheckley, Robert, 207
Shelton, Toby, 362, 408, 445
Shephard, Ernest H., 108
Sherlock Holmes. *see The Great Mouse Detective; Young Sherlock Holmes*
Sherman Antitrust Act, 21
Sherman Brothers (Richard and Robert)
 Bedknobs and Broomsticks, 45, 61–62, 88–89
 with Disney (Walt), 44
 The Disney Family Album, 376
 Eight-Ball Express, 48
 Mary Poppins, 45, 89
 The One and Only, Genuine, Original Family Band, 45, 47
The Shining (film), 287
Shor, Dan, 260

Shusett, Ronald, 288
Sibley, John, 86
Silva, Henry, 50
Simmons, Rosemary Anne, 237
Simon and Simon (television series), 221, 297, 382
The Simple Things (film), 302
Sinden, Donald, 119
Sir Hiss (*Robin Hood* character), 94
Siskel, Gene, reviews by
 The Black Hole, 246
 Condorman, 311
 The Fox and the Hound, 310
 Night Crossing, 324
 The North Avenue Irregulars, 222
 One Magic Christmas, 417, 419
 The Shaggy D.A., 167
 Tron, 329
 The Watcher in the Woods, 317
Sisson, Rosemary Anne, 115, 116
Sleeping Beauty (animated feature)
 animators, 28–29, 36, 87
 dark moments, 240
 directors, 36, 188
 as inspiration, 32
 lackluster box-office performance, 29, 82
The Small One (short), 188–191, 193–194, 203, 218, 234
Smith, Charles Martin
 American Graffiti, 105, 124, 124
 Herbie Goes Bananas, 238–239
 on Miller (Ron), 250
 More American Graffiti, 250
 Never Cry Wolf, 261, 262, 287, 315, 324–325, 349–351, 350
 No Deposit, No Return, 124, 124–126
Smith, Dave, 75, 446
Smith, Hal, 74, 339
The Smith Family (television show), 52
Smoke (television film), 77
Sneak Previews (movie review program), 222, 253. *see also*
 Ebert, Roger; Siskel, Gene
Snowball Express (film), 121, 167, 183
Snow White and the Seven Dwarfs (animated feature)
 Anderson (Ken) as art director, 82
 animators, 37, 62
 dark moments, 240
 distributor, 21
 rerelease success, 125
 sale of cels from, 291
 scenes reused in *Robin Hood*, 129
 soup-eating seqence, 128
 success, 16, 18
So Dear to My Heart (film), 16
The Solitaire Creature (film project), 353
Something Wicked This Way Comes (Bradbury novel), 272
Something Wicked This Way Comes (film)
 cast, 315–316, 334, 335
 computer animation, 334–335
 director, 272, 273
 filming, 315, 316
 initial plans, 272–273
 mechanical effects artists, 348
 music, 335–336
 release, 333, 344–345

498 INDEX

reshoots, *333, 333–334, 335*
set, *272, 315, 379*
special effects sequences, *333–335, 345*
test screening, 332–333
"Somewhere Out There" (song), 427
Song of the South (film), 16, 139
Son of Flubber (film), 51, 66–67, 114
Sons of Anarchy (television series), 382
Sony Pictures Animation, 435
"The Sorcerer's Apprentice" (*Fantasia* segment), 37
Sound Department, 302
The Sound of Music (film), 44, 254, 325
Southern, Terry, 57
Spacek, Sissy, 342
Spalding, Harry, 237
special-effects animation, 71, 86–87
Special Effects Department, 157–158
Spencer, Dave, 376
Sperry, Armstrong, 99
Spielberg, Steven
 Amblin Entertainment, 427
 An American Tail, 427
 Back to the Future, 400–401
 as dominant force in Hollywood, 105
 E.T., 327
 as inspiration, 232
 Jaws, 177
 The Land Before Time, 438
 Murch and, 368
 Poltergeist, 327, 333
 redefining family films, 327–328
 Sport Goofy, 386
 Star Wars, 177–178
 The Sugarland Express, 309
 Who Framed Roger Rabbit, 343, 385–386, 431
 Wilhite and, 270
Spin and Marty (television series), 38, 168
"The Spirit" (W. Eisner comic), 441
Splash (film), *341–342, 344, 361, 364–365, 365*
Sport Goofy (character), 363
Sport Goofy (film), *362, 363–364, 386*
The Sporting Proposition (film project). *see Ride a Wild Pony*
Spottiswoode, Roger, 346, 399
Stakeout (film), *430, 431*
Stallone, Sylvester, 400
Stanton, Harry Dean, 419
Star! (musical), 43
Starman (film), 293
Starr, Steve, 370–371
Star Trek (television series), 66, 67
Star Trek II (film), 327
Star Trek: The Motion Picture (film), 254
Star Wars (film), 134, 177–178, 201, 247, 312, 343
Steamboat Willie (short), 18, 151–152
Steenburgen, Mary, *418, 419*
Steinberg, Saul, 377
Stevens, Art
 Animation's old guard and new blood, 7, *141*, 217, 225, 232, 242, 243, 369
 Bedknobs and Broomsticks, 76
 The Black Cauldron, 273, 276, 277, 278, 281, 298–299, 369, 437

character traits, 205–206, 215, 369
The Fox and the Hound, 205, 215, 216, 224, 225, 229, 232, 240, 369
Guedel's resignation from Disney, 229
It's Tough To Be A Bird, 64, 65
Reitherman and, 205–206, 215
retirement, 437
Robin Hood, 205
Stevens, George, 53
Stevenson, Robert
 Bedknobs and Broomsticks, 72
 Blackbeard's Ghost, 57
 on Disney (Walt), 24
 The Love Bug, 57, 58, 59, 72
 Mary Poppins, 57, 72, 89
 retirement, 167
 The Shaggy D.A., 167
 storyboarding, 72
Still Camera Department, 22, 381
Still of the Night (film), 336
The Sting (film), 104
Stirdivant, Jill, 362
Stirdivant, Marc
 Condorman, 310–311
 hired by Studio, 101–102
 The Istanbul Express, 207
 The Last Flight of Noah's Ark, 207, 235
 Night Crossing, 235–236, 323–324
 Pit Ponies, 116
 as producer, 236
 Ride a Wild Pony, 115–116
 on sameness of Disney movies, 270
 volleyball games, 268
 Who Framed Roger Rabbit, 337, 340–341, 342–343, 385, 432
 as writer, 206–207
stockholders' meeting, 364
Stones, Tad, 294, 363, 370, 408, 445
Story Department
 Disney (Walt) and, 24
 Ermine as head, 249, 272
 Hibler's career, 38
 live-action refresh, 249
 Mattinson's career, 135
 Stirdivant's career, 101–102, 206–207
The Story of Robin Hood (live-action film), 16
Strange World (film), 448
Streep, Meryl, 336
The Streets of San Francisco (television series), 283
Strelzyk family, 235–236, 322
studio system, 19, 21, 270
The Sugarland Express (film), 309
Sukara, George, 243
Sumac, Yma, 217
A Sundae in New York (stop-motion short), 359
Superman II (film), 310
Supreme Court, 21, 32
Surf's Up (film), 435
Sutton, Missy, 180
Svendsen, Julius, 203, 204
The Swan Princess (film), 437
Swenson, Charles, 175
Swift, David, 24, 148–149

DISNEY IN-BETWEEN

499

Swiss Family Robinson (film), 168
The Sword and the Rose (live-action film), 16
The Sword in the Stone (animated feature), 29, 36, 339

T

Tait, Don, 153, 167, 183
Take Down (film), 274
A Tale of Two Critters (live-action nature short), 179
Tale Spin (television series), 445
Taliaferro, Al, 22
Tamblyn, Russ, 153
Tantin, Roland, 348
Taplin, Jonathan
 Baby, 345–349, 399
 Under Fire, 346
 frustration with Miller, 355, 377
 My Science Project, 404–405, 407
 Rainwater and, 355, 377
Tarzan (film), 434, 435, 436, 448
Tate, Louis, 243, 262, 266
Tatum, Donn, 27, 40, 55, 339
Taxi Driver (film), 134
Taylor, Richard, 252, 260
Taylor, Robert Lewis, 48
Tea Room, 185, 265
Television Academy Archives, 72
Temple, Barry, 306
Terminator 2 (film), 440
Tex (film), 271, 289, 331–332
Tex (Hinton novel), 271, 289, 331–332
Texas John Slaughter (television series), 48
That Darn Cat! (film), 21, 51, 265
That's Entertainment, 412
"There's Room for Everyone in This World" (song), 199
The Thing (film), 310, 327
Thomas, Bob, 32
Thomas, Frank
 Animation's old guard and new blood, 7, *141*, 180, 206, 213, 263
 The Black Cauldron, 179–180, 196
 Bluth and, 88
 CalArts and, 97
 caricature, *14*
 Clements and, 110–111, 142, 291
 as directing animator, 36, 109
 Disney Animation: The Illusion of Life (book), 263, 285, 290–291, 427
 The Fox and the Hound, 190–191, 196, *196*–197, 202
 Johnston and, *144*
 Kahl and, 146
 on Lounsbery, 142
 Mattinson and, 93–94, 134–135
 as mentor, 88, 93–94, 110–111, 144
 The Rescuers, 136, 146, 147, 155–156, 215
 retirement from animating, 202–203
 rivalries, 143
 Robin Hood, 84, 94
 self-caricature, *92*
 story development, 138
 Winnie the Pooh and Tigger Too, 109
 work schedule, 142

Thompson, Bill, 303
Thompson, Brett, *123*
Those Calloways (theatrical drama), 38, 121
The Three Caballeros (film), 16, 18
3D animated cartoons, 63
3D films, 426
The Three Lives of Thomasina (live-action film), 105, 115
Three Men and a Baby (film), 430, 431
The Three Musicians from Bremen, 81
A Thrill a Minute with Jack Albany (book), 48–49
A Thrill a Minute with Jack Albany (film project), 48–49.
 see also *Never a Dull Moment* (film)
THX 1138 (film), 105, 271
Tiger Town (The Disney Channel film), 353
Tilly, Meg, *331*, 421
Time Bandits (film), 293
Tippet, Phil, 347
Titus, Eve, 373
Tokar, Norman, 45, 121, 125
Tokyo Disneyland, 392
Tombragel, Maurice, 48, 66
Tomlinson, David, 88, 89, 91
Tommy (rock musical), 132
Tondreau, Bill, 312–313
Tonka (feature film), 168
Tony Awards and nominations, 71–72, 133, 153
Toot, Whistle, Plunk and Boom (educational short), 63
Tootsie (film), 352
Top Gun (film), 426
Tora, Tora, Tora (film), 130
Total Recall (film), 288
Totten, Robert, 77–78
Touchstone Films/Touchstone Pictures
 1984 releases, 364–365, 382
 1985 releases, 399, 419
 1986 releases, 421–422, *422*, 425
 1987 releases, 431
 creation of, 361, 364, 444
 rebranding, 425
Tough Guys (film), 422, 425
The Towering Inferno (disaster film), 115, 131, 132
Towne, Robert, 341
Toy Story (film), 440, 451
Travers, P.L., 45
Treasure Island (live-action film), 16, 149
Treasure of Matecumbe (film), 153, 168, 183
Trenchcoat (film), 323, 340, *340*
Trick or Treat (film), 354
Triple-I, 312
Tri-Star Pictures, 405
Tron (film)
 animators, 258–260, 334
 backlit animation, 257, 261, 318–319
 computer animation, 258, 311–312, *312*, 313, 335, 357, 360, 440
 crew, 257–258
 in *Disney on Film* (film and college tour), 287
 filming, 311
 Kodalith prints, 260, 261
 leadership, 256–247
 legacy, 440
 Linsberger's concept, 226–227, 256–259

motion control cameras, 312–313, *313*
multiplane shots, 358
release, 320, 329–330
reviews, 320, 329
screenings, 313–314, 320
special effects, 260–261, *319*
storyboards, 258–259, 263
Studio enthusiasm for, 314–315
success, 329–331
Trousdale, Gary, 436
True-Life Adventures (nature series), 21–22, 26, 37, 38, 113, 250
Twain, Mark, 183
20th Century Fox
Anastasia, 438
Berger's career, 343, 344, 361
Cocoon, 400
Star Wars, 134, 177–178, 201, 247, 312, 343
Tait's career, 183
20,000 Leagues Under the Sea (live-action film), 16, 53
The Twilight Zone (television series), 66
Twins of Evil (film), 116
Two Against the Arctic (docudrama), 112–113, *113*
2001: A Space Odyssey (film), 130
Tyner, Charles, 153
Tytla, Bill, 291
Tytle, Harry, 23, 36, 37, 38, 40, 167

U

Underdog (character), 73
Under Fire (film), 346, 349
"Under the Sea" (song), 433
The Unidentified Flying Oddball (film), 183
Universal Pictures, 177–178, 183, 250, 405, 427
The Untouchables (television series), 67
UPA animation studio, 97
Ustinov, Peter, 38, 87

V

Valentine, Karen, 211
Van Citters, Darrell
on backlot, 266
The Black Cauldron, 402
on Bluth, 230
on Burton, 233, 279
as CalArts student, 122, *123*, 124
career after Disney, 436
cost-effective animation R&D, 343
Doctor of Doom, 234
EPCOT Center promotional films, 294
The Fox and the Hound, 214, 225, 231–232, 242–243
Fun with Mr. Future, 294–295, 336, 355
Gabriel and, 234
on generation gap, 213, 243, 336
hired by Studio, 212, *212*
as inbetweener, 224
pace, 242–243
on Reitherman, 214–215
Sport Goofy, 362, 363–364, 386

volleyball games, 268, 269
Who Framed Roger Rabbit, 337, 340–341, 342, 343, 385–386, 432
Van Dyke, Dick, 49, 50, 73, 325
The Vanishing Prairie (nature film), 26
Vanity Fair (magazine), 6–7
Van Osten, Carson, 147
Van Patten, Dick, 133
Varab, Jeffrey, 194
Verhoeven, Paul, 288
Vietnam War, 42, 71
Villa Cabrini school, Burbank, 63
Vincent (stop-motion short), 282, *282*, 283, 354, 355
Vinton, Will, 293
The Virginian (television series), 67, 222
Voght, Dolores, 22
Von Hagen, Lulu May, 62
Voorheis, Sally, 229

W

Walker, E. Cardon "Card"
Anderson (Ken) and, 81
Bluth and, 320
character traits, 269
Disney (Roy E.) and, 378
Disney (Walt) and, 27
The Disney Channel, 344
Eisner and, 366
profit-sharing program, 270
roles at Studio, 27, 40, 91, 167, 181, 248, 339
Tron, 320
"What would Walt do?" school of thought, 354–355
Walk the Line (film), 423
Wallis, Shani, 415
Walsh, Bill
Bedknobs and Broomsticks, 89
Blackbeard's Ghost, 38, 57
death, 167
Kasha and Hirschhorn and, 131
live-action films, 37, 38, 40
The Love Bug (film), 57
The Magic Bedknob, 61
Mary Poppins, 38, 57, 89
Mickey Mouse comic strip, 38
as television producer, 38
The World's Greatest Athlete, 99
Walt Disney Animation Studios, 223–224, 445, 446
Walt Disney Archives, 75, 445
The Walt Disney Company, 428. *see also former name* Walt Disney Pictures
Walt Disney Home Video, 445
Walt Disney Imagineering (WDI), 258, 295, 376
Walt Disney Pictures
Benji the Hunted, 431
Berger as president, 343
The Disney Channel, 344
Flight of the Navigator, 425
high school sports sponsorship, 363
The Journey of Natty Gann, 417, *418*
One Magic Christmas, 417, *418*, 419
Walt Disney Productions

1972 production schedule, 93
Disney (Roy Jr.) coup rumors, 378
hostile takeover attempt, 377
Miller as president, 339
renamed The Walt Disney Company, 428
restructuring, 343
Walt Disney's Disneyland (television series), 19
Walt Disney Studio
 aftermath of Walt's death (1967), 35–45
 Christmas parties, 51
 connected universe between movies, 114
 Disney (Walt)'s death, 13, 14–15
 family environment, 51–52, 125–126, 157–158, 180, 270
 hierarchy, 248–249
 Hollywood studio system, 21, 270
 insular approach, 102, 117
 letterhead, *44, 50*
 live-action filmmaking, 16–17, 40, 47–48, 49
 loyalty, 126, 157
 Mattinson as traffic boy, 15, 16, 22–23
 One Magic Christmas, 417, 418, 419
 outside filmmakers, 270–271
 Paramount Pictures partnership, 274, 309–310, 366
 profit-sharing program, 270–271
 story development process, 138–139
 television production, 19
Walt Disney's Wonderful World of Color (television show), 31, 49, 63, 65
Walt Disney Television Animation, 445
Walt Disney: The Man and His Miracles (documentary film), 101
Walt Disney World. *see also* EPCOT Center
 Contemporary Resort Hotel, 364
 Discovery Bay (planned), 118
 as east coast Disneyland, 14, 62
 The Island at the Top of the World dioramas, 118
 Main Street Electrical Parade, 197–198
 opening day, 91
The Waltons (television series), 182
Walt's Time (Sherman Brothers memoir), 61–62
The Waltz King (television special), 48
Warburton, Cotton, 53
Warner, Jack, 43, 44
Warner Bros.
 animation style, 386
 Avery as director, 227
 Bonnie and Clyde, 42–43
 Camelot, 43–44
 Cats Don't Dance, 435
 commercials, 436
 leadership, 43, 44, 176
 Splash, 341
 Tait's career, 183
Warren, Gale, 223–224, 243, 287, 445
Warren, Lesley Ann, 44
The Washington Post, 152–153
The Watcher in the Woods (film), 236–237, 253–255, 276–277, 283, *317, 317*
The Watcher in the Woods (Randall book), 236–237
Watergate scandal, 42
Watson, Ray, 339, 377, 378
Wayne, Patrick, 114

WDI (Walt Disney Imagineering), 258, 295, 376
Weaver, Sigourney, 217
Webb, Frank, *69*
Webber, Kem, 212
Webster, Michael, 408
Wechter, David, 253
Wedge, Chris, 313
Weird Science (film), 405
Wells, Frank, 176, 378–382, *380,* 410, 412
"We May Never Love Like This Again" (song), 131
Wenzel, Paul, 81, 220
Westinghouse Broadcasting, 344
West Side Story (film), 254, 325
Westward Ho the Wagons! (film), 51, 53
Wetzel family, 235–236
Whedon, John, 99
Whedon, Joss, 99
Whelchel, Lisa, 221
"When You're the Best of Friends" (song), 287
"When You Wish Upon a Star" (song), 178
Where the Wild Things Are (animation test), 358, 360, 410, 441
Where the Wild Things Are (Sendak book), 358
Whitaker, Johnny, 52
White, Al, 300
White, Larry, 165
White, Onna, 154–155
White, T.H., 412
Whitney Museum of American Art, New York, 290
The Whiz Kid and the Carnival Caper (television film), 168
Who Censored Roger Rabbit (Wolf book), 337
Who Framed Roger Rabbit (film), 432
 Academy Awards, 432
 budget, 343
 characters, 385, *432, 432*
 creative team, 337, 340–341, 431–432, 446
 director, 342–343, 431
 internal friction, 340–341, 385
 release, 431
 resurrected by Eisner and Katzenberg, 385–386
 story, 337, 340–341
The Wild Country (Western), 77–78, *79*
Wilder, Gene, 311
Wilder, Myles, 54–55
Wild Wild West (television series), 67
Wilhite, Tom, 182
 Baby, 346, 349, 367
 Bebe's Kids, 444
 The Black Cauldron, 275–276
 The Black Hole publicity, 245, 247
 on Bluth's exodus, 231
 The Brave Little Toaster, 360–361, 442
 Burton and, 281–282
 changing Disney processes and culture, 247–249, 269–270, 351, 355, 444
 "Disney Animations and Animators" exhibition, 290
 Disney on Film, 285, 286–288, 318
 Einstein, 318
 on end of Walt era, 291
 Fun with Mr. Future, 294–295
 hired by Studio, 181–182
 Hyperion Pictures, 361, 442, 444

Lasseter and, 281, 357
legacy, 444
Life with Louie, 444
Miller and, 247–248, 355
Never Cry Wolf, 262, 350, 351
outside filmmakers and, 270–273, 293
The Proud Family, 444
resignation, 361
Return to Oz, 343, 367
Rover Dangerfield, 444
Sendak and, 358
Something Wicked This Way Comes, 273
Splash, 341, 342, 361, 365
Story Department, 249
on Studio management, 248–249
Tex, 332
Touchstone Pictures, 444
Tron, 256, 440
Vincent, 355
Who Framed Roger Rabbit, 337, 340, 341, 343
Williams, Cindy, 423
Williams, Jan, 168, 207, *268*, 311, 354, 382
Williams, Jay, 353
Williams, John, 178
Williams, Richard, 131, 175, 186, 431–432
Williams, Robin, 274, 431, *443*, 443
Willie and the Yank
(Sunday night television show episode), 39
Winchell, Paul, 339
"Wind in the Willows" (*The Adventures of Ichabod and Mr. Toad* segment), 37
The Wind in the Willows (film), 139, 307, 374
Winnie the Pooh (film), 447, 448
Winnie the Pooh and the Blustery Day (featurette), 77, 106
Winnie the Pooh and the Day for Eeyore (short), 339
Winnie the Pooh and the Honey Tree (featurette), 77
Winnie the Pooh and Tigger Too (featurette), 106, *108*, 109–110, 119, 134–135, *150*, 204
Winters, Shelly, 154
Wisconsin Death Trip (book), 292
Wise, Kirk, 436
Wise, Robert, 237
"With a Flair" (song), 91
Wittliff, William D., 352
The Wizard of Oz (film), 54. *see also Return to Oz*
The Wizard of Speed and Time (short film), 287
Wizards (film), 175
Wolf, Fred, 175
Wolf, Gary K., 337
The Wonderful Wizard of Oz (Baum book), 292
Wonderful World of Color (television show), 31, 49, 63, 65
The Wonderful World of Disney (television series)
The Boy Who Talked to Badgers, 133
Disney (Roy E.) as director, 99
Donovan's Kid, 221
fading popularity, 244
Miller as executive producer, 91, 93
Shadow of Fear, 221
Yates as writer, 283
Woodward, Morgan, 77, *103*
The World's Greatest Athlete (live-action film), 99, 121, 266
World War II, 16, 18, 105, 127

Wreck-It Ralph (film), 447
Wright, Ralph, 339
Writers Guild Award and nominations, 365
The Wuzzles (television series), 408

X

Xerox animation process, 82, 83, 129–130, 376
The X-Files (television series), 427

Y

Yates, William Robert, *268*, 283
Young, Alan, 303
Young, Pete
The Black Cauldron, 277–278, *278*, 280, 298
death, 413
Gong Show, 413, 433
The Great Mouse Detective (formerly *Basil of Baker Street*), 373
Oliver & Company, 413, 433
The Small One, 188
Winnie the Pooh and the Day for Eeyore, 339
Young, Sean, 349
Young Sherlock Holmes (film), 389, 415, 440
Your Show of Shows (television series), 326

Z

Zemeckis, Bob, 343, 385, 386, 400–401, 431
Zielinski, Kathy, 373, 434
"Zip-A-Dee-Doo-Dah" (song), 132
Zootopia (film), 6
Zorro (television series), 38, 51, 53, 265, 266
Zorro and Son (television series), 283
Zucker, David, 422
Zucker, Jerry, 422
Zuniga, Frank, 99

Author Bio

Stephen Anderson is a director, writer and storyboard artist with over 30 years of experience in the animation industry. At Walt Disney Animation Studios, he was a story artist on *Tarzan* and was later promoted to story supervisor for *The Emperor's New Groove* and *Brother Bear*. As a director, he has helmed the feature films *Meet the Robinsons* and *Winnie the Pooh*, followed by a role as supervising director at Walt Disney Television Animation on the first season of *Monsters at Work*, which debuted on Disney+ in July of 2021.

Over a period of approximately ten years, Stephen was an instructor at the California Institute of the Arts, teaching story development to both sophomores as well as juniors and seniors. He has lectured on storyboarding and the creative process at San Jose State, Loyola Marymount University, Penn State, Santa Barbara Community College, The California Arts Project and Sheldon High School in Sacramento, California.

After leaving the Walt Disney Company in 2021, Stephen storyboarded on the upcoming *Garfield* feature film from Alcon Entertainment and served as animation director on *Young Love*, a series that aired on Max in September of 2023.

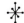

"Stephen Anderson has written a highly important book. *Disney In-Between* chronicles the important Studio transition period that led to what we now refer to as the "Disney Renaissance." Having known and worked with many of the key players profiled here, I can tell you that Steve's account is accurate, well-researched, and moreover, no-holds-barred-truthful, about both the difficulties and the triumphs of a group of artists who wanted to see Disney return to its glory days. It was a bumpy, contentious period, but the survivors gave us what many consider to be Disney Animation's finest films. Bravo!

—Eric Goldberg, *Animator/Director,*
Walt Disney Animation Studios